Exhibit Design

High Impact Solutions

Exhibit Design

High Impact Solutions

Bridget Vranckx

COLLINS | **DESIGN**

An Imprint of HarperCollins*Publishers*

EXHIBIT DESIGN. HIGH IMPACT SOLUTIONS
Copyright © 2006 Collins Design and Loft Publications

HarperCollins books may be purchased for educational, business, or sales promotional use.
For information, please write: Special Markets Department, HarperCollins Publishers,
10 East 53rd Street, New York, NY 10022

First Edition published in 2006 by
Collins Design
An Imprint of HarperCollins*Publishers*
10 East 53rd Street
New York, NY 10022-5299
Tel.: (212) 207-7000
Fax: (212) 207-7654
collinsdesign@harpercollins.com
www.harpercollins.com

Distributed throughout the world by:
HarperCollins*Publishers*
10 East 53rd Street
New York, NY 10022
Fax: (212) 207-7654

Packaged by
LOFT Publications
Via Laietana, 32 4.° Of. 92
08003 Barcelona, Spain
Tel.: +34 932 688 088
Fax: +34 932 687 073
loft@loftpublications.com
www.loftpublications.com

Editor:
Bridget Vranckx

Art Director:
Mireia Casanovas Soley

Layout:
Zahira Rodríguez Mediavilla

Library of Congress Cataloging-in-Publication Data

Exhibit design / [edited by] Bridget Vranckx.
 p. cm.
 ISBN-13: 978-0-06-113968-0
 ISBN-10: 0-06-113968-8
 1. Exhibit booths—Design and construction. 2. Trade
shows—Exhibition techniques. I. Vranckx, Bridget. II. Title.

 T396.5.E883 2006
 607'.34—dc22

 2006024910

Printed in Spain

First Printing, 2006

CONTENTS

Introduction

Evanescence in Business, Pleasure and Leisure

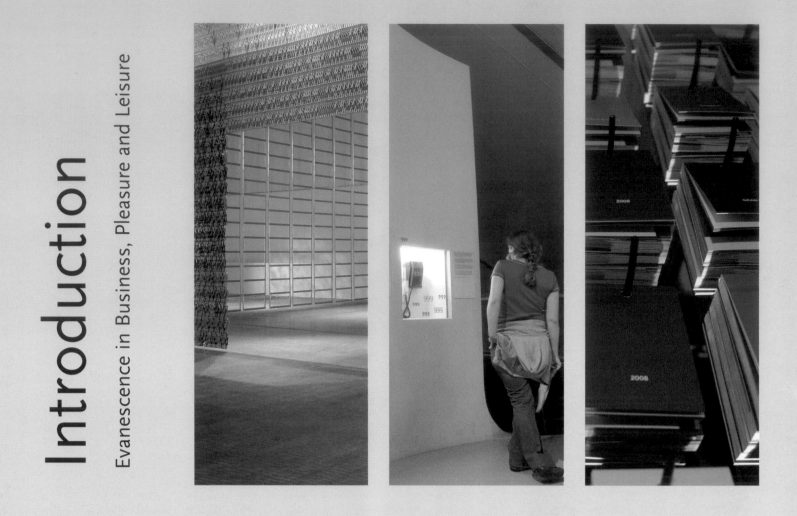

The interior design of exhibitions has become increasingly important in both business and leisure. Architects and designers find innovative ways of displaying exhibits, presenting company products and conveying philosophies using light, color, sound and graphics. The very transcience of such short-lived events has turned them into opportunities avant-garde exploration and innovation.

International trade fairs concentrate a large number of producers and dealers under one roof, all competing for attention. Just as businesses present new products, architects and designers—plus, increasingly, scenographers, and advertising and event agencies—introduce design trends via interdisciplinary experiments with new technologies and materials. As always, time, space and budget restrictions present interesting challenges.

Werner Sobek's 2003-2005 design for the Mercedes-Benz exhibition stand deftly promotes maximal brand recognition while requiring minimal assembly and disassembly time. Another easily moved display format is Kreon's semi-fabricated exhibition module "Containing Light", a semi-prefabricated exhibition stand which has traveled around the world to exhibit at a number of international lighting exhibitions. Another crucial objective, is attracting visitors' attention. Effective conglomerations of brands, sounds, graphics and other visuals distinguish Atelier Brückner's Blue Scape multimedia installation for Panasonic and Atelier Markgraph's design for DaimlerChrysler's corporate presentation at the 73rd Geneva International Motor Show.

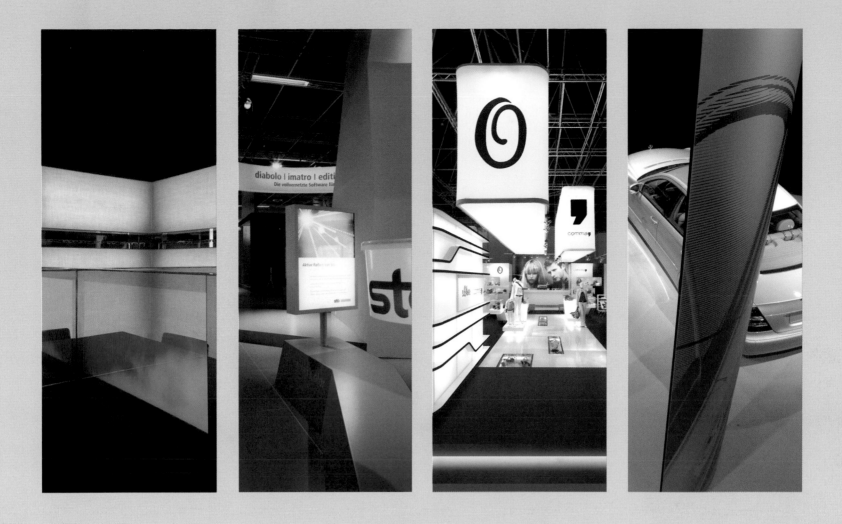

Companies large and small, aren't the only ones to realize the value of exhibition stands as a three-dimensional marketing presentations. Cultural and leisure institutions similarly require a well-designed exhibitions, be they temporary or permanent. In such cases, designers must create memorable presentations, often in the face of severe space restrictions. Shigeru Ban's Nomadic Museum enabled a photographers to display his large-scale works all over the world while avoiding traditional exhibition spaces. Dagmar von Wilcken's designed the information center for Berlin's Memorial to the Murdered Jews of Europe to fit the unusual space designed by architect Peter Eisenman.

Beyond such practical concerns as display, lighting, color, sound and graphics, architects and designers are also increasingly aware of the long-term effects of these short-lived displays. Ecological concerns dictate the need to reduce costs and work within defined spaces and time limits. Indissoluble's 100-percent reusable exhibition stand for Barcelona City Council is one contemporary solution.

Sporting and cultural events, art projects, and other competitions of all kinds provide additional opportunities for architects, designers and presenters to flaunt their talents. Turn to the last chapter for some spectacular (if short-lived) exhibitions in the fields of art, architecture, culture and sports.

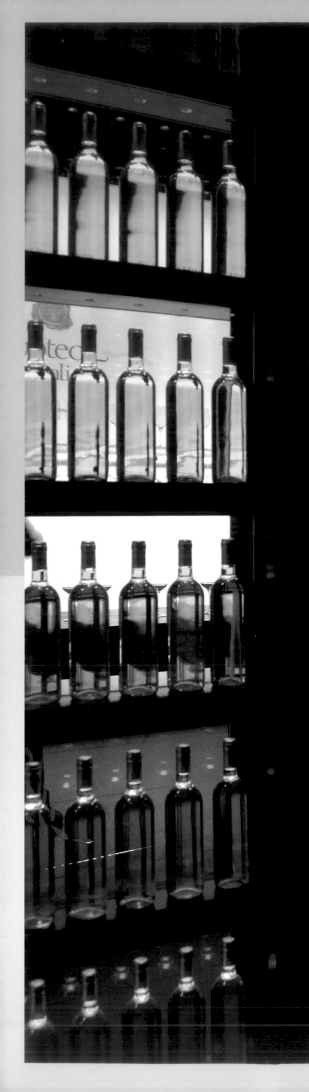
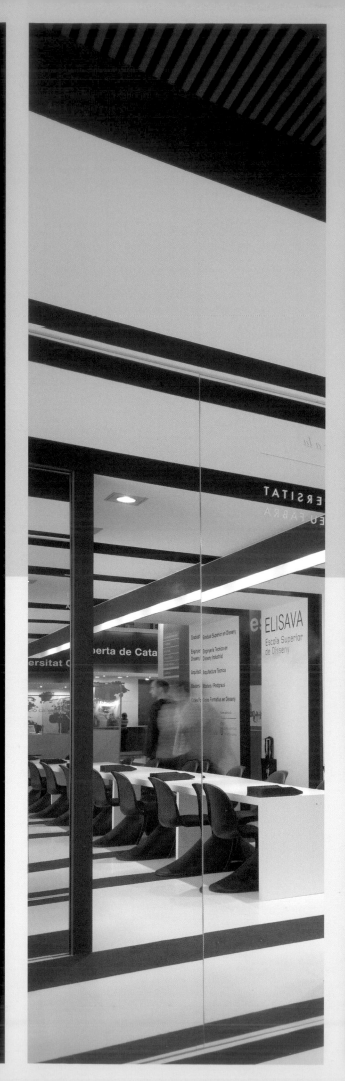
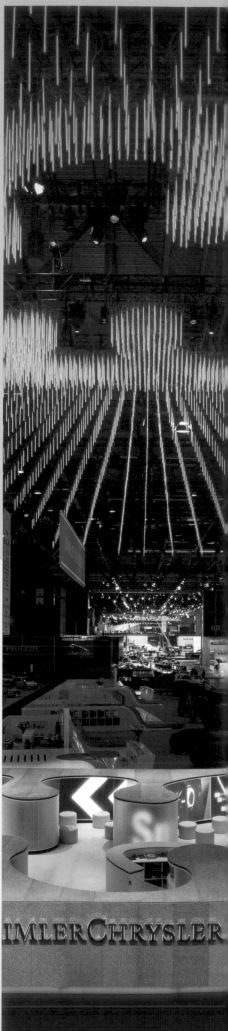

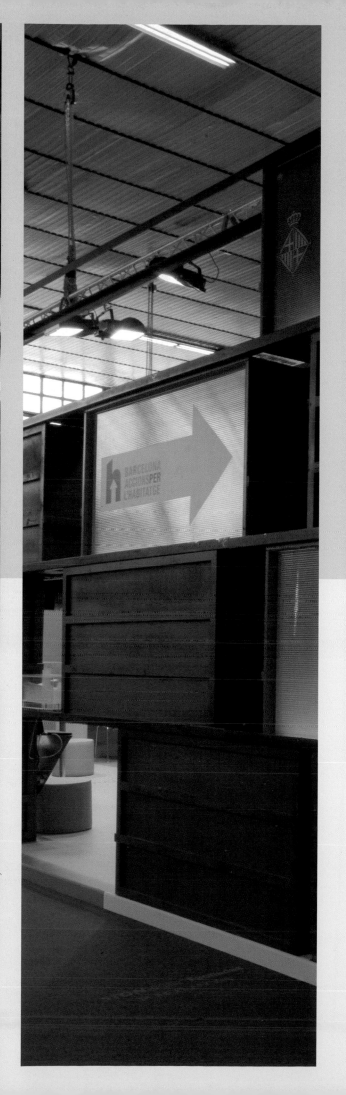

BUSINESS

Trade Fairs

Trade shows are important for companies seeking not only to present range of products, but also to expand their client lists and clinch important business deals. Outstanding exhibition design, by attracting visitors to important displays, can help a company achieve these goals.

However, stands must go beyond aesthetic appeal to the client's identity, present its products, and communicate its philosophy. Architects and designers face a number of challenges as they try to conform to a client's style, schedule and budget. Innovative solutions can be found on the following pages.

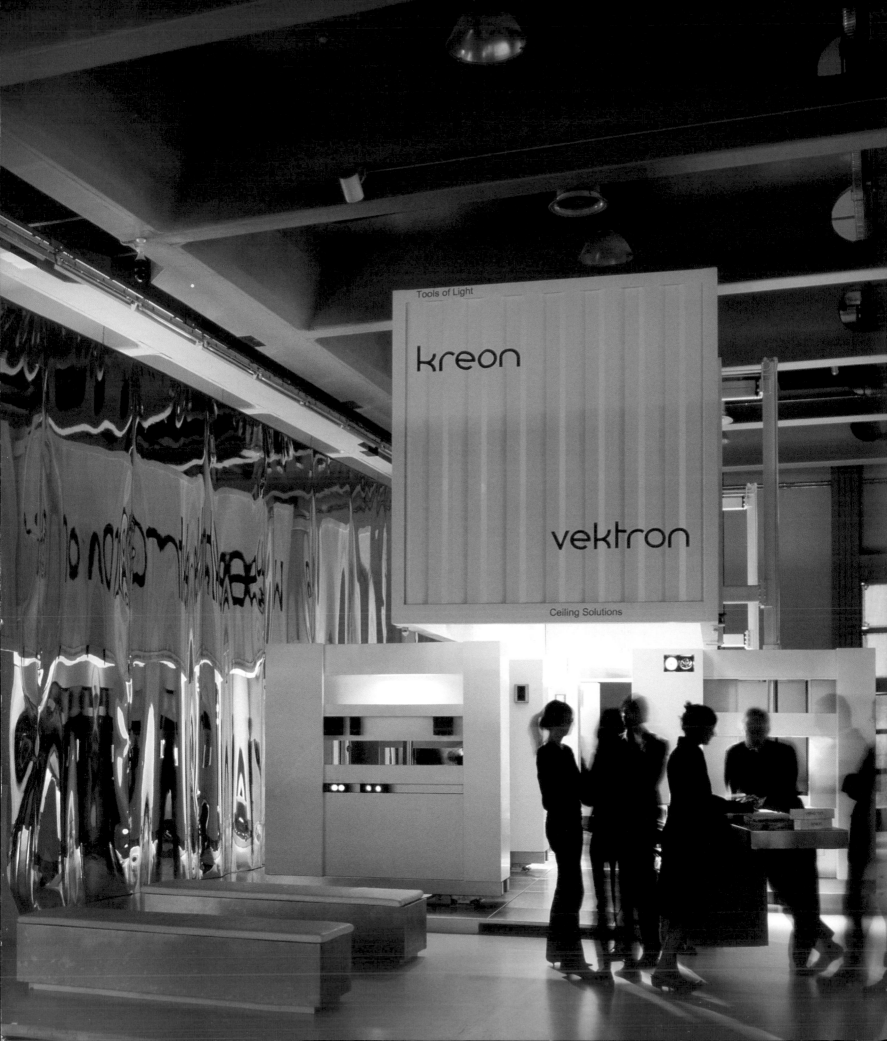

CONTAINING LIGHT
Brilliant Capsule

Kreon NV

Address
Kreon NV
112 Frankrijklei
B-2000 Antwerpen
Belgium

Fair
Euroluce, Milan, Italy
April 13–18, 2005

Other cities
100% Design, London, England;
Maison & Objet, Paris, France;
Light + Building, Frankfurt, Germany;
Interlight 2005, Istanbul, Turkey;
Design Block 05, Prague, Czech Republic;
Batibouw, Brussels, Belgium

Primary material
Metal container

Photography
© Dario Tettamanzi, Serge Bison,
Michael Voit

Kreon's mission is "lighting integrated into the surrounding architecture, where light and not the product is important." This concept must be expressed in an exhibition stand using limited time and space. Kreon presented its latest marketing tool in Milan at Euroluce 2005. Improving on a previous semi-pre-fabricated version, "Containing Light" is a mobile prewired exhibition module.

Kreon wanted a simple means of transporting their designs around the world and achieved it with the creative and spectacular 'Containing Light'. This metal container, with all of Kreon's products already assembled inside, has traveled around the world without disassembly. The robust exterior is a protective shell, made of welded steel beams and bent plates, while the interior consists of highly polished stainless steel and white leather. Certain constraints govern the module's placement (it must be the first stand installed and the last one removed, so that the hall is otherwise empty, accomodating, trucks for haul-ing) but once it has entered the exhibition venue, assembly and disassembly each require only one hour.

Euroluce is an international lighting exhibition (filling 35,140 square meters) that is held every two years in association with the Milan Salone Internazionale del Mobile. The theme of Euroluce 2005 was "Light and the City."

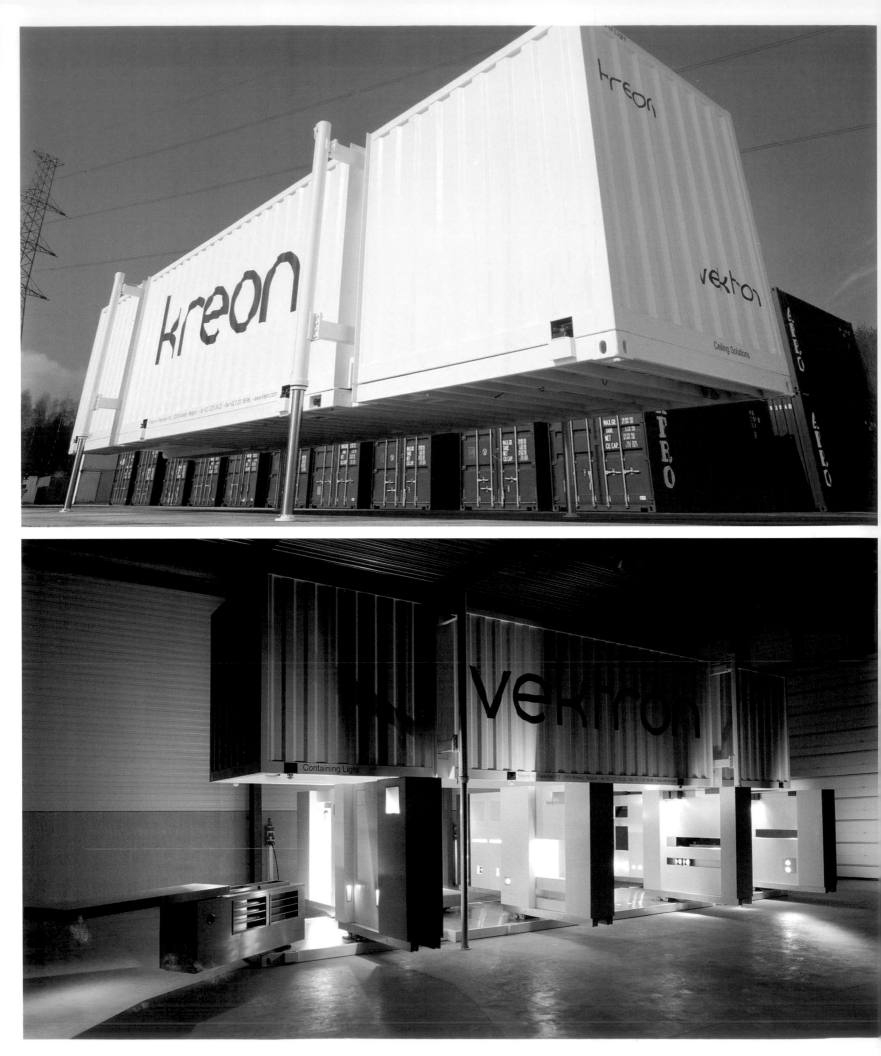

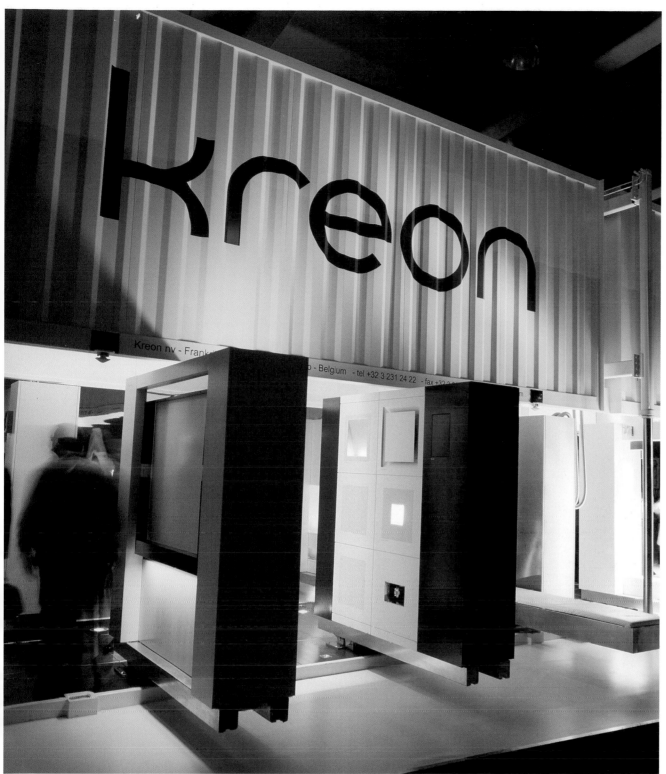

A metal container made of welded steel beams and bent plates carries all of Kreon's products around the world from exhibition to exhibition.

The forty-foot container is transported to its position, where it is jacked up by four five-meter-high computer-controlled hydraulic cylinders that have been integrated into the container. The container base is released from its body and lifted to its final height of five meters.

Once the container is opened, its internal architecture reveals displays made of highly polished steel and white leather.

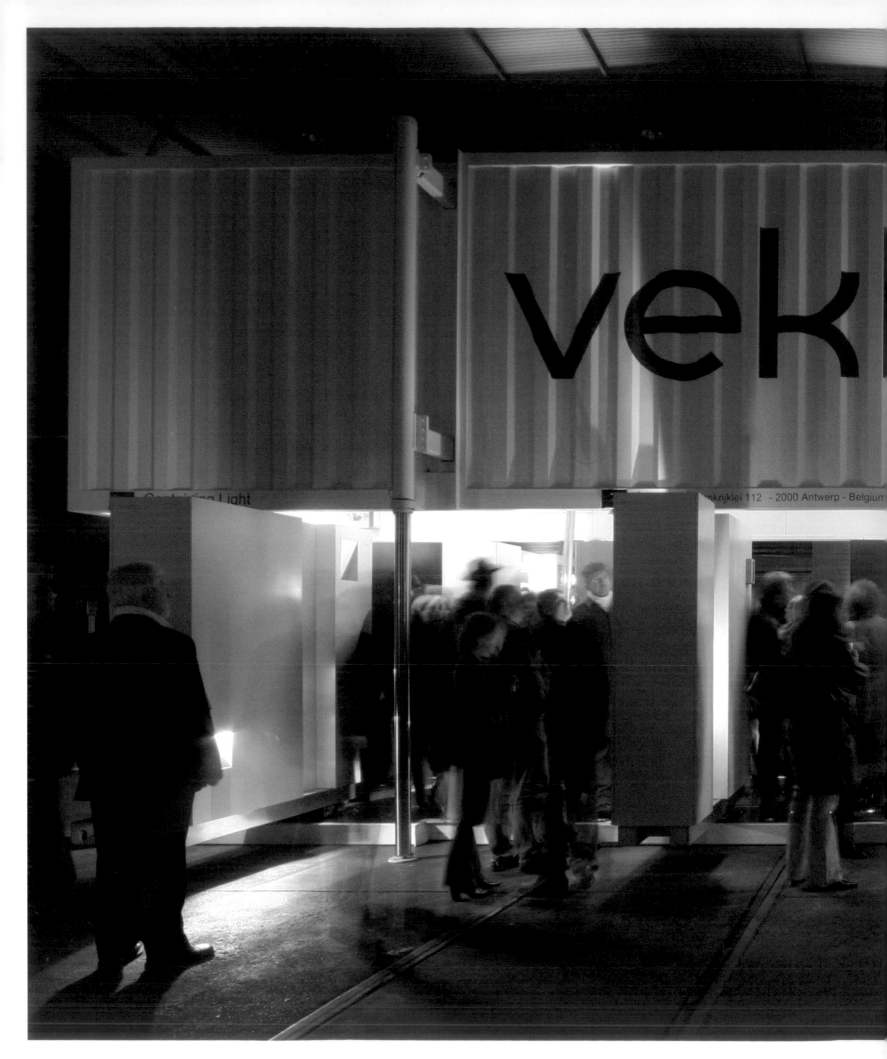

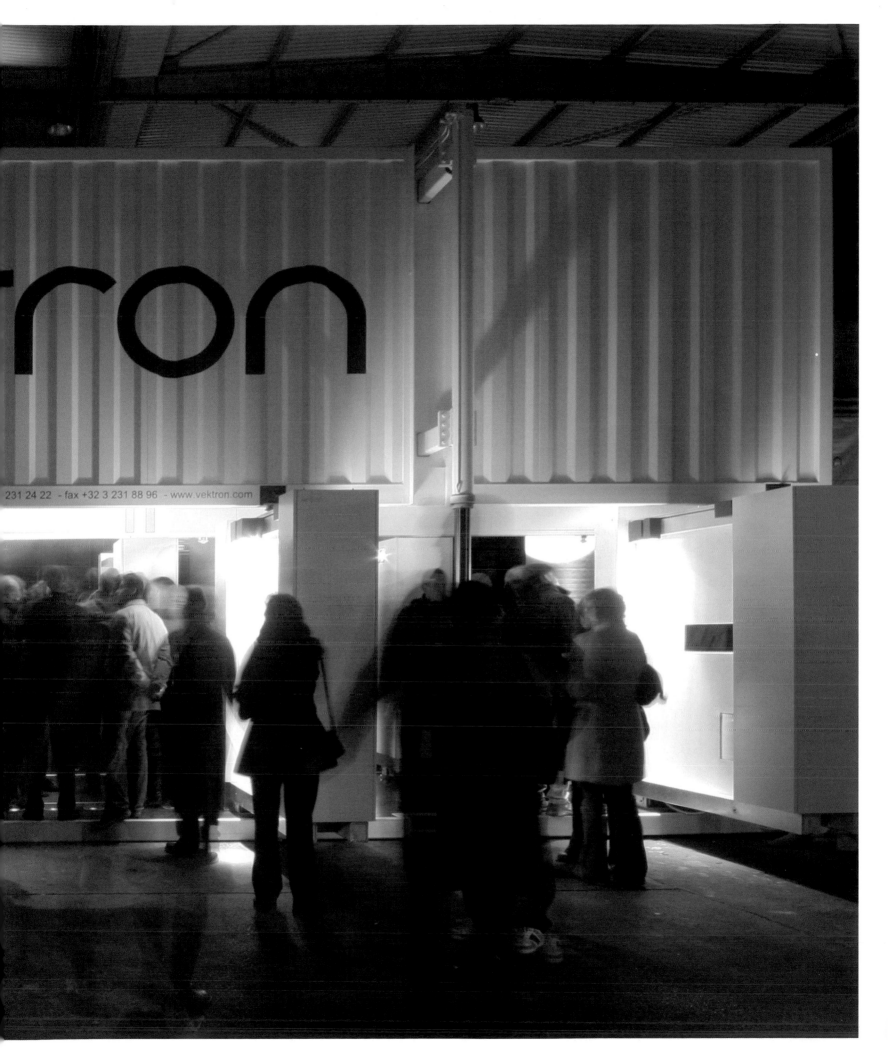

231 24 22 - fax +32 3 231 88 96 - www.vektron.com

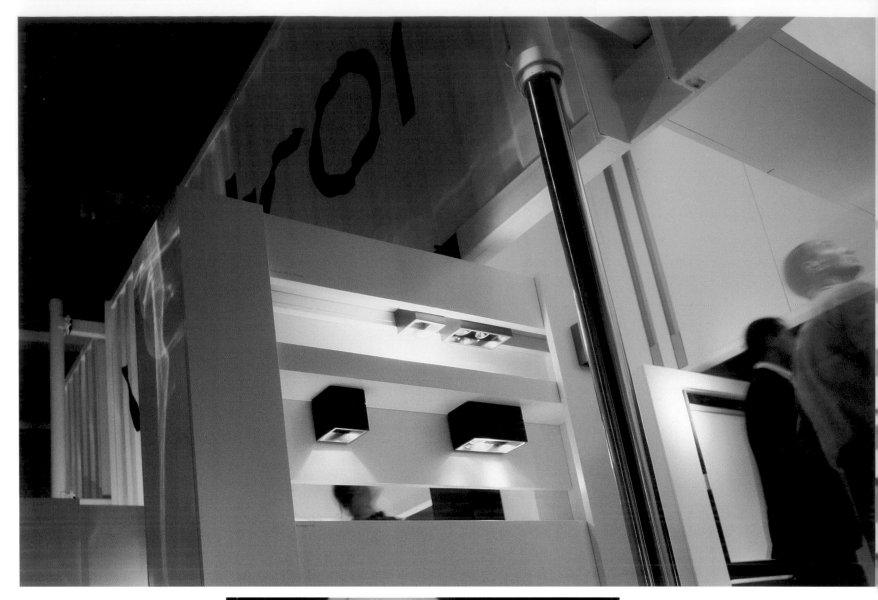

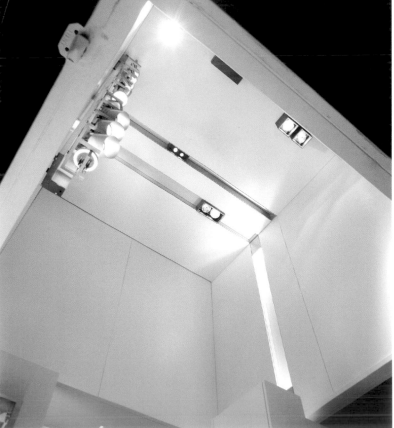

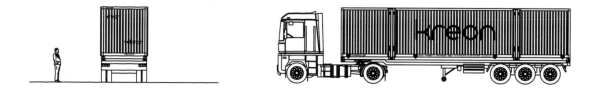

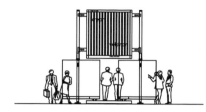
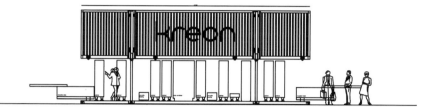

Exhibition cabinets inside the container are unpacked, doubling the original container's volume and creating a spectacular structure.

The truck carrying the metal container can drive straight to the location of the exhibition stand. However, to enable the truck's ingress and egress, the exhibition hall must be clear. This means the Kreon stand has to be the first exhibit erected and the last dismantled.

The packing and unpacking of the exhibition only takes one hour. All of Kreon's products have been preassembled inside the container.

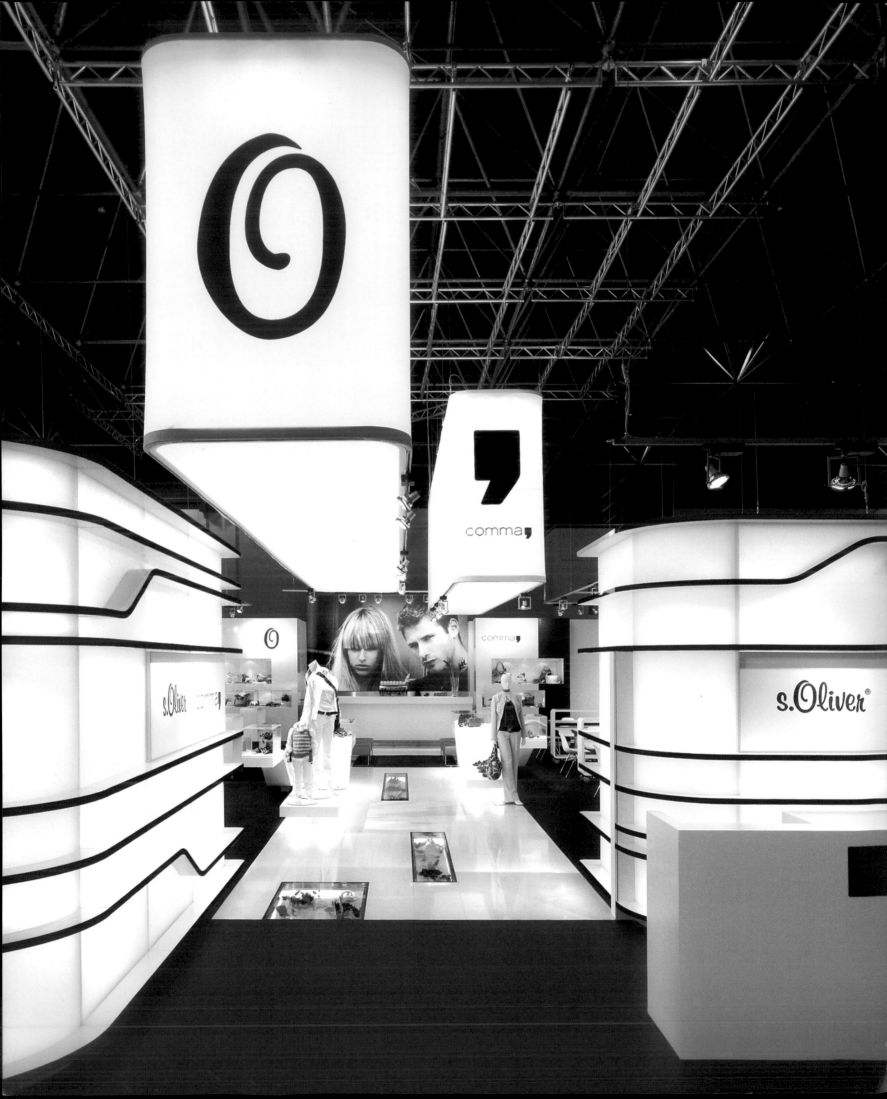

S. OLIVER AND COMMA SHOES

Urban Sophistication

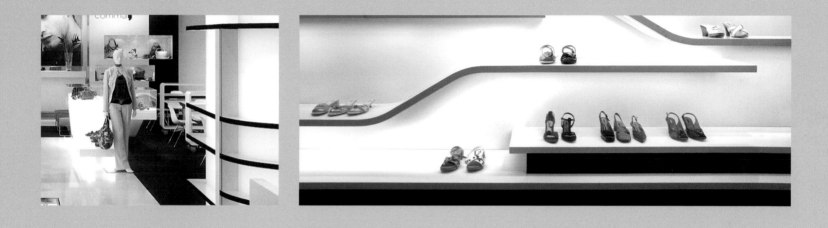

Plajer & Franz Studio

Address
 Plajer & Franz Studio
 Erkelnzdamm 59-61
 D-10999 Berlin
 Germany

Fair
 GDS, Düsseldorf
 March 5–7, 2005

Other cities
 None

Primary material
 Encircling band and translucent Plexiglas

Photography
 © Diephotodesigner.de

Plajer & Franz Studio was commissioned to create a trade show concept for two brands, S. Oliver and Comma Shoes. Its mandate was to illustrate the compatibility of the two brands while reinforcing their individual identities. The S. Oliver corporate group is one of Europe's largest fashion businesses, comprising nine product lines.

The main connecting theme for the S. Oliver and Comma exhibit was "city and urban development." S. Oliver is aimed at a creative, young and vibrant demographic, while Comma targets a stylish, self-assured and cosmopolitan clientele. The stand embodies dynamism and urban understatement. The color white, common to both brands, predominates in the stand, while the asphalt gray on the floor anchors the space; the combination produces a light and airy surrounding with a stylish and urban-feeling foundation. Three architectural elements define the booth for these two brands as well. A modular shelf band developed by Plajer & Franz was inspired by the curves of natural footwear arches; it displays seasonal merchandise and highlights of the collection. A catwalk provides a stage where both brands can be spotlighted in periodic presentations. Two illuminated "logo-sail" with the brand names are visible from afar.

GDS is one of the world's largest shoe trade fairs. More than 1,300 exhibitors from some 45 countries presented their 2006/07 Autumn/Winter and Spring/Summer collections at the 101st GDS.

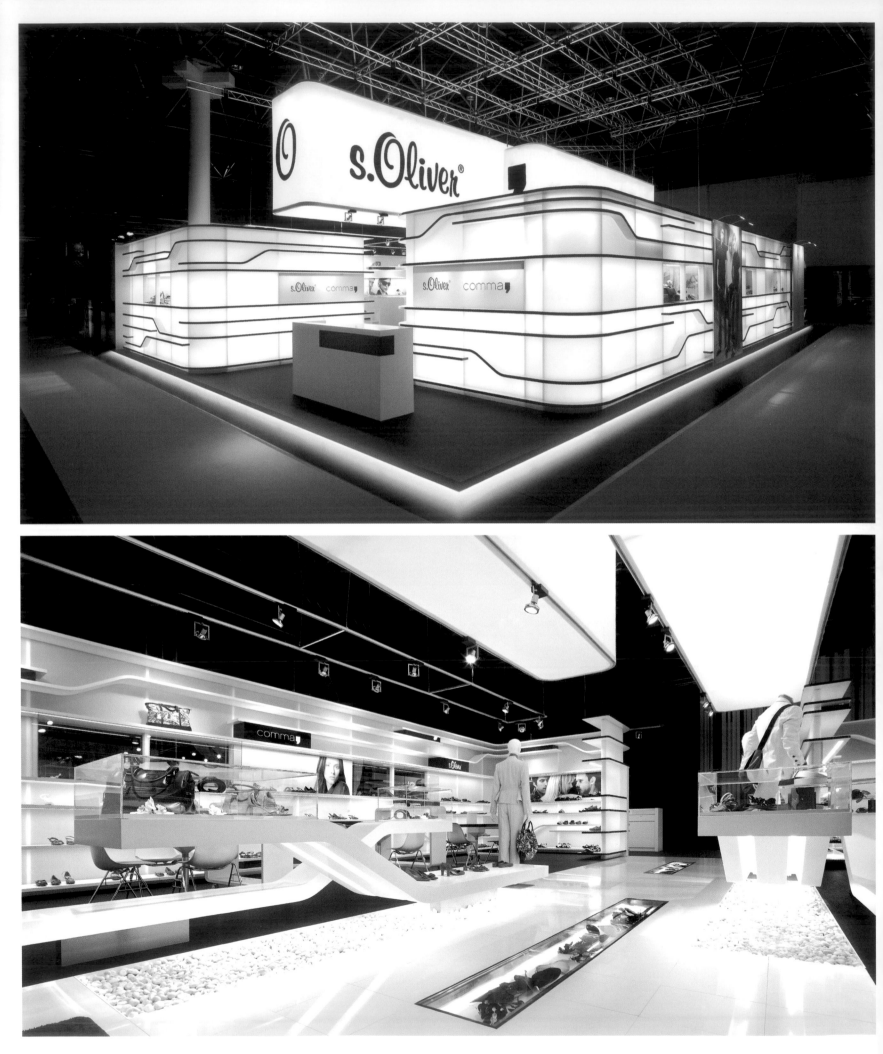

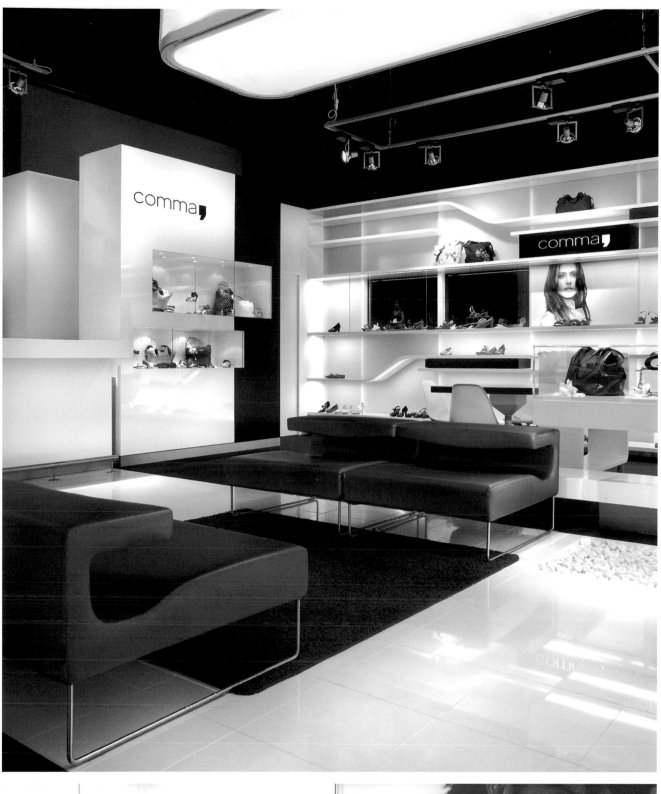

The booth appears open and bright from the outside. White, a color common to both brands predominates. The use of Plexiglas throughout gives the booth a radiant, dynamic aura. The asphalt gray flooring contrasts with the white structure, defining it parameters.

The illuminated ceiling elements carry the brand logos and are visible from afar. The pair of logo-sails also points to the catwalk below; the site of presentation events for both brands.

The lounge/bar area at the end of the stand offers clients a relaxed working atmosphere with the products at hand.

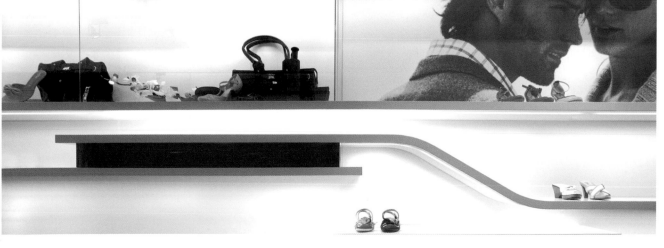

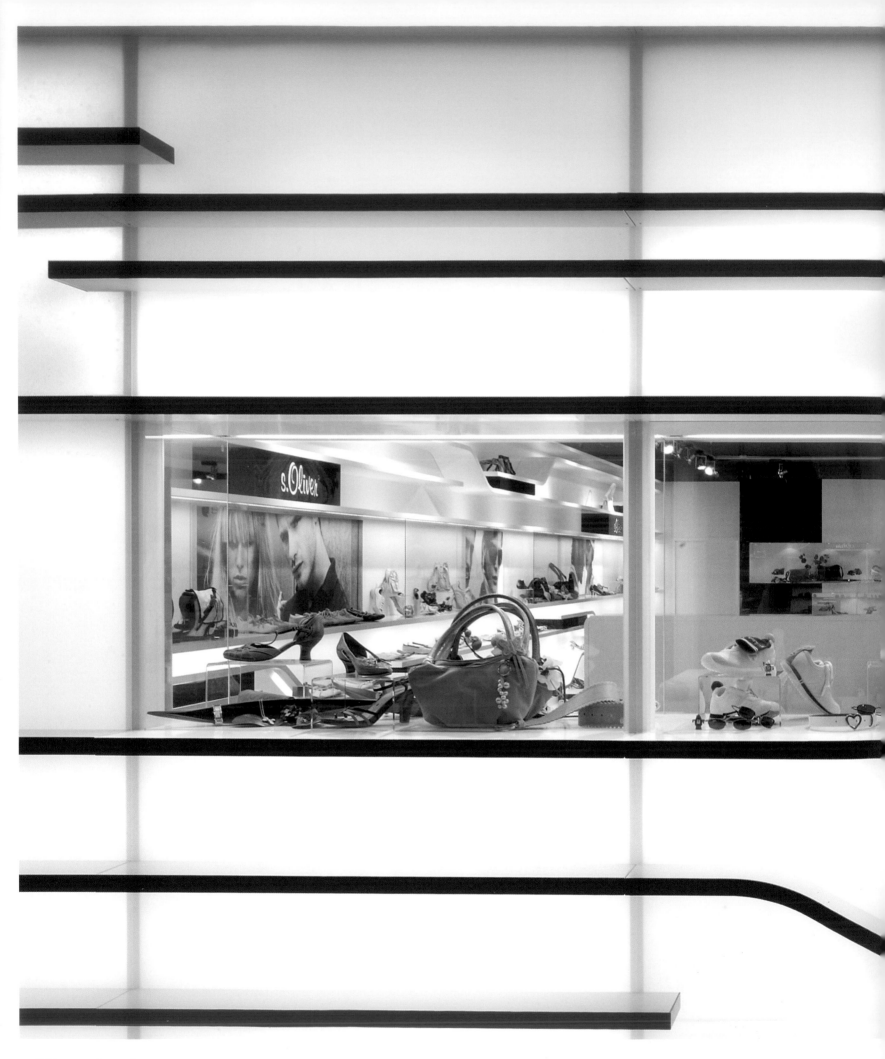

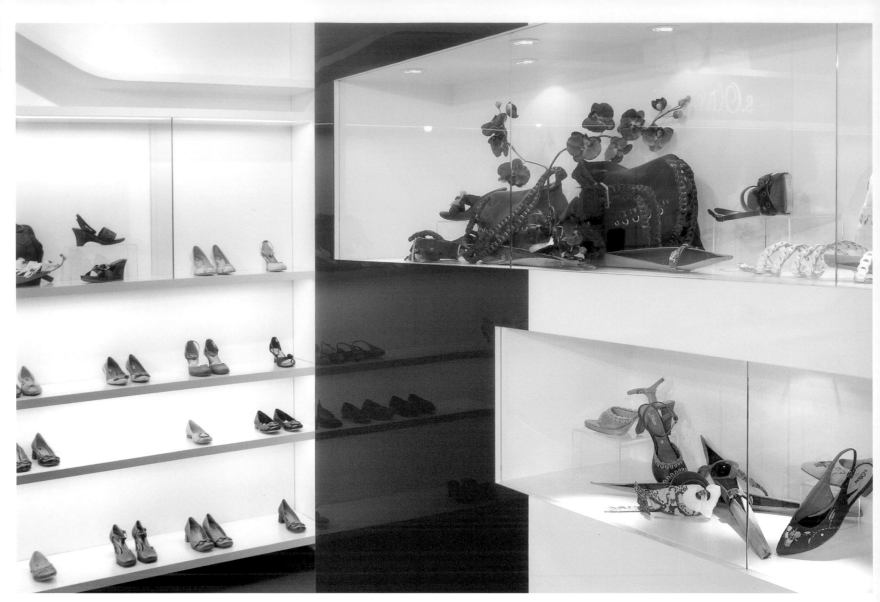

Focus walls at the end of the booth underscore S. Oliver and Comma brand identity. The walls also serve as showcases to highlight the season's new products and accessories.

The modular shelf band provides ample space for product display. Evoking the arches of natural footwear, the shelves' curves create a unique and dynamic look. The translucent material of the walls lends the products on the shelves a slight shimmer.

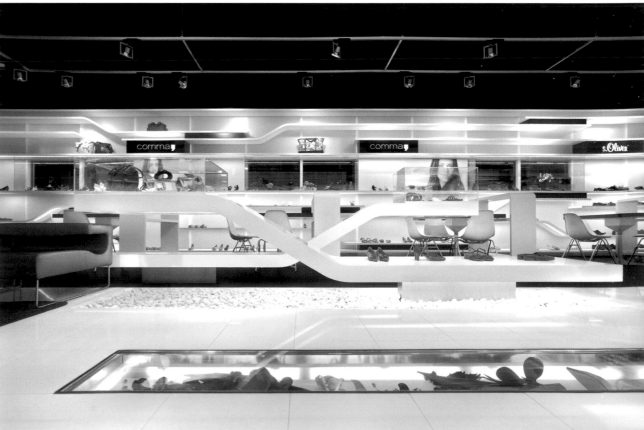

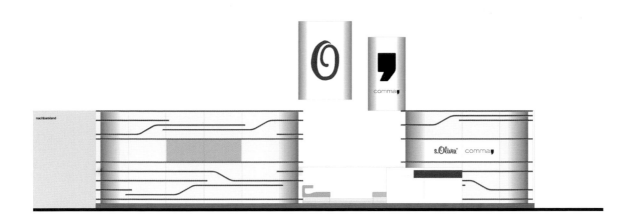

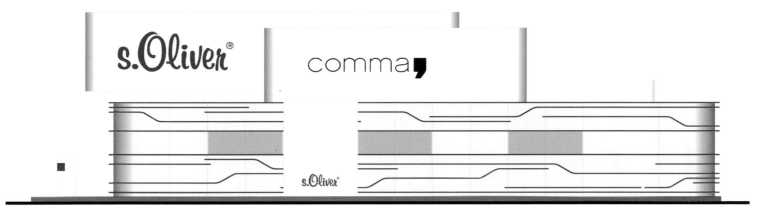

0 1 2 m

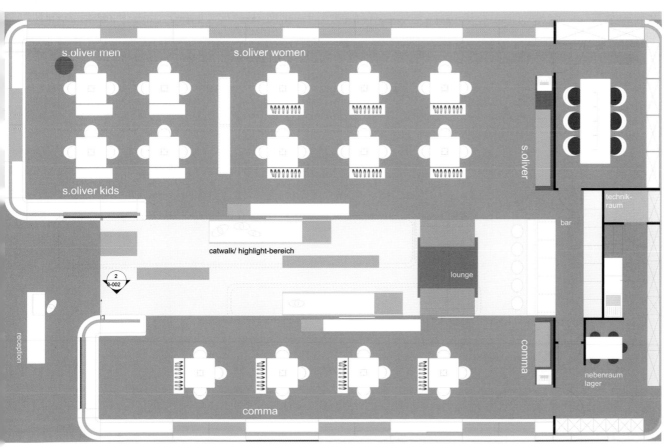

The encircling band encompasses and unifies the S. Oliver and Comma brands, with the illuminated logo-sails visible from afar.

The stand designed by Plajer & Franz incorporates two shoe brands: S. Oliver's creative, young and vibrant products and Comma's stylish and cosmopolitan.

A number of work units provide intranet and shoe trolleys so visitors can place orders immediately.

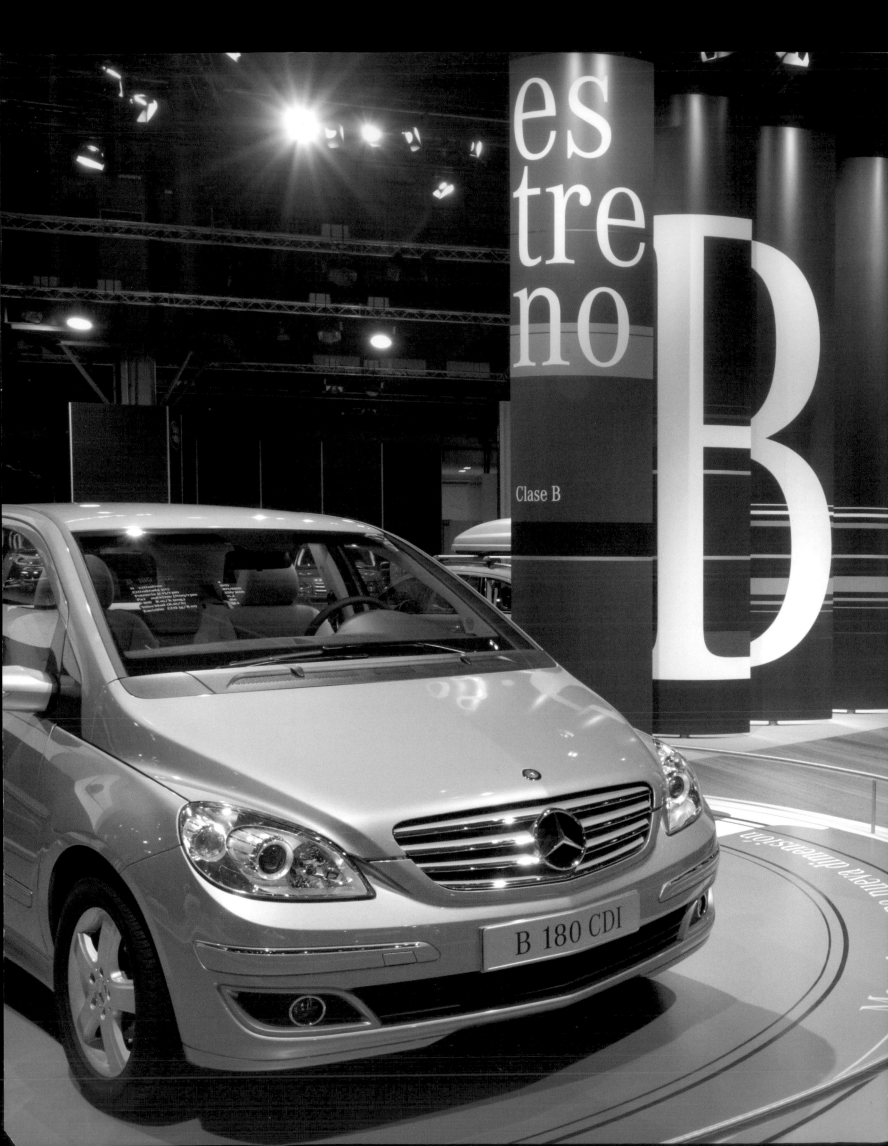

MERCEDES-BENZ

Winged Elegance

Werner Sobek and 3e

Address
Werner Sobek Ingenieure
Albstr. 14
70597 Stuttgart
Germany

Fair
International Motor Show,
Stockholm, Sweden, 2003
International Motor Show,
Barcelona, Spain, 2003

Other cities
2004: Brussels, Belgium; Lisbon, Portugal;
Leipzig, Germany; Madrid, Spain
2005: Amsterdam, The Netherlands;
Barcelona, Spain

Primary material
WINGS – modular system based on wing-
shaped elements

Photography
© Andreas Keller

In 2003, Mercedes-Benz Cars introduced a new exhibition-stand concept, which it has continued to deploy at various international motor shows, including Stockholm, Barcelona, Frankfurt, Brussels and Lisbon. Developed by Werner Sobek and his design team, 3e, the concept involves a modular system of made up of wing-shaped elements. The wings structure the interior space while also communicating the company brand and image. These elements measure 1.1 meters in width and up to 5.6 meters in height, and incorporate some of the basic elements of automotive design: smooth lines, dynamic forms, and light reflection from the auto body.

The exclusive use of characteristic elements ensures a unique, consistent and always recognizable presentation of the Mercedes-Benz brand. The arrangement, spacing, and surface of the wing can vary, providing flexibility to accomodate different sites. Moreover, a mounting system of standardized bases in a double floor ensures structural safety and quick installation. The system easily accords with the client's plans, deadlines and budget.

The wings system, first presented at at Hockenheim in Spring 2005, also appeared with the Mercedes-Benz marquee at international auto-racing events, including Formula One and DTM races.

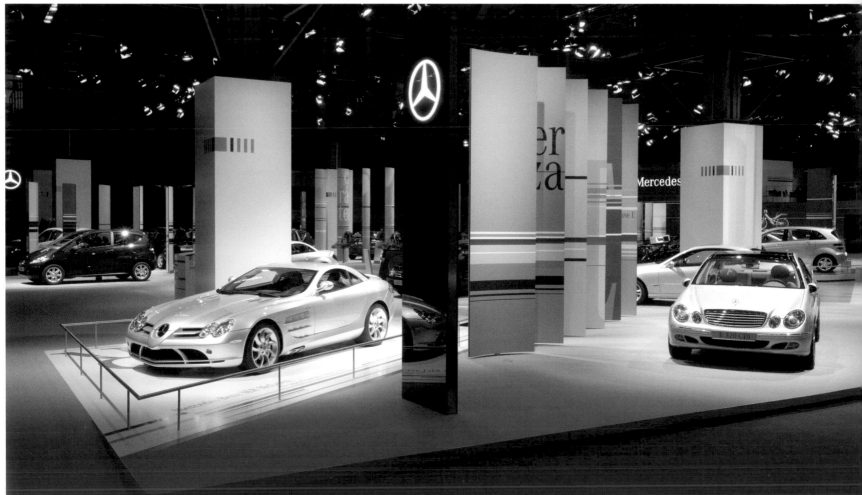

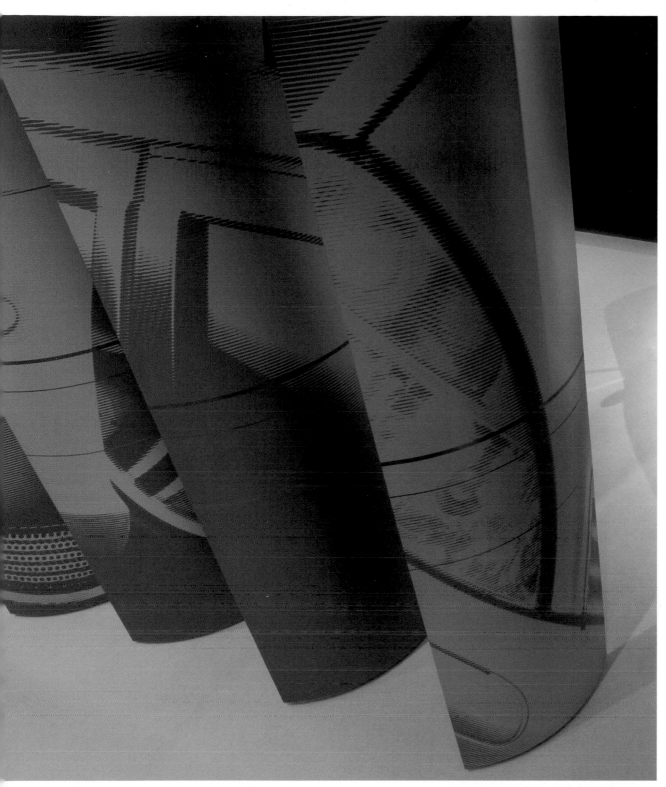

Mercedes-Benz's exhibition design concept, featuring the winglike elements, first appeared in 2003. The unique and characteristic elements have since been used at a number of international motor shows, thereby enhancing brand recognition.

The wings also convey product and theme information. Each wing's support structure is independent of its cladding, allowing its appearance and content to be changed easily.

Originally flat, the cladding panels take the shape of each wing during installation. The graphics for the cladding panels were developed in cooperation with Design Hoch Drei, a Stuttgart-based communications consultancy.

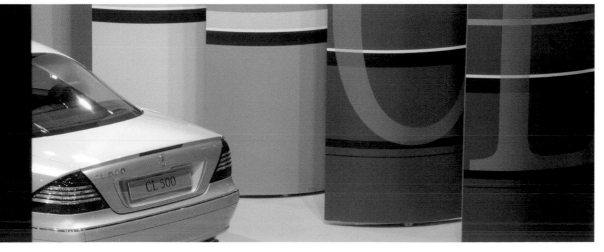

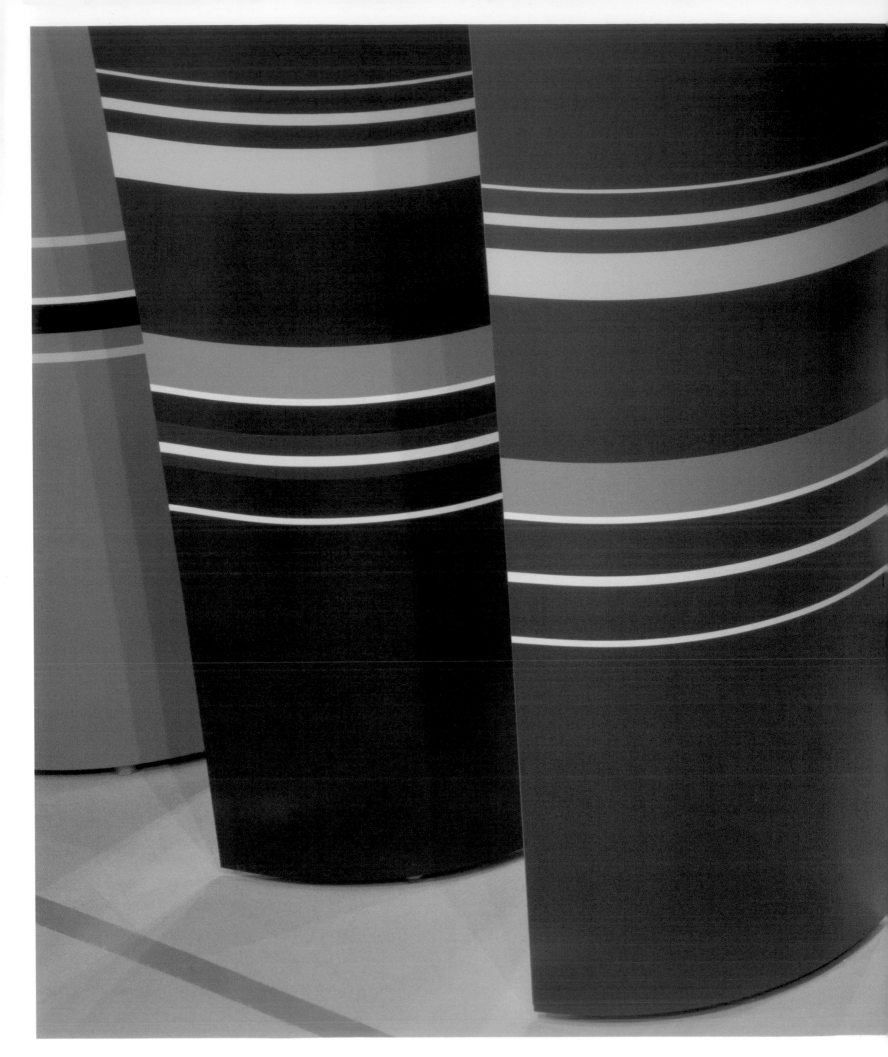

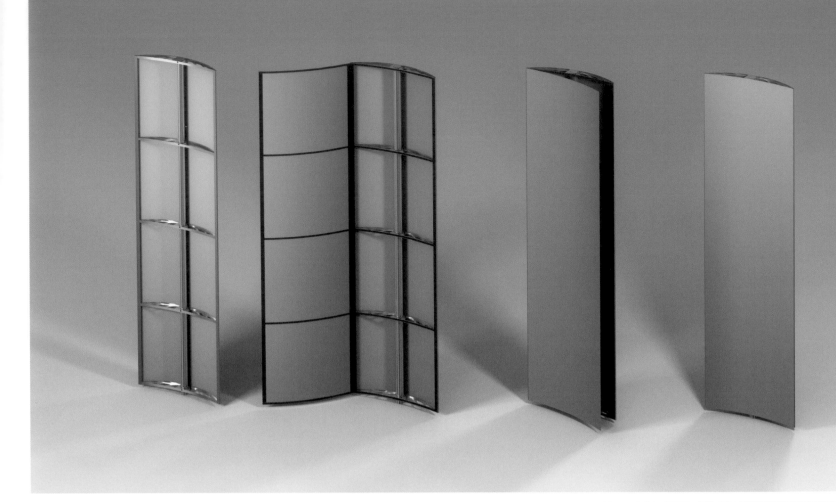

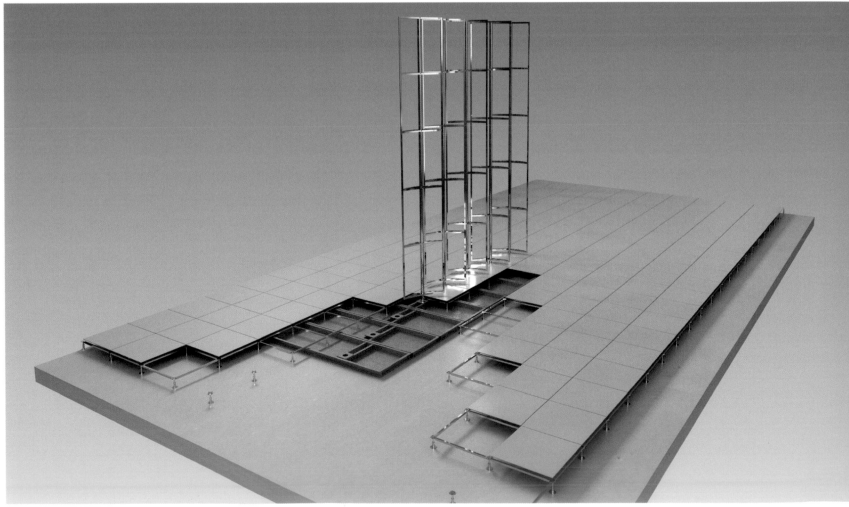

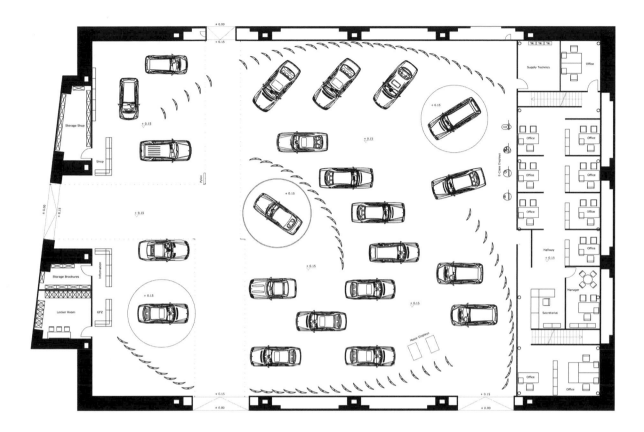

The elements are 1.1 meters wide and up to 5.6 meters tall. Standardized mounting bases in the double floor ensure quick installation as well as structural safety. Each wing consists of a support structure comprising a mast, a number of ribs, and concave and convex cladding panels. Support structures and mounting bases can be completely disassembled.

The flexibility of this design enables individual wings to be arranged and adapted according to the exhibition site and stand sizes. Although the individual Mercedes-Benz cars presented vary from exhibition to exhibition, the familiar wings provide a high degree of brand recognition.

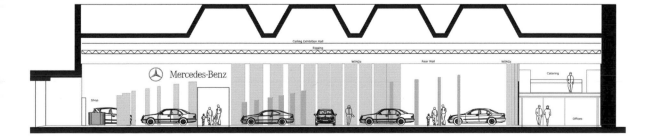

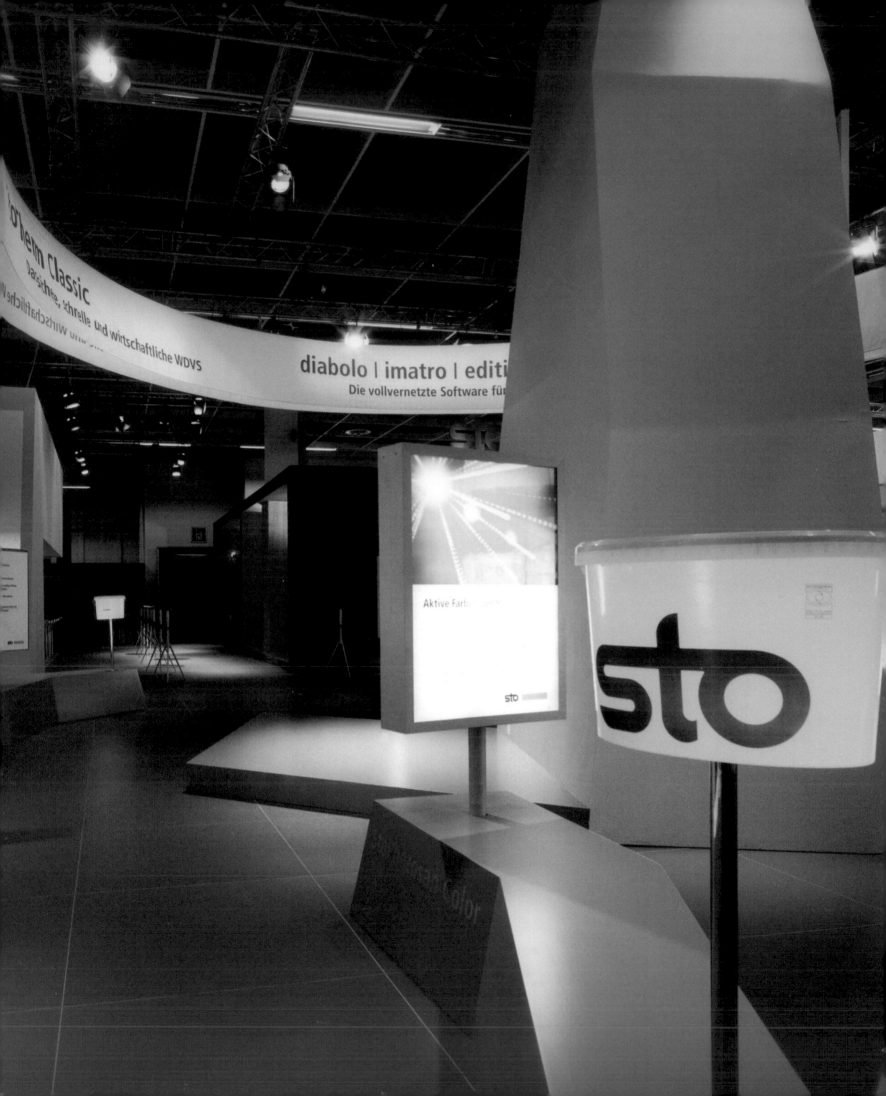

Sto
Tinted Concern

Arno Design

Address
Arno Design GmbH
Friedrichstr. 9
80801 Munich
Germany

Fair
Farbe, 2005

Other cities
None

Primary material
Middle-thick fibre plate

Photography
© Frank Kotzerke

Farbe, meaning "color" in German, is a leading international trade fair for paint, decorating and building protection. Held at three-year intervals since 1951—alternating between Munich and Cologne—the show is a platform for trends, presenting a varied range of products, methods and innovations in the industry. Sto AG, a paint and construction materials company that regularly exhibits at Farbe, used its 2005 exhibit as an opportunity to announce the establishment of a new Sto foundation and celebrate the firm's 50th anniversary.

As one might expect, bright colors are a main feature of the Sto exhibition stands. Yellow, the company's signature color is featured to attract visitors' attention. Fifteen color-coded zones, which appear to be arranged at random, surround conspicuous six-meter yellow towers. A white textile banner, that hangs from the ceiling and winds its way through the stand is printed with the company's key messages; it is attached to a number of plasma screens that show 30-minute product presentations. Furthermore, the open-plan booth contains a scattering of dynamically-shaped and brightly-colored benches emblazoned with product names.

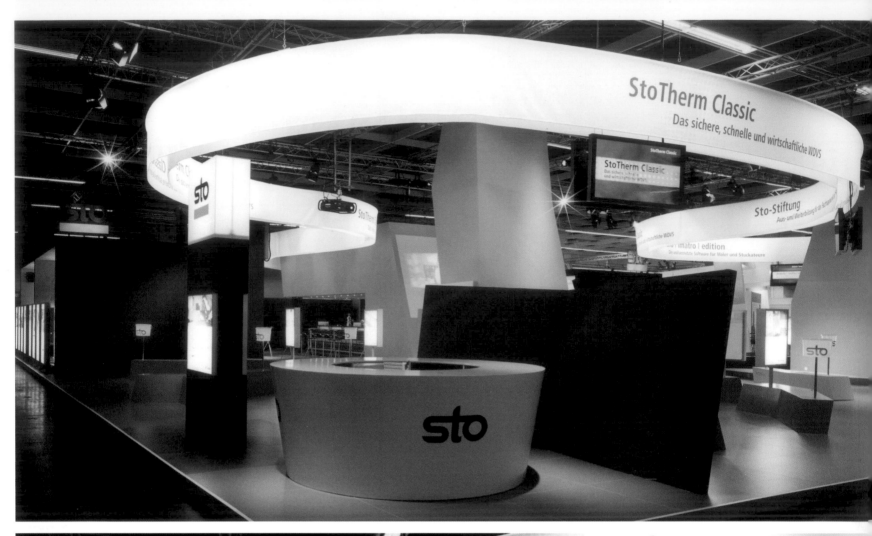

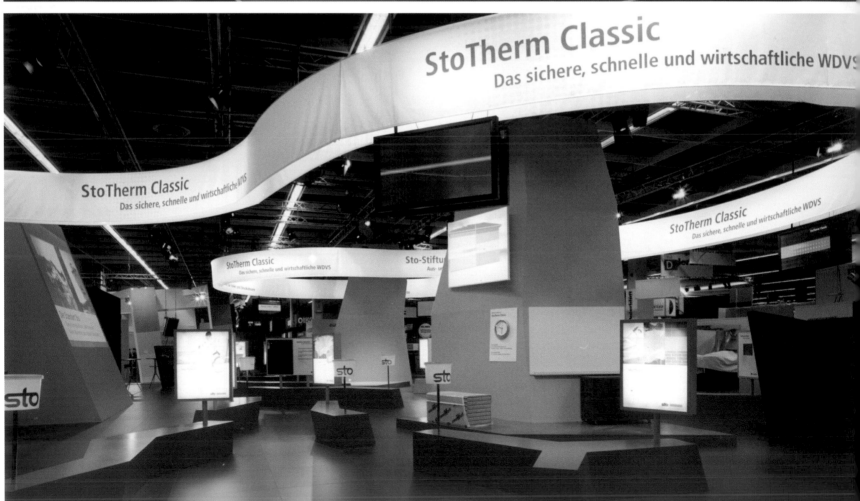

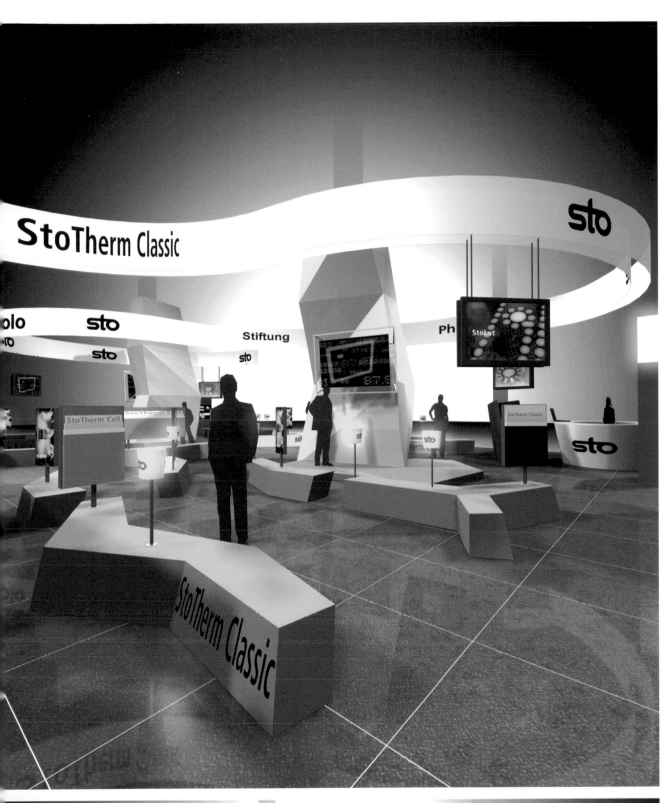

Color is the main theme of this stand, much presents Sto AG's product innovations. Yellow, the company's signature color, is the booth's main hue. Conspicuous six-meter yellow towers attract Visitors' attention, while brightly-colored and dynamically-shaped benches lure the visitors into the stand.

A white textile banner is suspended from the ceiling and winds its way through the entire stand. The banner communicates the company's key messages. Large plasma screens that hang from the banner show 30 minute product presentations.

Adjustable lights are incorporated into the benches while other guiding lights feature lampshades made of Sto painting pots.

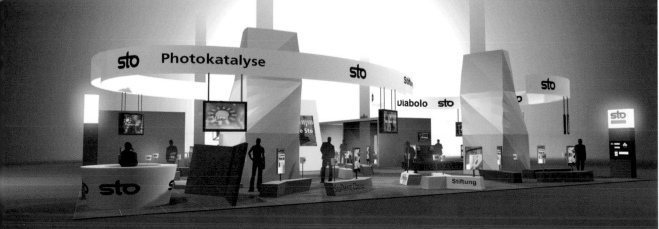

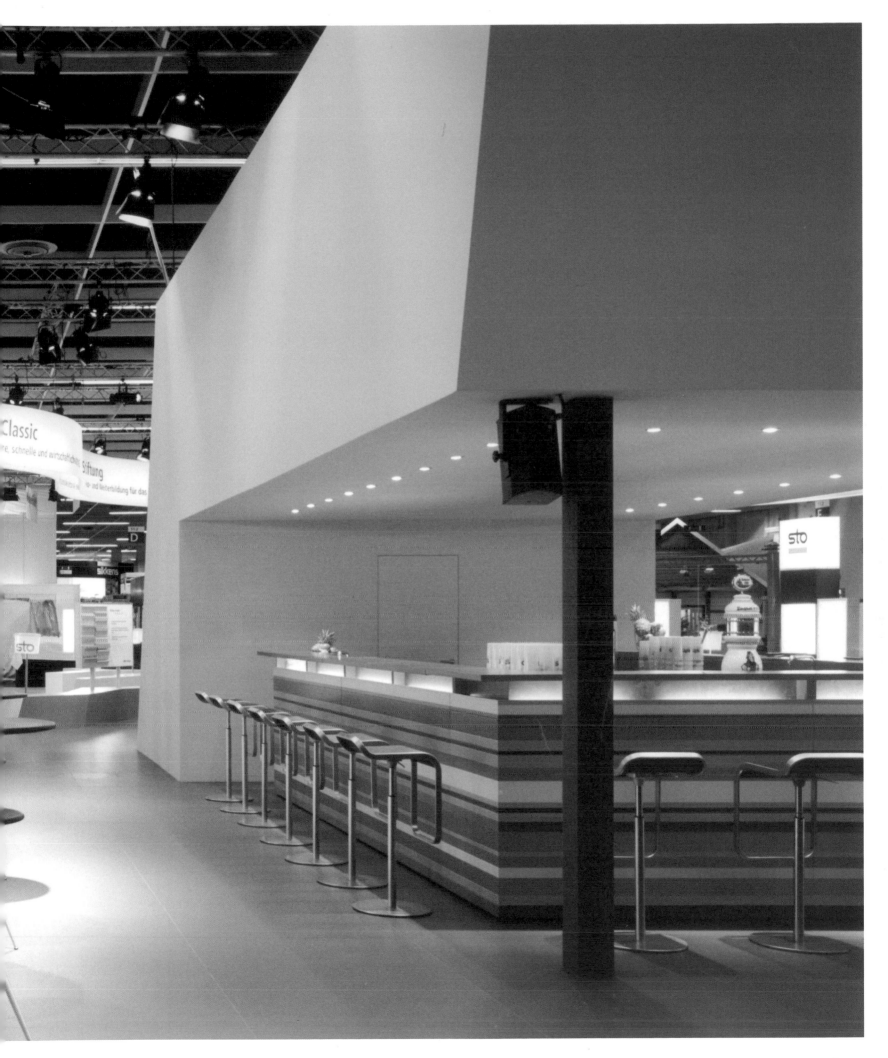

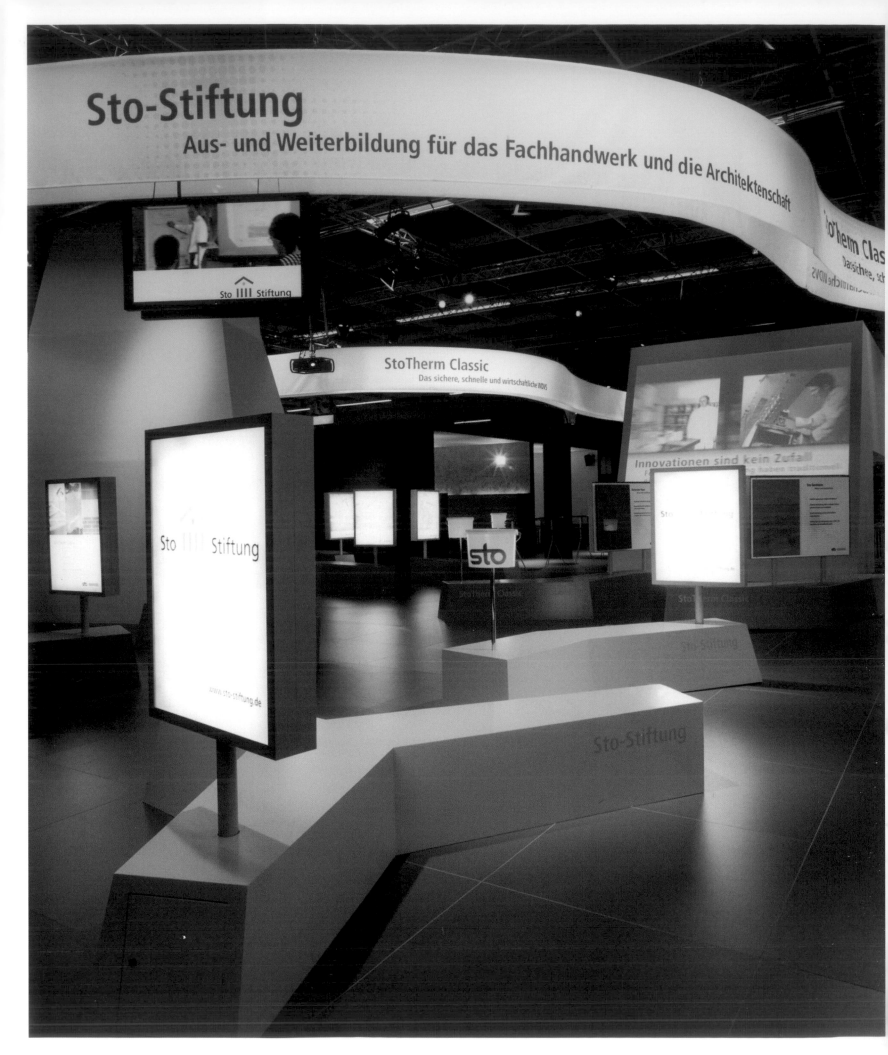

Four booths face the striped bar, where clients and visitors alike can do business and get refreshments.

Fifteen color-coded areas are scattered around the open-plan booth. The benches hold plasma screens and are lit by incorporated lights and lampshades in the shape of Sto painting pots.

AMSTERDAM FASHION WEEK
Fashionable Cylinders

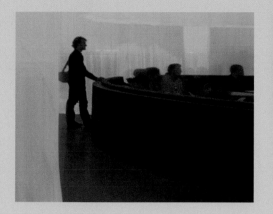

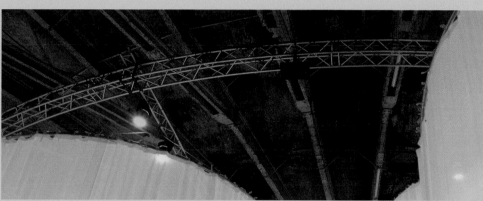

Concrete Architectural Associates

Address
Concrete Architectural Associates BV
Rozengracht 133 III
1016 LV Amsterdam
The Netherlands

Fair
Amsterdam International Fashion Week,
The Netherlands
January 27–30, 2005

Other cities
None

Primary material
Fifty-eight cylindrical steel-and-fabric stands
with five different diameters

Photography
© Jeroen Musch

To help put the Amsterdam Fashion Fair on the map, Concrete Architectural Associates aimed to move away from the standard presentation at fashion trade shows. In cooperation with District, the international exhibition dedicated to the growing New Luxury market segment, Concrete decided to create a milieu resembling an exciting night on the town during which a person might lose track of time.

The site of the Amsterdam International Fashion Week (AIFW) was divided into three areas. The catwalk shows, exhibiting more than 100 brands, were held in the Transformator building, while the Pavilion accommodated the lounge area for parties. The Fair filled the Gasthouder with 58 cylindrical stands in five different diameters. They consisted of circular steel trusses, suspended from the ceiling that supported semitransparent white curtains. Each cylindrical stand had clothing racks exhibiting a number of different brands. Wandering among the stands, a visitor might stumble upon new and unfamiliar brands. A big cylinder located in the middle of the Fair housed the restaurant. Surrounded by white curtains, like all the other stands, the restaurant also featured a comfortable pink leather couch around the perimeter that invited visitors to sit down and rest before setting off again.

AIFW was first held in July 2004. This biannual exhibition is a showcase for Dutch fashion and luxury goods. The event is growing and attracting an international audience of industry figures, buyers and press.

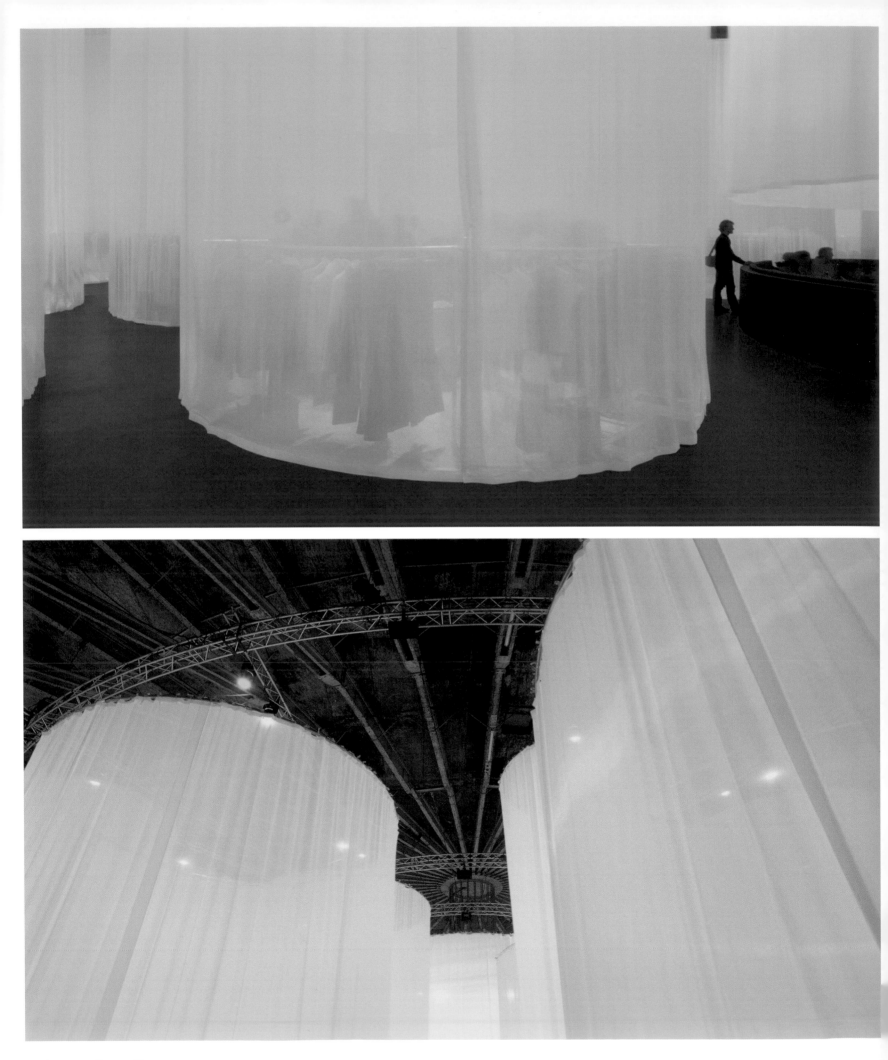

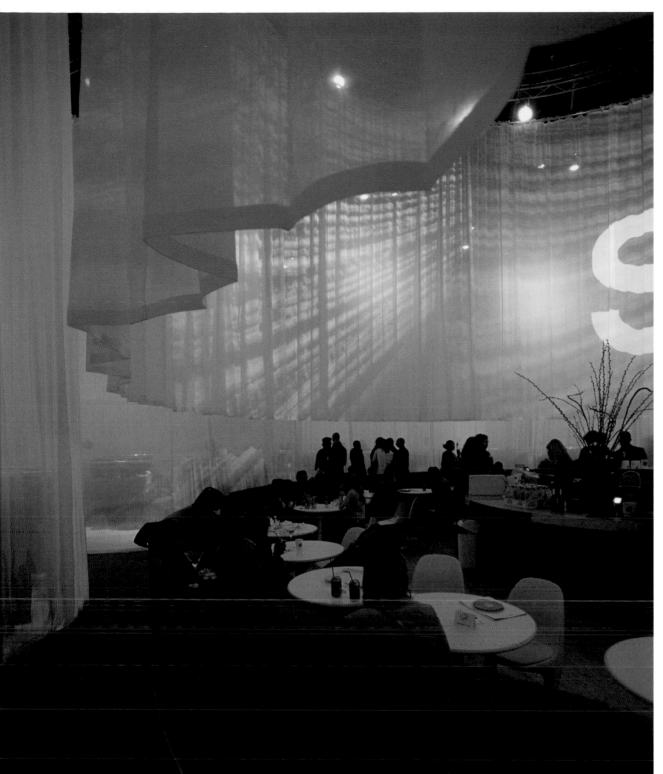

Fifty-eight cylindrical stands—defined by semi-transparent curtains suspended from circular steel bars—house clothing racks holding merchandise from a number of fashion brands.

Translucent fabrics and soft lights in changing colors create a warm and welcoming atmosphere, while the similarity of the stands encourages visitors to get lost amid the fair, possibly stumbling upon unfamiliar brands.

A comfortable pink leather couch runs around the perimeter of the restaurant, located in the middle of the Gasthouder.

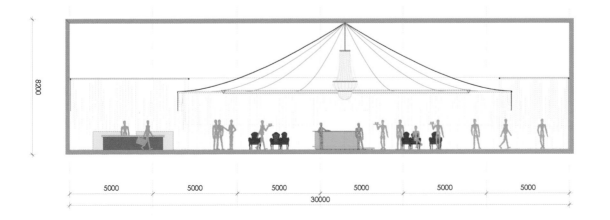

8200

5000 5000 5000 5000 5000 5000

30000

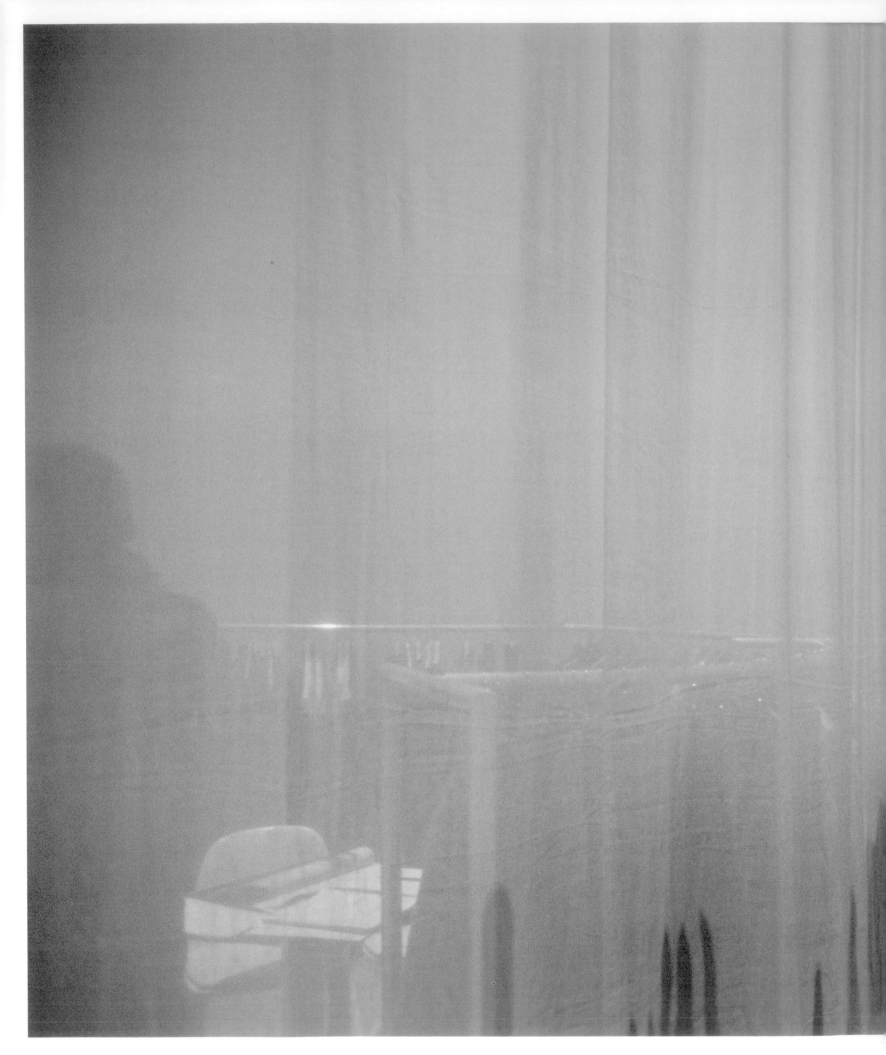

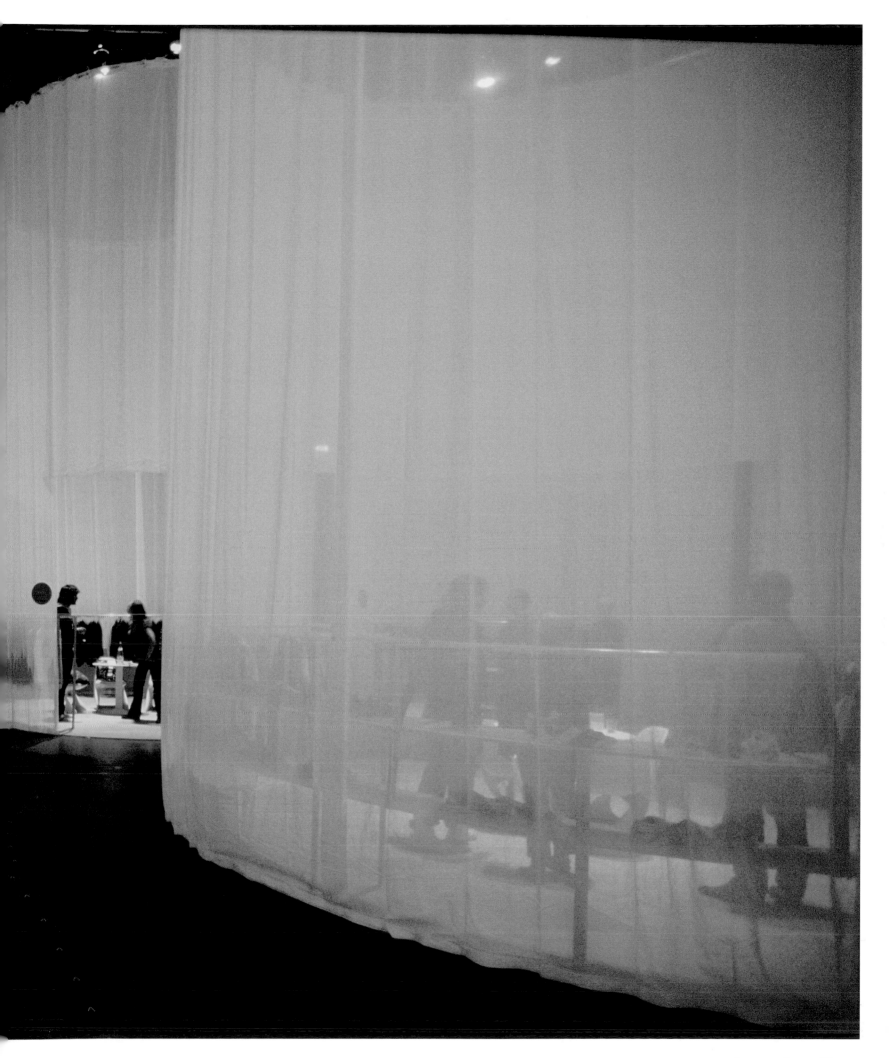

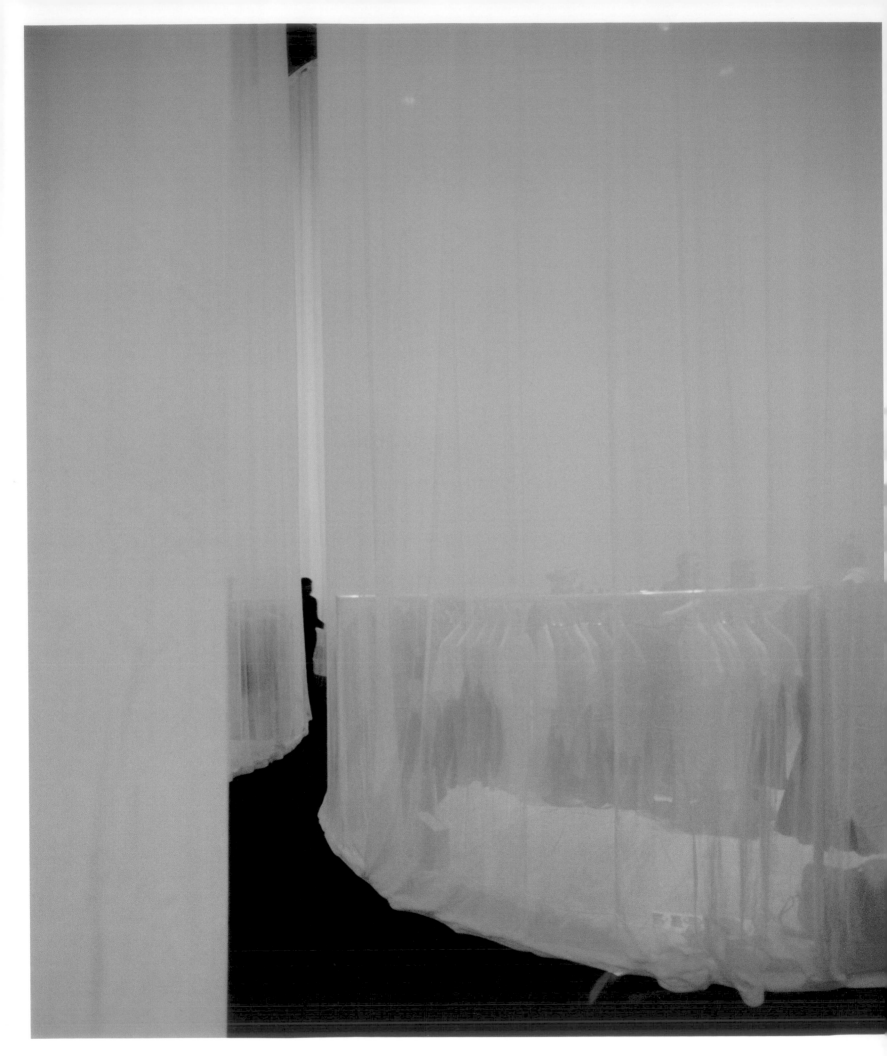

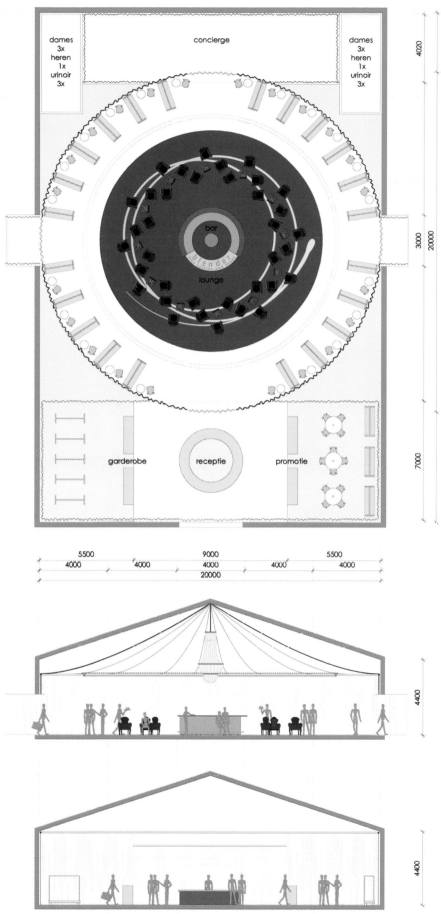

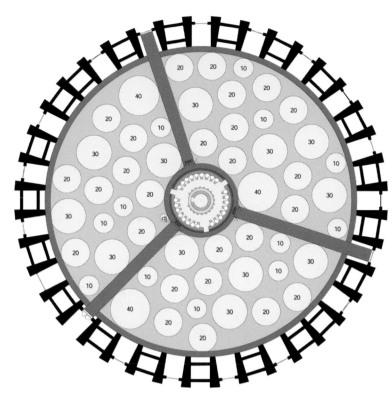

The walls, ceiling and main floor of the Gasthouder are left in their original state. Each individual stand, however, has its own round wooden floor made of okoume plywood.

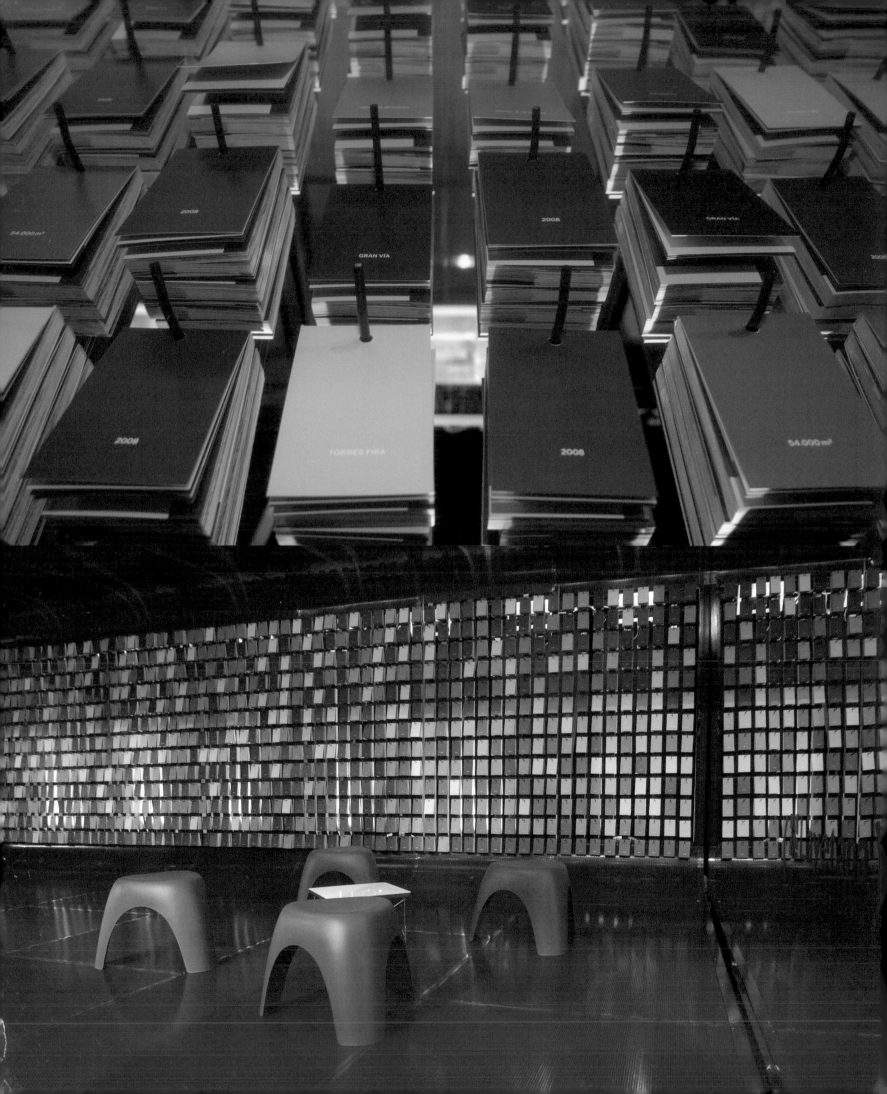

LAYETANA
Dynamic Space

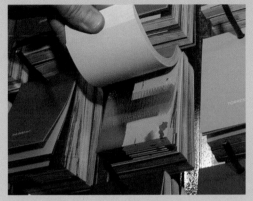

Saeta Estudi + Margarida Costa-Martins

Saeta Estudi was commissioned to design a meaningful yet empty space for Layetana Inmobiliaria, Spanish property development company, to use at the 2005 Barcelona Meeting Point, an international real estate symposium. Layetana wanted to attract visitors' attention by avoiding such typical real estate visuals as big slogans, product photographs and repititions of the company name.

The portable structure, with solid trims characteristic of good construction, is covered with perforated sheet metal, new product for sale. The empty space contains three elements: a large cantilevered overhang, a mirror of unusual dimensions and a vertical trellis holding more than 6,000 hanging flip-books. The flip-book is the only element with a message: an animated sequence of illustrations showing a panoramic view of the Fira Towers, a recent Layetana development. Hanging from a backlit wall, the flip-books are gently riffled by air fom four powerful ventilators. The company logo was visible only on the large mirror.

Barcelona Meeting Point has grown considerably since its in 1997 debut, increasing its exhibition space from 10,000 to 50,000 square meters, and its attendance from 55,000 visitors to more than 200,000.

Address
Saeta Estudi
Pg Sant Joan 12, pral. 2ª
08010 Barcelona
Spain

Margarida Costa-Martins
Placeta Montcada 3, pral.
08003 Barcelona
Spain

Fair
Barcelona Meeting Point 2005
October 25–27, 2005

Other cities
None

Primary material
Sheet-metal and structure and 6,000 colorful paper flip-books

Photography
© Xavier Berdala

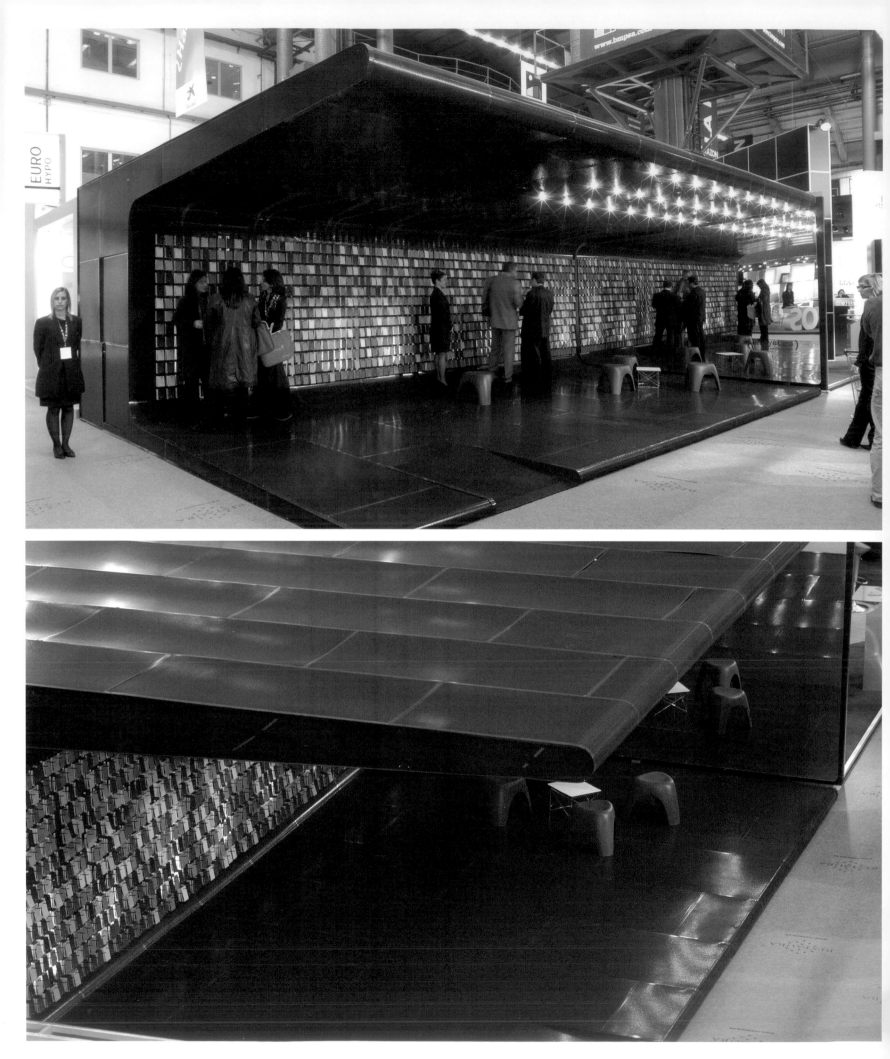

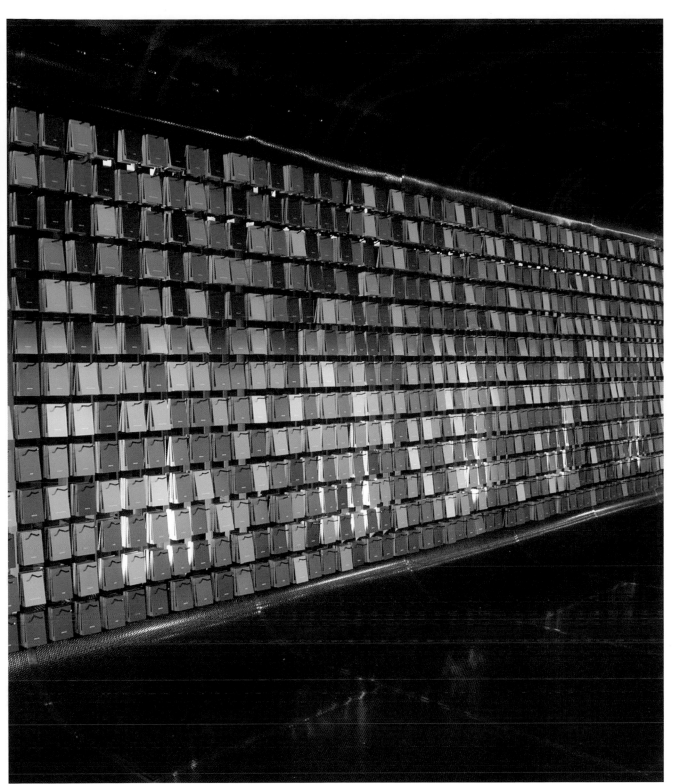

Layetana commissioned Saela Estudi to design an empty exhibition space, avoiding display elementsfound in a typical real estate industry exhibit, i.e., eye-catching publicity slogans, large brand names and company logo.

The portable structure is covered with perforated sheet metal, referring to the company's latest development in a subtle way.

The backlit wall covered with more than 6,000 colored flip-books is the stand's main attraction. Four powerful fans slightly move the pages of the flip-books as they run fresh air through the open booth.

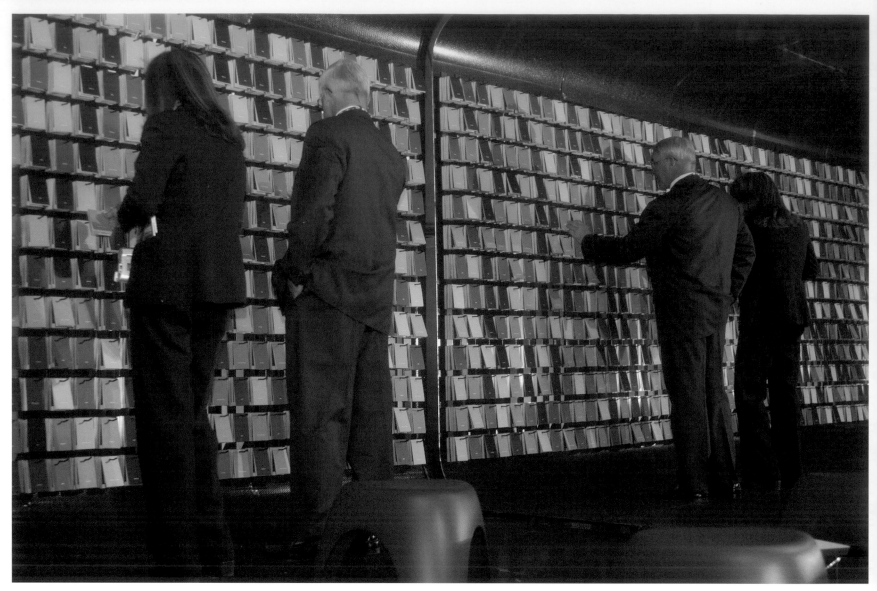

The flip-books are the booth's only element with a message. They contain an animated sequence of illustrations depicting Layetana Inmobiliaria's latest project, the Fira Towers.

The overall color scheme of the flip-books changed as people visited the stand and removed flip-books from the top layer; those underneath, with different-colored covers; collectively turned the display into a lively and original wall mosaic.

The company's logo was present only on the large mirror.

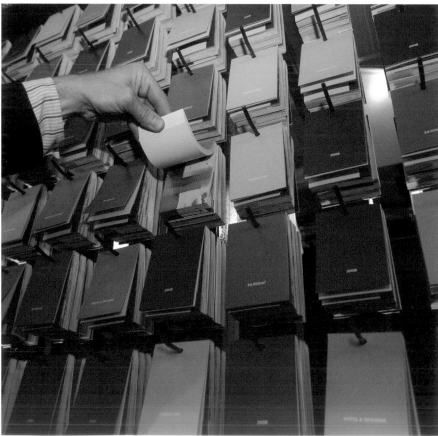

A backlit wall holds the 6,000 flip-books, their pages are gently moved by four powerful ventilators.

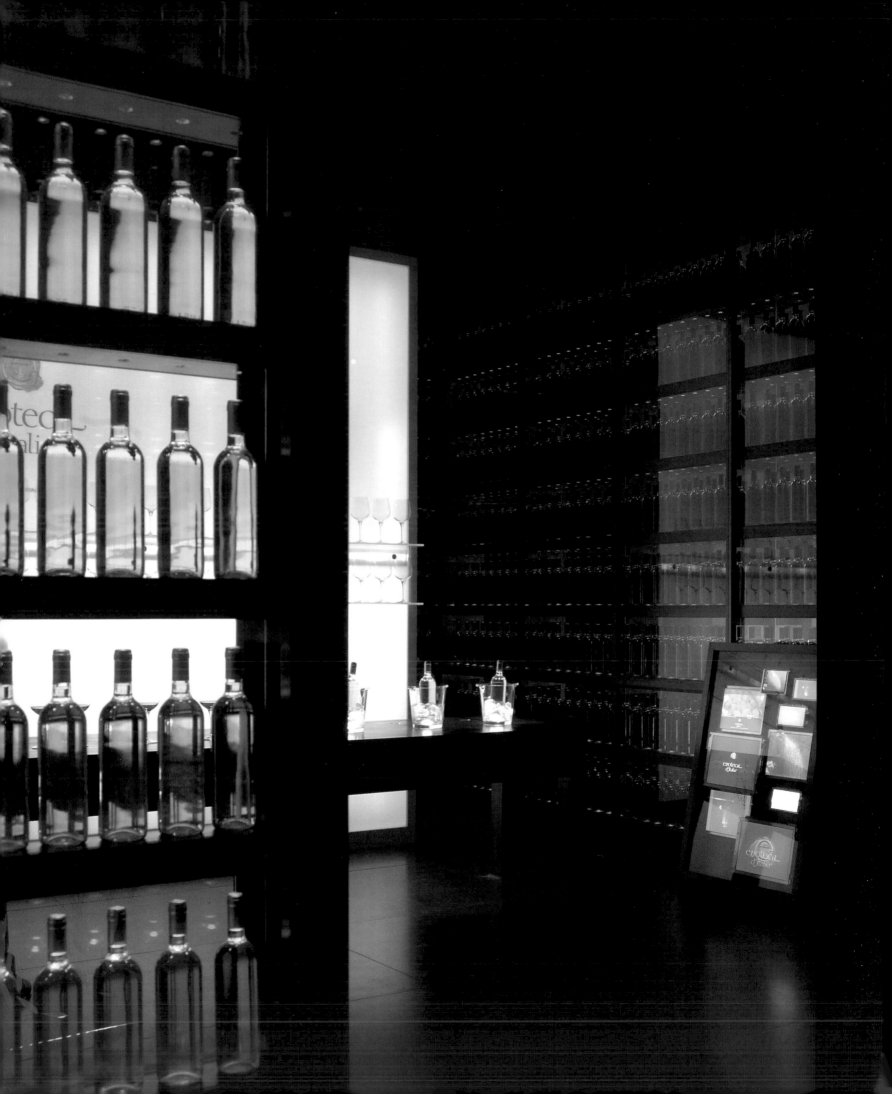

ENOTECA D'ITALIA

Message in a Bottle

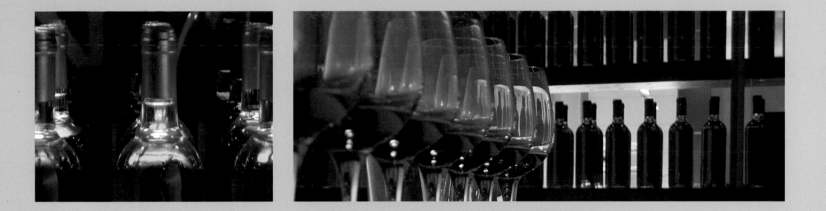

Studiomonti

Address
Studiomonti
Piazza S. Erasmo 1
20121 Milano
Italy

Fair
Street Dining Design, Salone del Mobile
c/o Triennale Milano
April 14–May 2, 2004

Other cities
European Football Championship 2004,
Lisbon, Portugal

Primary materials
Wood, 1,600 clear bottles of red wine, 1,600 green
bottles of white wine, LCD screens and
optical fibers

Assembly & disassembly time
3 days for assembly, 2 days for disassembly

Photography
© Alessandro Ciampi

Enoteca d'Italia was one of ten kiosks created by architects and designers as part of the Street Dining Design project at the Triennale di Milano (Milan International Design and Furniture Fair) in April 2004. Studiomonti's space presents a typical Italian product, wine, and scores the fundamental principles of custom, tradition and innovation.

Representing custom is the architectural enclosure, a box holding 1,600 clear bottles of red wine and 1,600 green bottles of white wine. The bottles of wine and the luminous white panel recall the colors of the Italian flag. The confined wooden structure displaying the bottles of wine, the wooden table for wine tasting, and the ambiance and earthy aroma of wood evoke a typical wine cellar, thereby symbolizing tradition. Meanwhile, the modern technologies used in this stand connote innovation in the wine industry. The booth's lighting concept, developed in cooperation with Jeremy Lord of the Colour Light Company, creates a warm environment. The rustic wine-tasting table is traversed by optical fibers, that illuminate elements placed on the surface, such as the ice buckets and glasses, while the white backlit panel with glass shelves brings out the color of the wines. The sort of blackboard found in old wine cellars is recreated in the form of a wooden panel with small LCD monitors showing clips featuring products, wineries, interviews and the like.

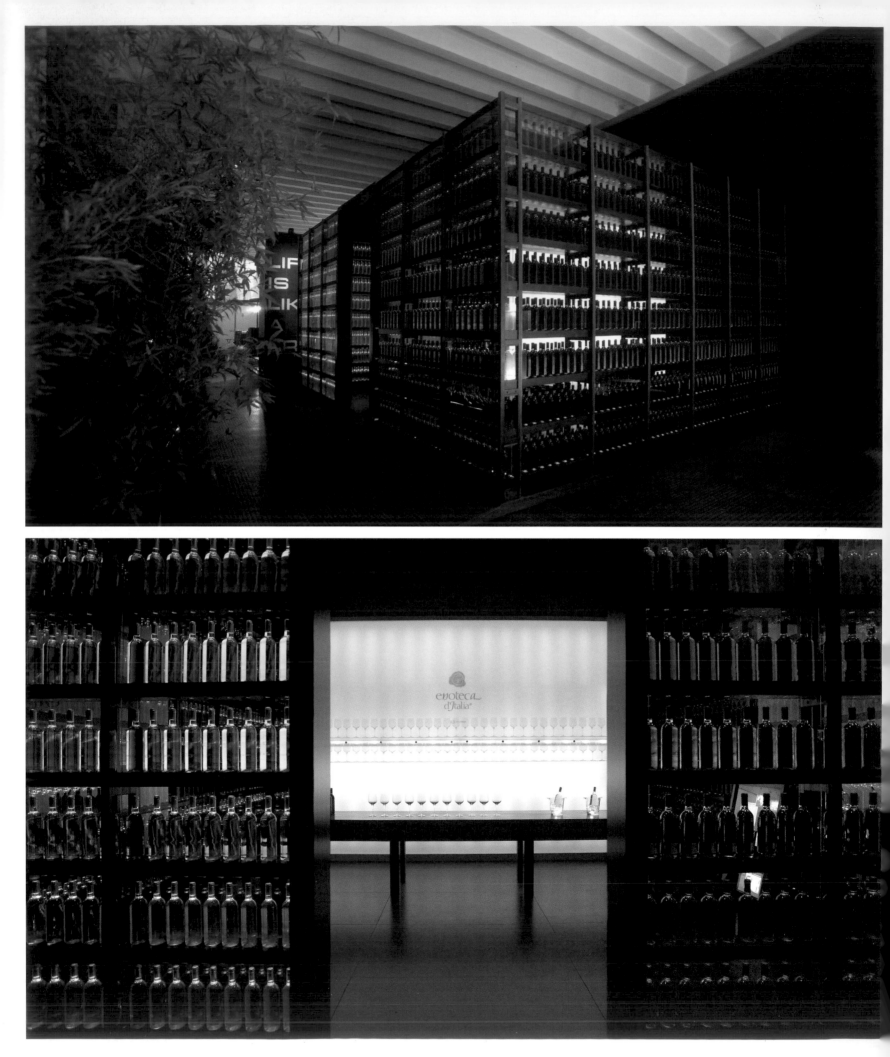

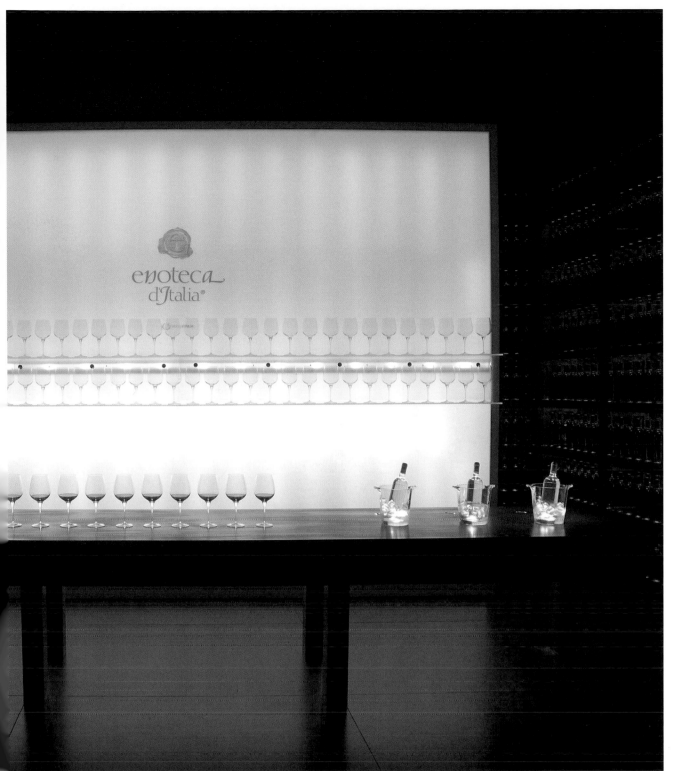

The linear racks of red and green bottles evoke a typical wine cellar. The red bottles (right partition) are red wines and the green bottles (left partition) hold white wines. Symbolically and literally they represent the entire, vast Italian wine industry.

The backlit white panel is made of woven glass fibers. Glass shelves are incorporated into the panel and arrays of wine glasses. The white light also illuminates the color of the wines.

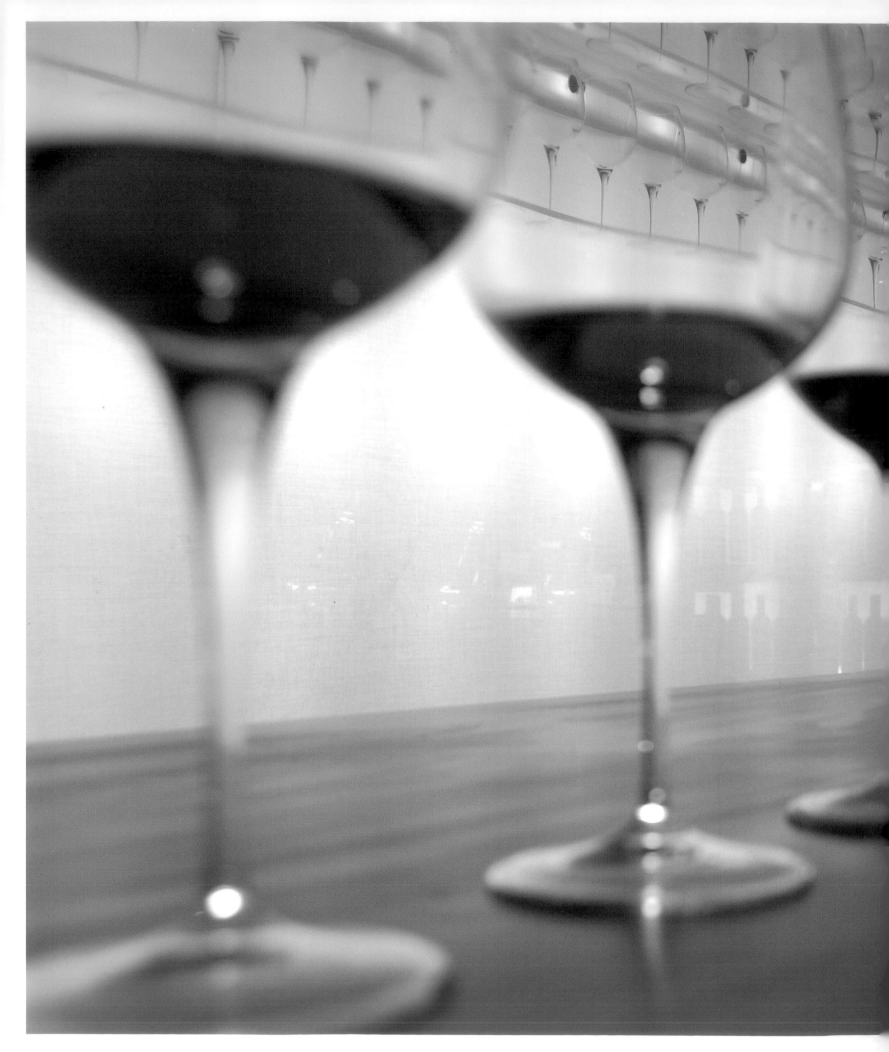

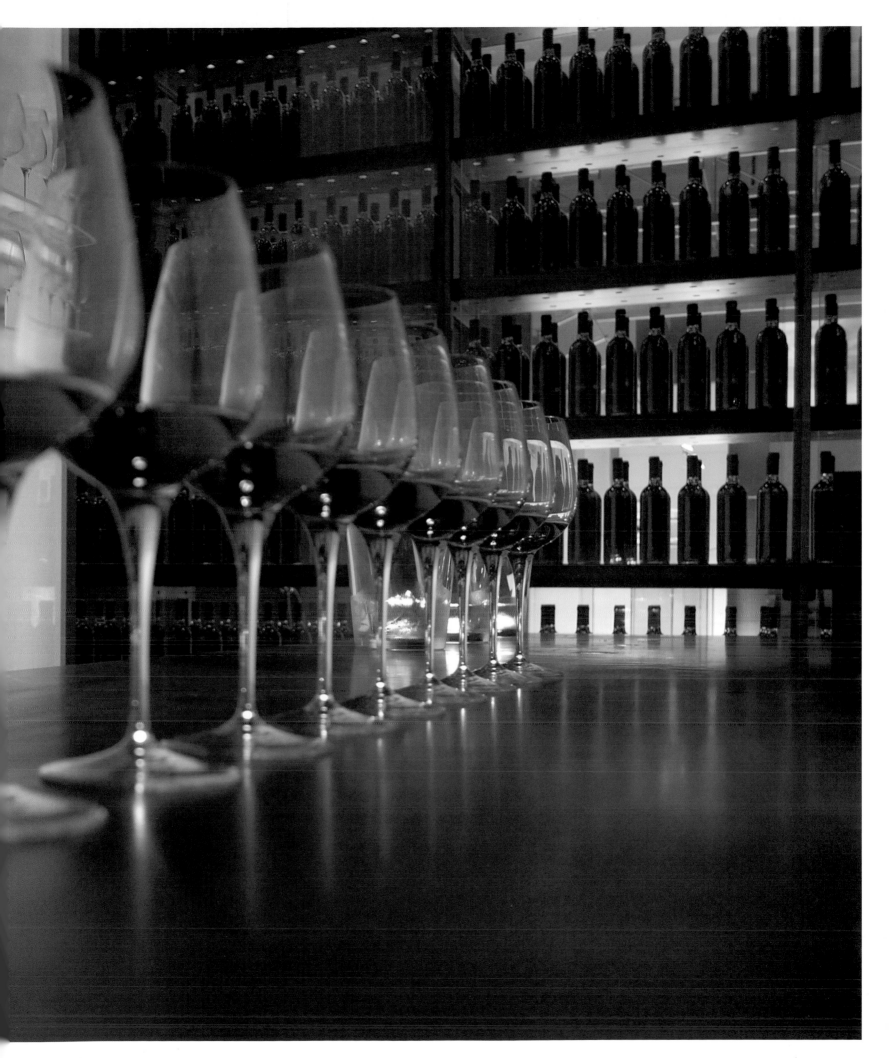

The lighting design was created in cooperation with Jeremy Lord of the Colour Light Company. The luminous environment creates a warm atmosphere. Wine, light and color are framed by a wooden structure: the walls, floor and roof.

The rustic serving table is a typical wine cellar fixture. The optical fibers that traverse this table make ice buckets and wineglasses on its surface glow.

A wooden panel with small LCD monitors is a modern-day version of cellar blackboards; it runs clips featuring products, wineries, interviews and trivia.

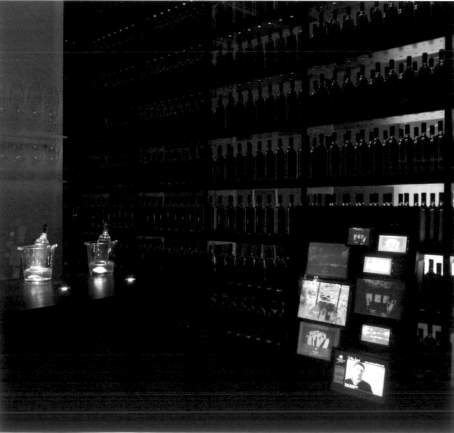

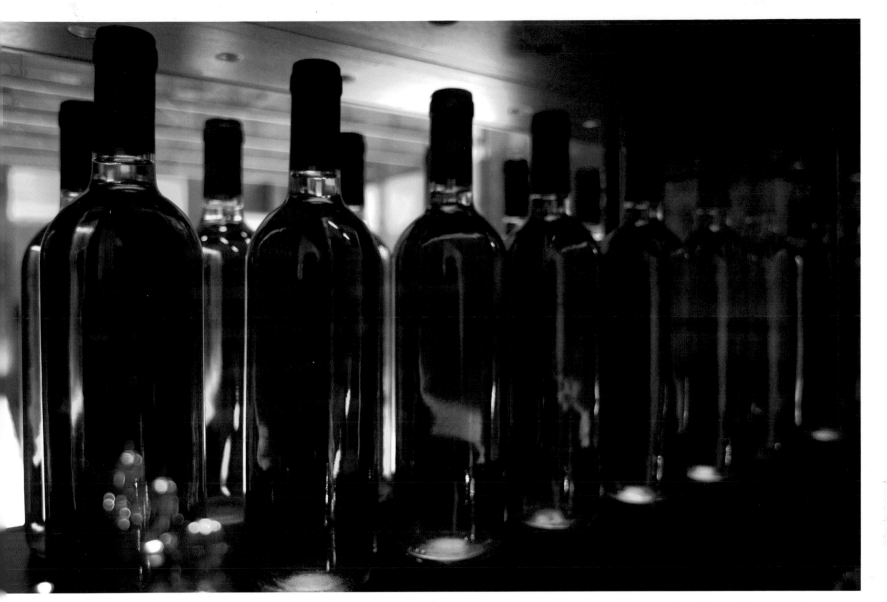

An architectural box comprising a wooden structure and more than 3,000 bottles of wine symbolizes a traditional wine cellar.

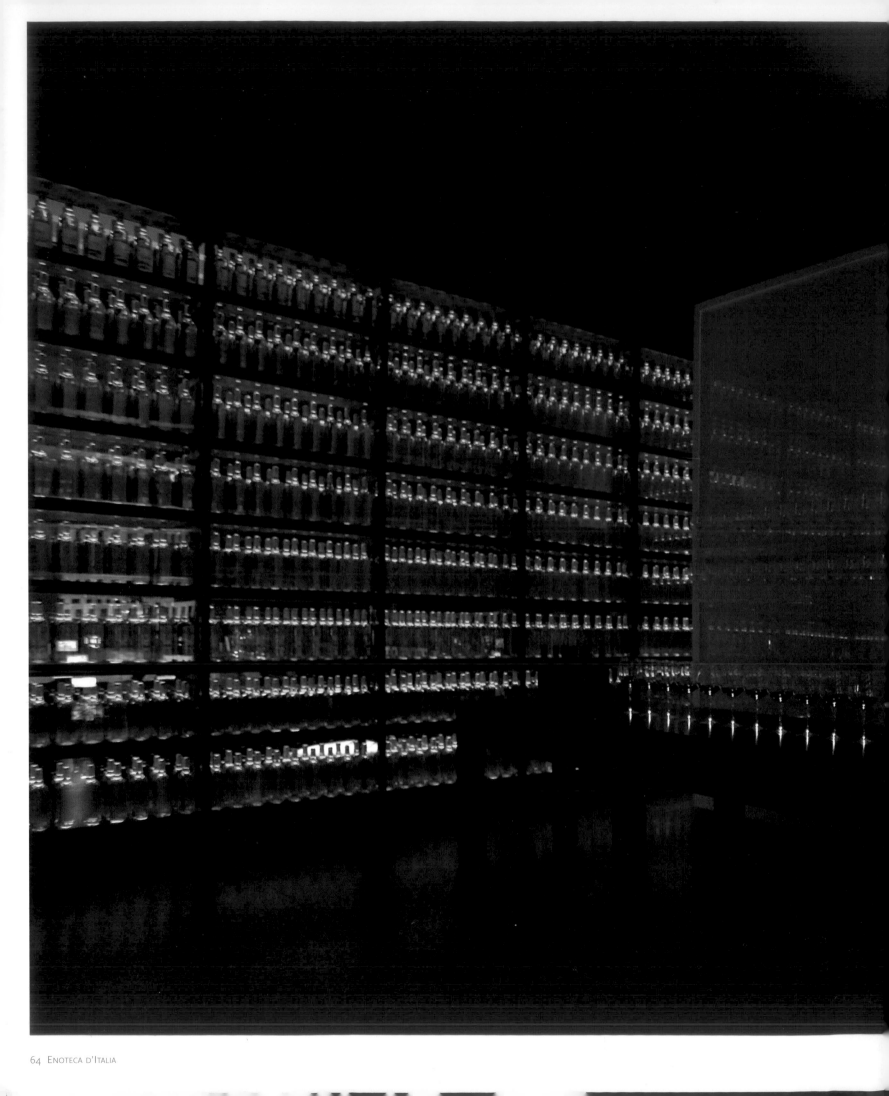

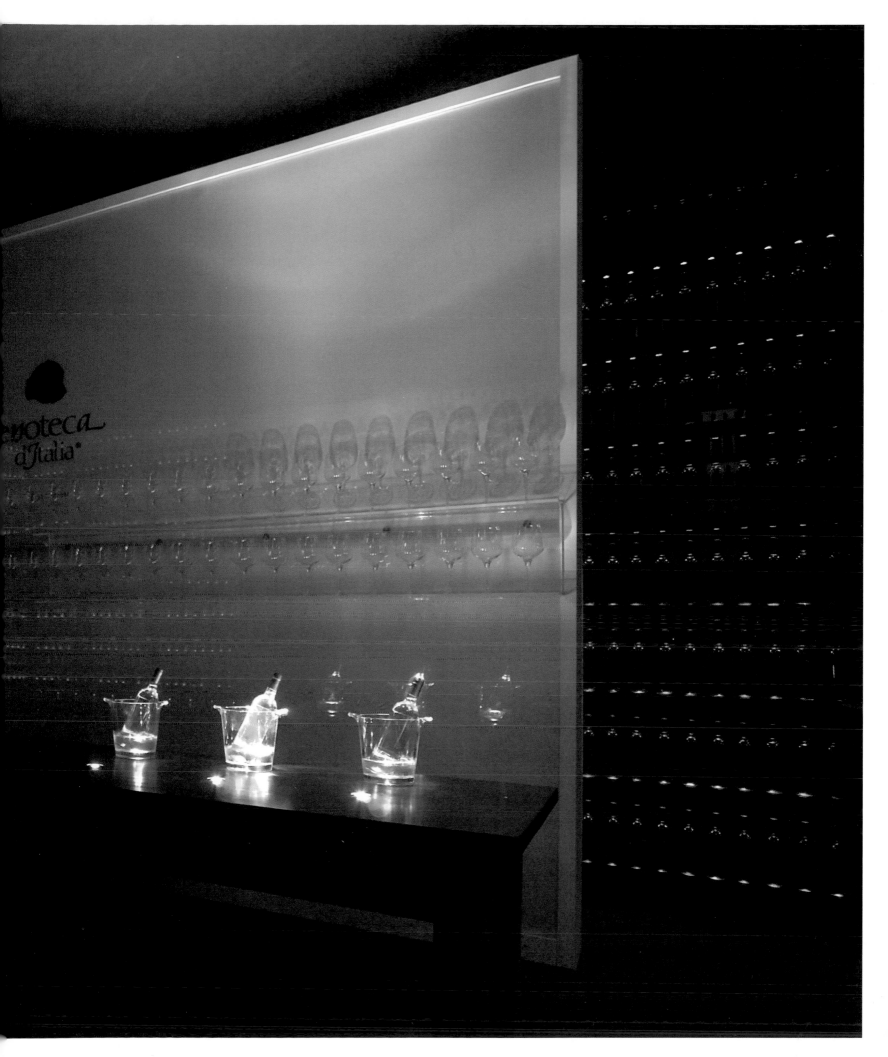

HATRIA
Suite Trilogy

Paolo Cesaretti

Address
Paolo Cesaretti
Corso Ventidue Marzo 42
I-20135 Milan
Italy

Fair
Cersaie, Bologna, Italy
2003, 2004, 2005

Other cities
None

Primary material
Painted plywood (main structure)

Photography
© Stefano Stagni/Serrap

Paolo Cesaretti designed three different versions of this booth for Hatria, a company specializing in the production of bathroom fixtures. Cesaretti envisions the exhibition stand as a theatrical space, where a new story is told each time, with Hatria acting as the host, the products as the characters, and the visitors the audience.

The company used Cesaretti's design concept to exhibit its products at the 2003, 2004 and 2005 Cersaie ceramic tile and bathroom fairs. Although the concept remains the same, the designer reworked the exhibit architecture each year to present the brand in a fresh light each time. The 2005 stand, for example, incorporated organic elements, such as Barrisol elastic film and fabric curtains, while the 2004 stand emphasized urban/industrial landscapes, and the 2003 version toyed with the idea of inside vs. outside, using walls made from glass panels.

Cersaie is an annual international exhibition of ceramic tile and bathroom furnishings held in Bologna, Italy. More than 30 countries were represented at Cersaie 2005, where more than 1,000 exhibitors presented their products to more than 80,000 professional visitors.

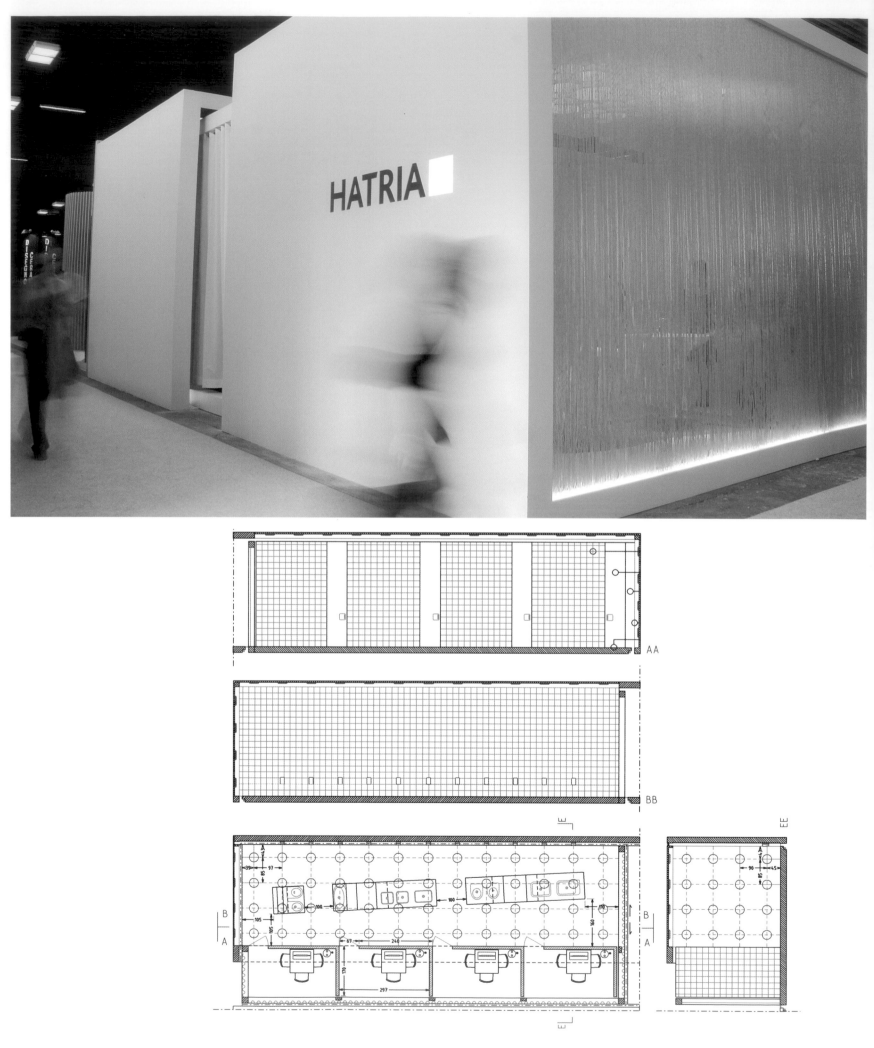

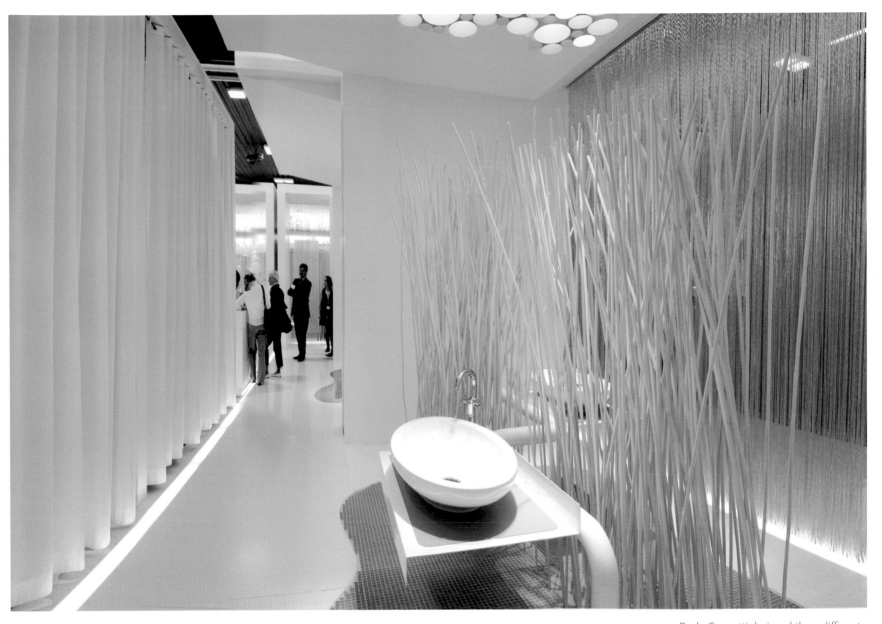

Paolo Cesaretti designed three different versions of the Hatria stand, for the Cersaie ceramic tile and bathroom fairs in 2003, 2004 and 2005. The main structure remains the same, but the exhibit is reworked every year.

A white-and-blue color scheme and organic materials dominate in the 2005 stand, made with mosaics, Barrisol elastic film and fabric curtains.

The 2003 booth consists mainly of walls made from glass panels, in the following years, white fabric curtains separate spaces within the booth.

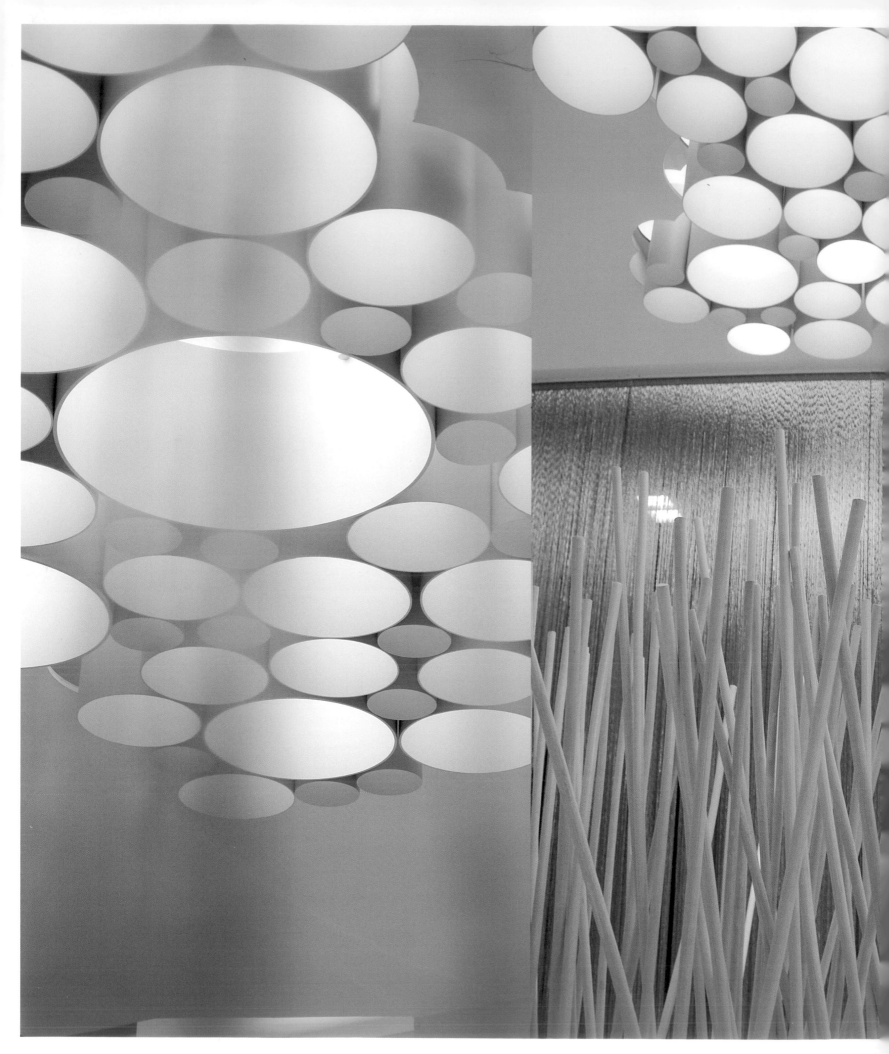

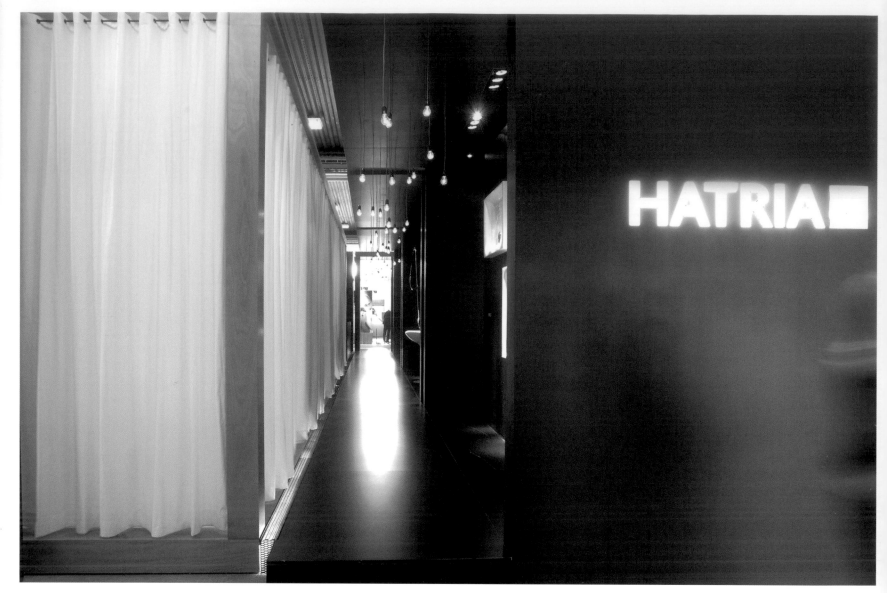

Presenting the same product and philosophy at each fair, Paolo Cesaretti has managed to created three different exhibition stands similar by using different materials and lighting.

Different colors and lighting produce a very different atmosphere for the 2004 stand. Black and white plus fluorescent light symbole urban/industrial landscapes; the white curtains will be reused in the following year's version.

The 2004 and 2005 stands also use ceramic tiles and plastic curtains, creating an industrial effect one year and an organic atmosphere the next.

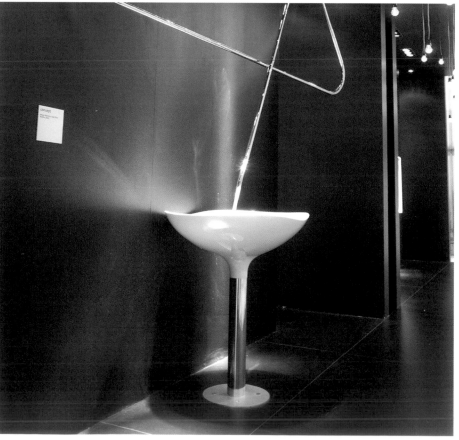

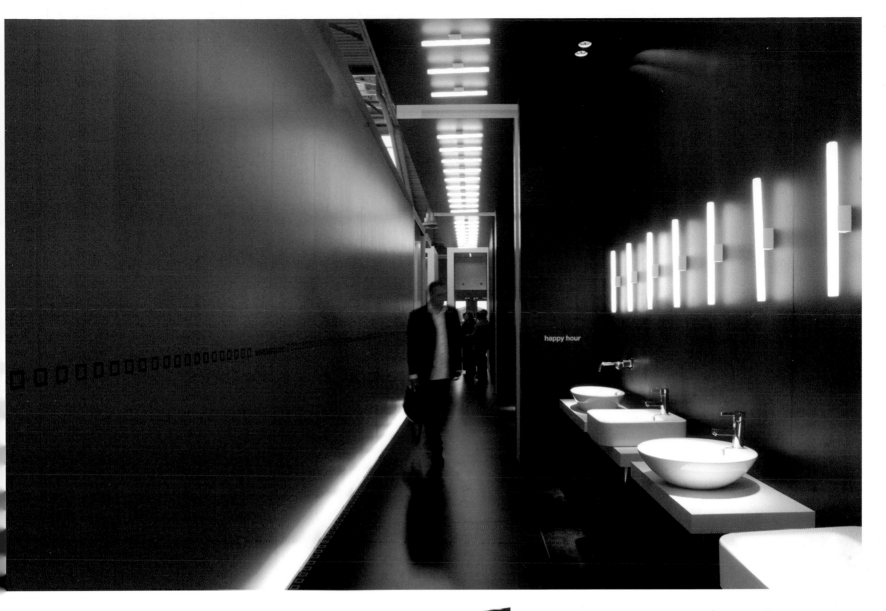

HPL and moquette floors are used for all three booths. Osram Linestra lighting creates an abstract atmosphere at the 2003 exhibition booth.

The urban/industrial landscape theme used black and red as the predominant colors, while 2005's stand had a light, organic feel, with white and blue used throughout. 2003's minimalism was achieved through the use of abstract designs.

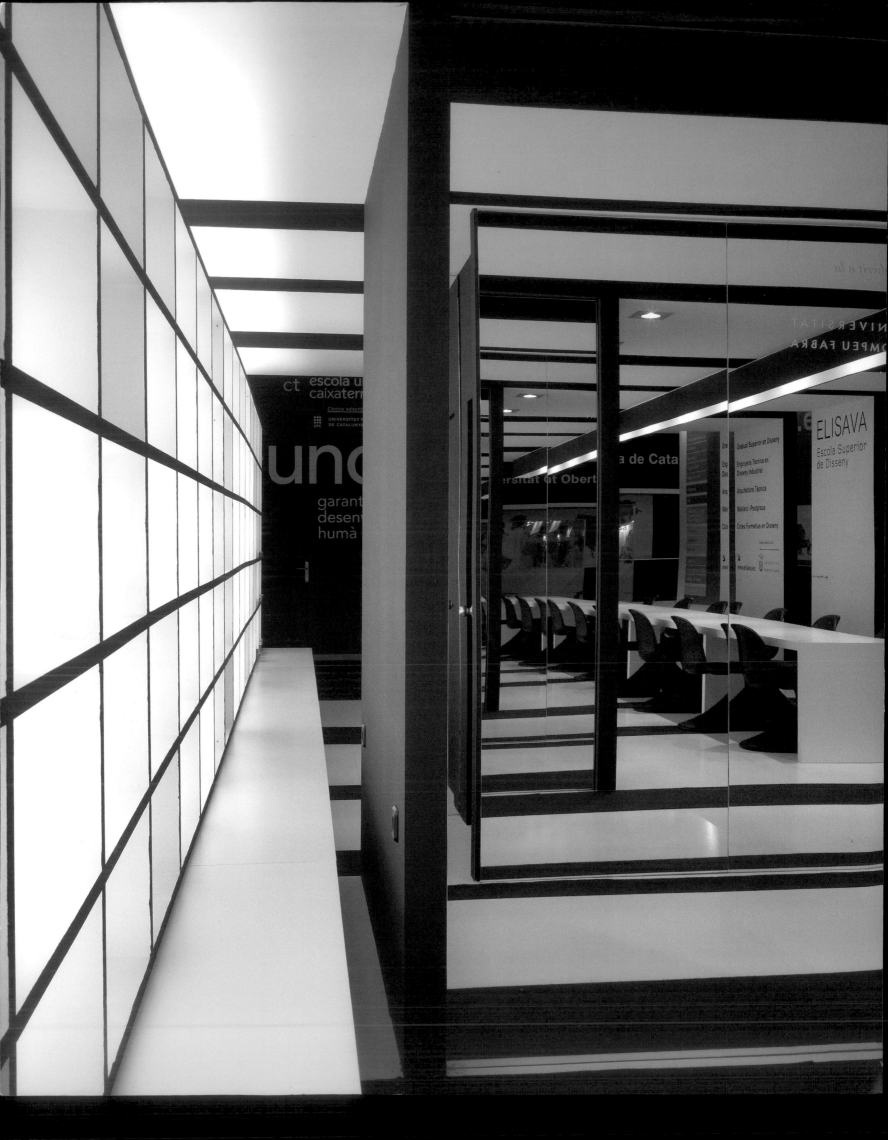

ELISAVA

Bookcase design

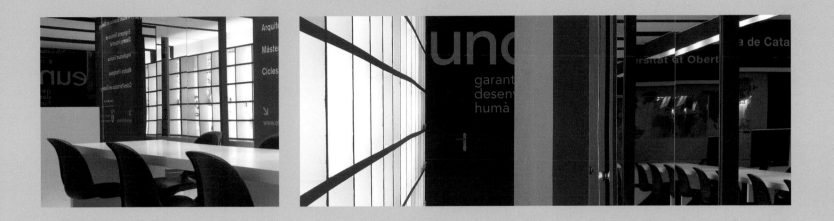

Bonjoch Associats

Address
Bonjoch Associats
Bonavista 6, int. pral. 4ª
08012 Barcelona
Spain

Fair
Estudia 2006, Fira Barcelona, Spain
March 2006 (5 days)

Other cities
None

Primary materials
Melaminic panel, MDF lacquered panels

Photography
© Eloi Bonjoch

Ignasi Bonjoch from Bonjoch Associats designed the Elisava stand for the Estudia 2006 fair. The concept was intended to evoke a large empty bookcase ready to receive prospective Elisava students. Held at Barcelona's Fira, Estudia is an annual education and training fair, where more than 150 schools and educational institutions present their programs and philosophies. The fair is visited by parents, students and teachers alike.

A rectangular space measuring six by ten meters (width by length) embodies this Higher Design School's mission. The space is sliced top to bottom into an irregular series of rectangular arches. (Black stripes on the floor appear to continue the slice across the bottom of the booth.) The predominant colors are black and white, with accents in red, Elisava's signature color. The stand's open design allows people to circulate freely while the white color and clear light of the presentation box give the booth a fresh and modern appearance. A long white lacquered table and a longitudinal bench recall classroom furniture. Several mirrors at the far end of the stand visually increase the series of arches for an infinite effect. The placement of the arches also allows for the Elisava logo and graphics to appear on the outside of the booth in a fragmented yet recognizable way.

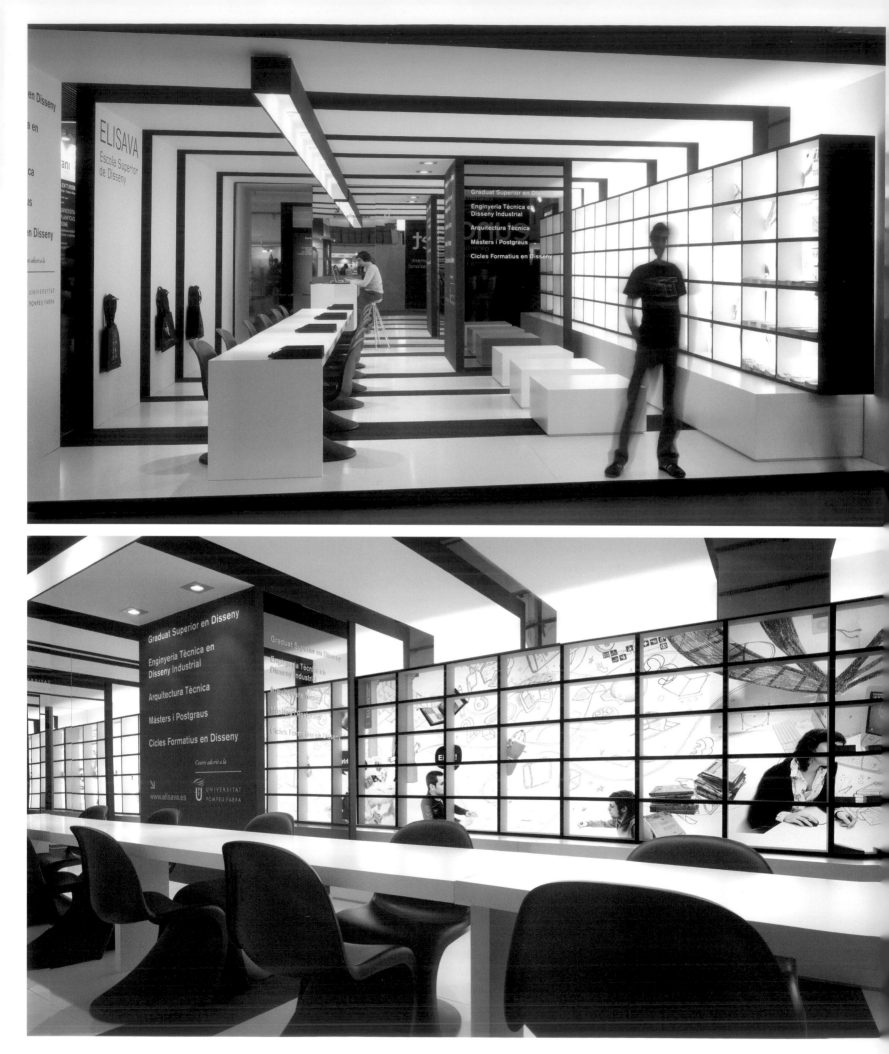

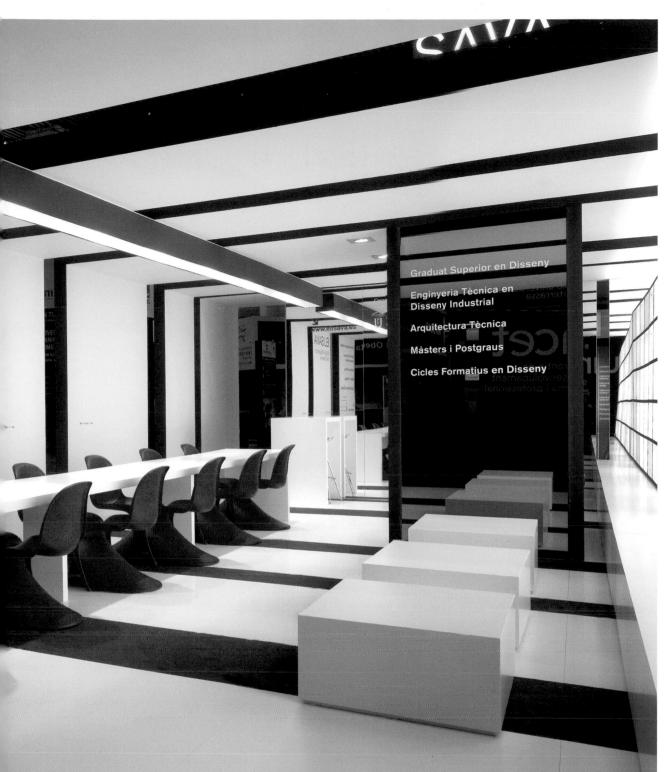

Graduat Superior en Disseny

Enginyeria Tècnica en
Disseny Industrial

Arquitectura Tècnica

Màsters i Postgraus

Cicles Formatius en Disseny

The booth's predominant colors are
white and black, with red accents.
The red Panton chairs, designed by
Vitra, add a fun curvilinear touch to this
rectangular space, and break up an
otherwise mono chromatic monotonous
atmosphere.

The rectangular booth is sliced into
irregular rectangular arches; the cuts are
reflected on the floor in the form of thick
black lines.

A long white lacquered table and a white
longitudinal bench provide informal
conference space. A bookshelf running
the length of the booth incorporates a
graphic backlit panel to illuminate the
stand's interior.

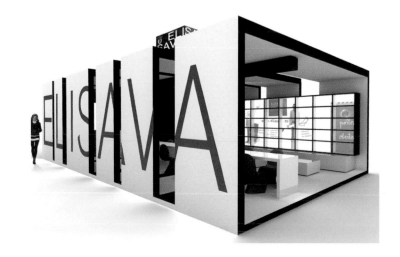

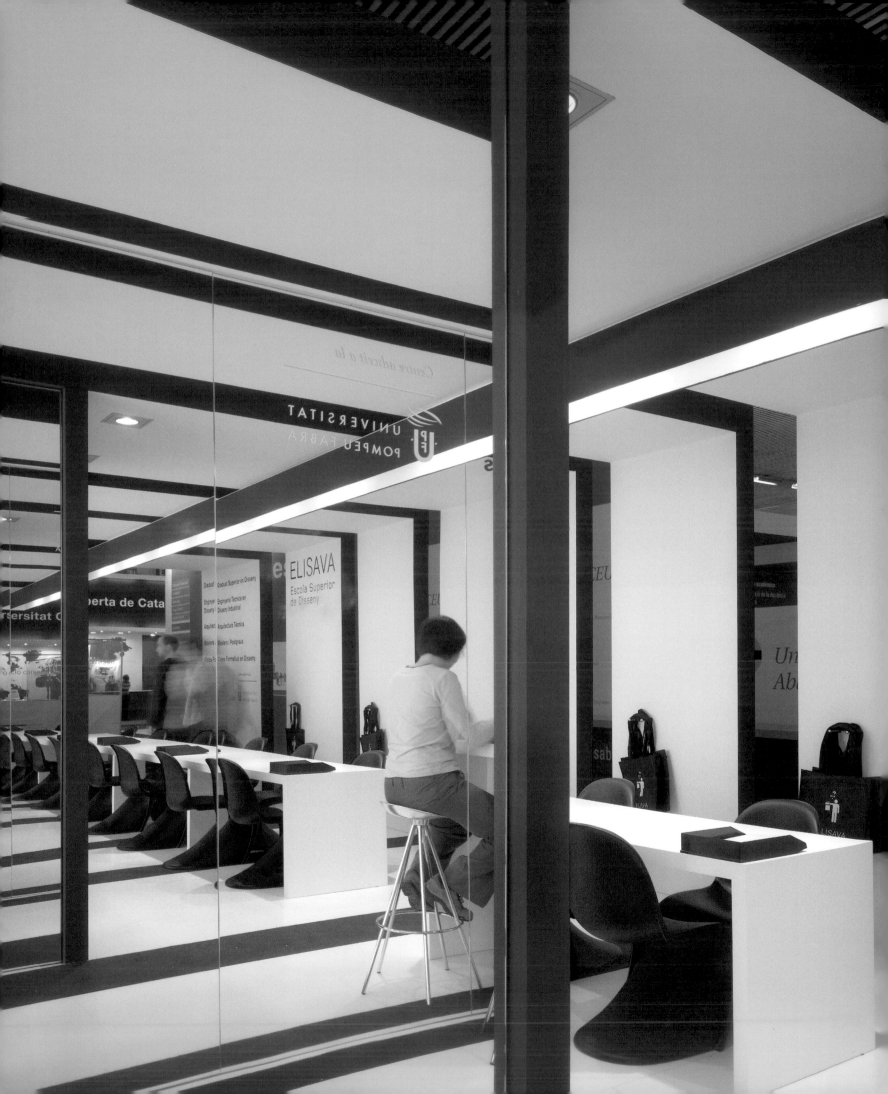

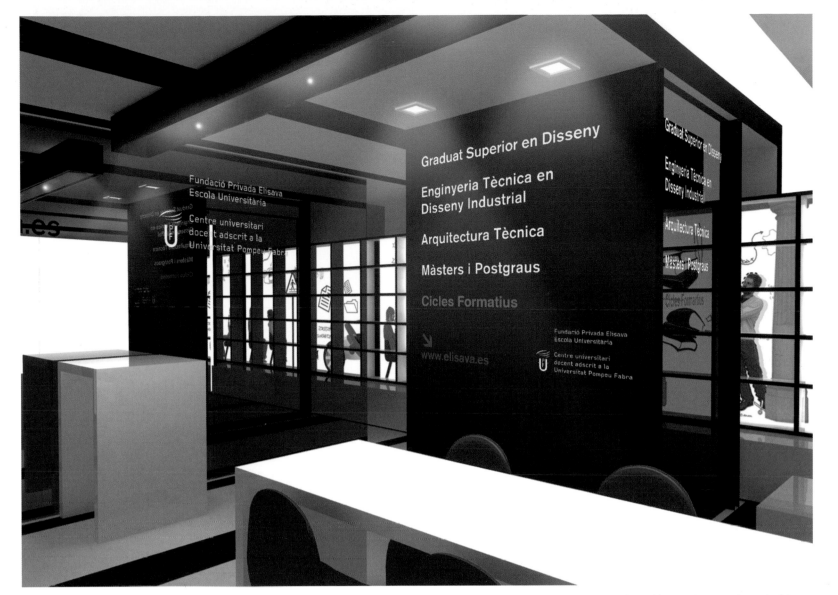

Graduat Superior en Disseny

Enginyeria Tècnica en
Disseny Industrial

Arquitectura Tècnica

Màsters i Postgraus

Cicles Formatius

↘
www.elisava.es

Fundació Privada Elisava
Escola Universitària

Centre universitari
docent adscrit a la
Universitat Pompeu Fabra

Several large mirrors at the end of the booth seem to lengthen the series of arches and give the space an infinite effect.

The Elisava logo and graphics are emblazoned on the outside of the arches, fragmented yet recognizable. On the inside, an open, modern and well-lit space allows people to circulate freely around the booth or sit down on benches and chairs for informal meetings and conversations.

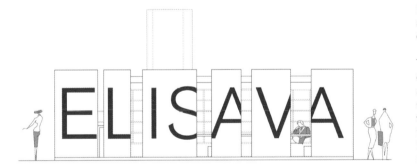

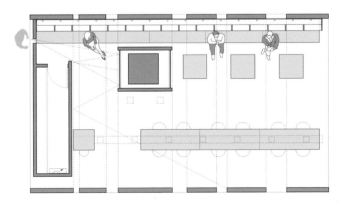

BARCELONA HOUSING SOLUTIONS
Environmental Collage

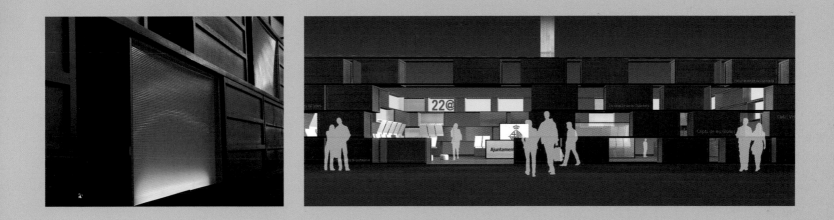

Indissoluble

Barcelona City Council commissioned local architects Indissoluble to design its exhibition stand for the ninth edition of Barcelona Meeting Point, an international real estate symposium held at the city's Fira.

This project emphasizes, the recycling and reusing of materials. The main element of this exhibition design is a modular box made from reforested wood. The entire exhibition stand consists of 180 wooden boxes on four levels, held together by a metal frame. The boxes make up the booth's walls. Gaps between them serve as the stand's entrance and windows, while inside the stand present the exhibition's contents and hold information flyers. Color-coded areas organize the exhibition in a unique way.

Moreover, 100% of these elements will be repurposed. The boxes are to be used by Indissoluble for future projects, while the metal structures will be used by the client, Barcelona City Council.

Barcelona Meeting Point (BMP) is an important international real estate fair. 2005's BMP welcomed more than 200,000 visitors, both professionals and members of the general public. The fair comprised of 70,000 square meters of exhibition space, more than 5,000 companies—of which almost half were based outside Spain—to present their products and philosophies.

Address
Indissoluble
Passatge de la Pau 11
08002 Barcelona
Spain

Fair
Barcelona Meeting Point 2005

Other cities
No

Primary material
Boxes made of recycled wood, galvanized steel plates, light boxes

Photography
© David Cardelús

Barcelona City Council presented their urban projects at the 2005 Barcelona Meeting Point. One hundred eighty wooden boxes made up this unique exhibition stand, conveying an overall message of environmental concern.

Color-coded presentations help the visitor focus on the information. The City Council's corporate colors are dark gray and red, which are used on the outside, while various types of information are presented in orange, yellow, green and dark gray zones.

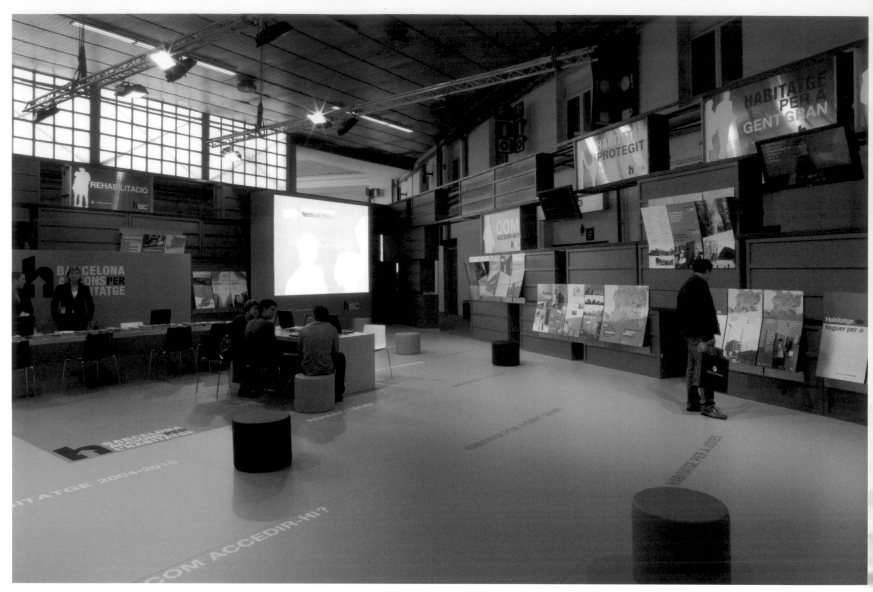

A series of 42-inch plasma screens connected to DVD players, highlights contents of the the City Council's exhibit.

Phrases written on the floor encapsulate some of the main themes for this exhibition. Round orange and gray stools provide informal seating areas while a number of information desks can be found elsewhere throughout the exhibition.

Further information is presented on folded-metal placards, which also hold informational leaflets.

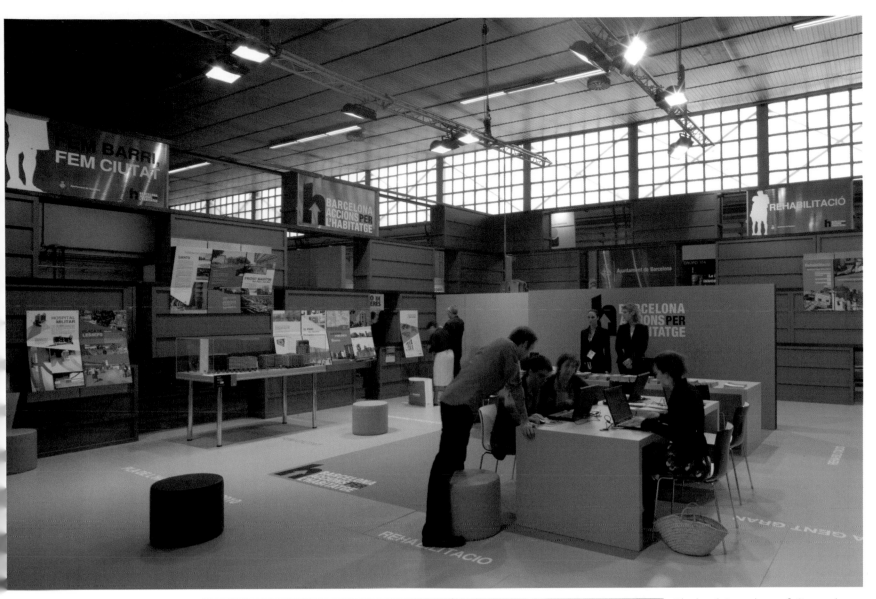

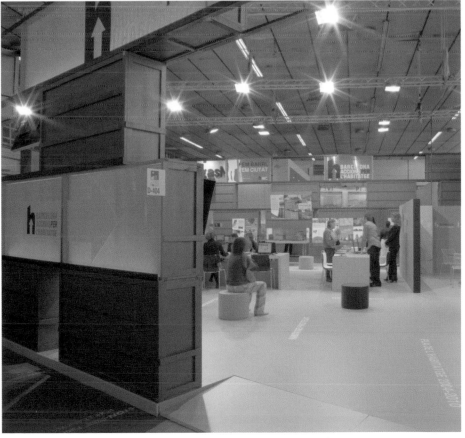

The booth is made up of 180 wooden boxes, arranged on four levels and supported by a metal frame. Openings between them serve as entrances. The wooden boxes will be reused in future Indissoluble projects, while the metal structures are to be donated to Barcelona City Council, which has pledged to repurpose 100% of the donation.

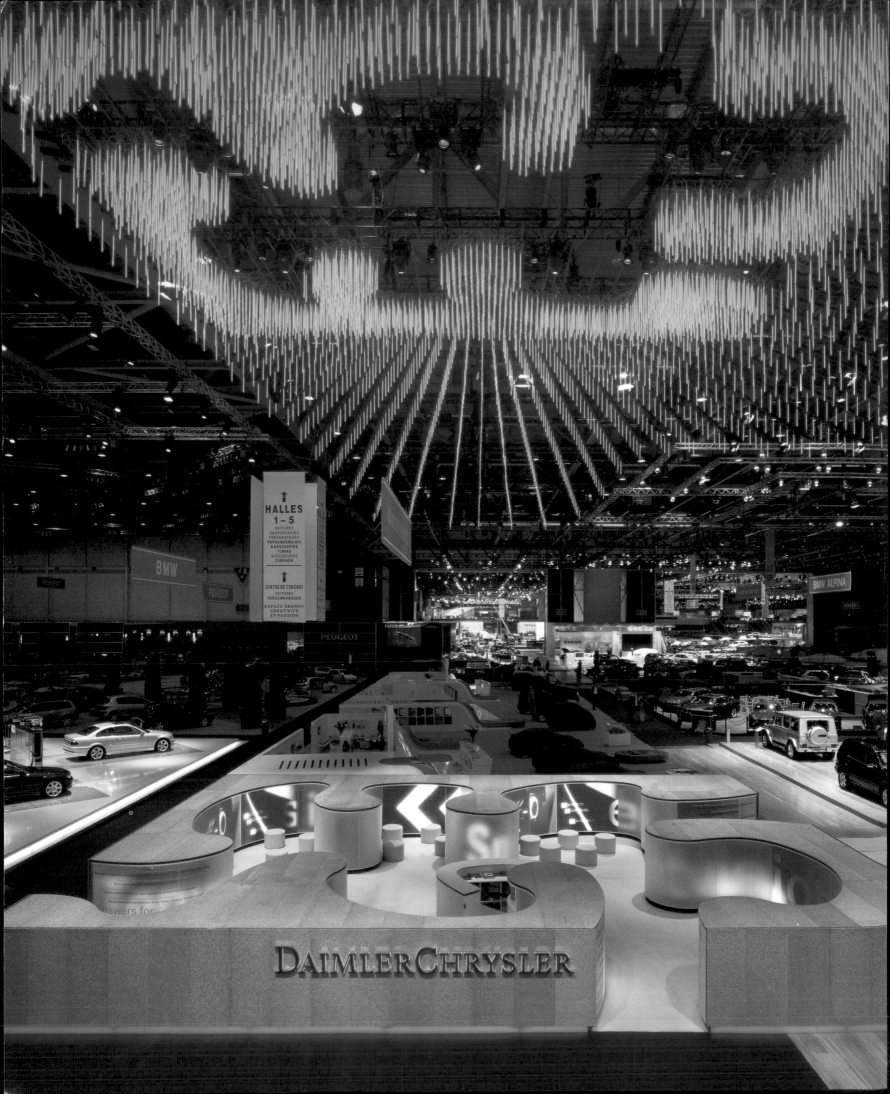

DAIMLERCHRYSLER
Blue Sky

Atelier Markgraph

Address
Atelier Markgraph GmbH
Hamburger Allee 45
60486 Frankfurt am Main
Germany

Fair
73rd Geneva International Motor Show
Geneva, Switzerland
March 6–13, 2003

Other cities
None

Primary material
5,000 neon tubes

Photography
© Andreas Keller

The first corporate-level platform where the DaimlerChrysler Group, presented all of its individual brands appeared at the 73rd Geneva Car Show in 2003. Atelier Markgraph's brief was to create a visual and conceptual framework to unite the individual brands. The DaimlerChrysler Group wanted to heighten brand awareness of the group as a whole, comprising such sub-brands as Mercedes-Benz, Maybach, Smart, Chrysler and Jeep, and to communicate the group's capacity for technological innovation.

As expansive multimedia installation expressing broad corporate themes was the result. "Blue Sky," ray-shaped light sculpture made of 5,000 neon tubes hung from the ceiling spanned the group's 220-square-meter platform; it was the design's main element and could be seen from a distance, guiding visitors towards the DaimlerChrysler stand. Thanks to Atelier Markgraph's cutting-edge design the DaimlerChrysler area impressed visitors, who promptly christened Hall 6, the "DaimlerChrysler Hall."

The 73rd Geneva Car Show was held at the enlarged Geneva Palexpo, boasting nearly 1.2 million square feet of exhibition space. The Geneva Car Show typically announces results and economic forecasts, though this was pushed aside in 2003 to make room to show even more cars.

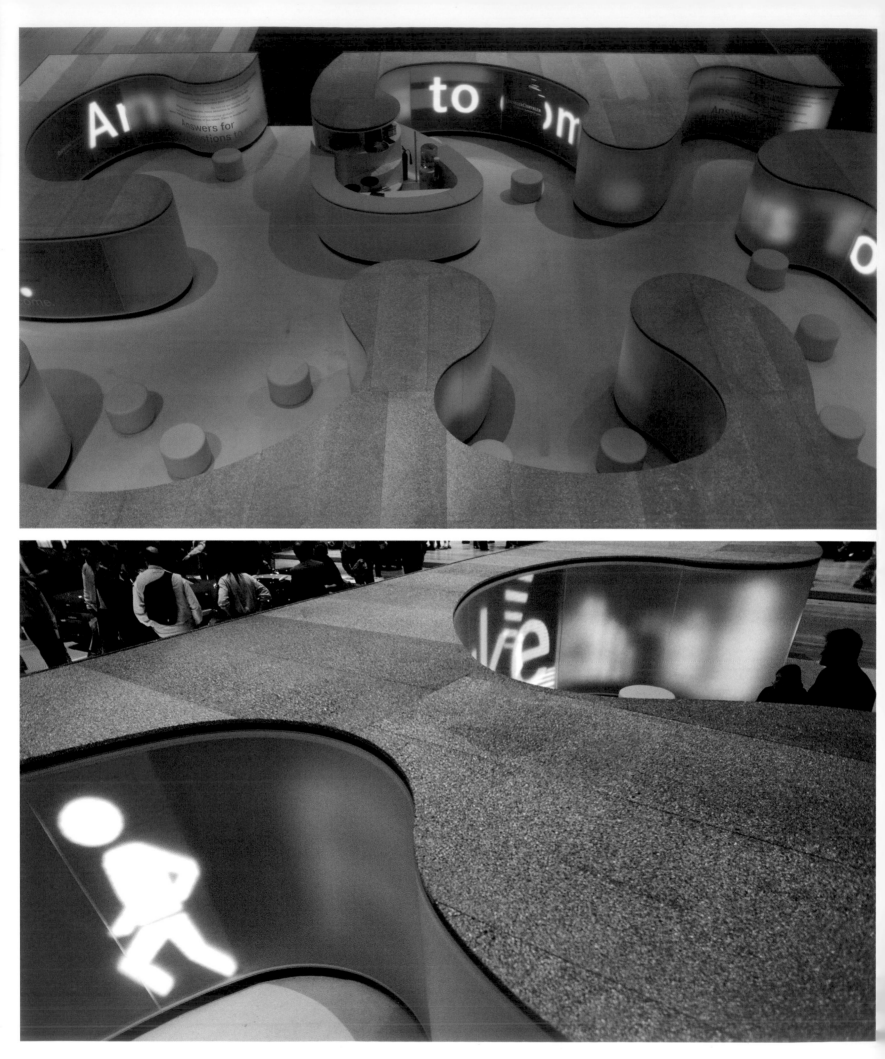

"Blue Sky" guides visitors toward the huge DaimlerChrysler forum. In 2003 this feature not only made DaimlerChrysler stand out from other brand platforms, but it also inspired visitors to christen Hall 6 the "DaimlerChrysler Hall."

From outside the exhibit appears calm, precise and simple, while the wraparound media installation inside, accessible from three sides, creates a softer mood.

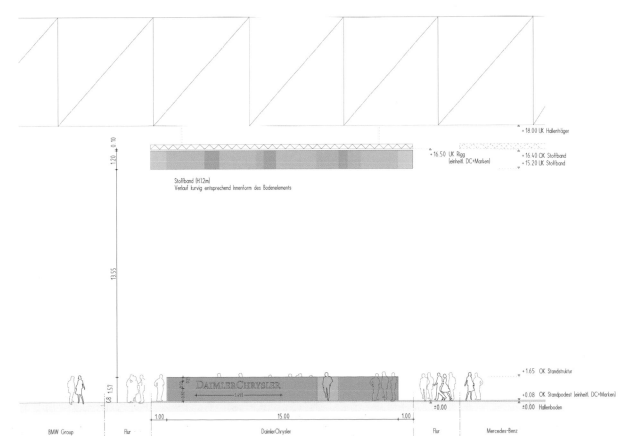

Stoffband (H.1.2m)
Verlauf kurvig entsprechend Innenform des Bodenelements

+ 18.00 UK Hallenträger
+ 16.50 UK Rigg (einheitl. DC+Marken)
+ 16.40 OK Stoffband
+ 15.20 UK Stoffband
+ 1.65 OK Standstruktur
+ 0.08 OK Standpodest (einheitl. DC+Marken)
±0.00 Hallenboden

DaimlerChrysler

BMW Group | Flur | DaimlerChrysler | Flur | Mercedes-Benz

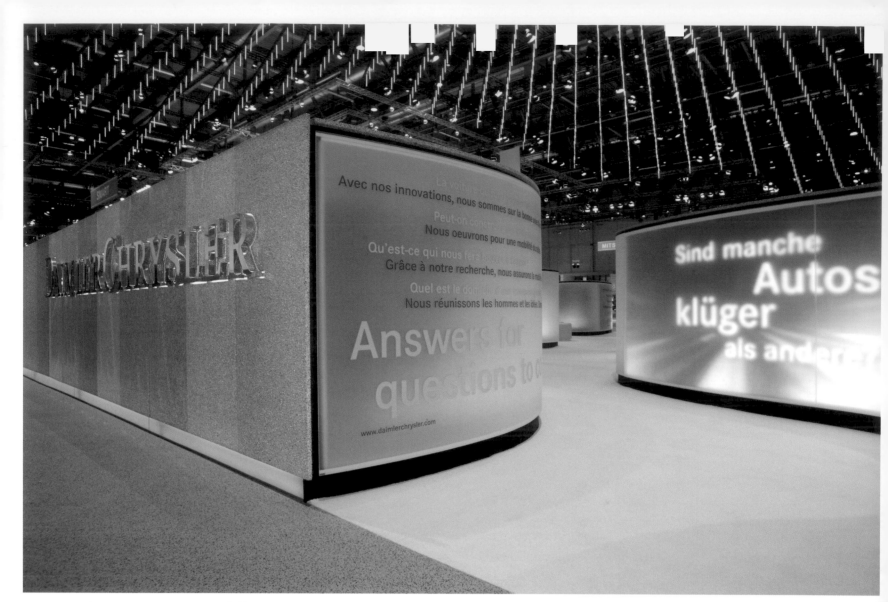

An interplay of questions and answers highlights DaimlerChrysler's research and its responsibility to people and the environment. The color scheme changes according to the subject matter being communicated.

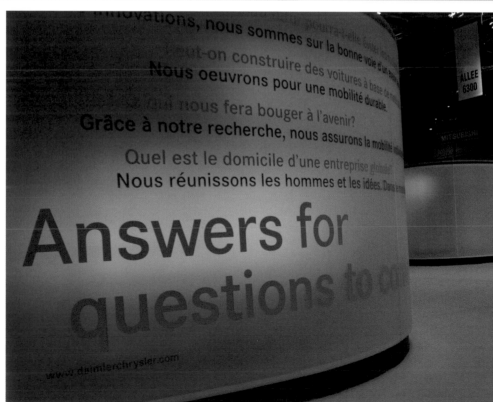

A ray-shaped light sculpture made of 5,000 hanging neon tubes, "Blue Sky" spans the group's 220-square-meter platform, guiding visitors toward DaimlerChrysler's corporate presentation.

An amoebashaped space cut out from a right-angled block 15 meters long, 11 meters wide and 1.5 meters tall (height restrictions were imposed).

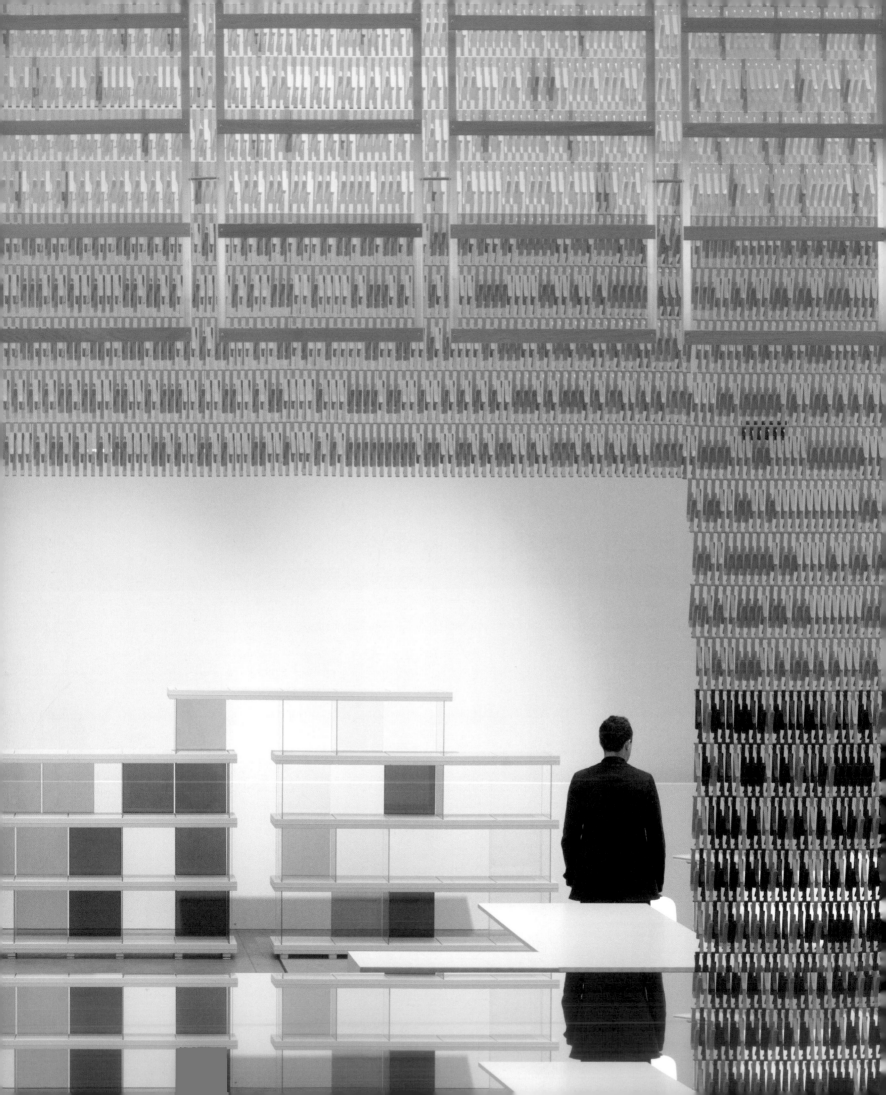

VITRA
Nimble Structure

 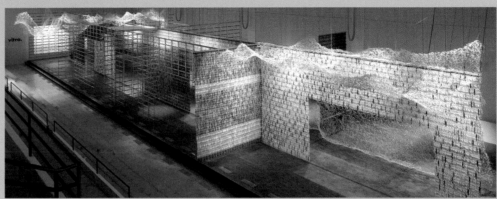

Ronan & Erwan Bouroullec

Address
Ronan & Erwan Bouroullec
23 rue du Buisson Saint-Louis
75010 Paris
France

Fair
Salone Internazionale del Mobile,
Milan, Italy, April 2005

Other cities
None

Primary materials
Algues and Twigs, metal and wood partitions

Photography
© Ronan & Erwan Bouroullec, Paul Tahon &
Ronan Bouroullec, Miro Zagnoli

The French furniture designers Ronan and Erwan Bouroullec presented a spectacular design for the Vitra stand at the 2005 Salone del Mobile, the last one to be held in Milan before its move to Rho-Pero. The German company, which had been absent from the fair for several years, presented a successful show at Milan's La Pelota, a former sports arena. The Vitra was specially designed for that venue. The Bouroullec brothers often use plastic element called Algues and Twigs that combine to make a screenlike partitions; for this event they developed special colors. The Vitra exhibition stand at La Pelota, contained within a series of these permeable walls, exhibited the siblings' home and studio office collections, as well as other designers' new products from the Vitra Home Collection.

Inspired by natural forms, the Algue and Twigs plastic elements resemble small branches. When the light, polypropylene-injected structures are joined together they produce a delicate branching effect; assembled in great numbers they become flexible screens. Ronan and Erwan had used the Twigs and Algues combination at previous installations and exhibitions, including La Piscine at the Roubaix Museum of Art's & Industry in France.

Milan International Furniture Fair is the leading international exhibition for the furniture design industry, with satellite fairs such as Euroluce, the International Biennial Lighting Exhibition and Salone del Complemento d'Arredo, an exhibition for decor accessories, among others.

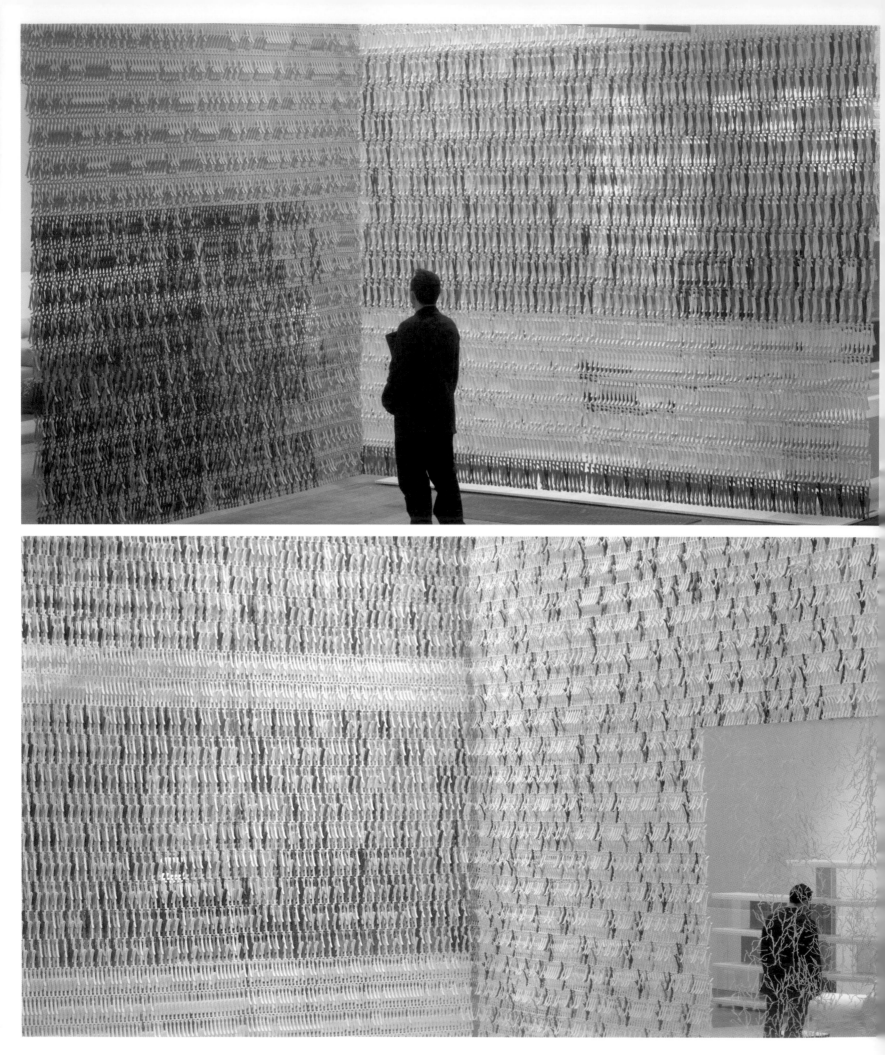

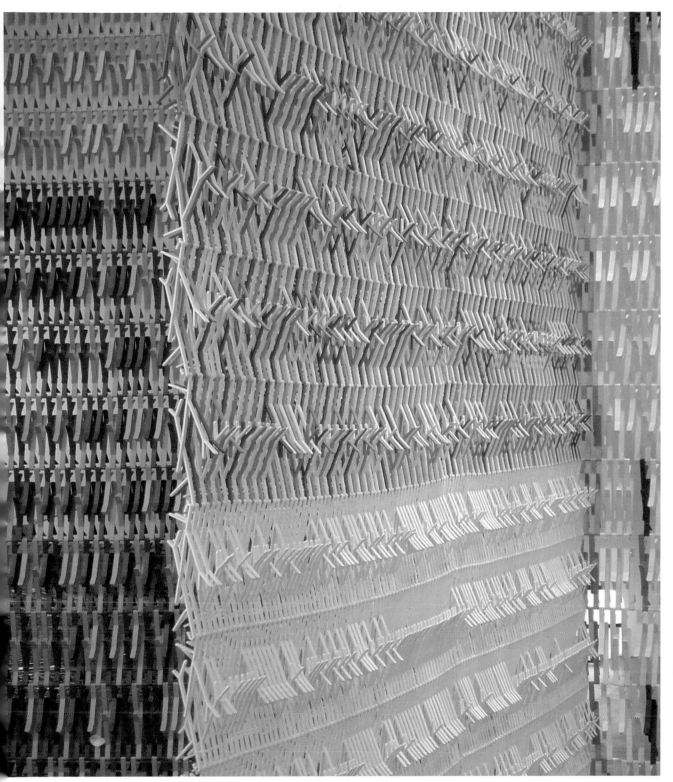

The specially designed Vitra stand was exhibited at La Pelota, a former sports arena in Milan, during the 2005 Salone del Mobile. The stand exhibited the Bouroullec brothers' home and office collections as well as new furniture by other designers.

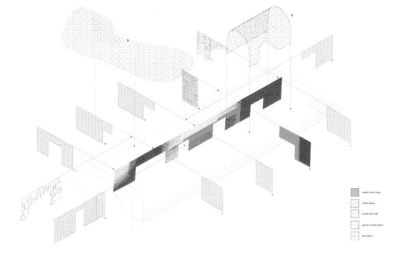

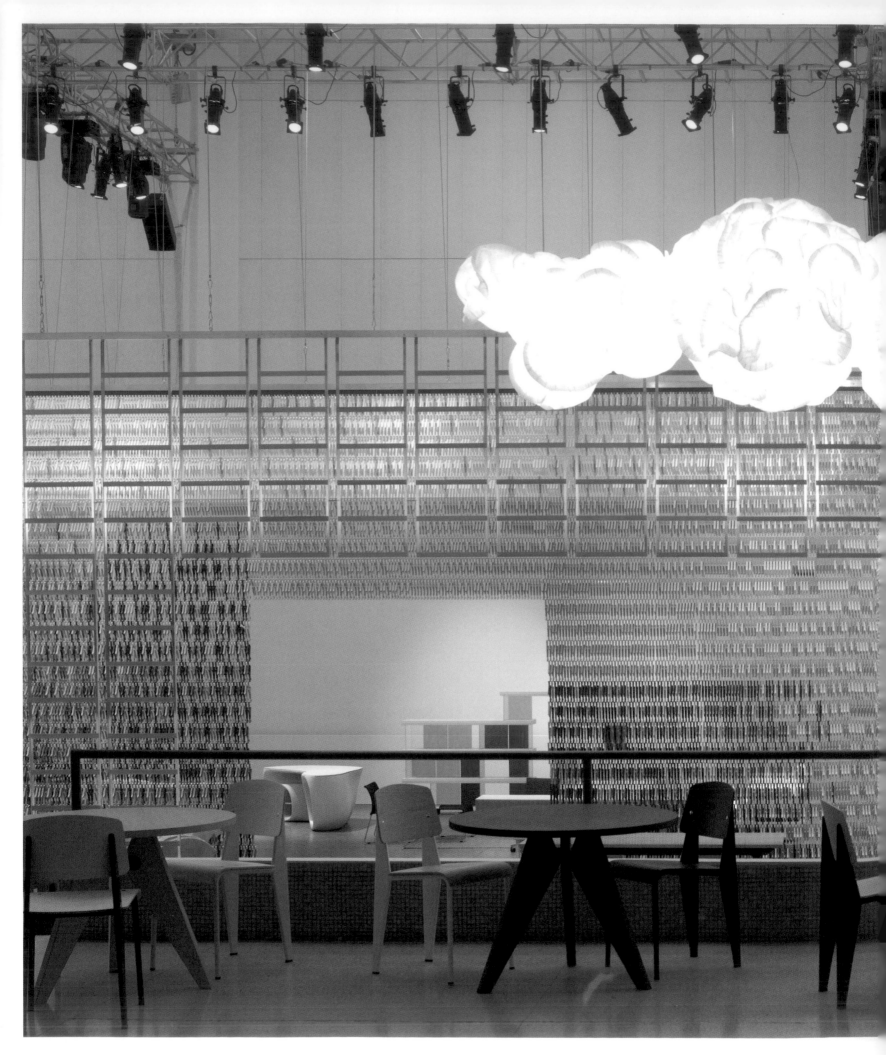

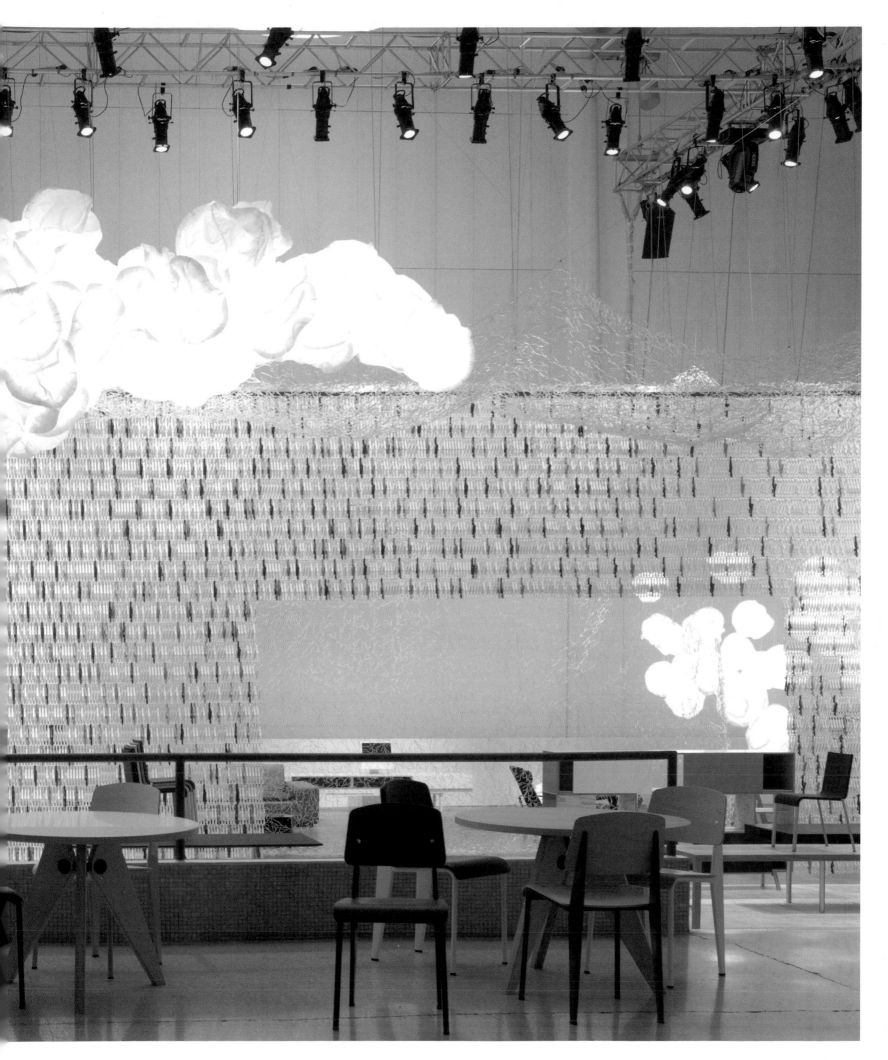

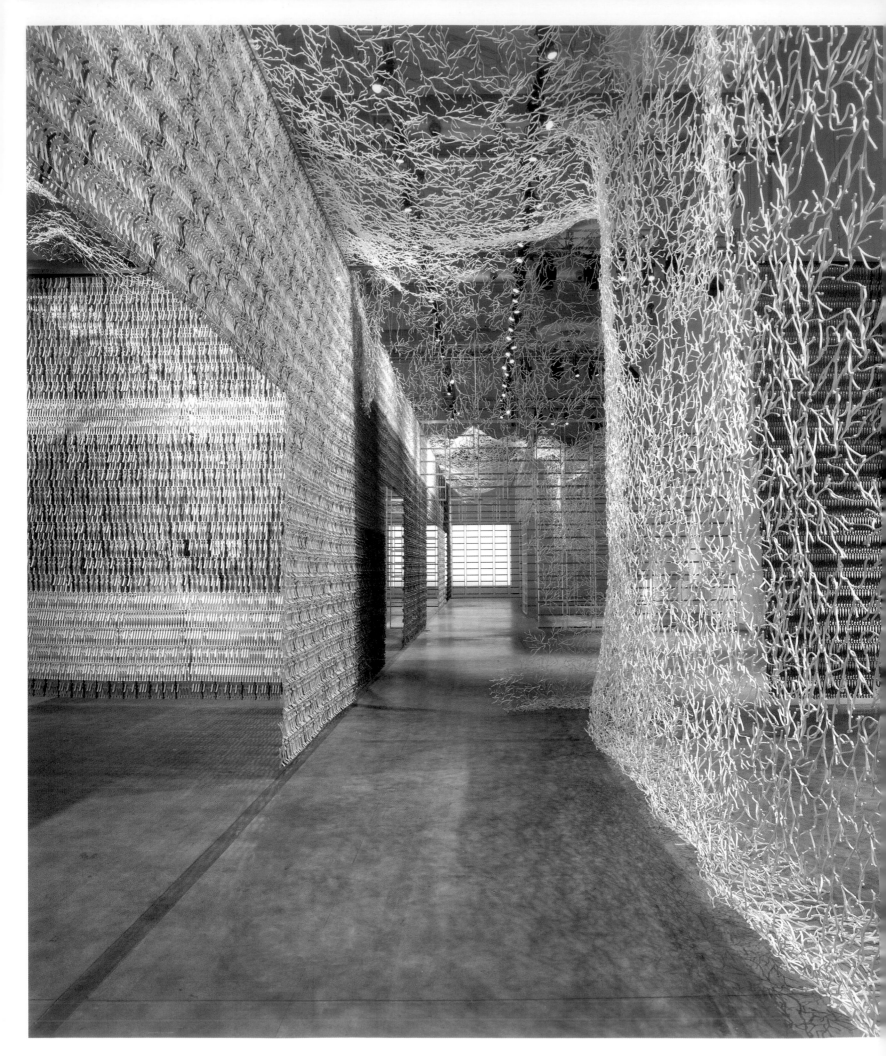

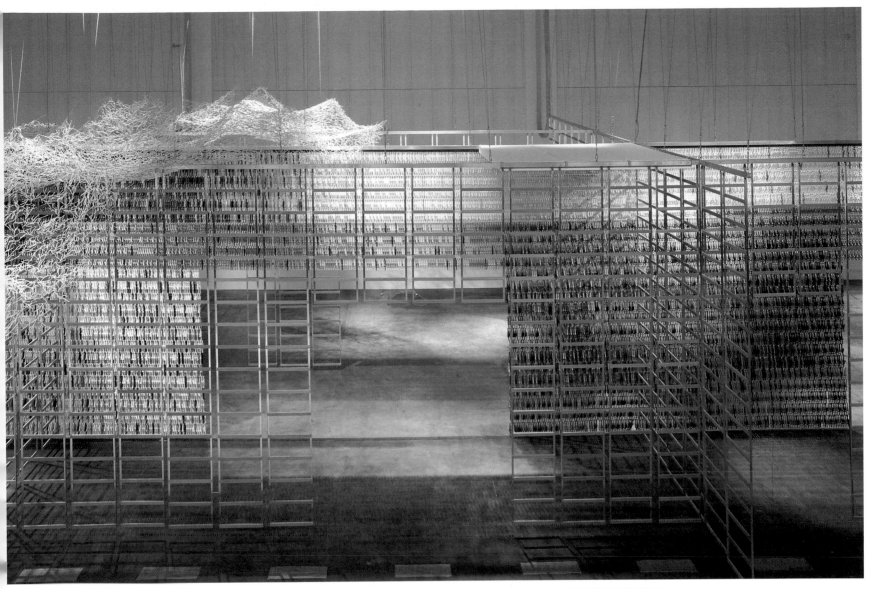

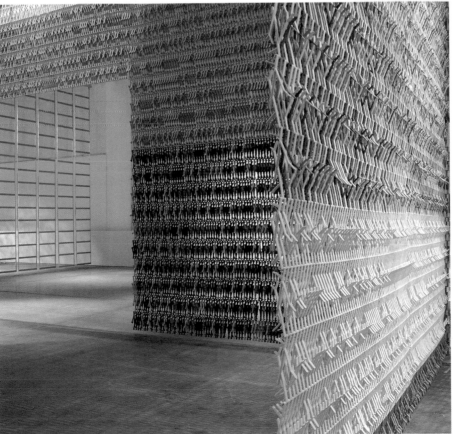

A converted soccer stadium housed the Bouroullec brothers' Vitra stand made of Algues and Twigs.

The installation took approximately ten days to mount. Some Algues and Twigs were preassembled and then mounted on the wood and metal partitions at La Pelota.

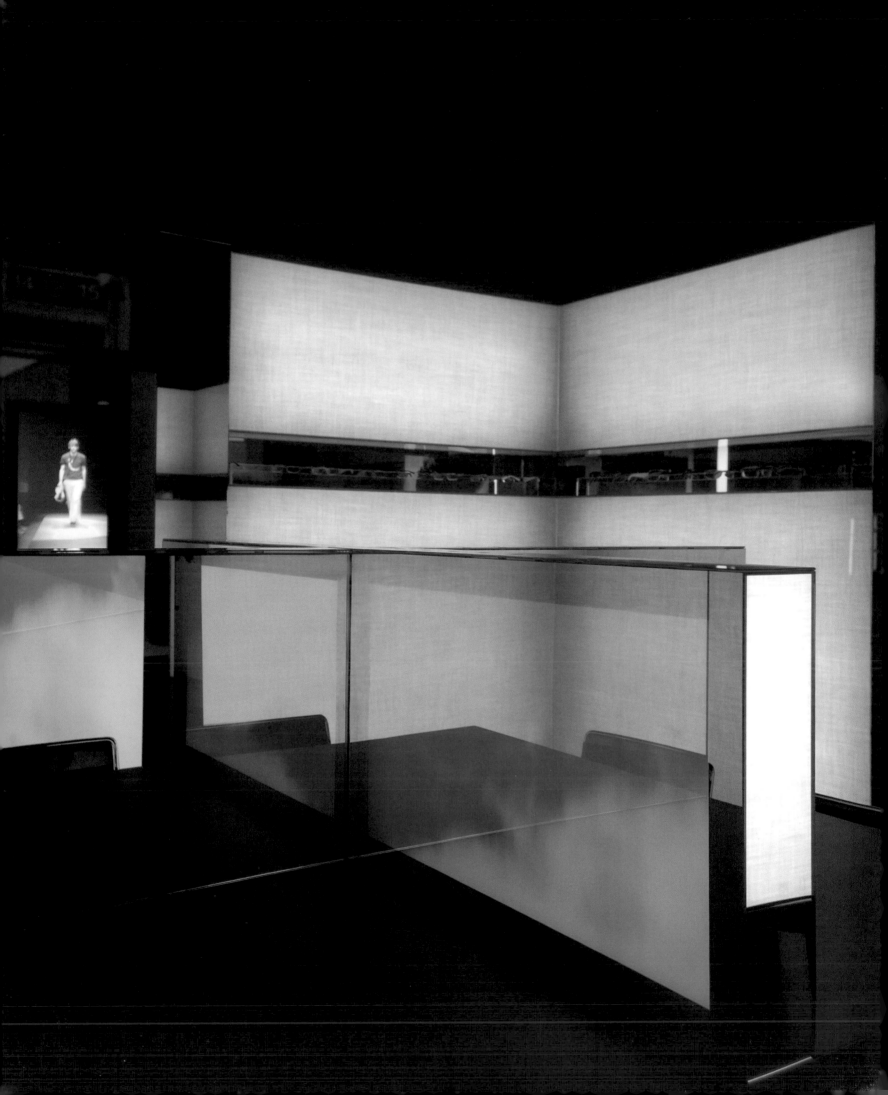

PRADA
Fashion Vision

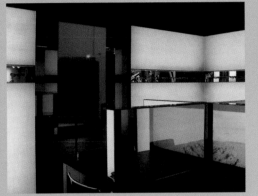
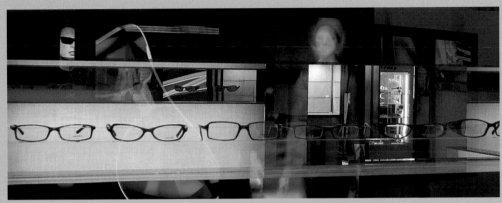

Studiomonti

Address
Studiomonti
Plaza S. Erasmo 1
20121 Milan
Italy

Fair
Mido, Milan
May 10–14, 2005

Other cities
Silmo 2005, Paris, France;
Mido 2006, Milan, Italy

Primary material
Wood, fifty plasma screens, dark mirrors,
backlit glass, fabric inserts

Photography
© Alessandro Ciampi

Claudio Monti designed the 2005 Prada stand for Mido, the annual international eyewear trade show for optics, ophthalmology and optometry which takes place in Milan every year. Mido presents innovative new processes and technical solutions as well as the latest models of eyewear, frames, lenses, machines and components.

Claudio Monti's stand looks simple, but in fact it reflects the style and technological details of Prada eyewear. The stand consist of a wooden base, fifty plasma screens, and dark mirrors. Scattered around the 180 square meters of Prada exhibition space, structures made of steel and wood hold LCD screens; the placement of the monitors encourages visitors to take alternate routes around the stand. A volume made of glass panels with fabric inside, placed next to the space where the glasses are on display, reflects images from the multiple screens. A display around the perimeter of the stand houses Prada and Miu Miu collections. At the center of the space, LCD screens displaying footage of the four elements: earth, water, air and fire.

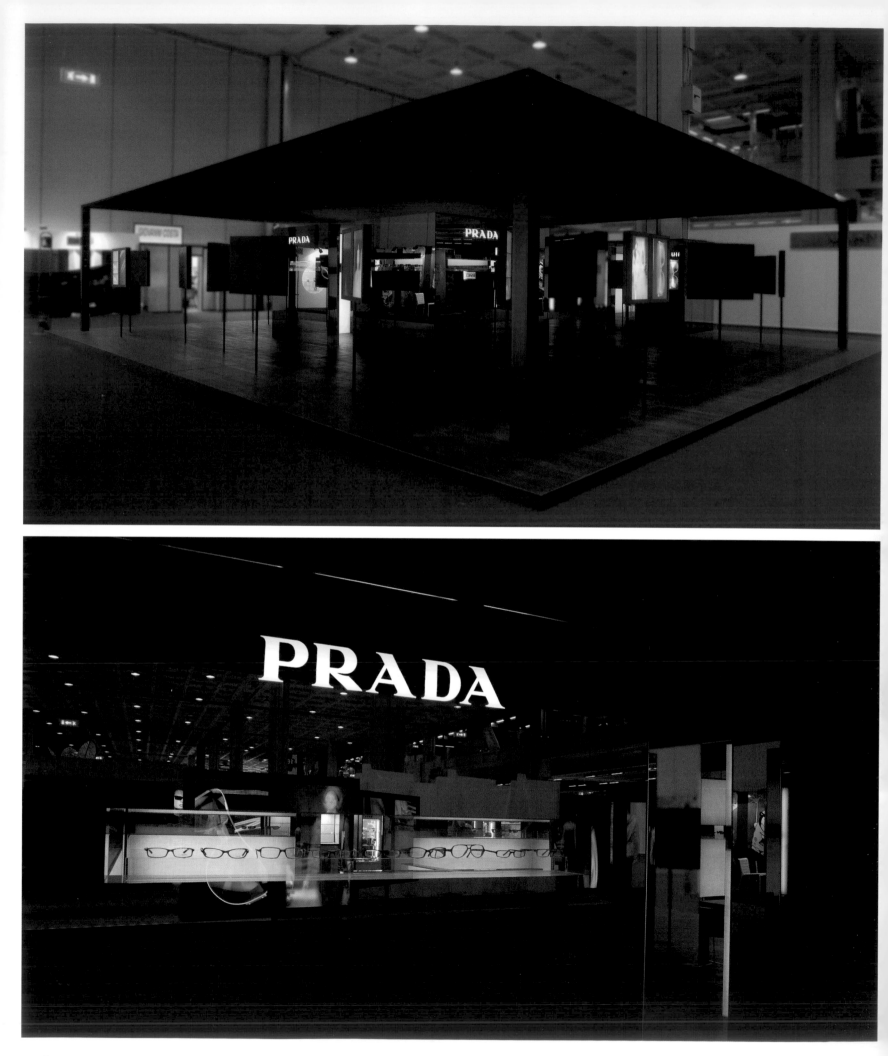

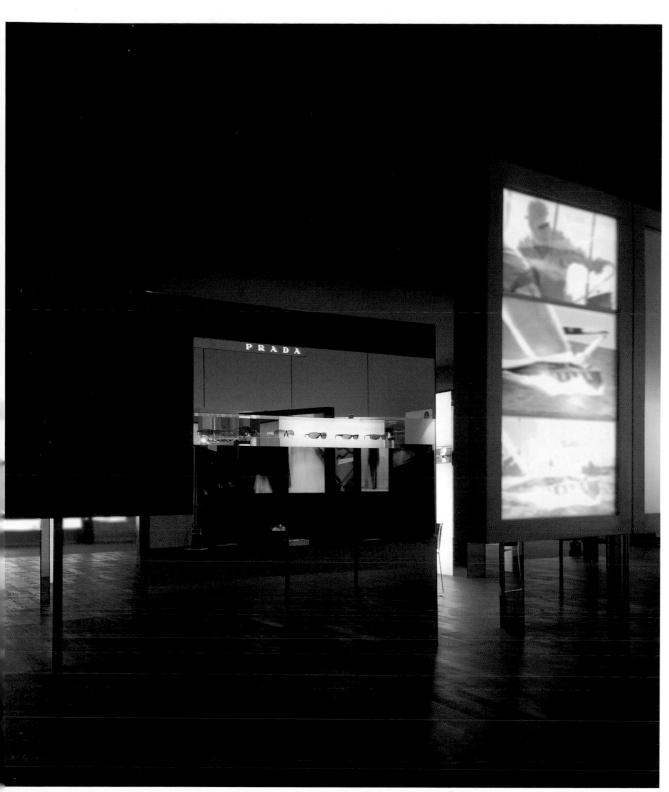

The seemingly simple yet innovative exhibition stand created for Prada reflects the detail and precision that characterizes the company's eyewear.

The stand's base is made of wood surmounted by a steel structure. Dark mirrors and fifty plasma screens are used in the exhibit as well.

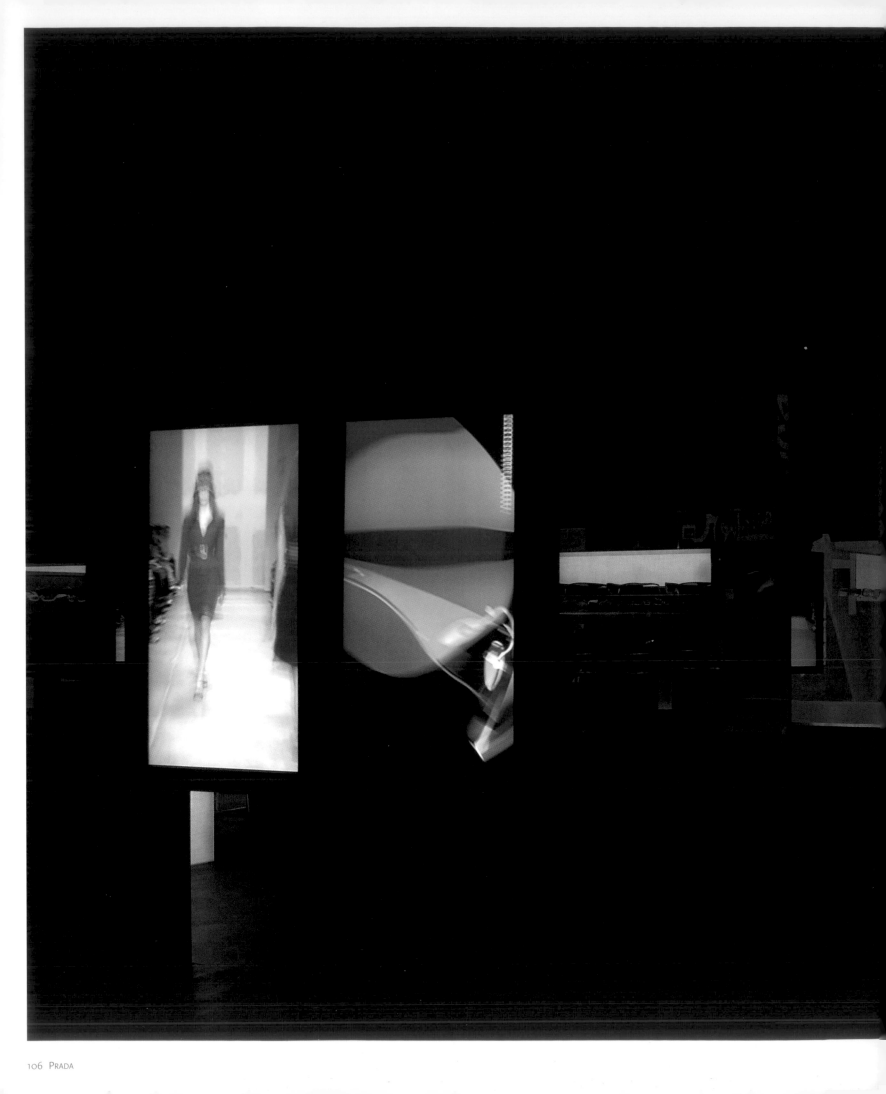

At the center of the space stands a table divided into fourths by vertical LCD screens. The screens display images of water, earth, fire and sky.

A vertical rectangular volume made from tinted glass houses the cables, DVD players and other audiovisual equipment used to create this innovative stand.

LCD screens mounted on light steel structures and are placed casually all around the stand. The screens, showing footage by Alfio Pozzoni, are an integral part of the Prada exhibition stand.

SEZIONE DD

SEZIONE AA

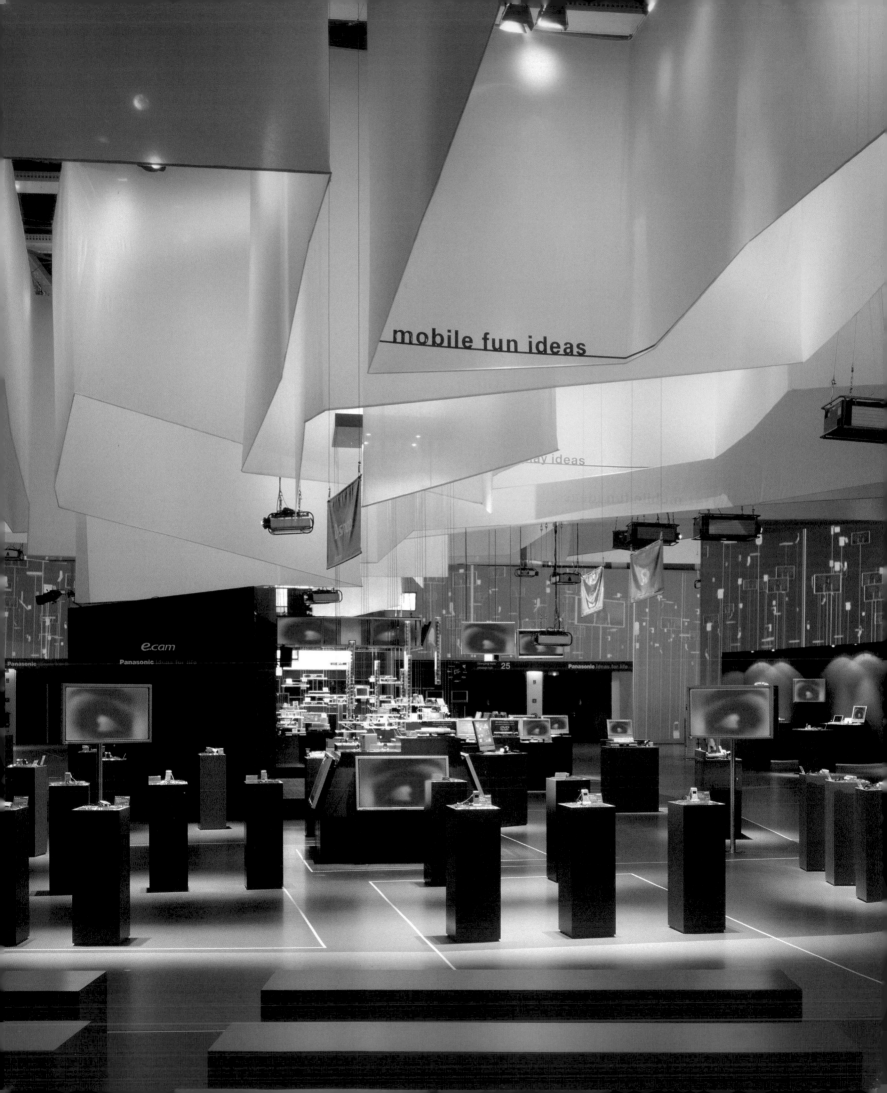

BLUE SCAPE
Network Solutions

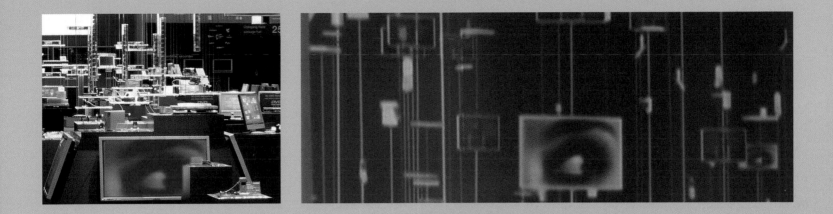

Atelier Brückner

Address
Atelier Brückner GmbH
Quellenstrasse 7
70376 Stuttgart
Germany

Fair
Internationale Funkausstellung (IFA),
Berlin, Germany, September 2003

Other cities
None

Primary materials
Wire frames and fabric ribbons

Photography
© Marcus Mahle

Atelier Brückner was commissioned to design Panasonic's multimedia booth for the 2003 Internationale Funkausstellung (IFA) held in Berlin. The Stuttgart-based designers created an interplay of architecture, film, light and sound that immersed visitors in a surreal, abstract world.

Panasonic sought to attract visitors and illustrates its network of ideas, its so-called "ideas for life." Atelier Brückner aimed to display Panasonic's products, and artistically convey their networking capabilities. The result, Panasonic "Ideas for Life," was a virtual landscape with blue hues dominating and an open architecture that gave visitors a grand overview as they entered the booth. "Blue Scape", at the center of the booth, was an environment defined by wire frames that consisted of "product fields" and "presentation islands." The "Artificial Cloud," a labyrinth of fabric ribbons suspended from the ceiling, covered more than 1,500 square meters and served as a visual landmark from a distance. A moving, wire structure connected three-dimensional objects and small, self-contained spaces. A woman in a crimson dress, a character that figured prominently in the IFA 2001 exhibit, enlivens the abstract world. The whole installation covered 1,700 square meters of floor space and 960 square meters of wall space.

IFA is one of Europe's leading consumer-electronics trade fairs, specializing in audio and video devices. The 2003 edition proved to be the largest in the IFA's 79-year history, with more than 1,000 exhibitors and some 270,000 visitors.

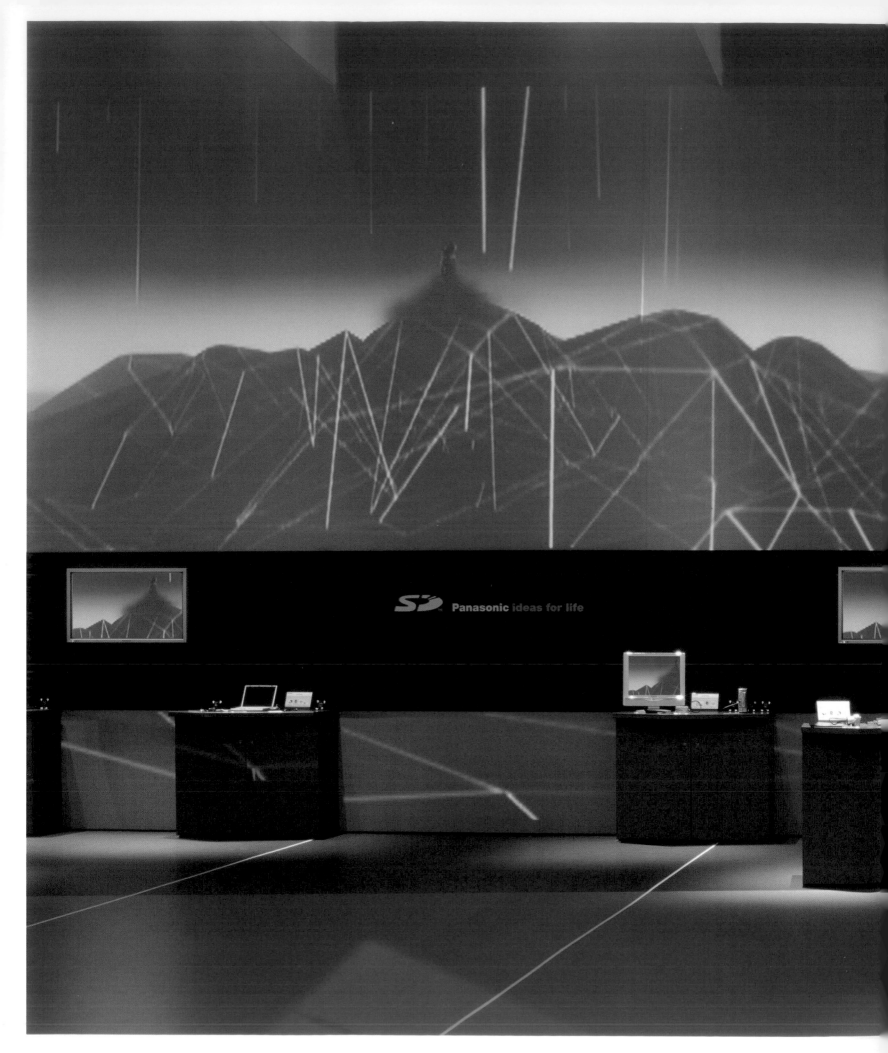

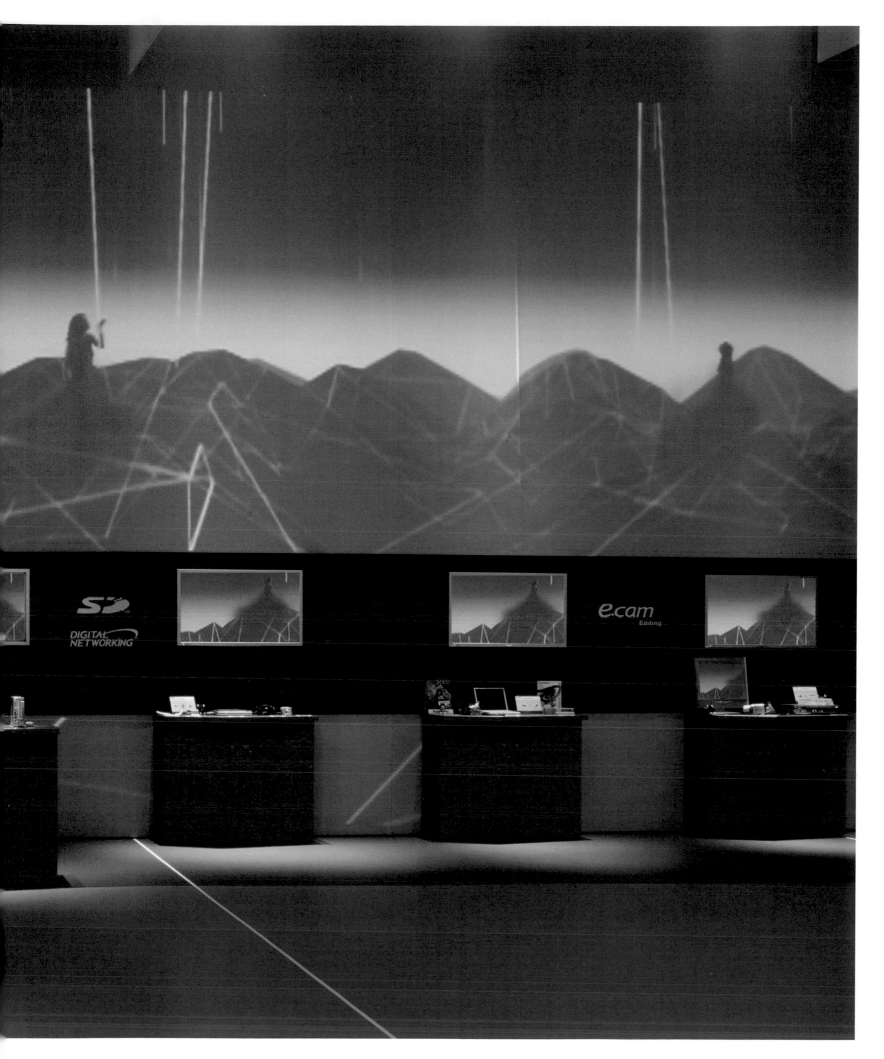

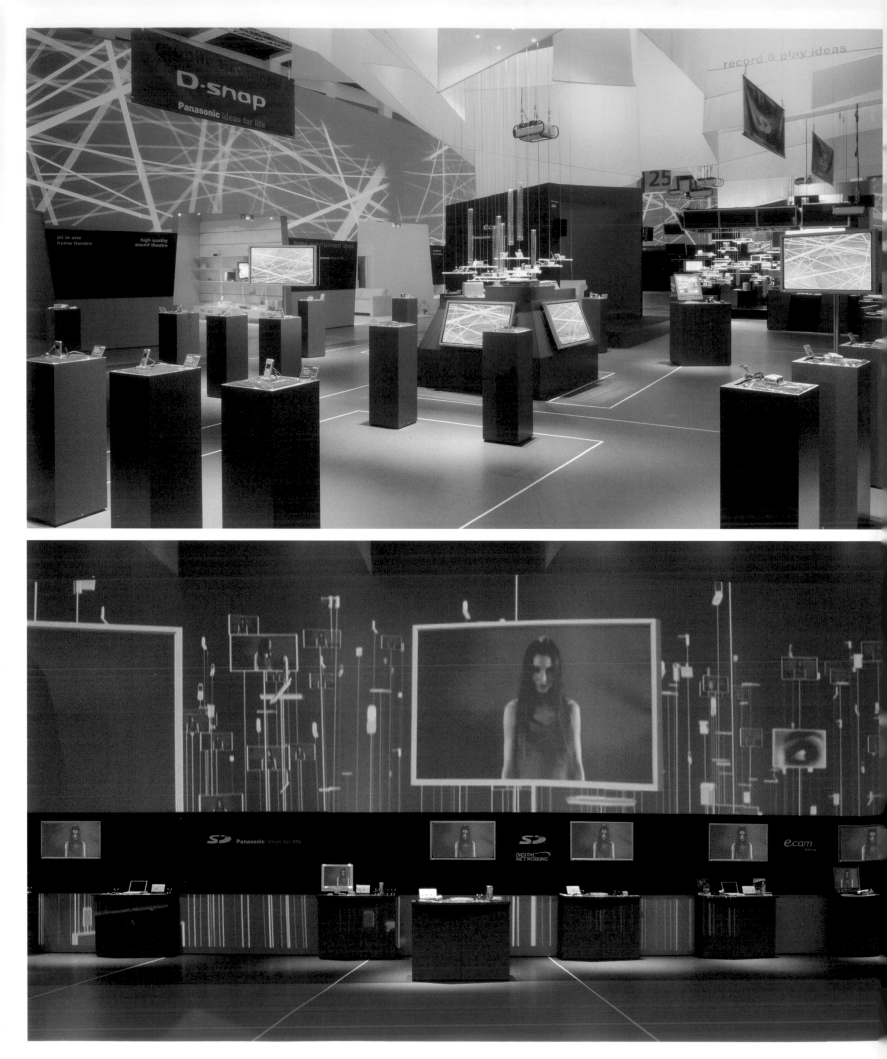

The "Changing Horizon" (previous page) is a 360-degree panorama using 22 LCD projectors. The Panasonic blue world incorporates red and yellow hues.

Products are exhibited below the "Artificial Cloud," a labyrinth of suspended white fabric ribbons.

A woman in a crimson dress, featured at a previous booth (IFA 2001), inhabits the abstract world. Her singing and the music composed by Monobeat, a Berlin-based sound studio, helps unify the moving images into a fascinating and emotional presentation.

Small niches in the "Changing Horizon" house hold home theater products.

The Panasonic booth occupied 1,700 square meters of floor space and 960 square meters of wall space.

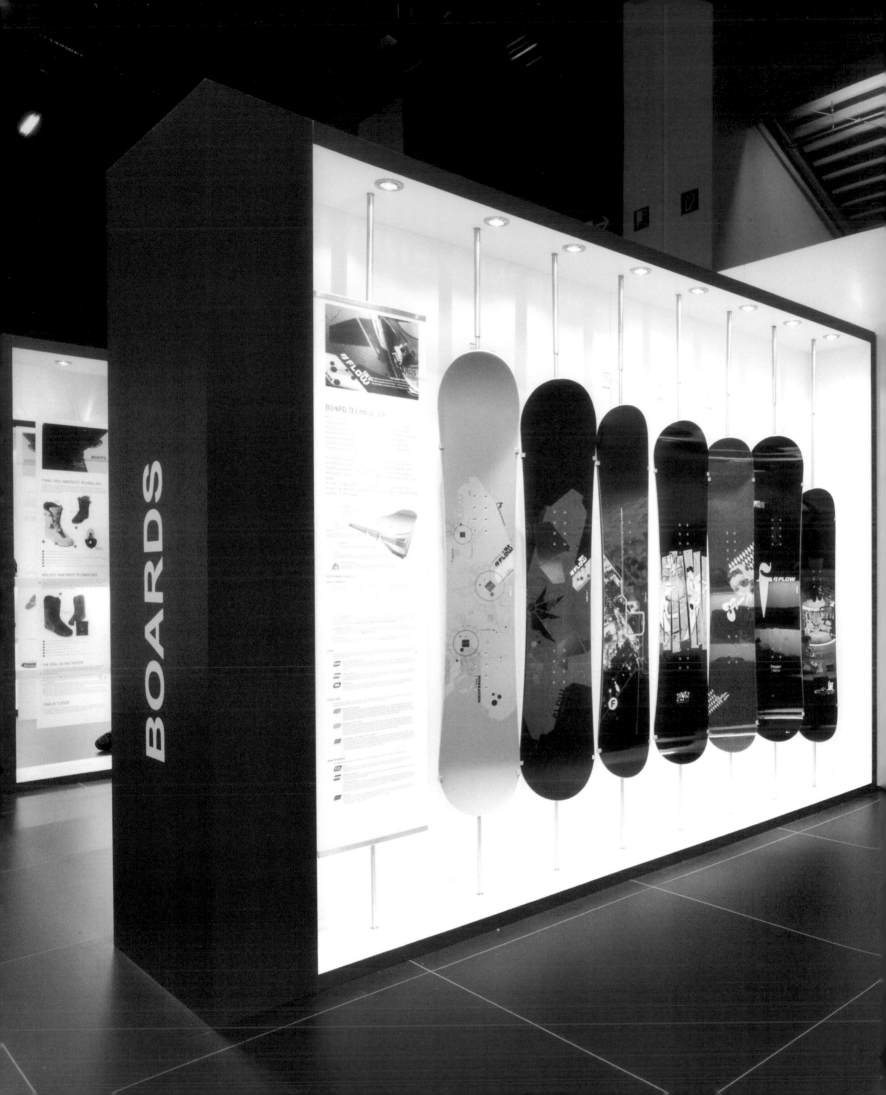

FLOW
Seasonal Apparel

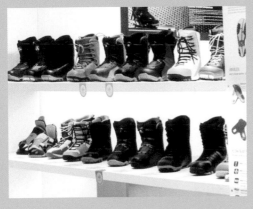

Arno Design

Address
 Arno Design GmbH
 Friedrichstr. 9
 80801 Munich
 Germany

Fair
 ISPO, Winter 2005, Munich
 February 6–9, 2005

Other cities
 None

Primary materials
 Wood, aluminum, Plexiglas

Photography
 © Arno Design GmbH, Frank Kotzerke

To display their snowboards and snowboarding accessories at the winter edition of Munich's International Trade Fair for Sports Equipment and Fashion, Flow commissioned Arno Desgin to design a stylish exhibit space.

The booth design deliberately separates the working area from the lounge area. Visitors to the Flow stand are received in the lounge area. The back room houses an exhibition area. Between the trio is a row of three cubicles where business meetings can take place. The stand's prominent feature is the curved shining white wall, reminiscent of a ski run, that has the Flow logo printed along the top. The lounge's upholstered red benches and round stools invite visitors to come in and relax before doing business. The entrance area also serves as a display area with highlights of the Flow product line. The products are exhibited in display cabinets made of stacked glass. The working area in the rear presents a selection of Flow's snowboards, boots, bags, bags, clothes and bindings. The products are exhibited in red display cases where placards of satin-frosted Plexiglas provide product information.

The biennial ISPO presents trends and innovations to the international sports community. With more than 1,600 exhibitors from 40-plus countries represented at ISPO, trade visitors can learn about new brands, while exhibitors shows off their work to a professional and international audience.

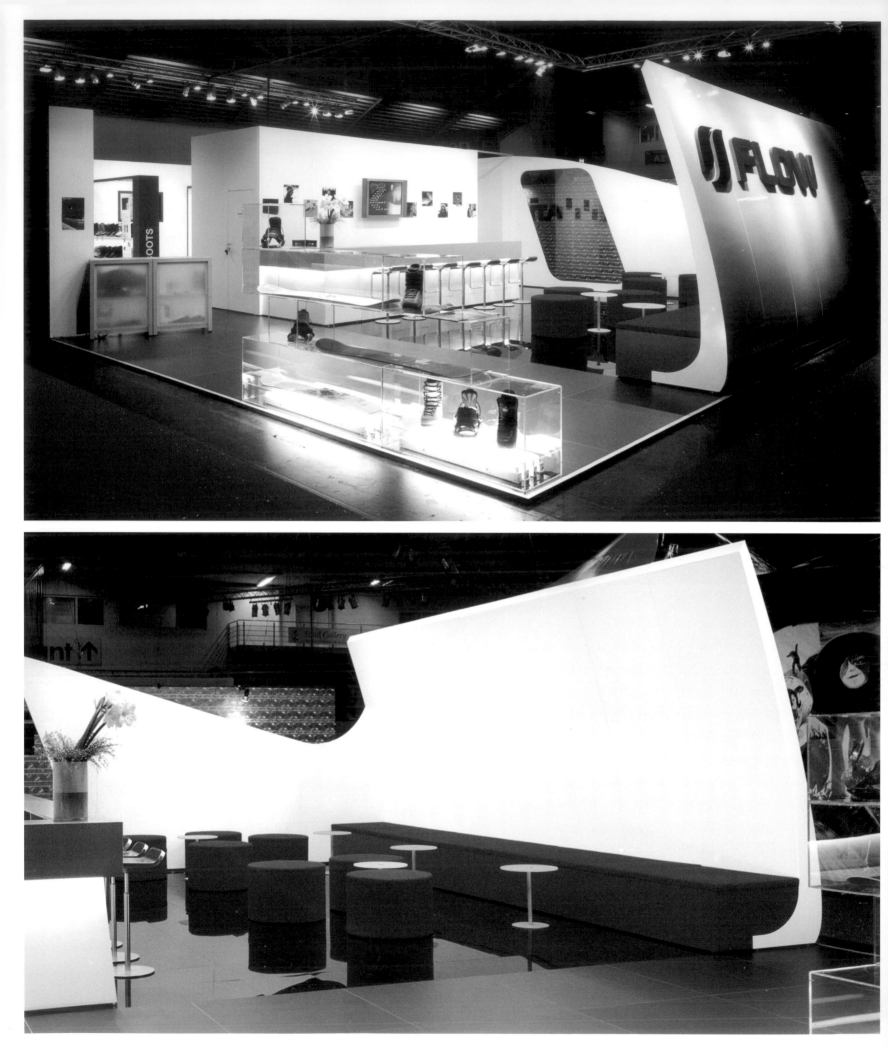

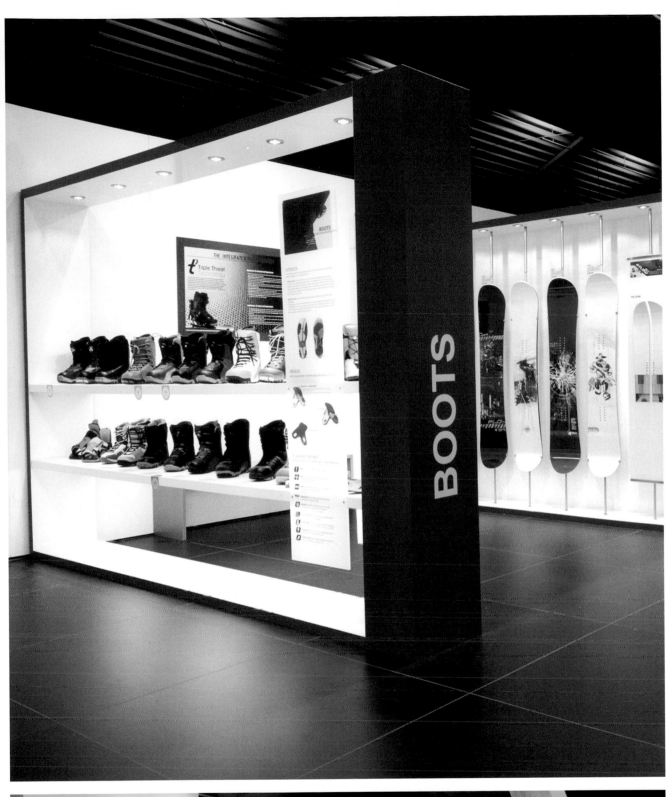

Visitors are received in the white-and-red lounge area. A red upholstered bench sits at the foot of of the curved wall. Red stools and white tables provide visitors with plenty of seating space and a place to relax before entering the cubicles for the a business meeting.

Glass display cabinets present some of the company's highlighted products, while the back room exhibits a wider range of Flow products, including snowboards, boots and clothing, on red and white display cases. Satin-frosted Plexiglas signs provide product information.

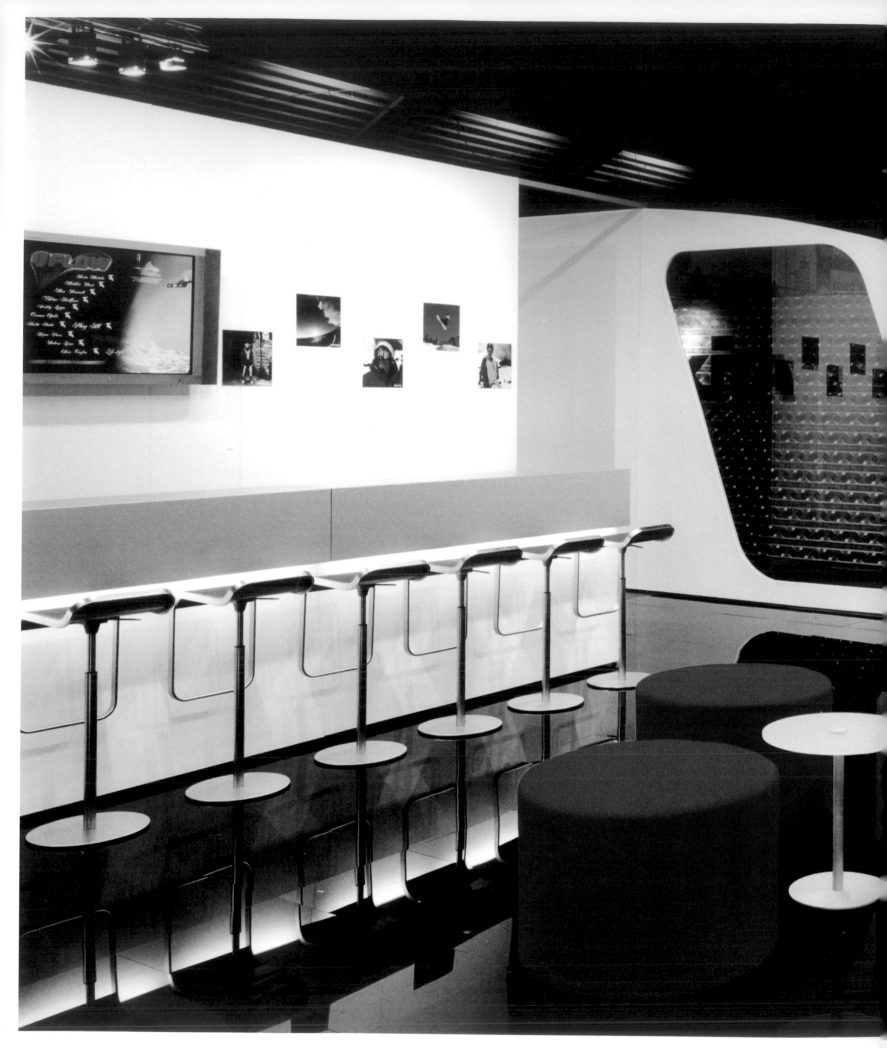

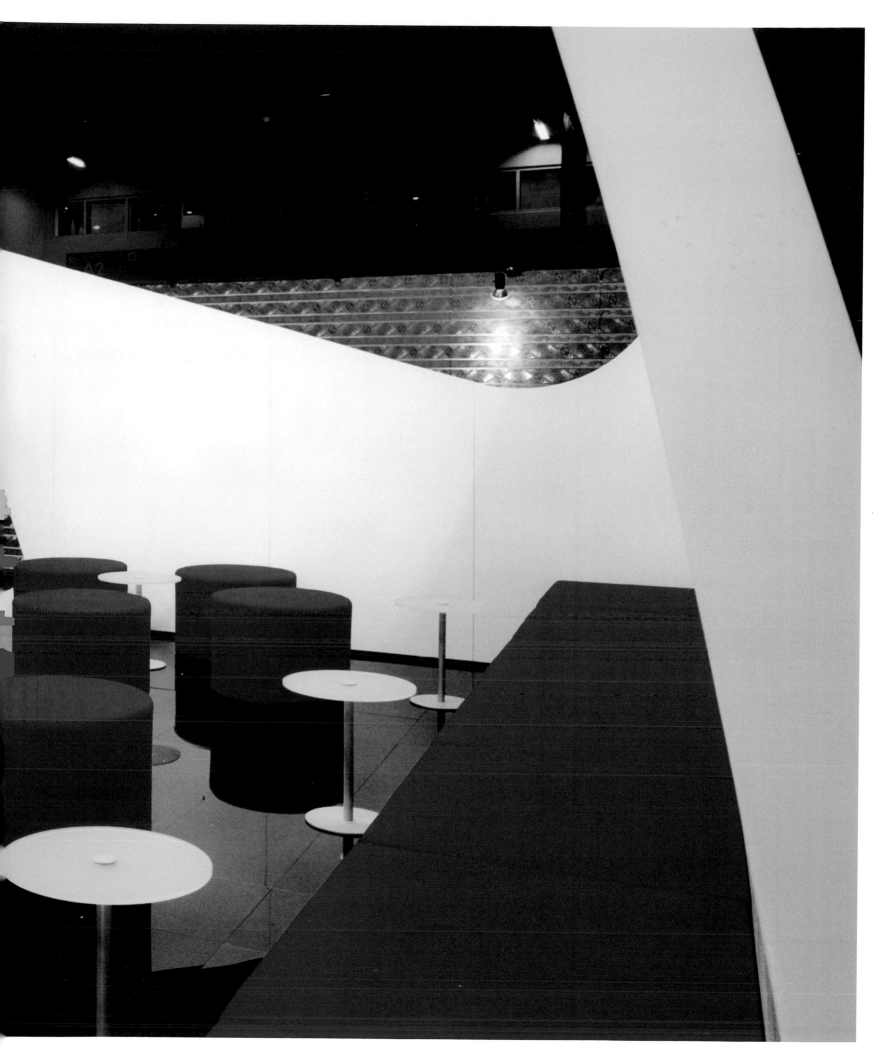

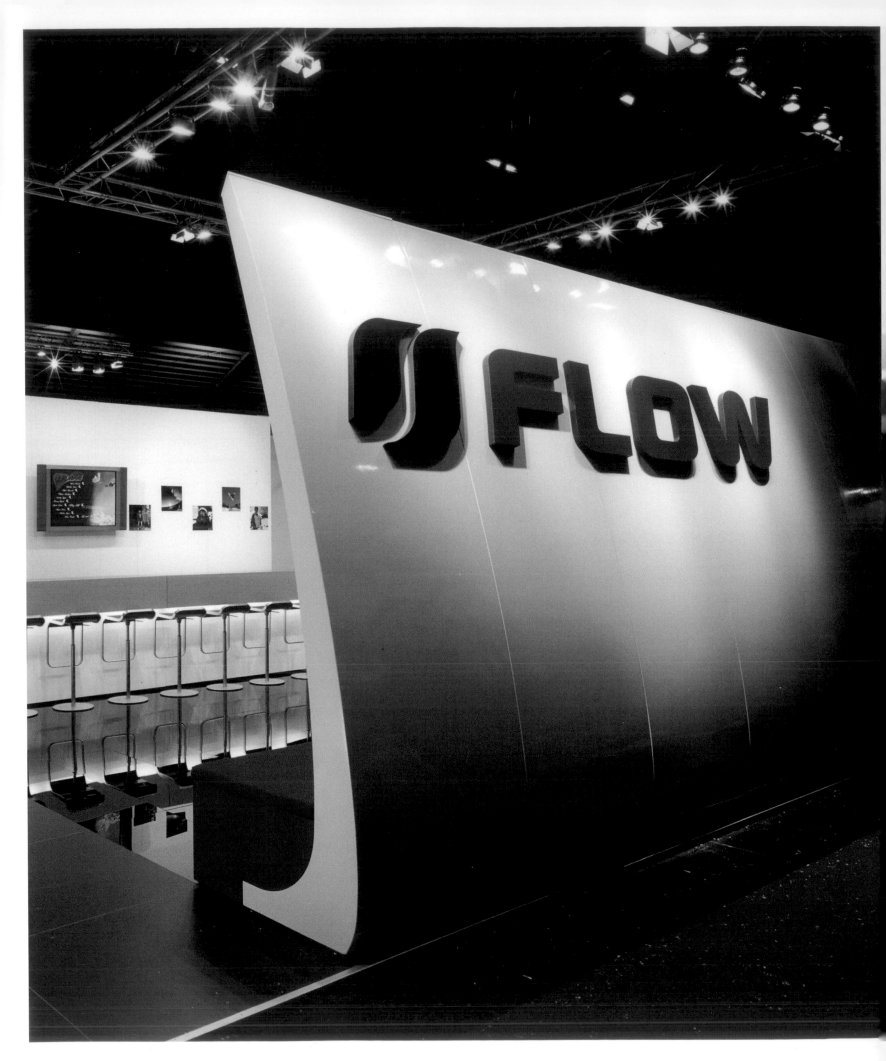

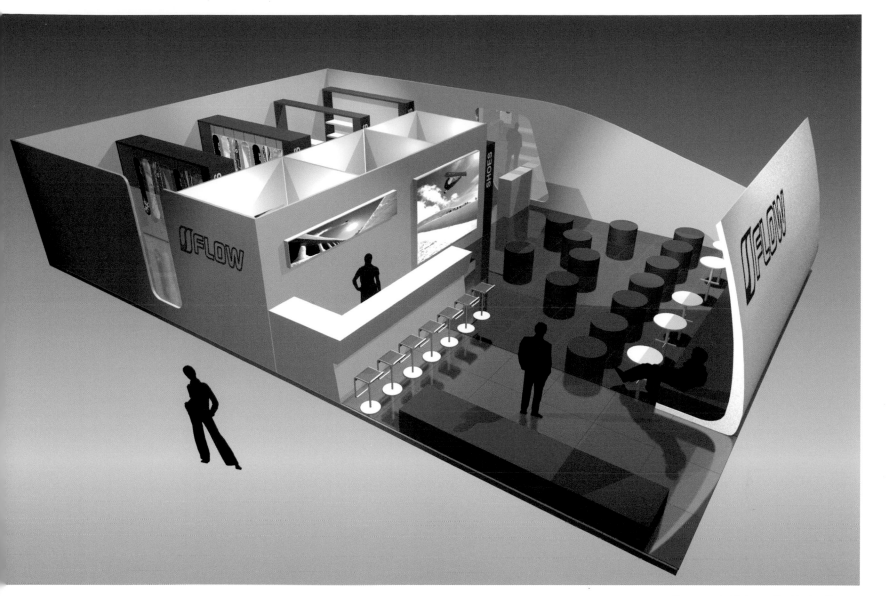

The curved shining wall with the Flow logo is the booth's signature feature. The shape recalls a ski run.

The working area is deliberately separated from the lounge area. In the middle of the stand are three cubicles, where business can be done with clients. The lounge and exhibition areas flank the trio of cubicles.

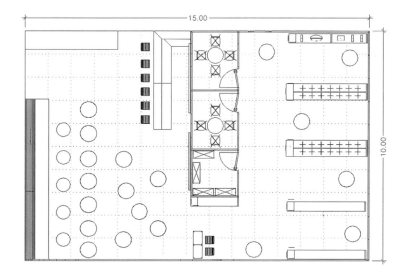

15.00

10.00

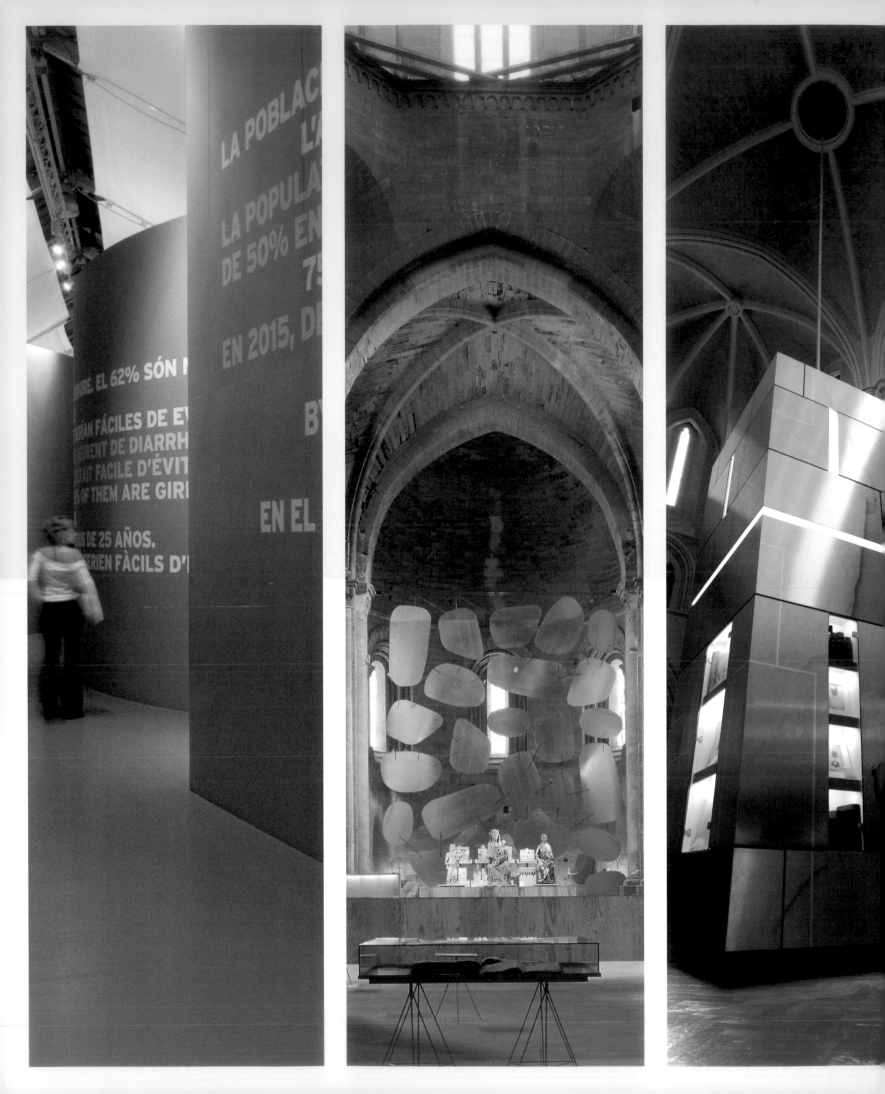

CULTURE
Museums and Galleries

Exhibits can be conceived to display any medium or combination of media, including the fine arts, architecture, graphic design, photography, interior design, industrial design many others. They can be located inside an existing museum or gallery or in a temporary or purpose-built space. Exhibits can be any size or shape, filling the entire exhibition space or occupying no more than a small part of it. Exhibits may take the form of single observation and contemplation stations or may be spread throughout a room or over a number of rooms.

Exhibitions are ephemeral yet complex installations intended to convey ideas, showcase objects and excite the senses of a large audience. Their efficcacy at doing so can be the key to an exhibition's success. The pressure is on, and design trends in contemporary exhibitions are changing fast.

SWISS PAVILION
Swiss Box

 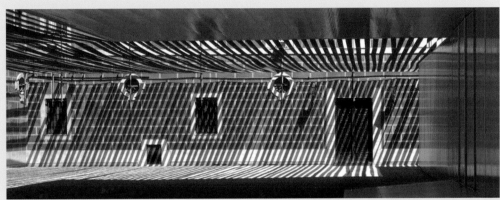

2b Architectes

Address
 2b Architectes
 20 Av. De Jurigoz
 1006 Lausanne
 Switzerland

Location
 Centro Cultural Conde Duque, Madrid
 2002-2003

Other cities
 None

Primary materials
 Canvas and acrylic glass

Photography
 © Luis Asin Lapique, 2b Architectes, DRACE

The Conde de Duque in Madrid was designed by Pedro de Ribera during the reign of Felipe V in the 18th century to house the King's Royal Guard. Today, the baroque barracks houses a cultural center. In 2002, two Swiss designers with only a handful of realized projects to their name, Stéphanie Bender and Philippe Béboux of 2b Architects in Lausanne, Switzerland, won a design competition for ARCO, Madrid's international art fair. Using the two national colors of Switzerland, the courtyard was transformed into a temporary Swiss pavilion.

A criss cross of red bands covered the northern courtyard of the Conde de Duque, while two superimposed white boxes, made of acrylic glass, were placed in the middle of the court, thus resembling the Swiss flag. The white boxes represented the Swiss cross while the red bands made up the rest of the flag. The canvas covering the courtyard is reminiscent of the awnings, known as *toldos*, which shade the streets of southern Spain from the summer heat. Once inside the pavilion, the non-color of white is everywhere. The top box contains the exhibition area, providing a calm space, far from the hubbub of the colorful courtyard. Moveable partitions inside the exhibition space supply the required light for each installation. At night, the box lights up and becomes a huge lantern, illuminating the animated courtyard of the Conde Duque through its canvas sides.

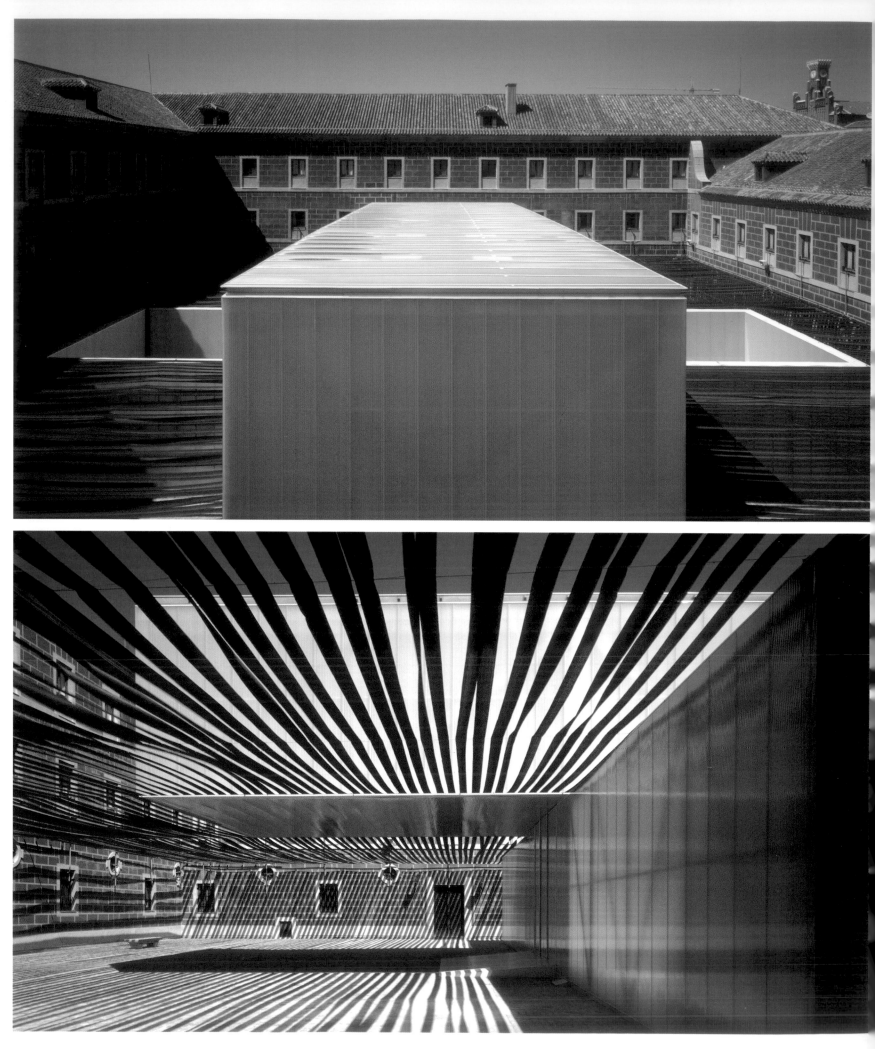

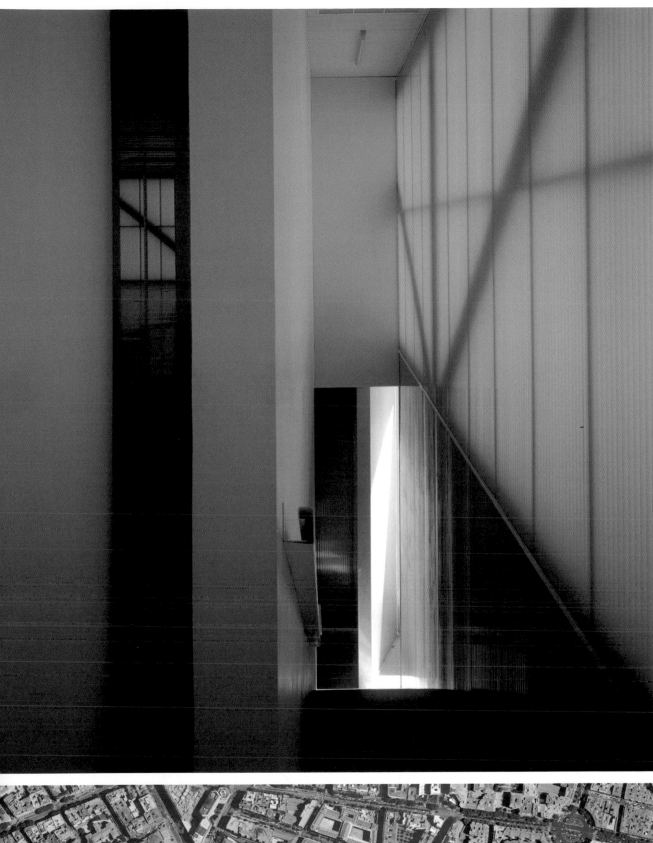

Using the two national colors of Switzerland, the acrylic glass boxes and red canvas create a spatial contrast inside Madrid's Conde de Duque courtyard creates

A Swiss cross is made with two superimposed translucent white boxes and strips of red canvas resembling the *toldos* used to provide shade in the streets of southern Spain.

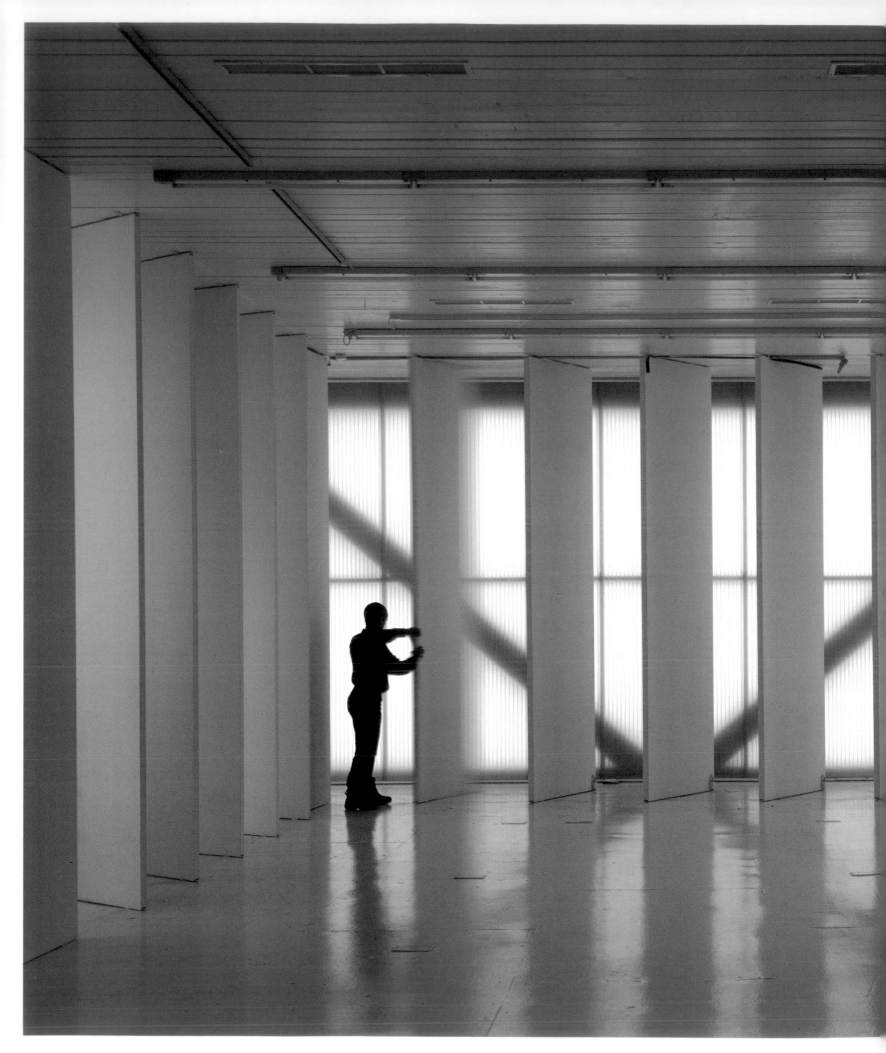

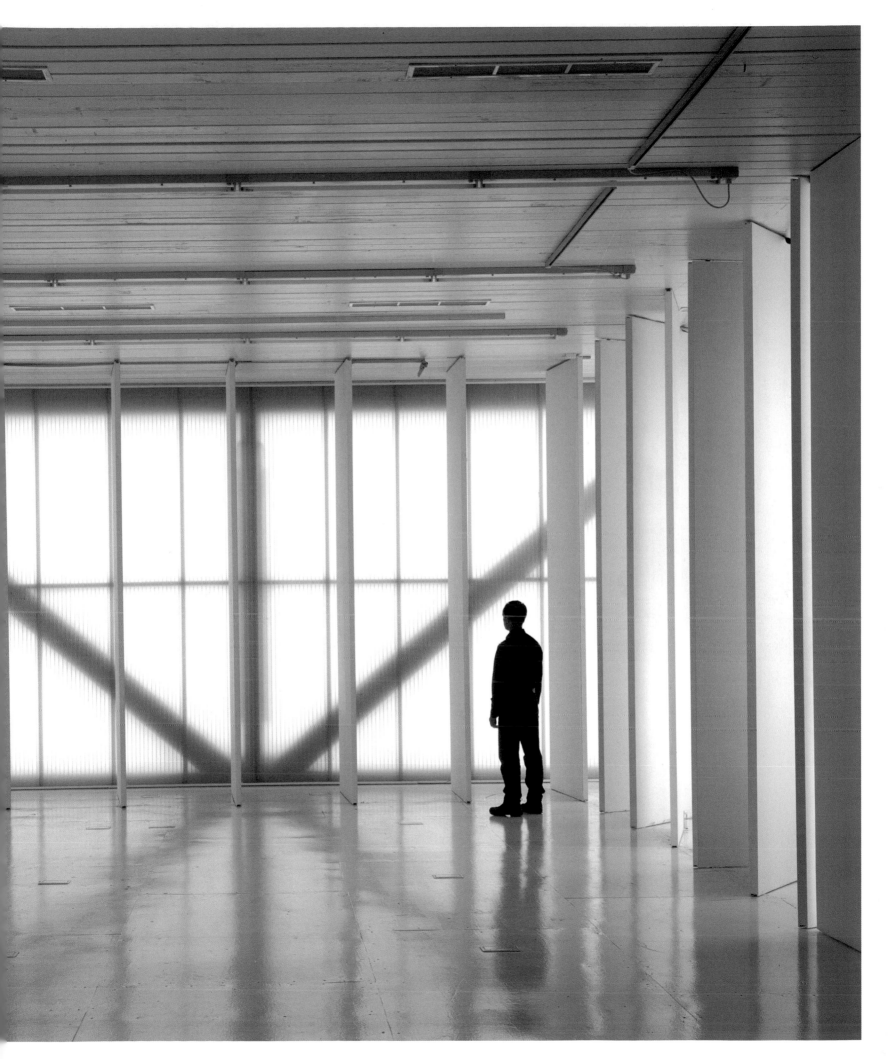

During the day, the canvas shade plunges the visitor into a festive ambience while at night, the box lights up and turns into a huge lantern, illuminating the baroque courtyard of the Conde Duque.

The upper box houses the white exhibition space. The neutrality of this color provides the mainstay for the work as a whole.

HABITATS, TECTONICS, LANDSCAPES
Spanish Architecture

Asymptote: Hani Rashid & Lise Anne Couture

Address
Asymptote Architecture
160 Varick Street, Floor 10
New York, New York 10013
USA

Location
Ministerio de Fomento, Madrid, Spain

Other cities
None

Primary material
Large transparent modules

Photography
© Jordi Bernadó

Since 1998, Asymptote Architecture, founded by Lise Anne Couture and Hani Rashid, has been turning out sleek and provocative art installations. Their designs include a virtual trading floor for the New York Stock Exchange, a virtual version of the Guggenheim Museum and a workplace system for Knoll.

In 2002, Asymptote was commissioned to design display space for architectural images as part of the exhibition "Habitats, Tectonics, Landscapes: Contemporary Spanish Architecture." Asymptote tried to increase the gallery's minimal space by adding three-dimensional volumes enhanced by light and sound. The images are exhibited on the surface of large translucent modules, protruding from a backlit panel into the viewer's space. The result is an illusion of floating images. Each exhibited piece is accompanied by abstract sensor-triggered sounds, which adds to the unique atmosphere of each piece of work. The same projecting modules are affixed along a black wall on the lower level of the gallery; to accord with the smaller space downstairs, those modules display residential-scale buildings. On the upper level's two sets of full-size modules, units project on either side of a central spine, creating the effect of two large translucent floating objects.

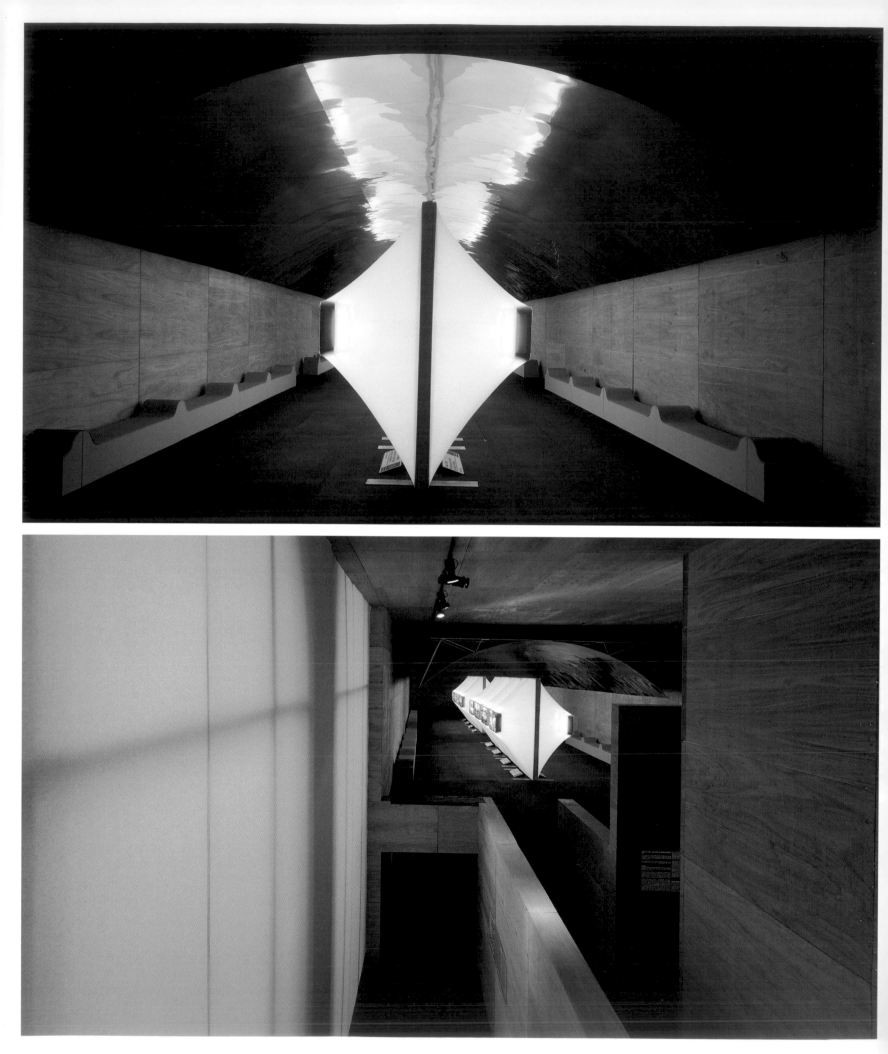

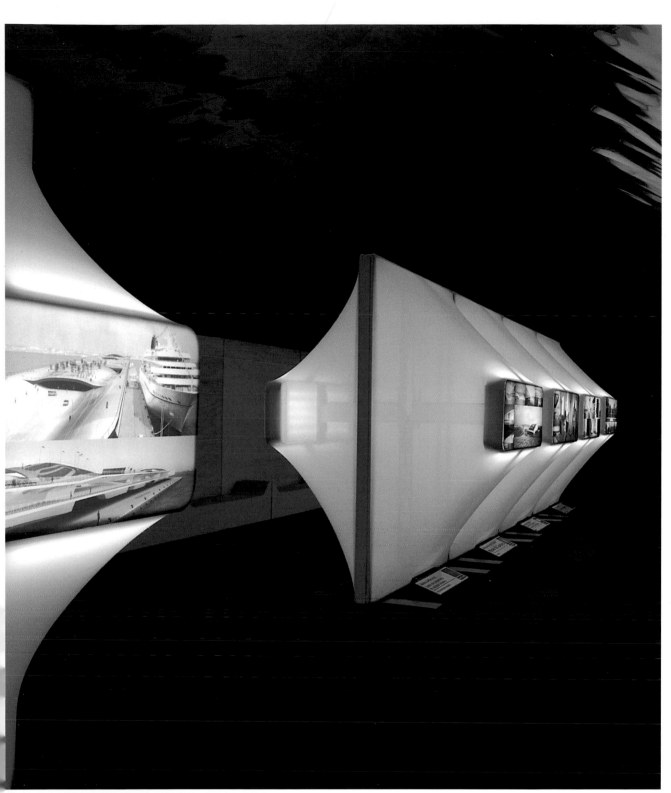

The upper level of this minimal exhibition space contains two sets of large translucent modules. The units project on either side of a central spine thereby creating the effect of two large, illuminated floating objects. The exhibited images, in turn, seem to float on the surface of these modules.

Sculpted seating elements on both sides of the display complement the arrangement of the modules. The modules are also aligned with the building's windows, thus enabling passersby to view the exhibition from the outside.

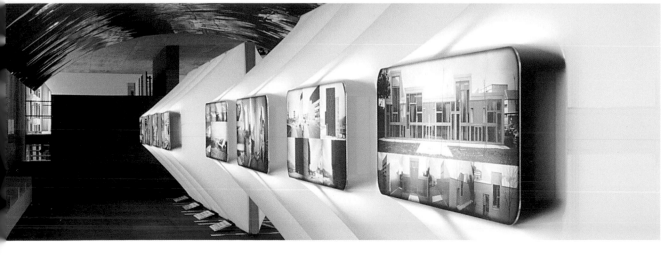

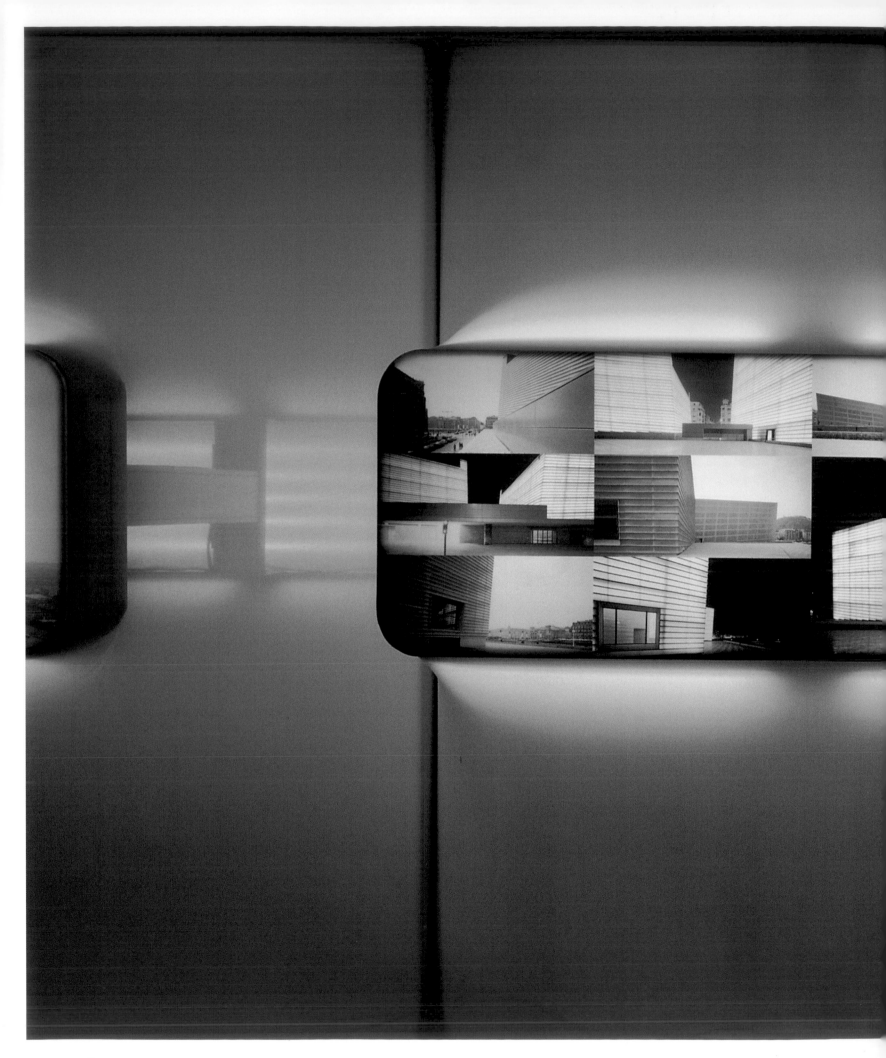

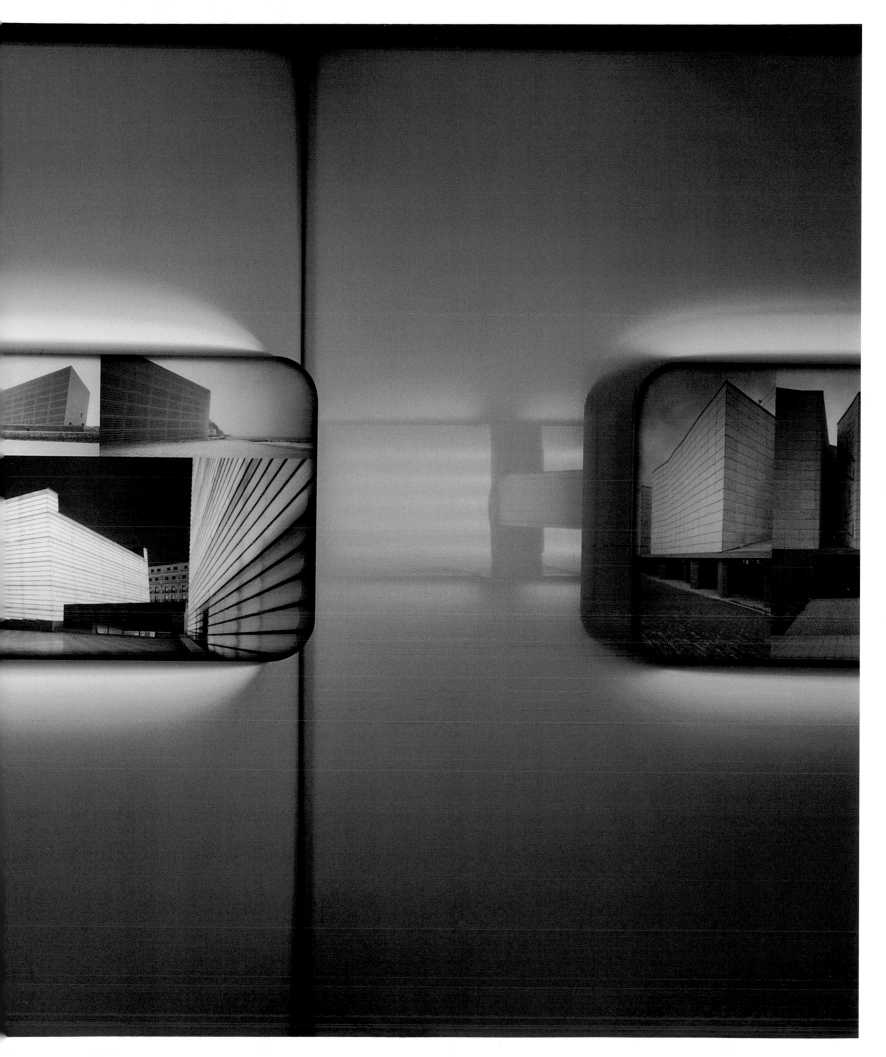

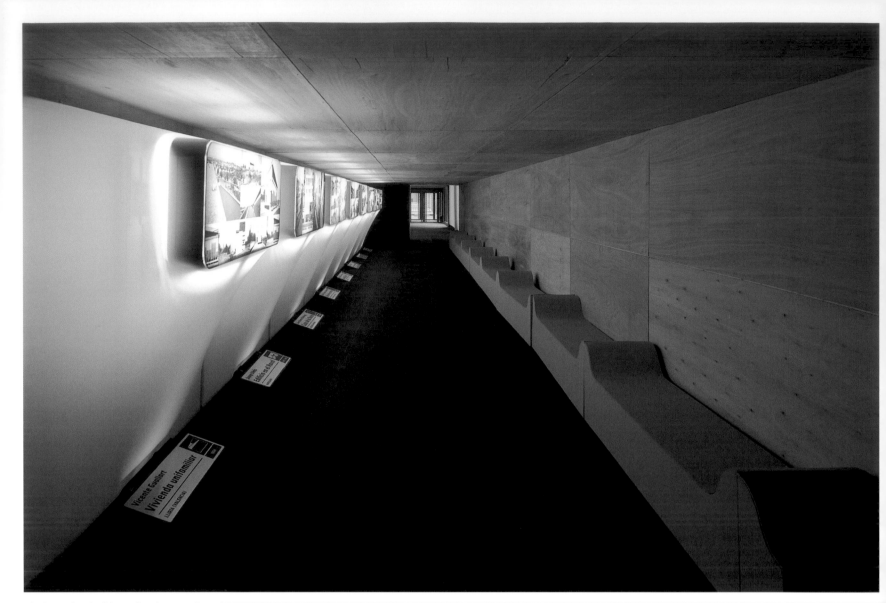

The lower level of the gallery houses the same translucent projecting modules affixed along a black wall.

The intimacy of the lower level lends itself to the display of residential-scaled projects. The modules are downsized accordingly, with less depth. The result is a vertical "landscape."

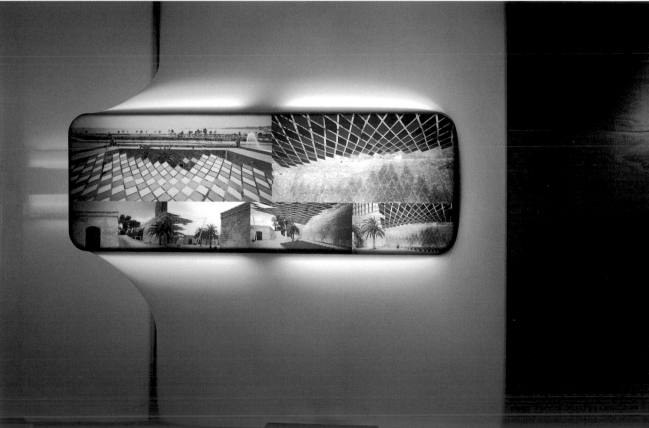

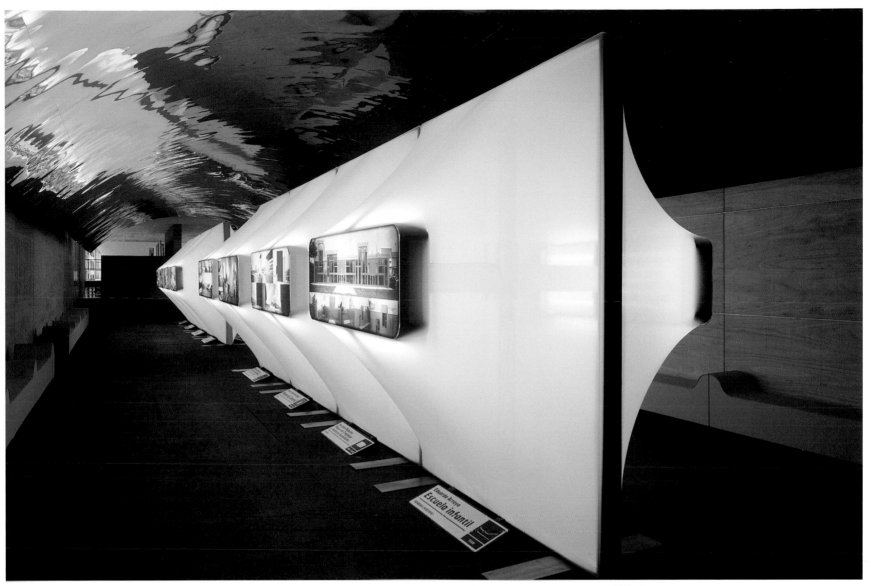

Projecting modules jut out into the viewer's space. The floating and autonomous quality of the installation pieces, which display large landscapes a curved, mirrored surface above.

The exhibited images that seem to float on the large translucent modules are accompanied by sensor-triggered abstract sounds.

PRACTOPIA

Capsules of Knowledge

Bonjoch Associats

Address
 Bonjoch Associats
 Bonavista 5, pral. 1°
 08012 Barcelona
 Spain

Fair
 Universal Forum of Cultures,
 Barcelona, Spain
 May 9–September 26, 2004

Other cities
 None

Primary materials
 Plywood, marine wood panels, fireproof
 canvas, glass fiber, glass

Photography
 © Eloi Bonjoch

Practopia contains two exhibitions in one space inside the Haima at Barcelona's 2004 Universal Forum of Cultures. These two components are "Practopia: The City of Solutions" and "Water Talks." When designing this exhibition, Ignasi Bonjoch had to take into account not only the materials used, the duration of the exhibition, the prefabricated tents making up the Haima, and the proximity of the sea, but also the large number of people who would be passing through and the estimated time spent at each exhibition (twelve to twenty minutes). To accomodate these factors, Ignasi Bonjoch presented information in flashes, capsules of knowledge to be consumed quickly.

The exhibition space is dominated by a long winding central passageway (30 meters long and 6 meters high at the highest point) with three circular spaces, called clusters, accessed from the passage. The dark gray shades of the central corridor create a gloomy atmosphere, befitting the challenges the world faces today, such as the lack of water, inequality and illiteracy. Messages about these topics in large letters are written in four languages. The bright orange of the clusters evokes a brighter more positive atmosphere. Each cluster contains showcases and posters depicting 45 real projects from communities and organizations around the world.

A large bell-like structure at the end of the passageway presents an audiovisual overview of the main ideas behind the exhibition. It also serves as a sort of hinge between the two coexisting exhibitions.

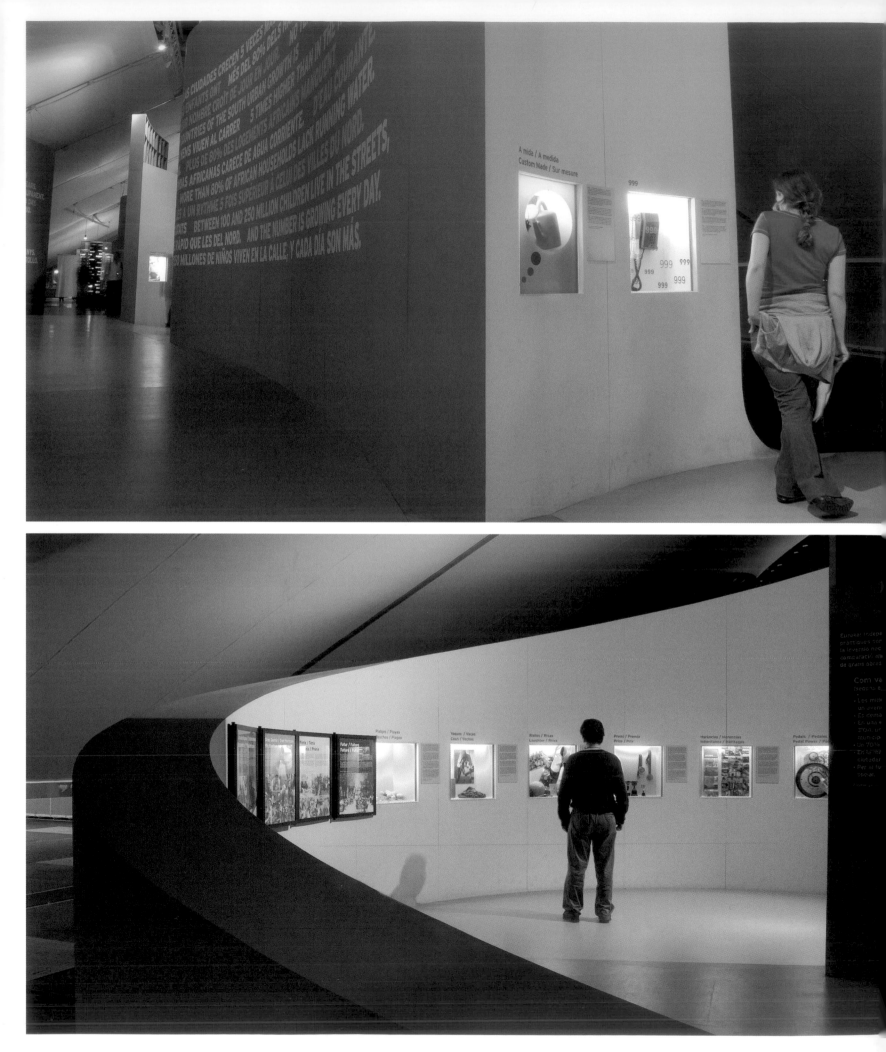

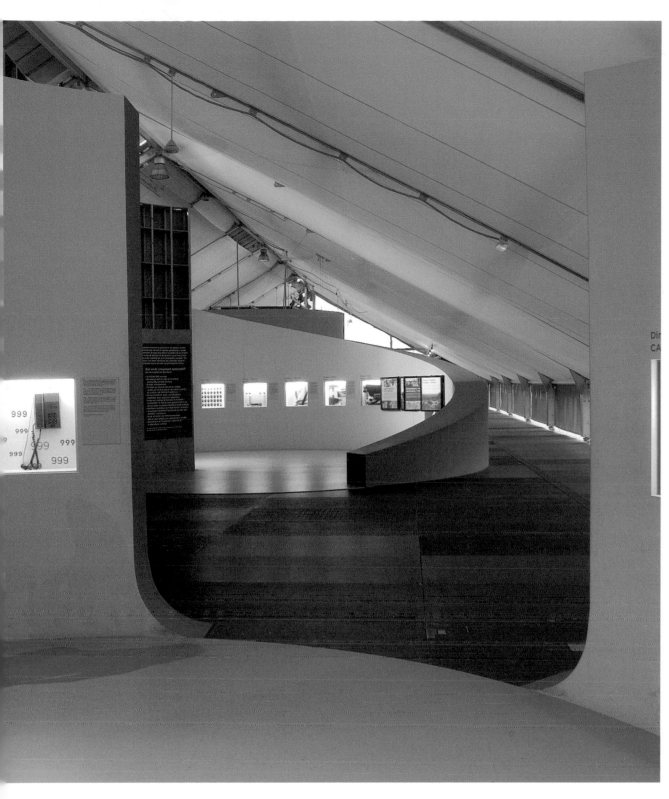

The so-called clusters, (the circular spaces that flank the winding corridor) contain examples, provided by the United Nations, of positive changes at a global level. The walls contain bold messages written in four languages. Each wall contains seven windows, each of which has a title, an object-metaphor and a brief description of the habit.

The display stand is built within the Haima, a tent-like structure made of translucent material. A winding corridor leads to a large suspended bell which houses an audiovisual presentation. At the same time, this landmark at the end of the corridor acts as a sort of hinge between the two exhibitions.

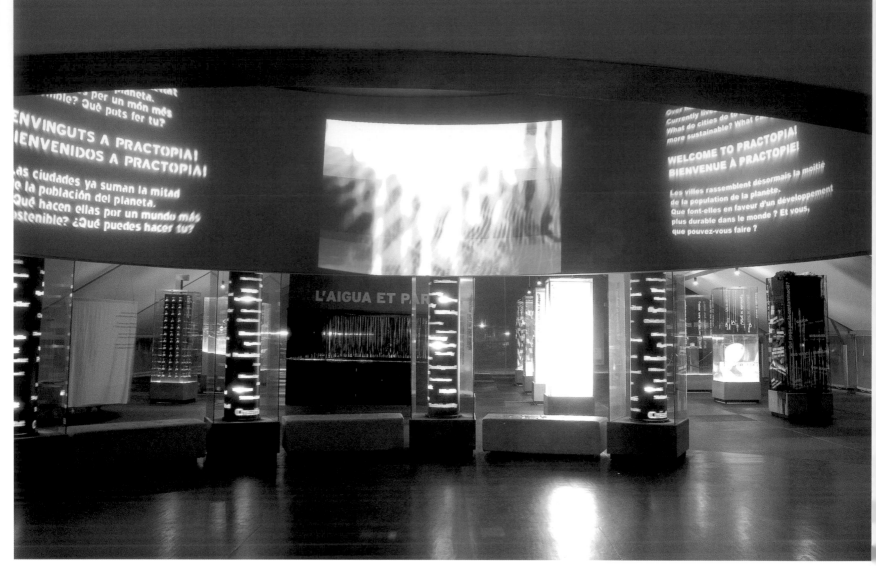

A bell-shaped structure solves the problem of projecting audiovisuals in an open room made of translucent materials. This structure (6 meters in diameter, 2 meters tall and suspended 1,90 meters from the ground) not only allows the area to be completely shrouded in darkness during the day, also enables people to move around freely below the structure as the visuals are projected in four languages inside it.

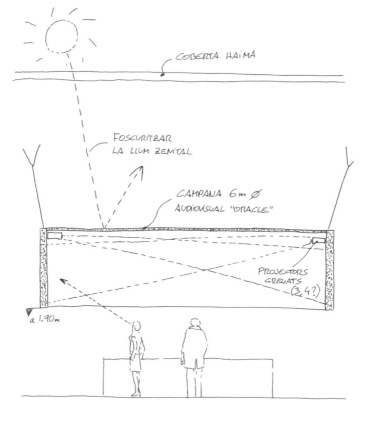

COBERTA HAIMA

FOSCURITZAR
LA LLUM ZENITAL

CAMPANA 6m Ø
AUDIOVISUAL "ORACLE"

PROJECTORS
GREUATS
(3, 4?)

a 1.90m

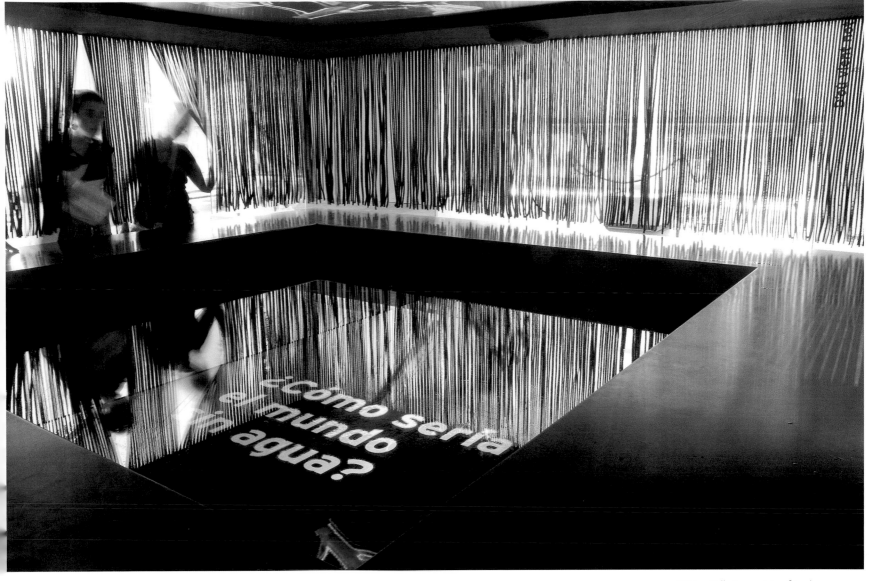

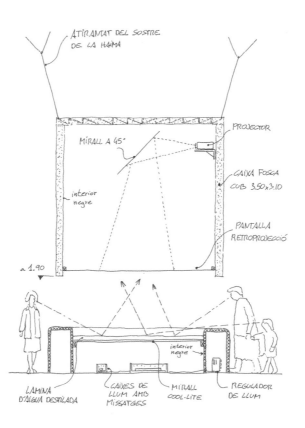

"Water Talks" consists of twelve glass prisms, each surrounding an audiovisual display about the theme. Each prism measures 80cm by 80 cm and 2.4 cm in height. Each one contains a message, in four languages, represented by an allegorical object. A small pond with a mirrored bottom reflects these messages, which appear and disappear, interacting with the visitors' faces.

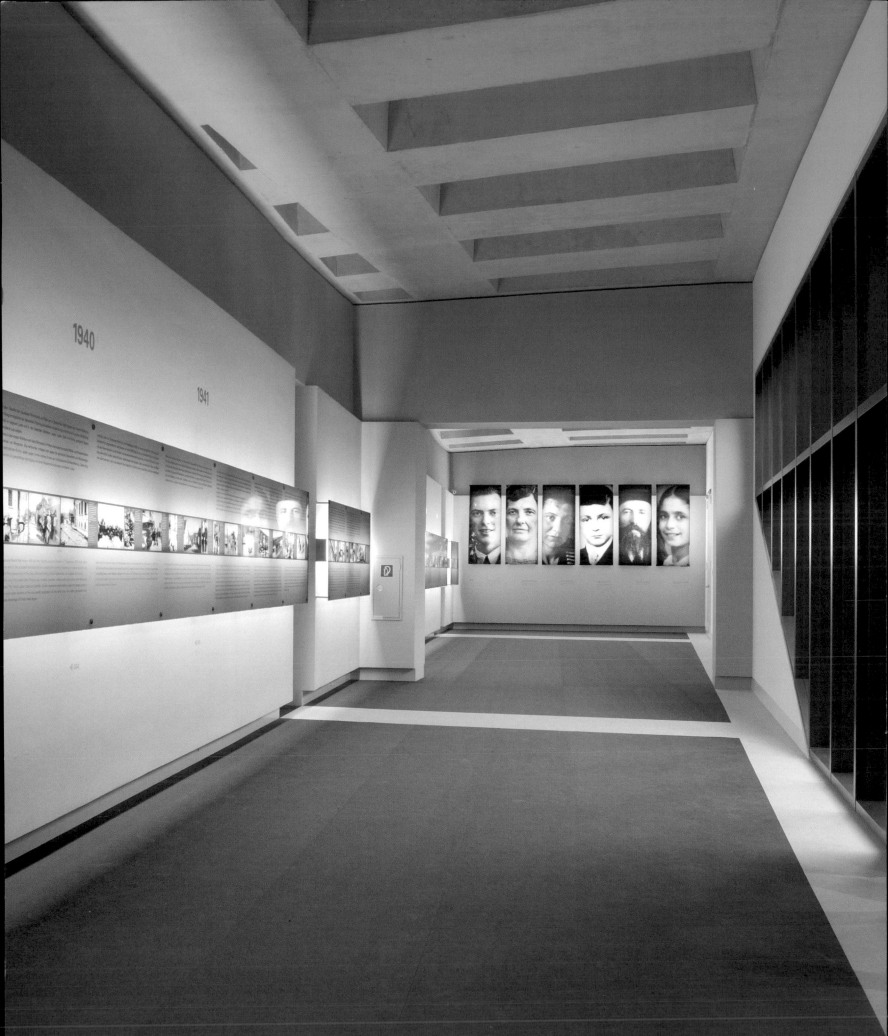

INFORMATION CENTER
Historic Legacy

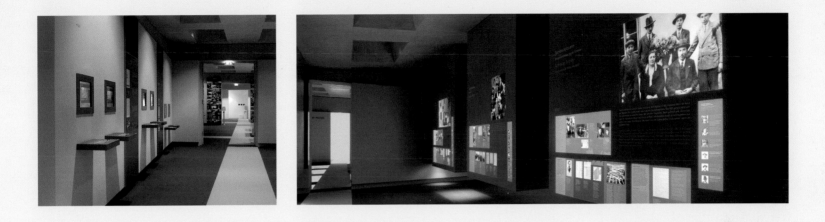

Dagmar von Wilcken

Address
Dagmar von Wilcken
Friedrichstrasse 217
10969 Berlin
Germany

Location
The Memorial to the Murdered Jews of
Europe, Berlin, Germany
Permanent exhibition. Opened May 10, 2005

Other cities
None

Primary material
Glass, light, MDF covered with Armourcoat

Photography
© Gunter Lepkowski

Central Berlin's Memorial to the Murdered Jews of Europe was designed by the architect Peter Eisenman. The Bundestag resolution of June 25, 1999, demanded the architect to create a space for an exhibition explaining the museum's dedication. A Board of Trustees agreed on four main themes for the exhibition, all to be presented in rooms of approximately equal size.

Consequently the architect designed the four rooms of the subterranean Information Center in such a way that the two levels, above and below, overlapped. The walls of the exhibition rooms were turned five degrees off the axis of the grid of the above-ground field of stelae. The grid is reproduced in the ceiling of the rooms as well. With all these factors in play, the Information Center's exhibition design proved a challenge for Dagmar von Wilcken; she had to take into consideration the content requirements and the structurally set framework to create a unified whole. The extension of the stelae underground is a pivotal element in the exhibition design. Each stela is a source of information while also representing destruction of a human life.

As well as successfully linking the "above" with the "below," von Wilcken creates a rhythmical exchange among the four rooms. The first and third rooms hace a contemplative atmosphere, while the second and fourth rooms are more informative, requiring a denser exhibition structure. Light plays an important role throughout the exhibition: Texts and photos are lit from behind or projected on the walls.

1933–1937

1938

1939

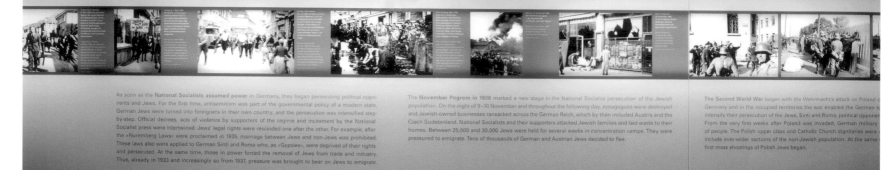

Mit der Machtübernahme der Nationalsozialisten begann die staatliche Verfolgung politischer Gegner und der Juden in Deutschland. Antisemitismus war erstmals Bestandteil der Regierungspolitik eines modernen Staates. Juden wurden zu Fremden gemacht, die Verfolgung schrittweise verschärft. Dabei griffen staatliche Verordnungen, Gewalttaten von Anhängern des Regimes und die Hetze der national-sozialistischen Presse ineinander. Die rechtliche Gleichstellung der Juden wurde schrittweise aufgehoben. Nach dem Erlass der »Nürnberger Gesetze« im Jahr 1935 waren unter anderem Eheschließungen zwischen Juden und Nichtjuden verboten. Auch die deutschen Sinti und Roma wurden als Zigeuner durch diese Gesetze entrechtet und diskriminiert. Zugleich erzwangen die Machthaber das Ausscheiden von Juden aus der gewerblichen Wirtschaft. Auf diese Weise sollte schon ab 1933, verstärkt aber seit 1937 ein Druck zur Auswanderung erzeugt werden.

Die Novemberpogrome 1938 markierten eine neue Stufe der nationalsozialistischen Verfolgungspolitik gegen die jüdische Bevölkerung. Im gesamten Deutschen Reich, zu dem mittlerweile auch Österreich und das tschechische Sudetenland gehörten, wurden in der Nacht vom 9. auf den 10. November und im Laufe des folgenden Tages Synagogen zerstört und Geschäfte jüdischer Kaufleute geplündert. Nationalsozialisten und ihre Sympathisanten überfielen jüdische Familien und verwüsteten ihre Wohnungen. 25.000 bis 30.000 Juden hielt man über mehrere Wochen in Konzentrationslagern fest. Ihre Auswanderung sollte erzwungen werden. Zehntausende deutscher und österreichischer Juden entschlossen sich zur Flucht.

Mit dem Überfall der deutschen Wehrmacht auf Polen am 1. September 1939. Der Krieg ermöglichte der deutschen Führung die radikale Ausdehnung ihrer politik im eigenen Land und in den besetzten Gebieten: gegen Juden, Si Behinderte und andere.
Bereits in den ersten Wochen nach dem Einmarsch in Polen erschossen deu Tausende von Menschen. Die Verbrechen richteten sich gegen die polnisch der katholischen Kirche, später gegen immer breitere Kreise der nichtjüdis begannen die gewalttätige Verfolgung und erste Massenerschießungen po

As soon as the National Socialists assumed power in Germany, they began persecuting political oppo-nents and Jews. For the first time, antisemitism was part of the governmental policy of a modern state. German Jews were turned into foreigners in their own country, and the persecution was intensified step-by-step. Official decrees, acts of violence by supporters of the regime and incitement by the National Socialist press were intertwined. Jews' legal rights were rescinded one after the other. For example, after the »Nuremberg Laws« were proclaimed in 1935, marriage between Jews and non-Jews was prohibited. These laws also were applied to German Sinti and Roma who, as »Gypsies«, were deprived of their rights and persecuted. At the same time, those in power forced the removal of Jews from trade and industry. Thus, already in 1933 and increasingly so from 1937, pressure was brought to bear on Jews to emigrate.

The November Pogrom in 1938 marked a new stage in the National Socialist persecution of the Jewish population. On the night of 9–10 November and throughout the following day, synagogues were destroyed and Jewish-owned businesses ransacked across the German Reich, which by then included Austria and the Czech Sudetenland. National Socialists and their supporters attacked Jewish families and laid waste to their homes. Between 25,000 and 30,000 Jews were held for several weeks in concentration camps. They were pressured to emigrate. Tens of thousands of German and Austrian Jews decided to flee.

The Second World War began with the Wehrmacht's attack on Poland o Germany and in the occupied territories the war enabled the German l intensify their persecution of the Jews, Sinti and Roma, political opponen From the very first weeks after Poland was invaded, German military of people. The Polish upper class and Catholic Church dignitaries were include ever-wider sections of the non-Jewish population. At the same first mass shootings of Polish Jews began.

•)) 001 •)) 002 •)) 003

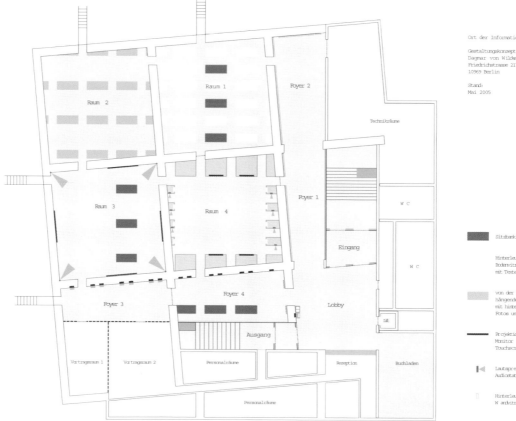

Ort der Information

Gestaltungskonzept
Dagmar von Wilcken
Friedrichstraße 217
10969 Berlin

Stand:
Mai 2005

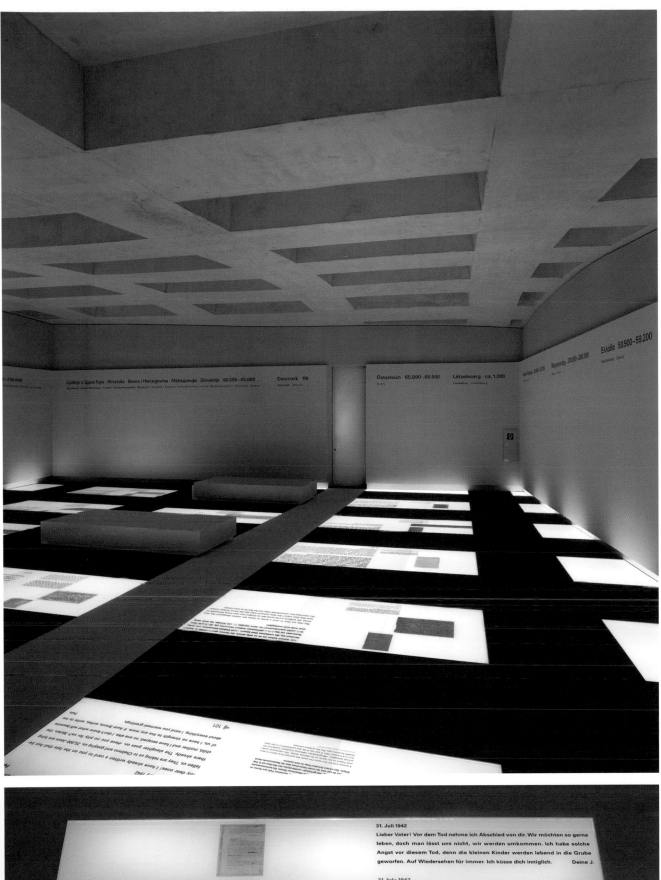

The entrance foyer presents the historical and political context from 1933 to 1945. A 24-meter-long backlit panel gives a condensed historical overview. As seen on the previous page, the corridor leads to six large portraits of men, women and children, that represent the six million victims and the start of the exhibition route.

In the Room of Dimensions the number of murdered Jews from each European country is displayed in a continuous frieze on the walls, while illuminated glass plates present quotations from victims. The plates are arranged on the floor in a grid corresponding to the field of stelae above ground.

A Board of Trustees agreed on four main themes for the exhibition, all presented in rooms of approximately equal size. Between the entrance foyer and exit foyer are the Room of Dimensions; a room dedicated to the destroyed families; the Room of Names; and a room explaining the organized murder.

31. Juli 1942
Lieber Vater! Vor dem Tod nehme ich Abschied von dir. Wir möchten so gerne leben, doch man lässt uns nicht, wir werden umkommen. Ich habe solche Angst vor diesem Tod, denn die kleinen Kinder werden lebend in die Grube geworfen. Auf Wiedersehen für immer. Ich küsse dich inniglich. Deine J.

31 July 1942
Dear father! I am saying goodbye to you before I die. We would so love to live, but they won't let us and we will die. I am so scared of this death, because the small children are thrown alive into the pit. Goodbye forever. I kiss you tenderly. Your J.

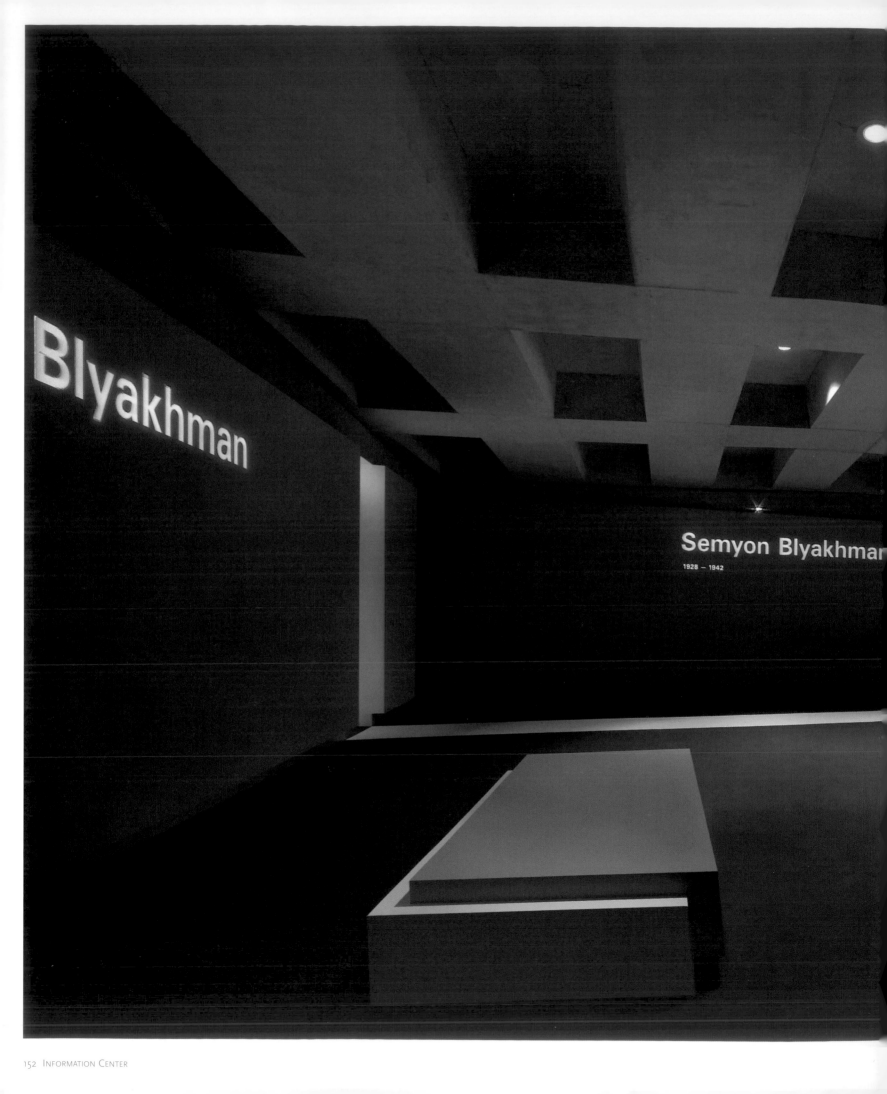

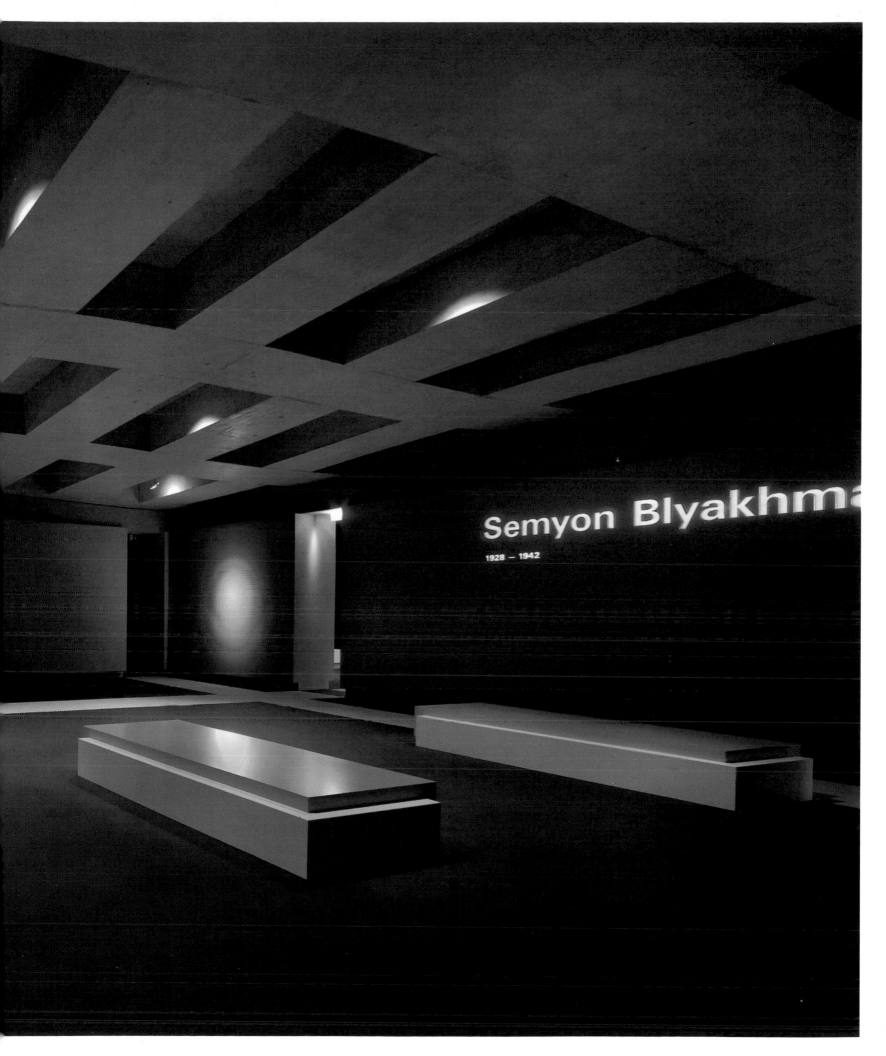

Semyon Blyakhma

1928 — 1942

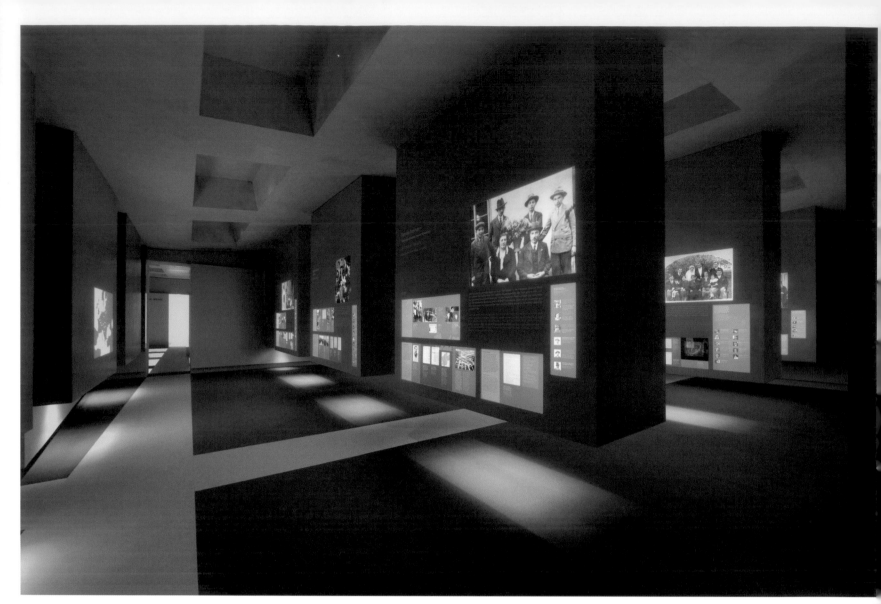

The third room is Room of Names (pages 152-153), which lifts individual victims out of anonymity by reading out their names and imparting short biographies. Each victim's name is projected simultaneously onto all four walls.

The Information Center's second room is dedicated to the destroyed families. The concrete stelae from above seem to extend downwards into the room, providing space to explain individual families' fates before, during and after the Holocaust.

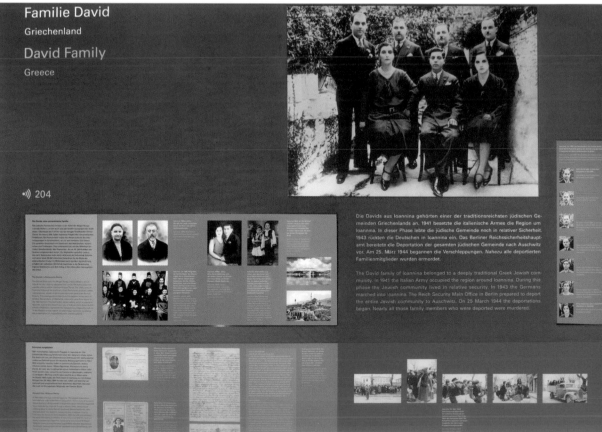

Familie David

Griechenland

David Family

Greece

)) 204

Die Davids aus Ioannina gehörten einer der traditionsreichsten jüdischen Gemeinden Griechenlands an. 1941 besetzte die italienische Armee die Region um Ioannina. In dieser Phase lebte die jüdische Gemeinde noch in relativer Sicherheit. 1943 rückten die Deutschen in Ioannina ein. Das Berliner Reichssicherheitshauptamt bereitete die Deportation der gesamten jüdischen Gemeinde nach Auschwitz vor. Am 25. März 1944 begannen die Verschleppungen. Nahezu alle deportierten Familienmitglieder wurden ermordet.

The David family of Ioannina belonged to a deeply traditional Greek Jewish community. In 1941 the Italian Army occupied the region around Ioannina. During this phase the Jewish community lived in relative security. In 1943 the Germans marched into Ioannina. The Reich Security Main Office in Berlin prepared to deport the entire Jewish community to Auschwitz. On 25 March 1944 the deportations began. Nearly all those family members who were deported were murdered.

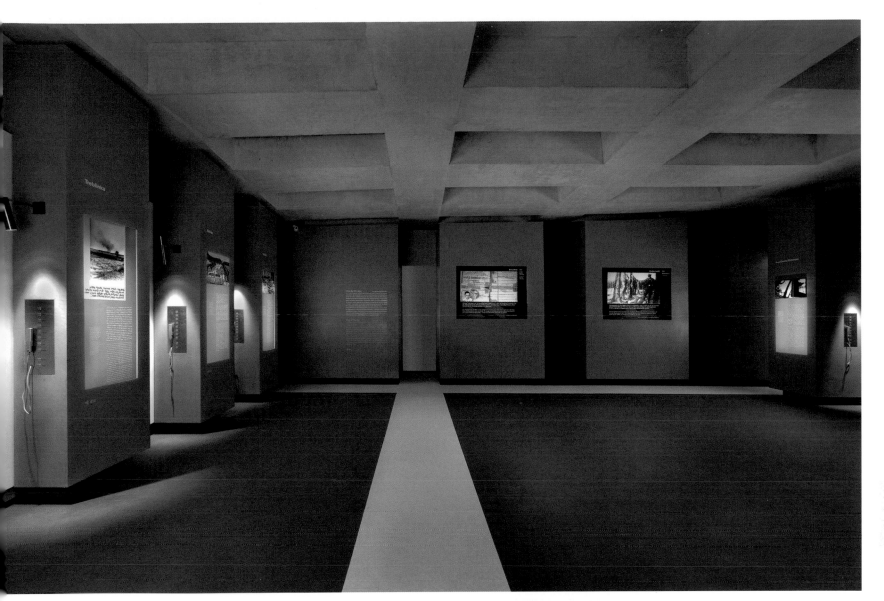

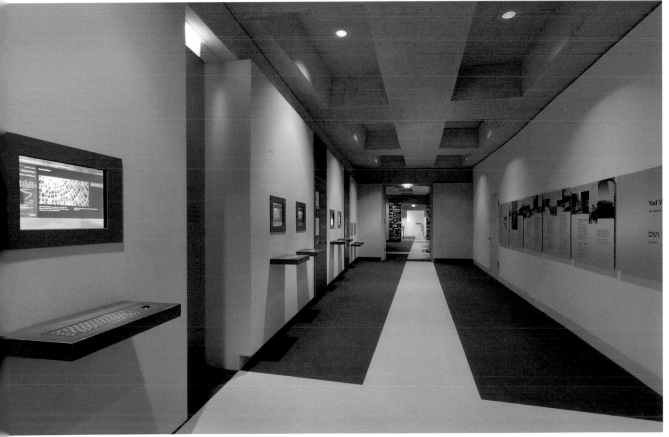

Room four pertains to the organized murder. Information is presented through films and photos, all displayed on the stelae which seem to extend down from above ground. Four video sequences expose the numerous murder sites and the crimes committed there. Audio stations between the stelae allow visitors to listen to eyewitness accounts.

The exit foyer depicts other memorials and museums. Here a visitor can consult the database from the Yad Vashem Memorial in Jerusalem, or those from other European memorials.

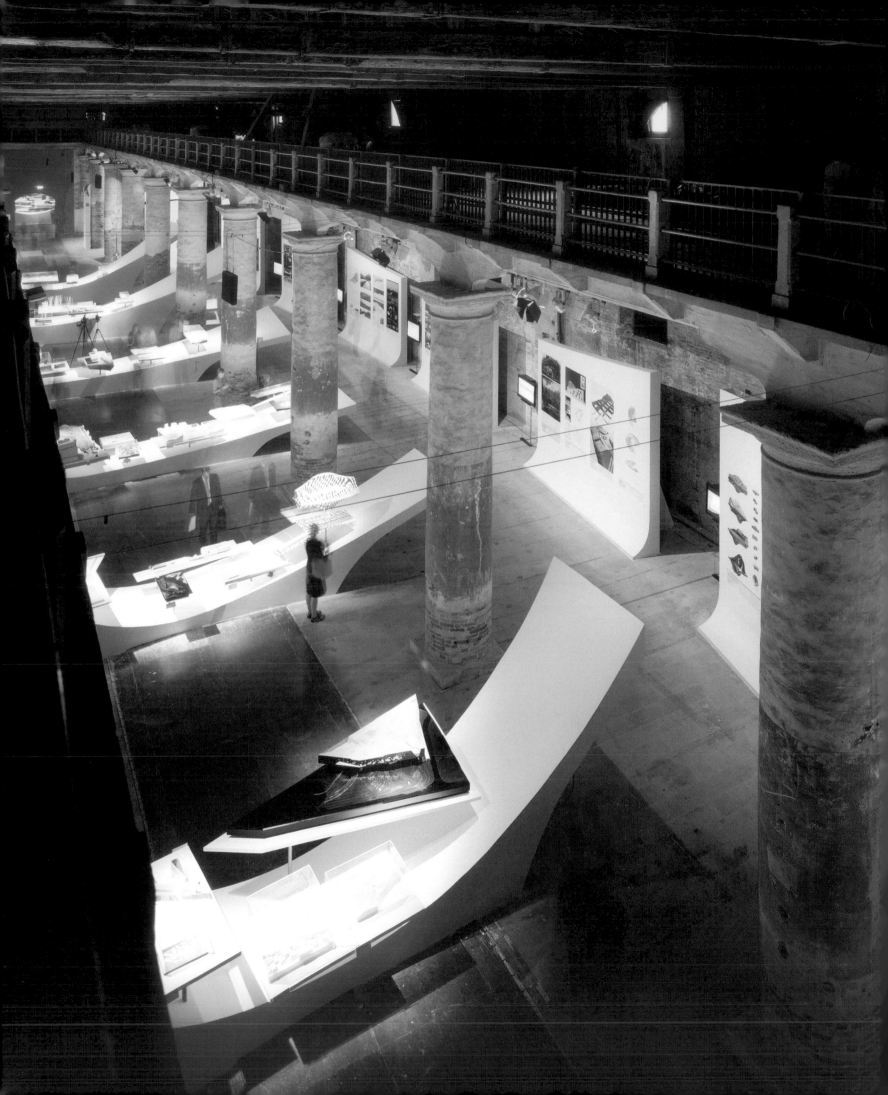

METAMORPH
Transforming Architecture

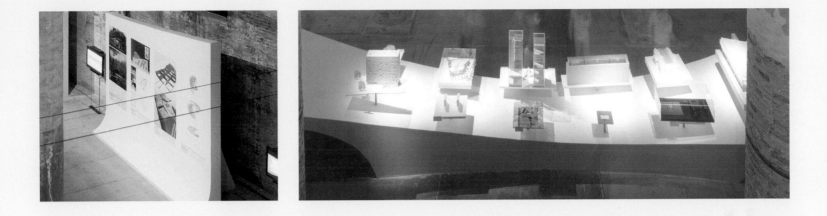

Asymptote: Hani Rashid & Lise Anne Couture

Address
Asymptote Architecture
160 Varick Street, Floor 10
New York, New York 10013
USA

Fair
Venice Arsenale, Venice, Italy
September 12–November 7, 2004

Other cities
None

Primary material
n/a

Photography
© Christian Richters
(photographic images of site)
© Asymptote: Hani Rashid and Lise Anne
Couture (renderings and drawings)

Founded in 1895, The Venice Biennale is still considered one of the most prestigious cultural institutions in the world, promoting new artistic trends and organizing international events pertaining to the contemporary arts. Its multi-disciplinary model includes the International Film Festival, International Art Exhibition, and International Architecture Exhibition, as well as music, dance and theater festivals. The International Architecture Exhibition, established in 1980, has thus far been staged nine times.

Metamorph, the ninth international architecture exhibition was designed by New York-based Asymptote Architecture, founded by Lise Anne Couture and Hani Rashid. Since 1998 this duo has been turning out sleek and provocative art installations. Their designs include a virtual trading floor for the New York Stock Exchange, a virtual version of the Guggenheim Museum and a workplace system for Knoll. Asymptote draws inspiration from historic and contemporary influences designing all their exhibition areas. "Metamorph: 9th International Architecture Exhibition" was held at the historic Arsenale, an immense dockyard once used for naval shipbuilding. The Cordiere is the long gallery where kilometers of rope were manufactured and prepared for the voyages of 16th-, 17th- and 18th-century Venetian ships. Asymptote used this longitudinal space to display works that move along trajectories to form a "terrain" of trends and forms rather than focusing on individual elements. In this way, Asymptote successfully integrated architecture, installation, multimedia, and graphic and exhibition design to create a complete exhibition experience.

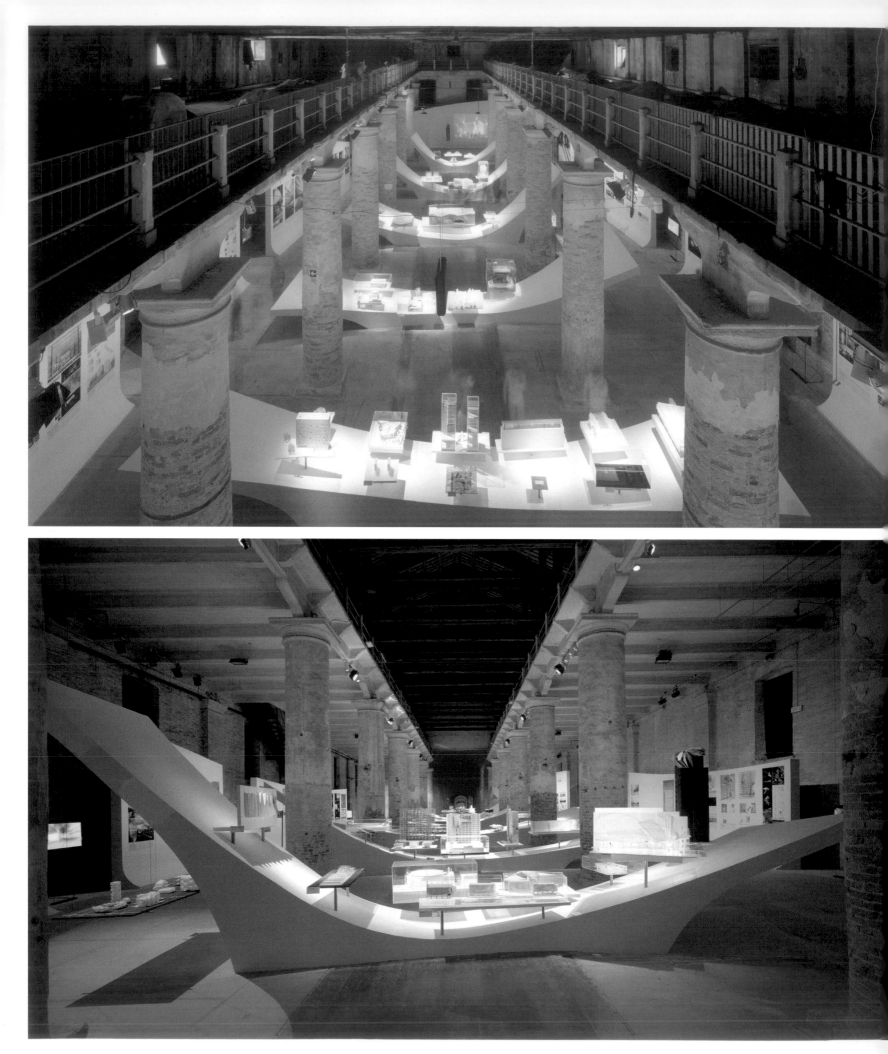

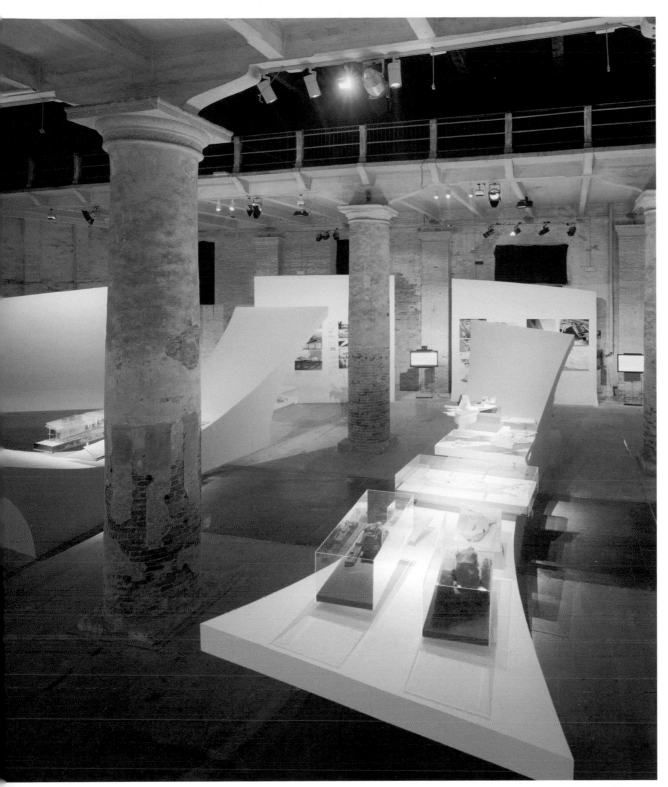

The Arsenale was founded in 1104 and built up considerably throughout the 16th century. The Venetian shipyard was very important for a republic based on sea power, and the Arsenale was legendary for its size and efficiency.

200-feet long galleys were built here sixteen thousand "Arsenalotti" (those working in the Arsenale) could build an armed warship in just 12 hours. Battleships built for the Battle against the Turks in Cyprus as well as several for World War I were made in the Arsenale.

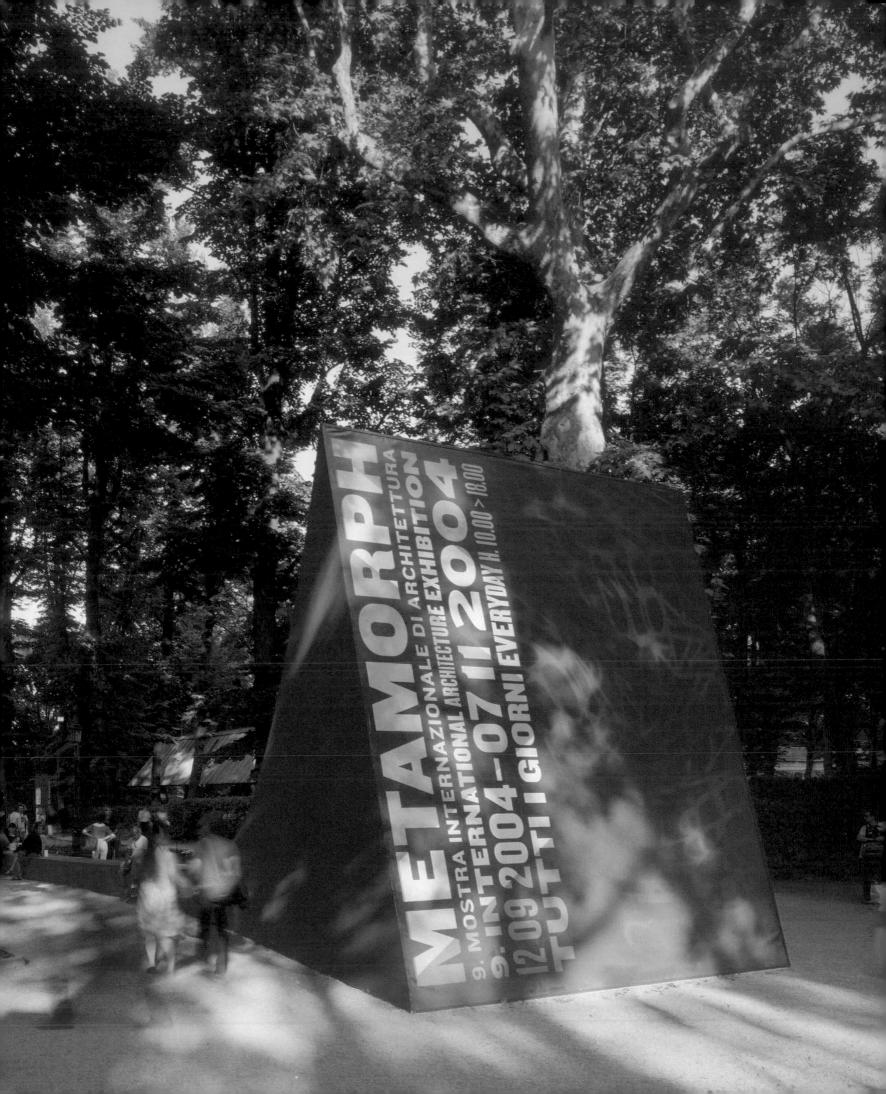

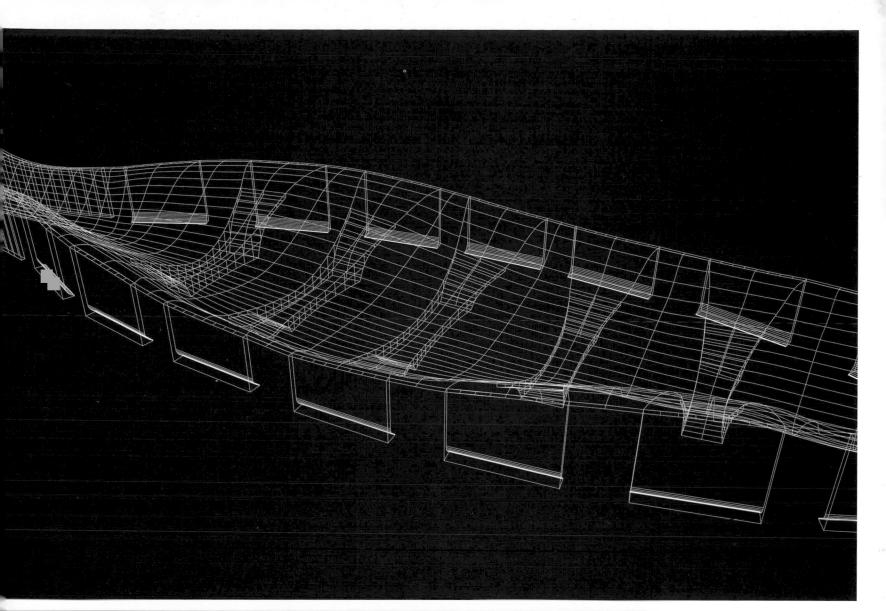

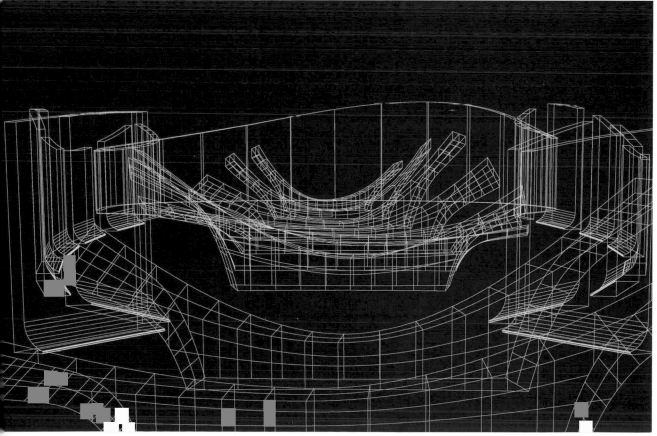

Asymptote's exhibition transformed the Cordiere using a computer-generated morphing animation sequence involving the actions of torquing and "stringing" the entire space. The result is a number of elements with the potential to be used as walls, surfaces and platforms, which in turn were used to accommodate models, drawings and video installations for the exhibition.

Llibres il·lustrats per
PICASSO
de l'11/11/05 al 8/01/06

Books Illustrated by Picasso

Sketching Genius

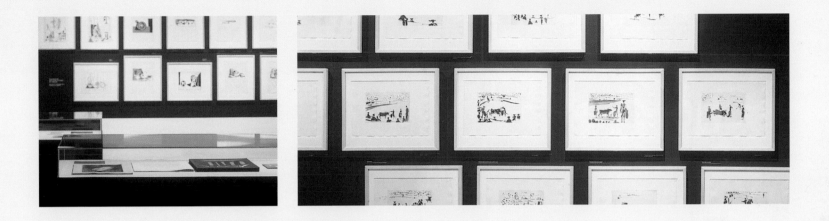

Saeta Estudi + Margarida Costa-Martins

Address
 Saeta Estudi
 Pg Sant Joan 12 pral. 2ª
 08010 Barcelona
 Spain

 Margarida Costa-Martins
 Placeta Montcada 3, pral.
 08003 Barcelona
 Spain

Location
 Museu Picasso, Barcelona, Spain
 November 11, 2005–January 8, 2006

Other cities
 None

Primary materials
 Rigid Orange fabric, brown vinyl applied to
 walls, floor and display cabinets, lighting

Photography
 © Oleg Ogurtsov

This exhibition at the Picasso Museum in Barcelona was designed by Saeta Estudi, studio based in that city. Designers Pere Ortega and Bet Cantallops were faced with the challenge of presenting Picasso's illustrations in an ordered and logical way within an existing exhibition space. The main aim of this design was to find an overachieving scheme to unite the works on display. The number of works exhibited in each room was taken into account, as well as the tense or relaxed nature of the works and the works' size, proportion, relationshipto one another and setting.

The designers aimed to establish logical connections among the works thus distributing them thematically. The atmosphere is made up of dark, warm colors (brown and orange), which help focus attention on the works. The order is broken when an object is to be emphasized. The materials are superimposed on the room's surfaces and run from the floor to the walls and even up to the objects in the display cases. Brown vinyl covers the cabinets and walls, while an orange fabric is stretched overhead, three meters above the floor. The fabric helps focus the light on the objects, creating a warm aura that attracts viewers to the work. The exhibition is entered via the patio or the interior staircase.

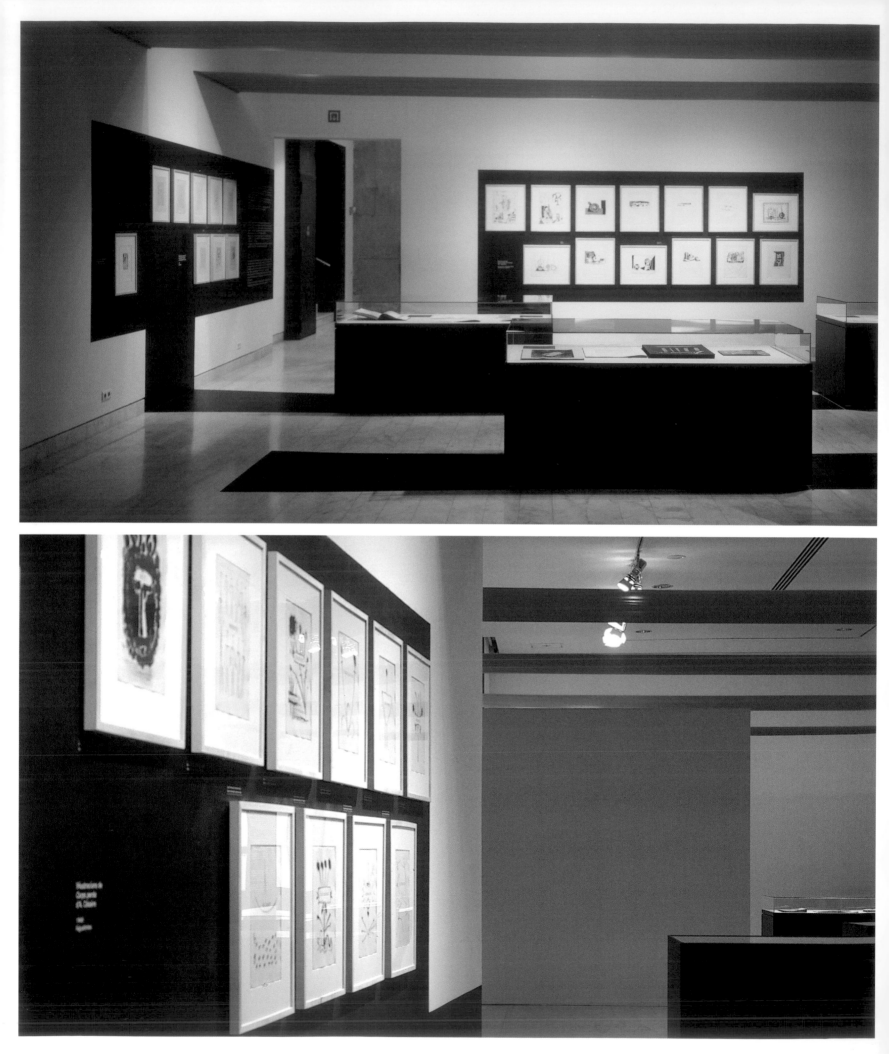

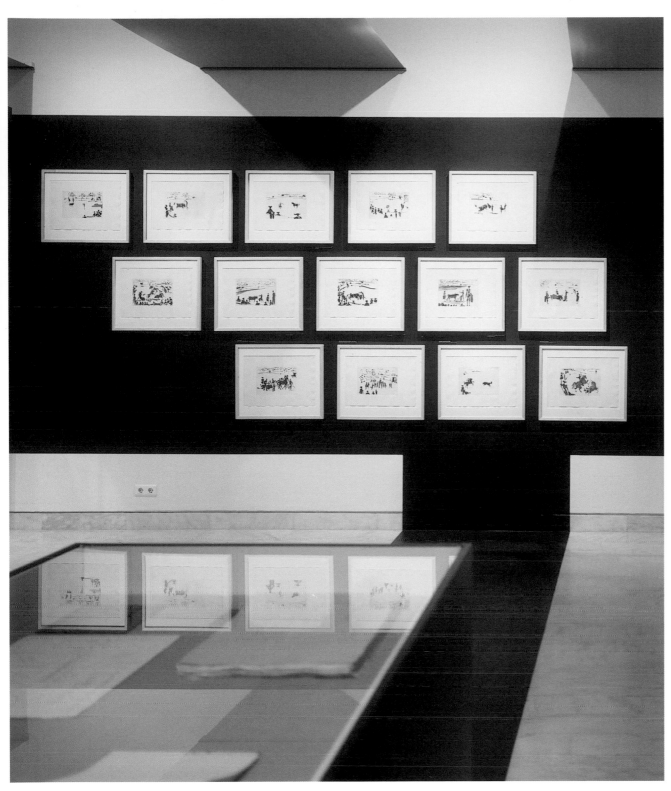

The exhibition is dominated by the colors brown and orange, which create a warm atmosphere.

Superimposed materials take over the room. Strips of rigid orange fabric are stretched overhead three meters above the ground, while brown vinyl covers the walls, floors and display cases.

The main aim of this exhibition design is to connect the work hung on the wall with the elements displayed in the cases.

The distribution of the works through the rooms was carefully considered, taking into account the tense or relaxed moods in the work, as well as the comparative proportion. The designers attempted to find an all-encompassing thematic structure for the exhibition.

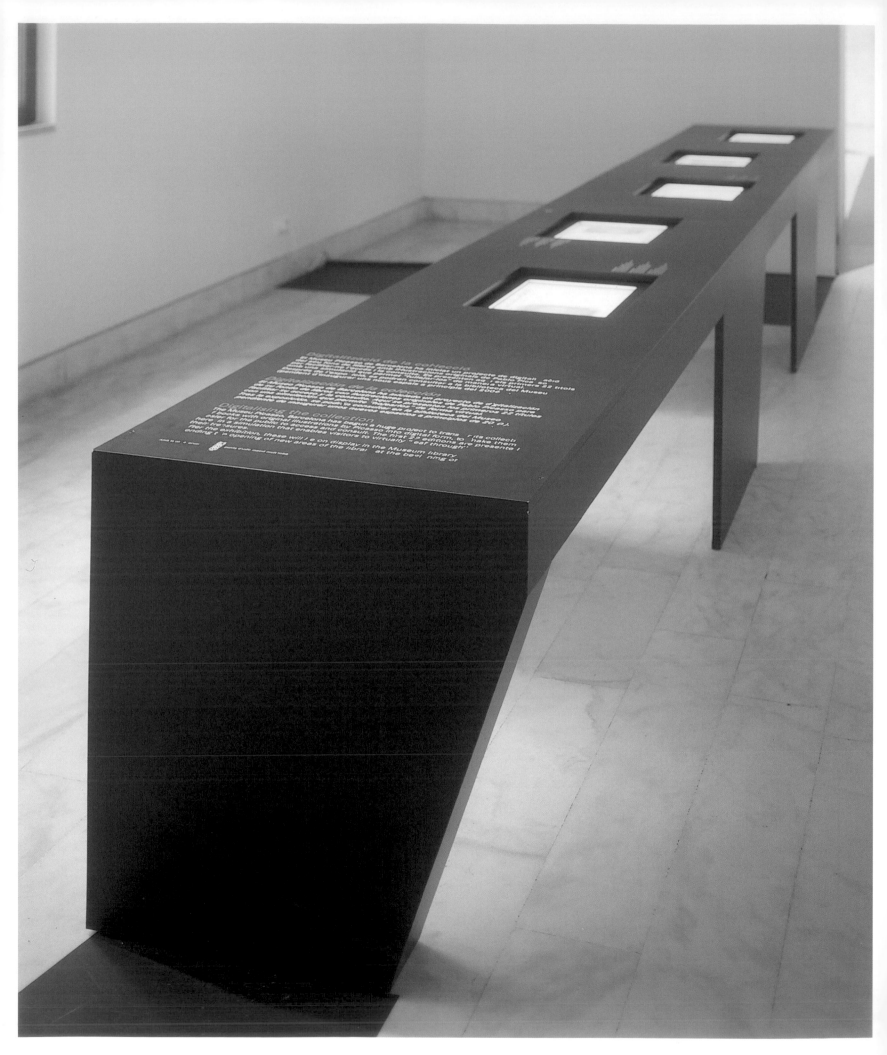

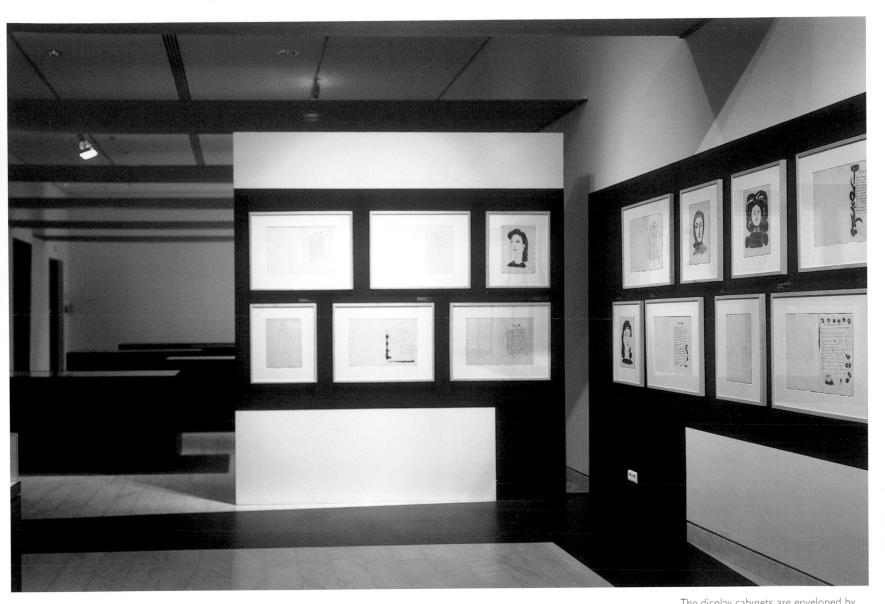

The display cabinets are enveloped by the brown vinyl running down from the walls and across the floor, thus creating a clear link between the pieces of work hung on the walls and the elements exhibited in the custom-built cases.

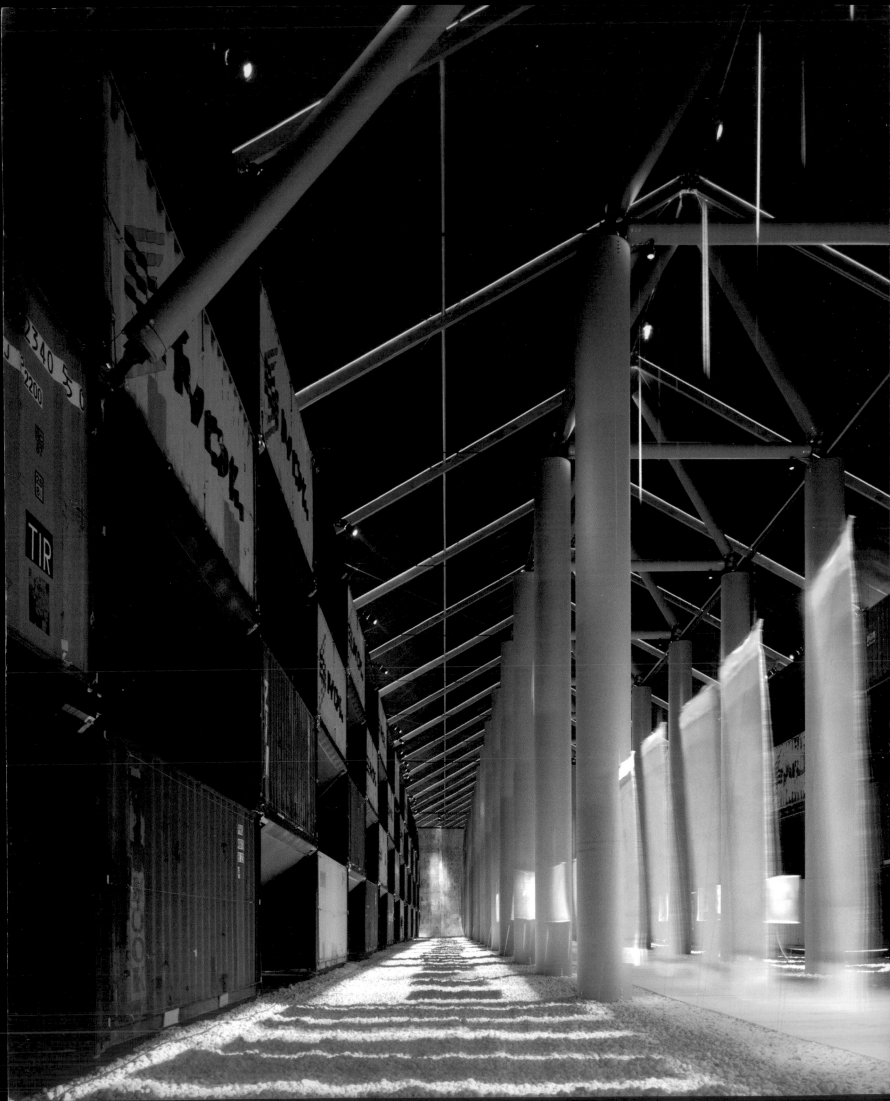

BIANIMALE NOMADIC MUSEUM

Traveling Art

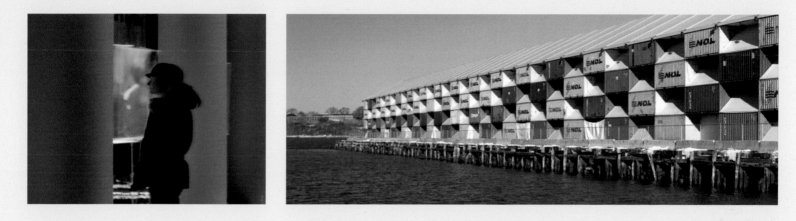

Shigeru Ban Architects
+ Dean Maltz Architect

Address
Shigeru Ban Architects
5-2-4 Matsubara Setagaya
Tokyo 156-0043
Japan

Dean Maltz Architect
330 W 38th St. Ste. 811
New York, New York 10018
USA

Location
Pier 54, New York, New York, USA

Other cities
Los Angeles, California, USA;
Beijing, China, Paris, France

Primary materials
148 steel shipping containers, 64 paper tube
columns

Shigeru Ban designed a nomadic museum for Gregory Colbert's photographs. The Canadian photographer did not want to exhibit his work in existing museums; he wanted a specially designed traveling museum of 4,000 to 5,000 thousand square meters that would allow him to show his photos around the world. After exhibiting his works at the 2002 Venice Biennale, he received approval from patrons, and Shigeru Ban in association with Dean Maltz Architect proceeded to develop the "Nomadic Museum," which would begin its world tour at New York City's Pier 54.

Several factors had to be taken into account for the huge structure. Not only did it have to be erected and disassembled as quickly as possible, but an economical method of transporting the elements around the world also had to be found. The fragility of the first site, New York's Pier 54, was another important element to consider. Famous for being the Titanic's intended destination, the wooden pier (24 meters wide and 25 meters long), could not hold too much weight.

The end result is a museum that doesnot travel: It uses 148 6-meters-long shipping containers, which were rented for five months from a yard on the opposite shore in New Jersey. For future installations, international standard containers will be rented on site in cities around the world. The roof membrane and paper-tube barn-roof framing are the only elements that will be transported to each venue. The paper-tube columns will be recycled after dismantling each exhibition and remade at the next locale.

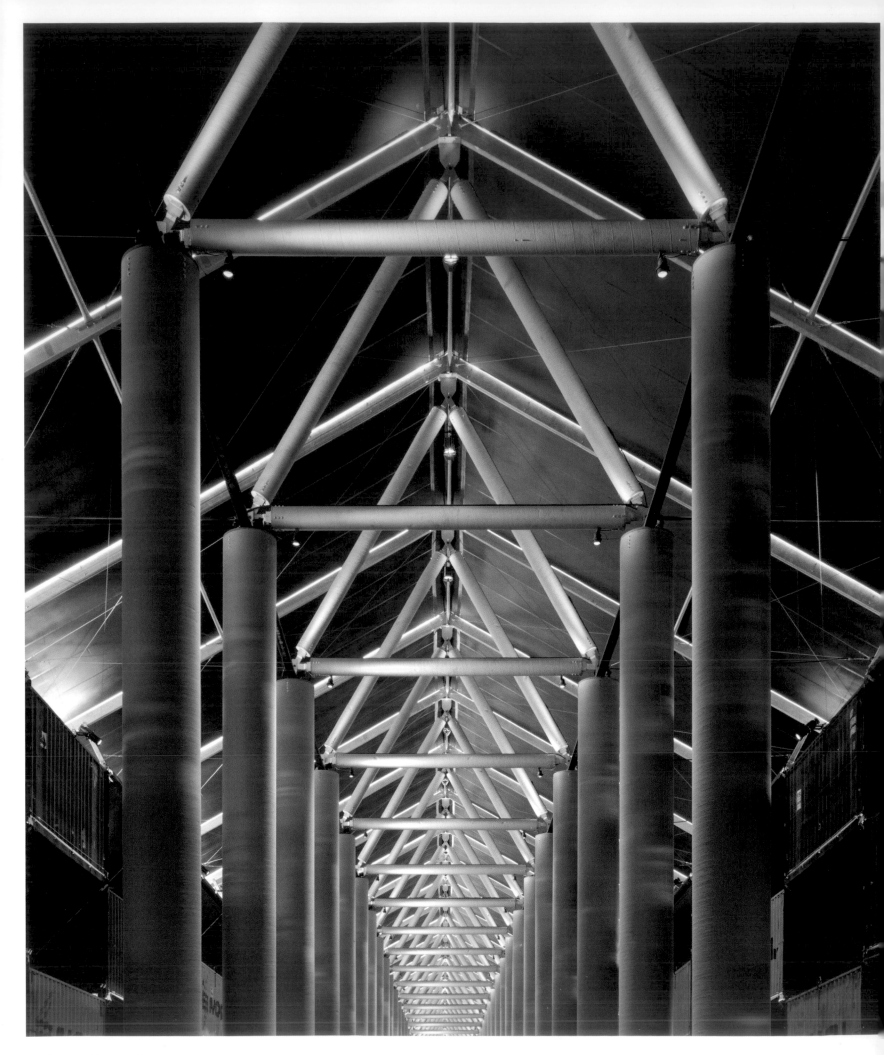

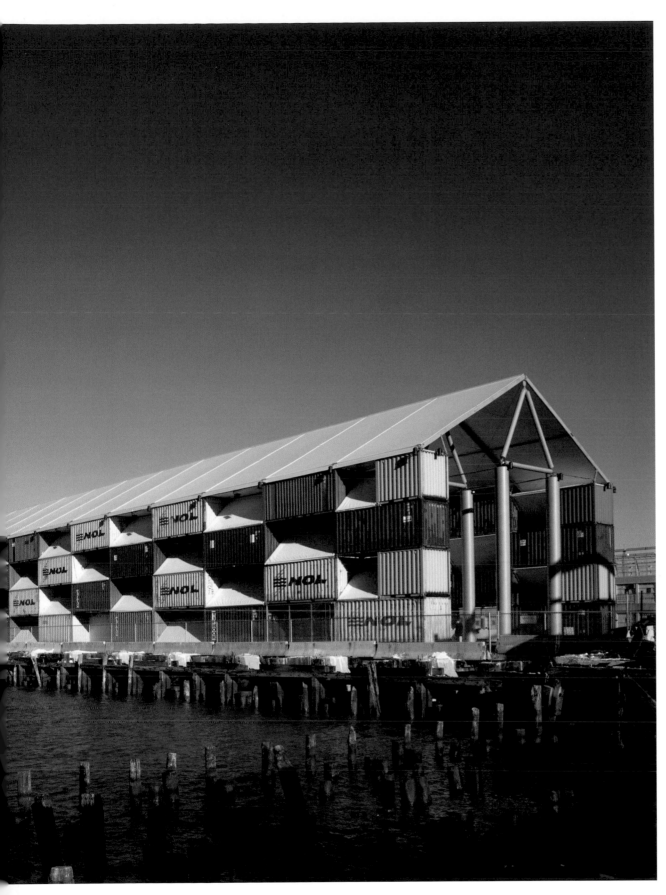

New York City's Pier 54 on the Hudson River is no longer in use, though it remains famous for being the intended destination of the ill-fated Titanic.

The exhibit space within centered on two colonnades of paper tubes 75 centimeters in diameter spaced at six-meter intervals, which served as columns to support an equilateral-triangle-trussed barn roof made with paper tubes 30 centimeters in diameter. Entering the space evokes the same overwhelming feeling as entering a cathedral.

The enormous works of art by Gregory Colbert seem to float weightlessly between the columns, each piece creating a separate world.

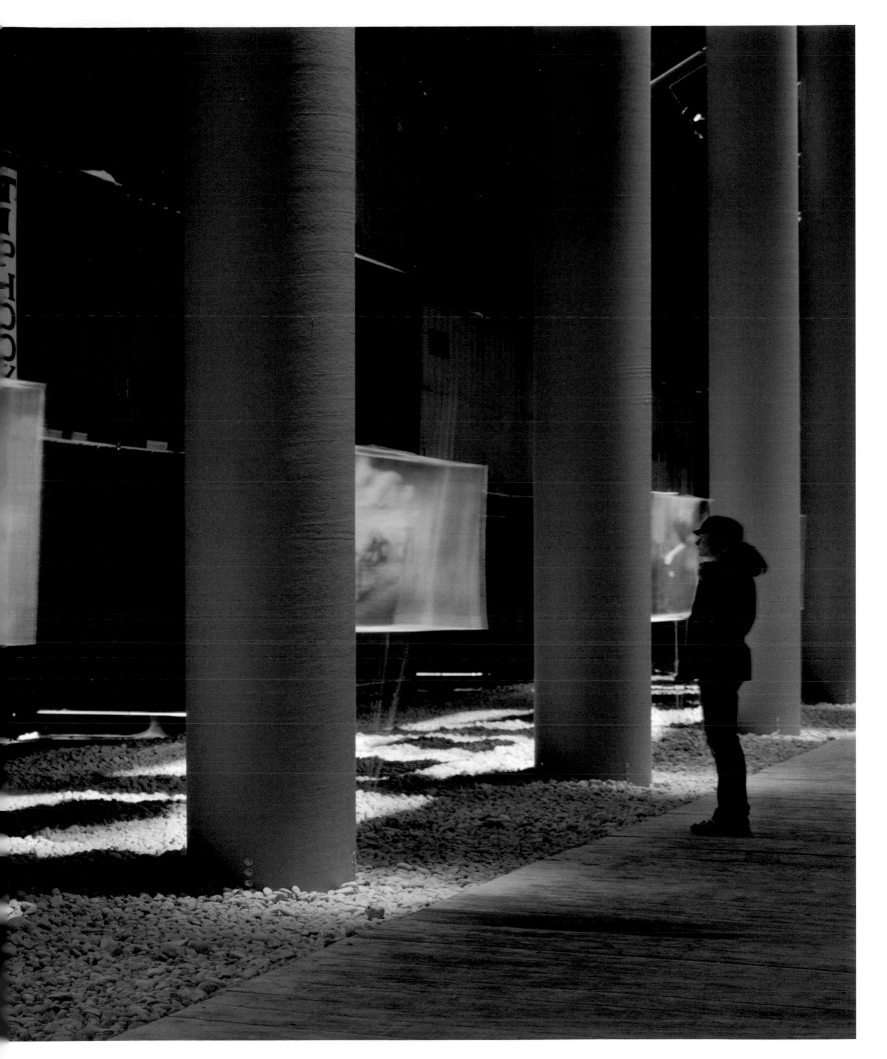

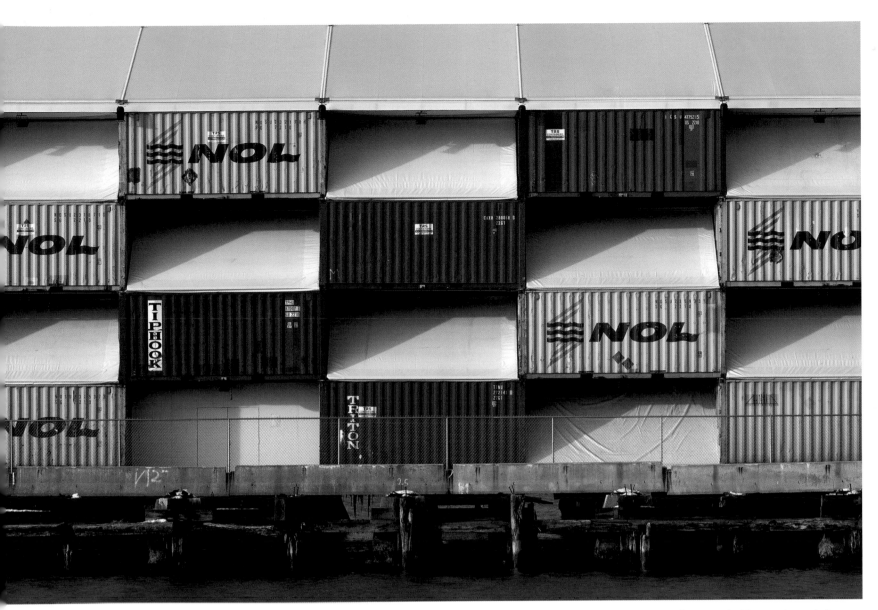

The Nomadic Museum is made from 148 shipping containers, each six meters long; they are stacked four high and arranged in two parallel rows measuring 205 meters long.

The wooden pier's load capacity had to be taken into consideration. To minimize the number of containers used, and maximize the usable space within, the containers were stacked in a checkerboard pattern.

Containers in the standard international size were rented from a yard on the opposite shore in New Jersey for five months. Identical containers will be rented at each locale on the exhibition's world tour.

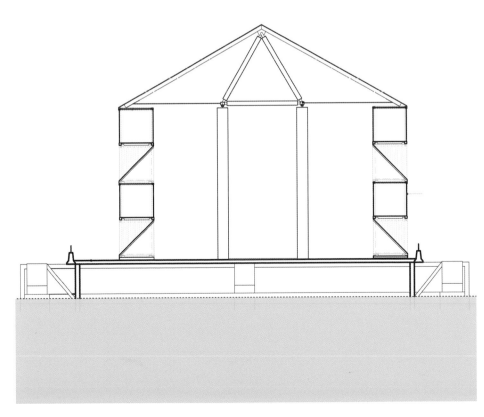

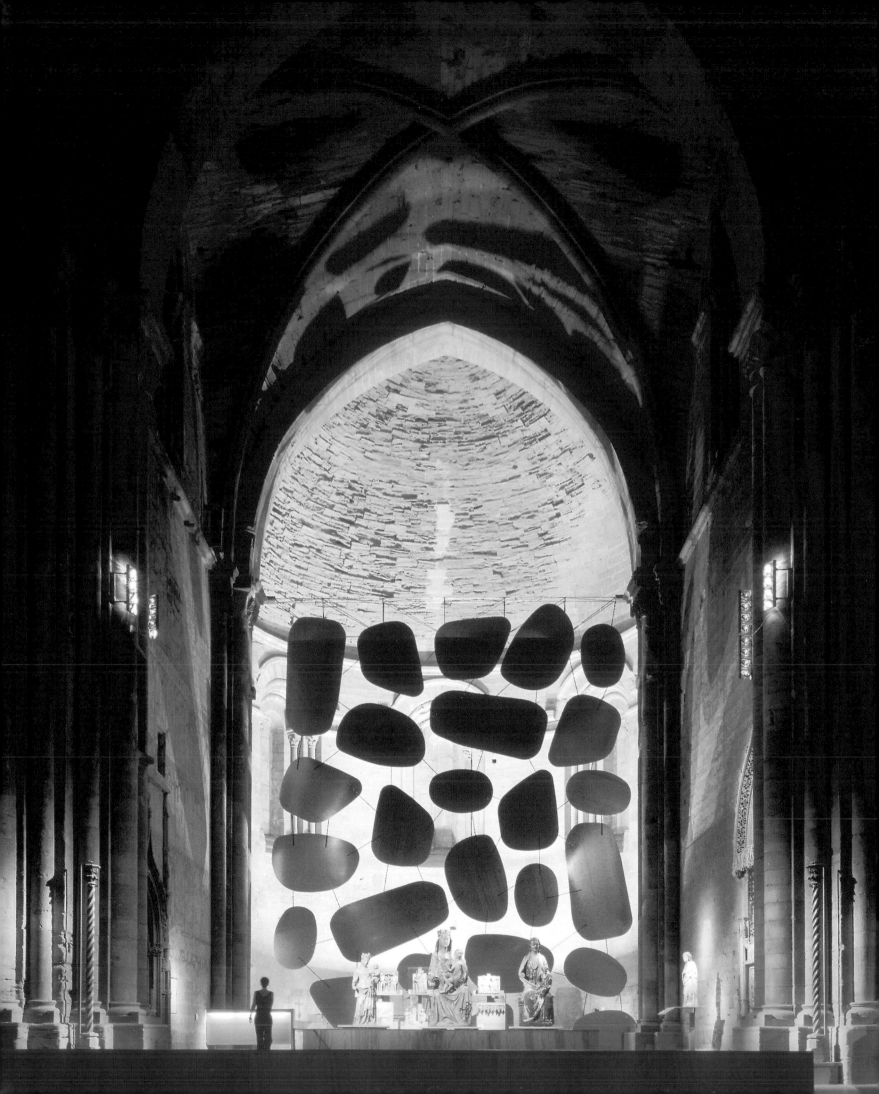

SEU VELLA, RENEWED SPLENDOR

Recovering Glory

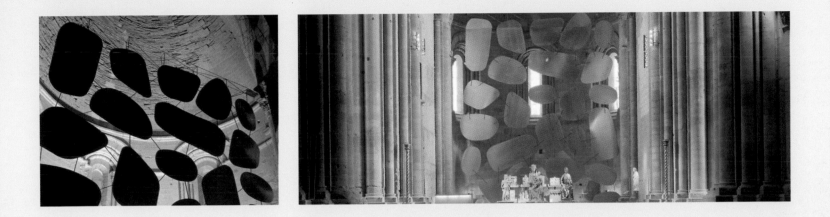

Domingo i Ferré Arquitectes

Address
Domingo i Ferré Arquitectes
Diputació 239, 1-2b
08007 Barcelona
Spain

Location
Lleida Cathedral, Spain
June 20–October 26, 2003

Other cities
None

Primary material
Sheet metal

Photography
© Jovan Horvath

On July 22, 1203, a solemn ceremony marked the placement of the first stone of Seu Vella in Lleida, which Father Josep Gudiol i Cunill has called "Catalunya's most sumptuous piece of work." The 2003 exhibition "Seu Vella, Renewed Splendor", commemorates the cathedral's 800th year. Renewed Splendor aims to recreate its lost grandeur with 91 valuable artifacts from various international museums and archives. Historians, restorers and archaeologists spent fifty years restoring the architecture and relics as well as tracking down and reuniting fragments that had been dispersed all over the world.

The Catalan architects Mamen Domingo and Ernest Ferré were asked to conceive the exhibition design for Seu Vella. Their main challenge was the vastness of the building, which occupies more than 5,000 square meters, and secondarily the diversity and condition of works to be exhibited. The architects needed very technical support structures which had to be developed in quickly and in some cases, required unforeseen last-minute adjustments. The fragmented of the works would be one of the key ideas for their final design.

The exhibition invites the visitor to envisionthe church's faded sparkle. The architects decided to use curved plates, which remind us of the wear and tear of the cathedral's stones. The fragmented plates also represent the fragile condition of the artifacts exhibited. The plates are suspended from the ceiling and form a tenous whole. Images are superimposed on them and light bounces off of the metal sheets.

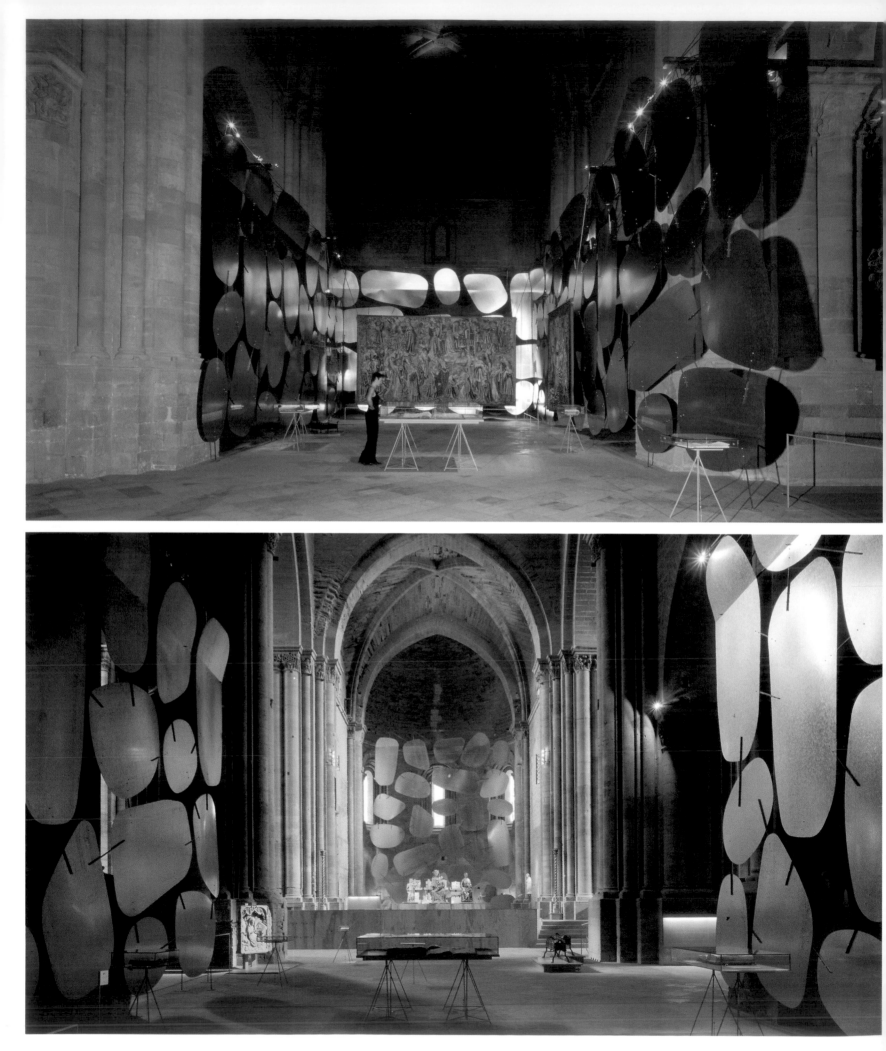

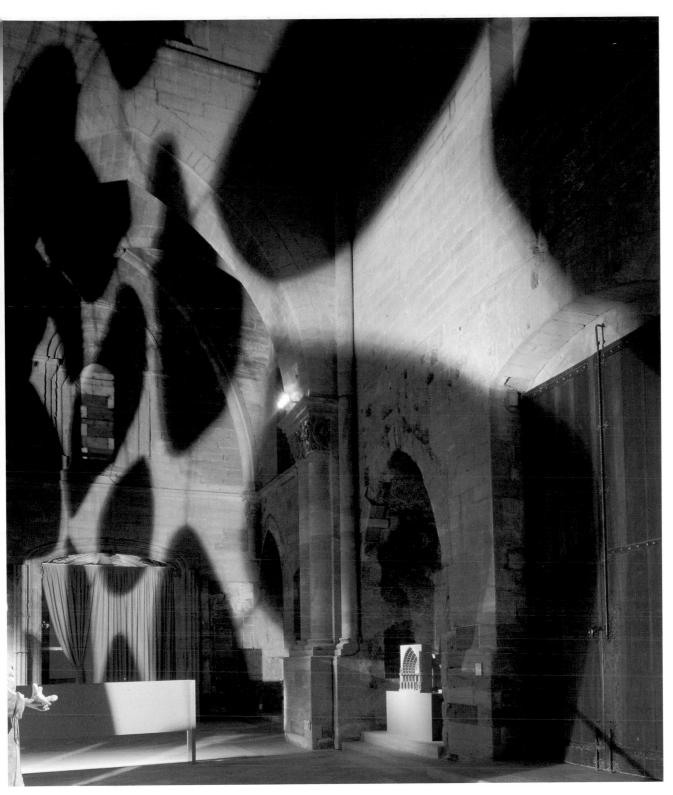

The metal sheets represent the fragmented pieces collected for this exhibition. Suspended pieces of metal reflect the artwork and the light, casting shadows on the cathedral's stones and creating new sparkles within this grand old building.

Glass display cabinets placed on tripod-like pedestals show off the exhibition's smaller items.

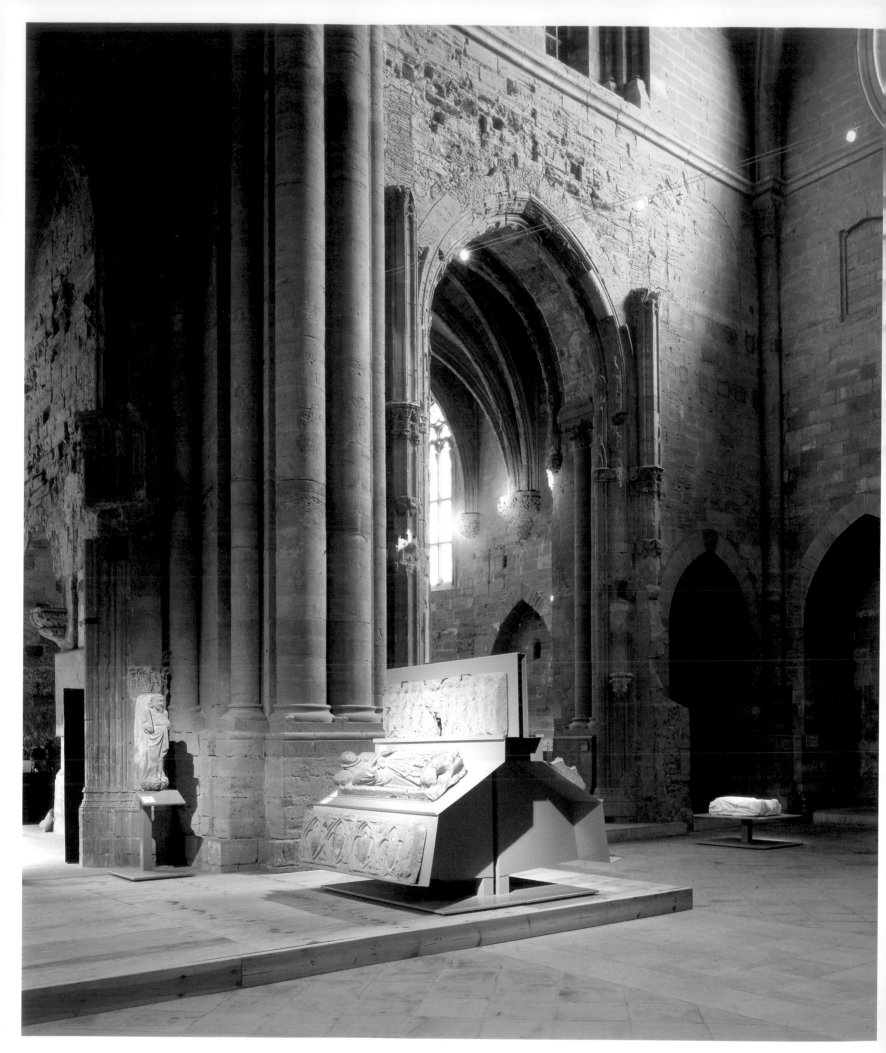

"Seu Vella, Renewed Splendor" reunites 91 valuable artifacts, including sculptural objects, paintings, headstones, fragments of altarpieces, manuscripts, silverwork, clothes and other objects and documents, that have been recovered from museums and archives around the world.

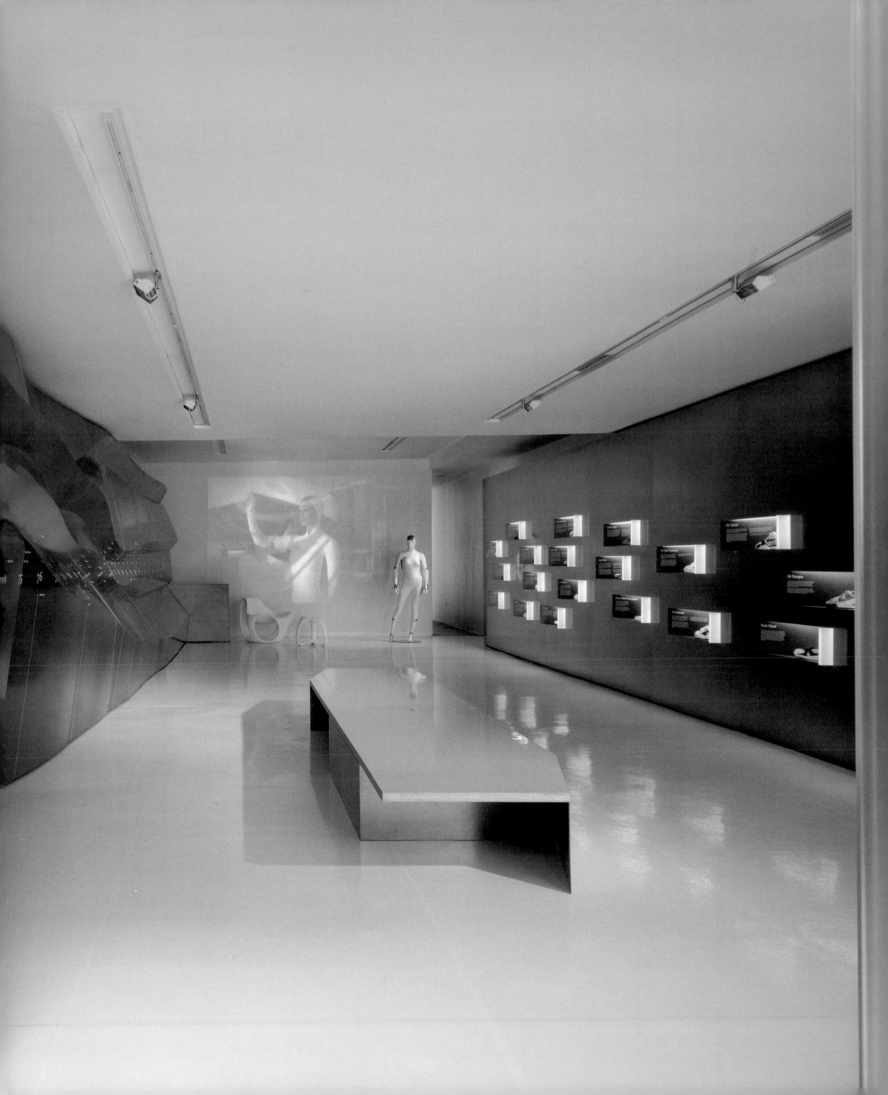

NIKE GENEALOGY OF SPEED

Sporting Velocity

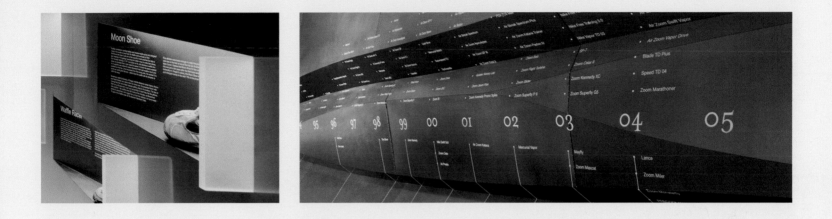

Lynch/Eisinger/Design + KD Lab

Address
Lynch/Eisinger/Design
224 Centre Street, 5th Floor
New York, New York 10013
USA

Location
New York, New York, USA

Other cities
A parallel exhibit (same content,
different designers and concept)
was put on in Los Angeles, California
April–August, 2004

Primary material
Cold rolled steel

Photography
© Albert Vecerka/ESTO,
Lynch/Eisinger/Design, Nike

Lynch/Eisinger/Design and KD Lab's challenge for this installation was to communicate the history of Nike product development, reflecting the company's 40 years in the competitive sports and fitness industry. At the same time the designers needed to evoke the intangible concept of speed. To avoid embodying speed in a static construction, the designers explored the physical shape of speed and examined the speed's secondary effects, such as the Doppler and Bernoulli effects, sonic booms and Lorentz transformations.

The exhibition design is shaped by three factors: the idea of speed, the artifacts on display and the developmental timeline relating speed to the artifacts through the years. A three-dimensional form with a timeline stretching across the surface represents a "family tree" of Nikes design. Chronological vectors are embodied in bent steel, resulting in a light and informative surface. The steel surface was laser-perforated so no welding had to be used in the fabrication. A steel plane opposite exhibits highlights of Nike designs. Brightly lit niches, laser-cut into the flat steel surface, show off a selection of Nike's iconic shoes. The visual impression the niches give varies: Upon entering, all you see are the glowing fins sticking out of the wall, but when you look back from the exit, the products are visible.

The hard steel walls contrasted with the white fabric-covered ceiling and micro-layer of vinyl laid over the existing concrete floor. Because the budget was extremely limited, the designers promised the steel to a recycler to cover the cost of disassembly at the end of the exhibit.

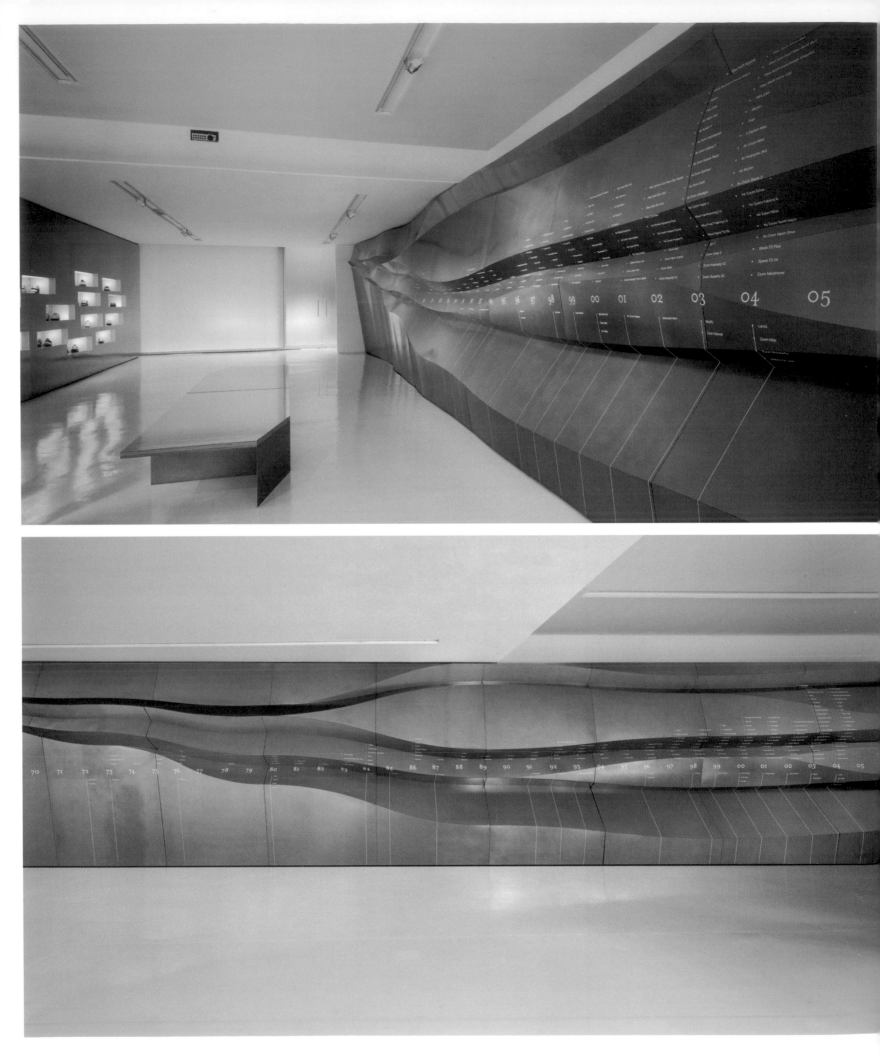

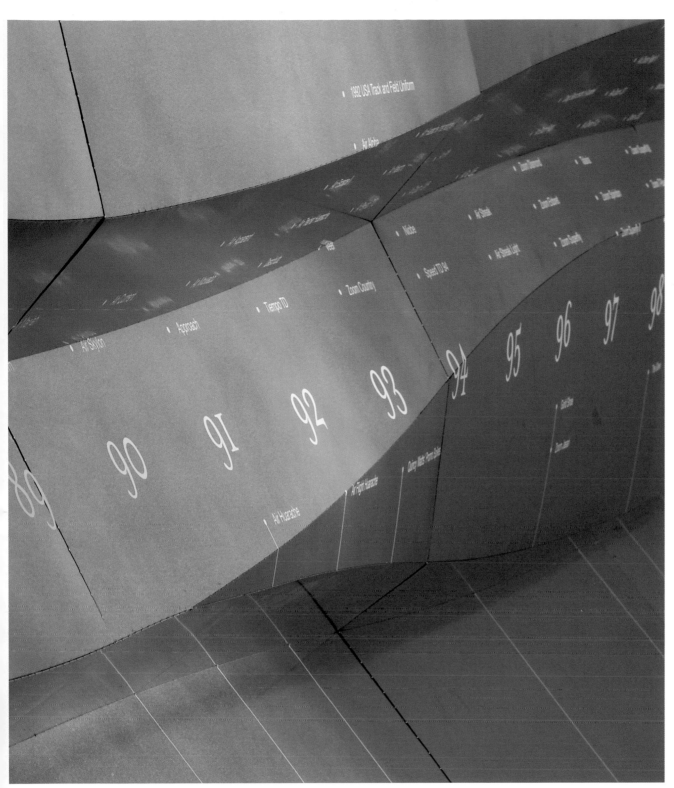

The double layer of white fabric on the ceiling contrasts with the hard steel walls, while a micro-layer of vinyl covers the room's concrete floor.

Chronological vectors inform the topology of bent steel. The deformation of the steel surface was determined by innovative algorithms. The steel surface was laser-perforated and then fabricated without welding.

The timeline stretches along the steel surface and registers highlights of Nike design. The products are displayed in the opposite steel wall.

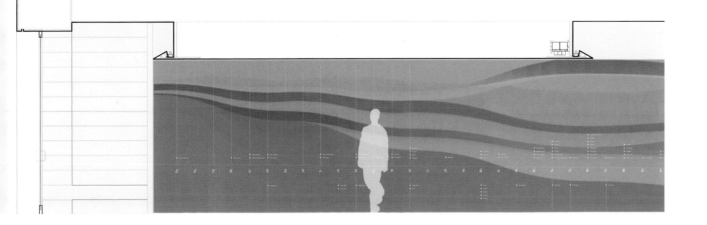

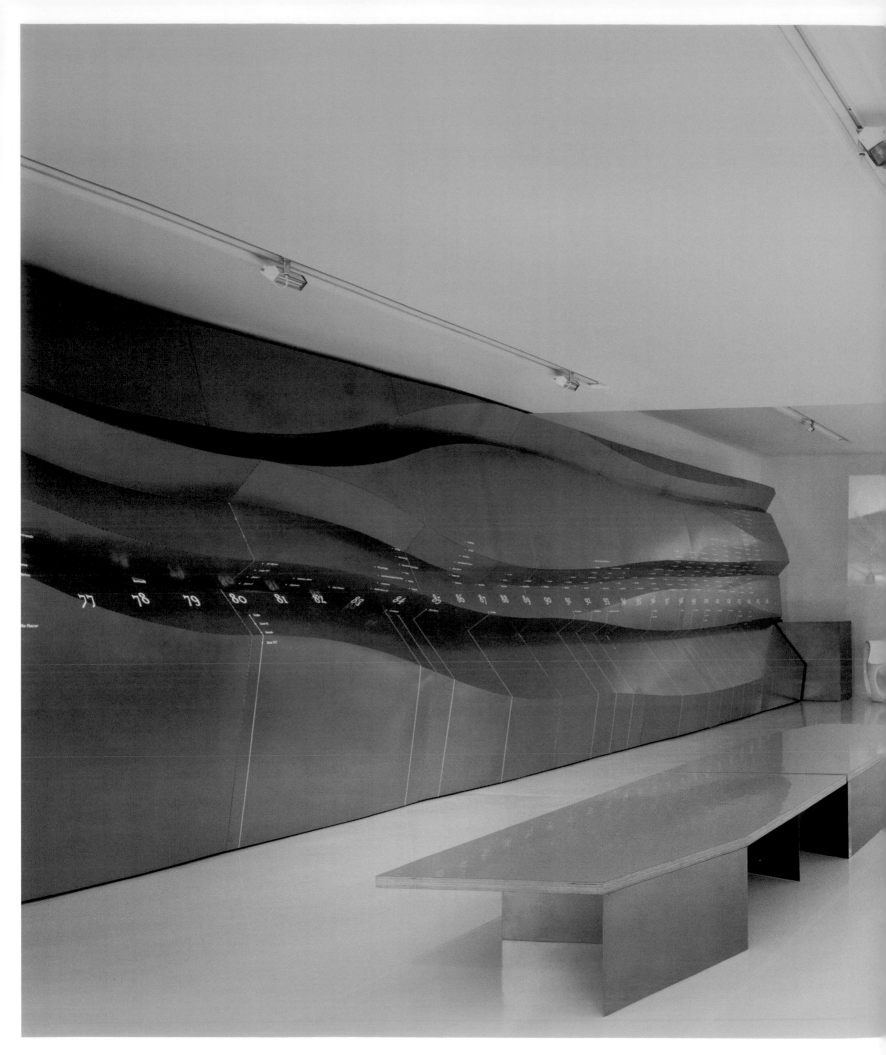

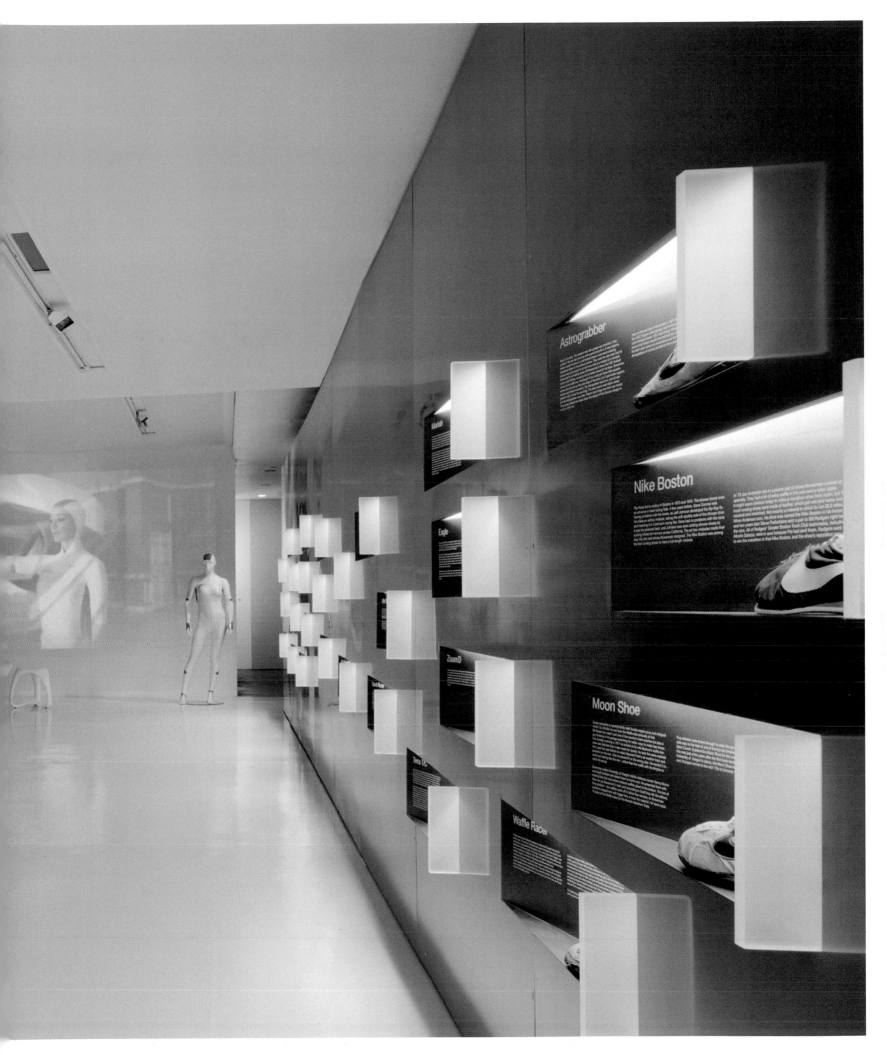

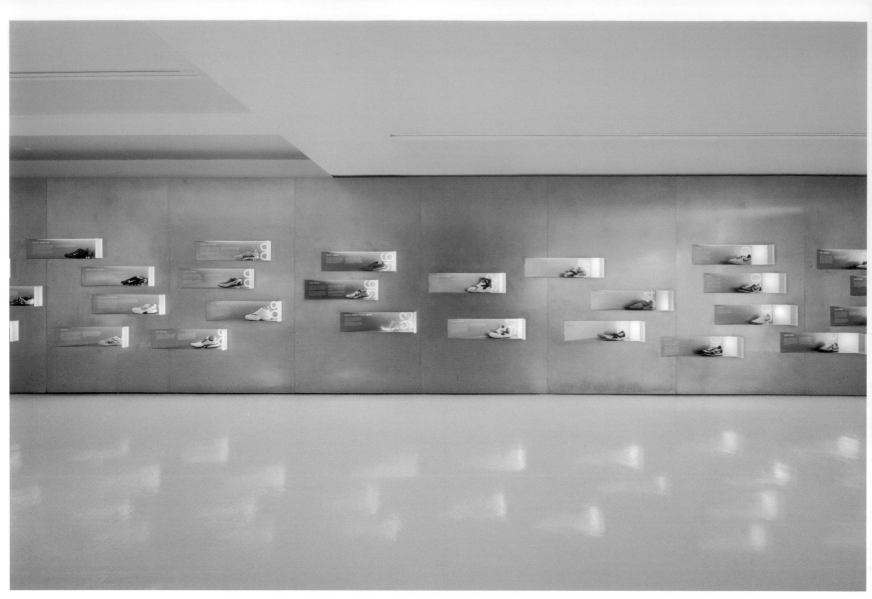

A flat wall opposing the bent steel timeline contains brightly lit niches which exhibit iconic Nike shoes. The niches are laser-cut into the flat steel surface and simultaneously reflect and contrast with the formation across the room.

Glowing fins protruding from the niches are the only elements visible upon entering the exhibition room. The artifacts can be seen when one looks back on the exhibition from the exit.

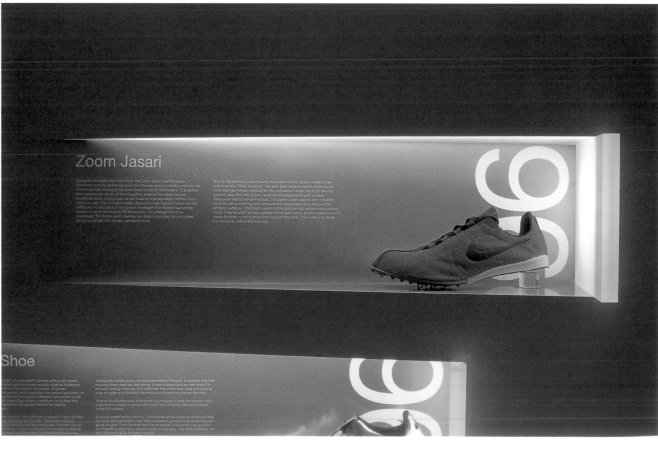

Zoom Jasari

The geometry of the niches gives a different impression upon entering and upon leaving, a concept suggested by the red shift (Doppler effect).

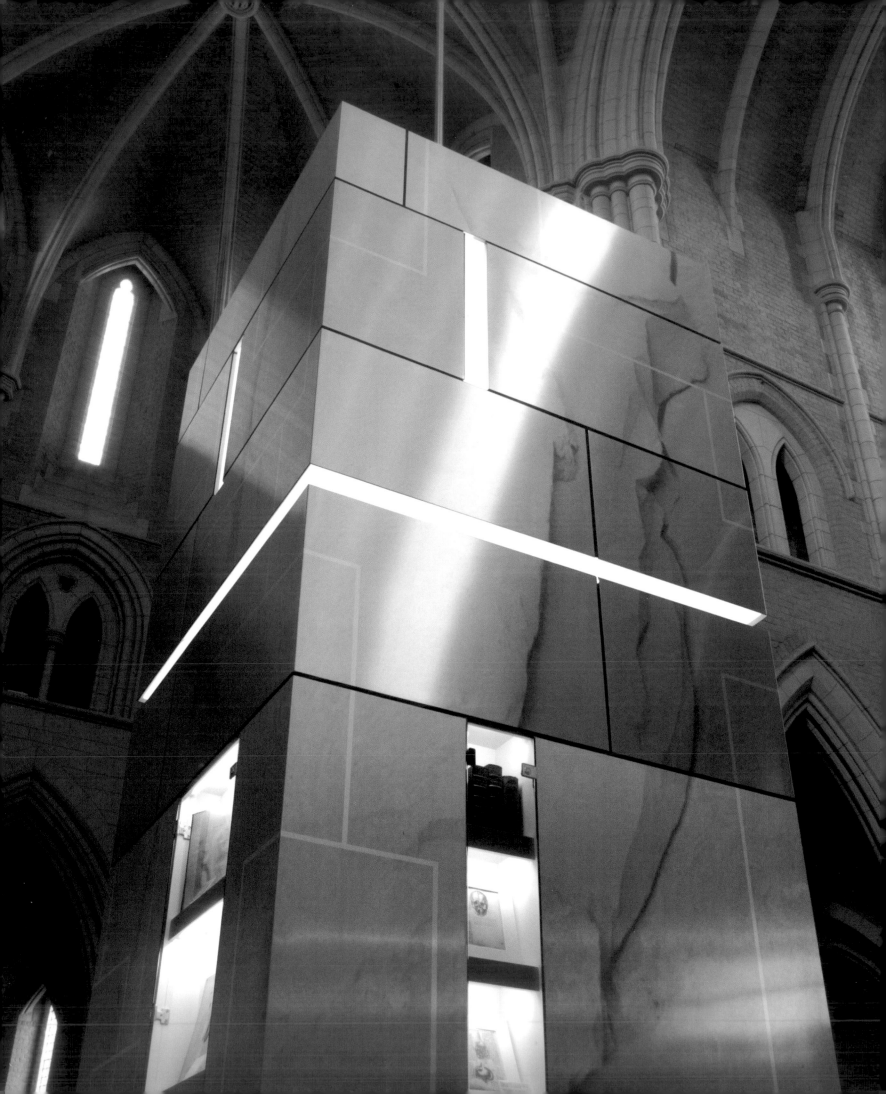

AMBIGUOUS OBJECT

Cryptic Rencontre

Surface Architects

Address
Surface Architects
51 Scrutton Street
London EC2A 4PJ
UK

Location
Queen Mary University of London Medical
School Library, Whitechapel, London, UK
Permanent exhibition. Completed April 2004

Other cities
None

Primary material
Stainless steel

Photography
© Killian O'Sullivan

To comply with the final phase of the UK's 1995 Disability Discrimination Act (DDA), Queen Mary Medical School had to provide wheelchair-accesible passage between the main body of Queen Mary University church and the crypt below. London-based Surface Architects were commissioned to come up with an original solution for this addition to a Grade II* listed building.

"Ambiguous Object" accommodates the elevator that provides wheelchair access to the crypt and also serves as a display area for precious books. This object was designed to occupy a symbolic space within the chapel. It sits on the strongest axes, the space where the nave and transept cross and the church is united with the congregation. This space is traditionally left empty in Christian architecture. Placing the object in this prominent place lets it act as a focal point. "Ambiguous Object" two seperate and unequal components made of stainless steel. The top is suspended from the center of the oculus of the roof, leaving it free to oscillate as a pendulum. The bottom part which rests on the ground, houses the elevator platform and a display of precious books. The empty space between the two steel boxes is filled with light that emanates from the bottom segment. Despite its sturdy construction material, the object manages to appear like a floating volume of light in the middle of the building.

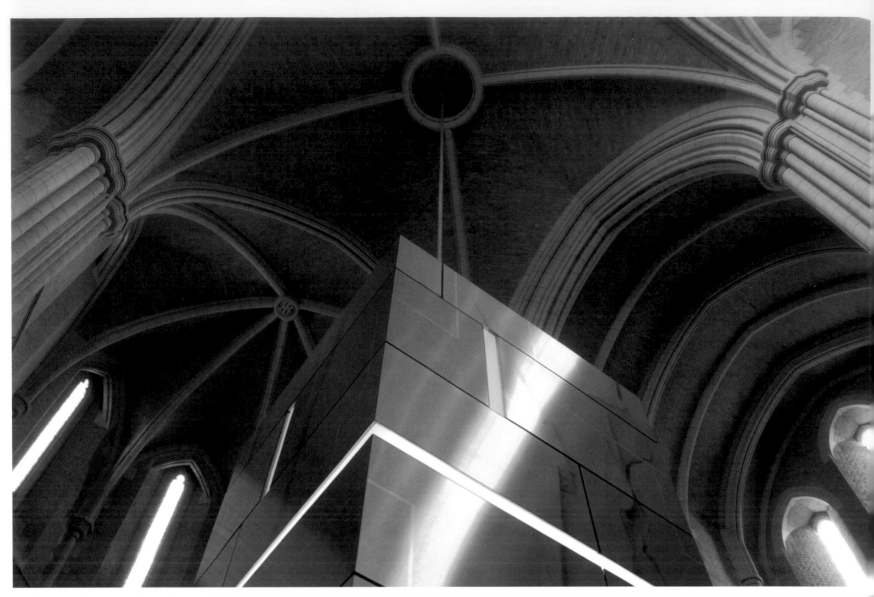

"Ambiguous Object" is made up of two unequal elements. The upper portion is suspended from the center of the oculus of the roof, free to oscillate as a pendulum. The lower portion, which houses the elevator platform, rests on the ground.

A thin horizontal void, filled with light separates the two components. The light is mounted on the lower part and shines into the upper part and into the library space.

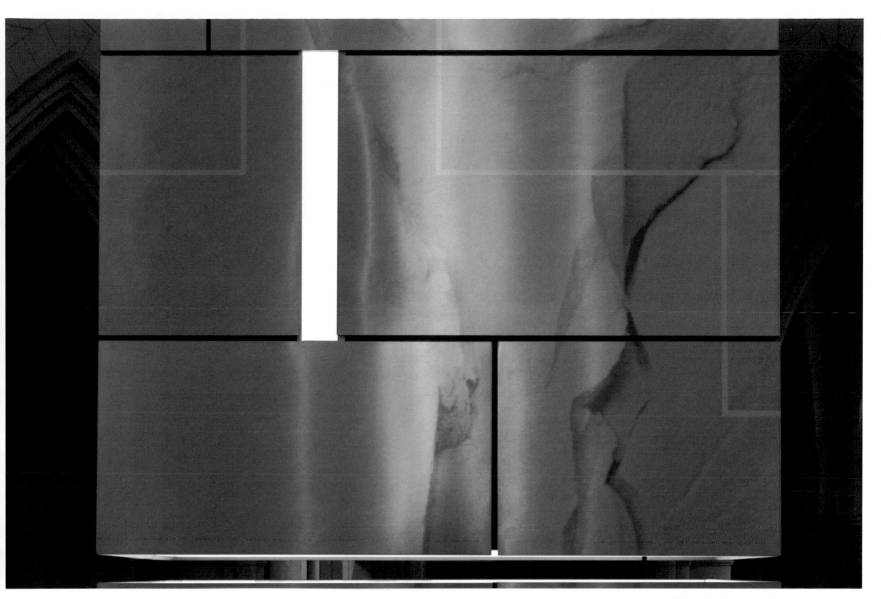

The object is made of stainless steel. The enlarged image of natural slate is photo-etched onto the steel surface, creating a contrasting effect of depth and complexity.

"Ambiguous Object" occupies the space where the nave and the transept intersect. This spot is traditionally left empty in Christian architecture as it symbolically hosts the union of the church and the congregation.

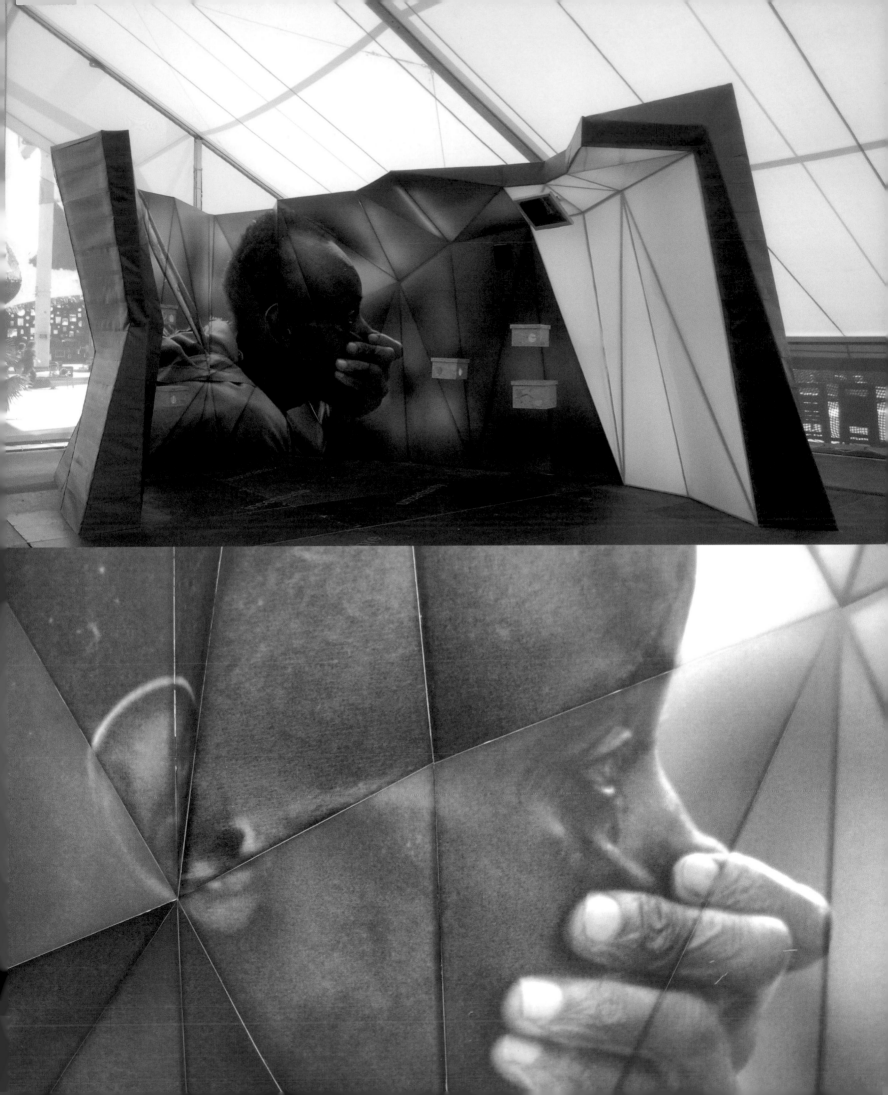

Three Installations for Haima
Conscious Experience

Saeta Estudi + Margarida Costa-Martins

Address

Saeta Estudi
Pg Sant Joan 12 pral. 2ª
08010 Barcelona
Spain

Margarida Costa-Martins
Placeta Montcada 3, pral.
08003 Barcelona
Spain

Location

Haima, Universal Forum of Cultures,
Barcelona, Spain
May 9–September 26, 2004

Other cities

None

Primary materials

Refugees and Displaced Persons: Living on
the Run: Wooden structures, organic
triangular plates covered in blue fabric, large-
scale photographs
Arms for Disarmament: Suspended round
metal structures, plastic colored tubes,
methacrylate inside lamp
Women and War: Suspended motorized
guide, white and black foam curtain, black
rubber floor, wooden cubicles covered in
Tablex board

Photography

© Jordi Bernadó, Saeta Estudi

The Universal Forum of Cultures was inaugurated in Barcelona on May 8, 2004. Co-organized by Barcelona City Council, the Catalan Autonomous Government and the Spanish Government, all partnering with UNESCO, the Forum was a 141-day celebration of three main themes: cultural diversity, sustainable development and conditions for peace. Large- and small-scale exhibitions, workshops, markets, performances and other events gave visitors the opportunity to experience cultures and forms of entertainment from around the world as well as encouraging fresh perspectives on the key phenomena characterizing the 21st century. The Forum's exhibitions analyze these phenomena and encouraged visitors to interact.

Saeta Estudi (Bet Cantallops and Pere Ortega), in cooperation with Margarida Costa-Martins, was commissioned to create three installations for the Forum's Haima section: Refugees and Displaced Persons: Living on the Run, designed for Doctors without Borders; Arms for Disarmament, for the International Peace Bureau; and Women and War, an exhibition for the International Red Cross Museum. The three installations composed one thematic block. The aim of the exhibition design was to create a setting in which the visitor could feel some ethical responsibility and solidarity, by the way of welcoming, disconcerting, contemplative and thought-provoking spaces.

The main Forum events were held along the waterfront in a purpose-built complex between Barcelona and Sant Adrià de Besòs. Other events took place museums and cultural spaces around the city.

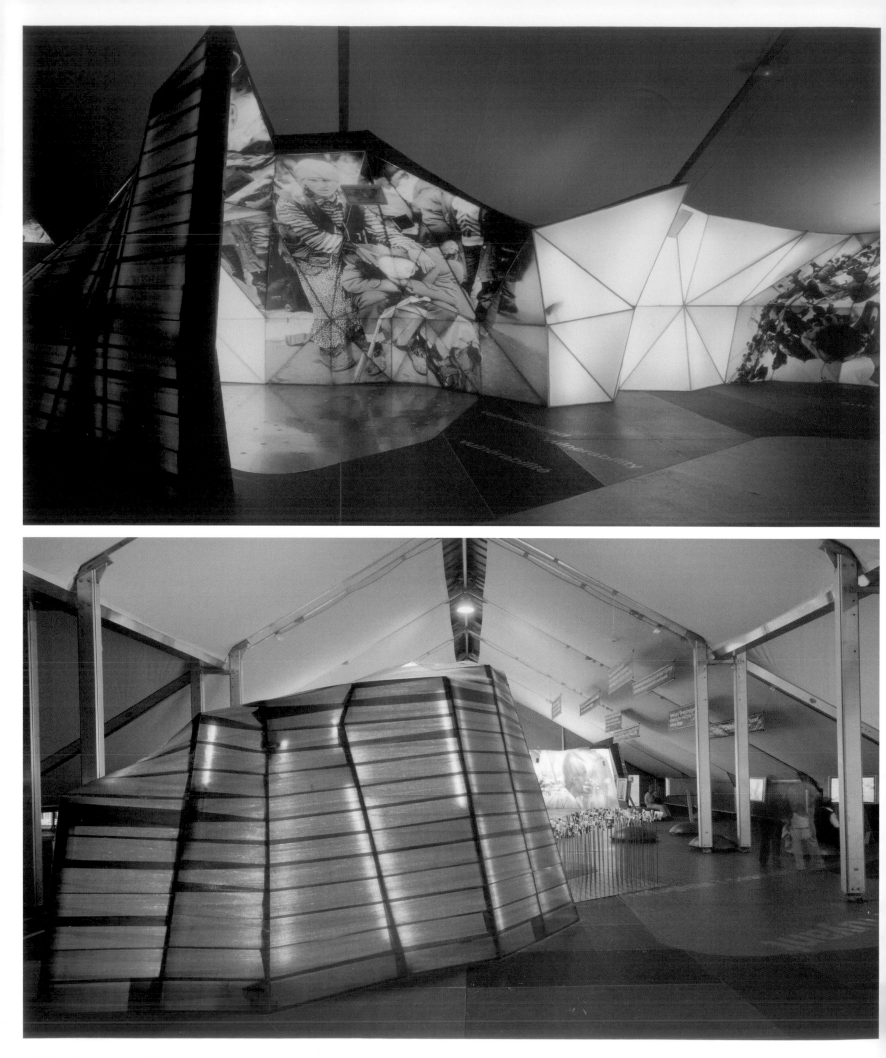

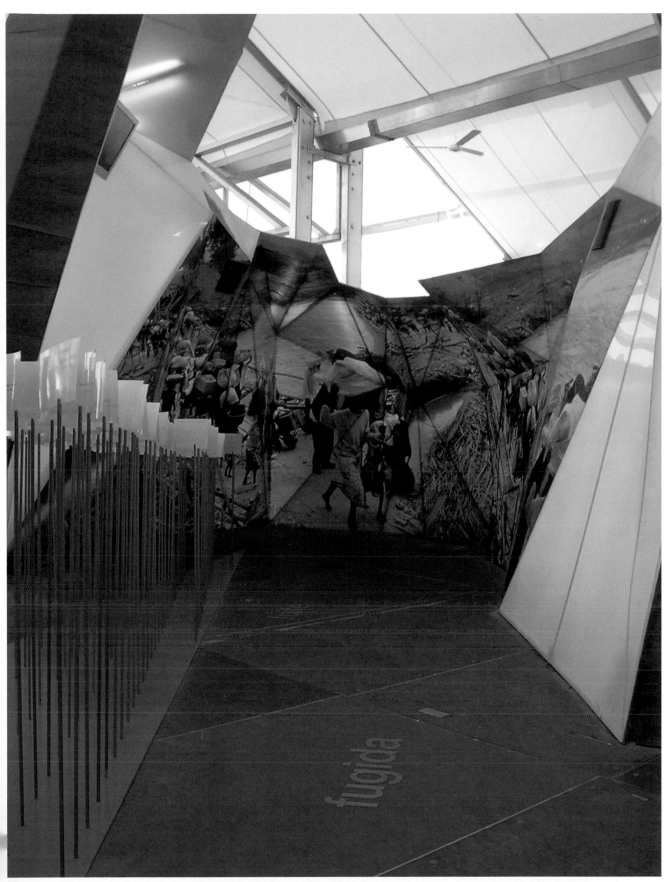

Refugees and Displaced Persons: Living on the Run:

The main elements of this installation designed for Doctors without Borders are five organic volumes covered by a blue fabric, the same fabric used to build shelters for displaced persons. Large-scale backlit images illustrate the refugees' different phases.

The focus of this installation is the emotional aspect of living on the run, it underscores the physical and psychological experience of displaced persons. Symbolic scenes reveal emotions metaphorically through sounds of fear, photographs of the good times, a dying light, and indispensable medicine, among others.

At the end of this emotional journey through less fortunate people's lives, the exhibit includes an open space where visitors can contemplate their own feelings and personal lives.

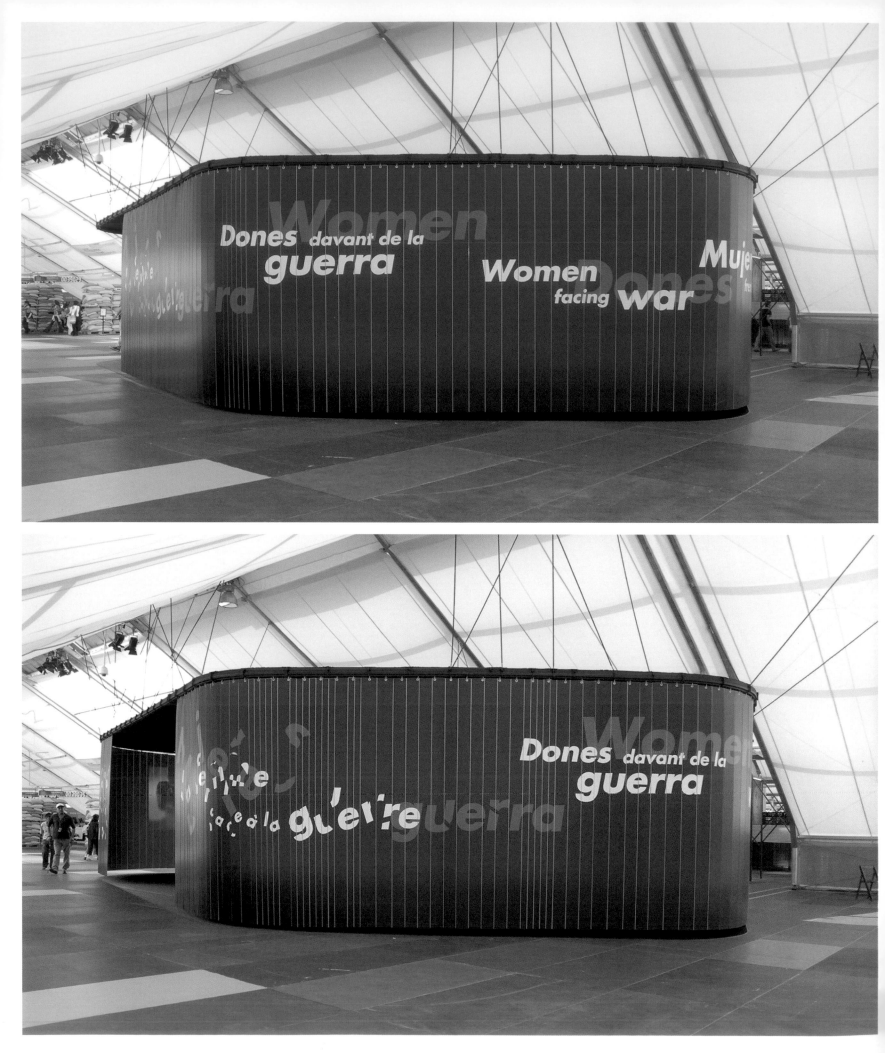

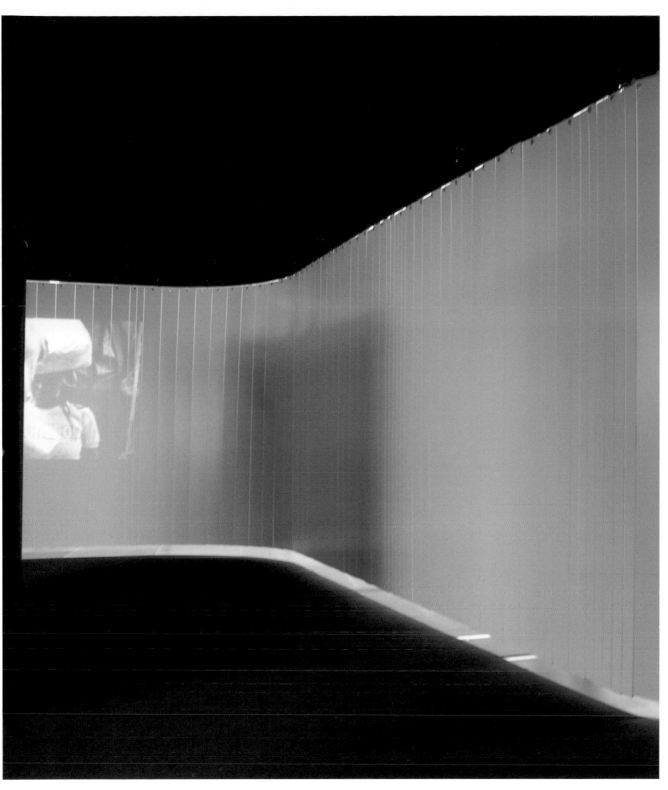

Women and War:
This installation depicts the role of women in armed conflicts. Women are presented as survivors of war, rather than victims, with an active role in post-conflict reconstruction and everyday life.

The installation is made up of two elements. The first element is a semi-enclosed area with two large screens that move slowly, almost imperceptibly. The installation's title slowly disappears on the black exterior of the space, as the walls advance. Inside is an audiovisual presentation explaining eight phases in these women's lives.

An audio feature plays women's voices relating their experiences during certain wars. To be able to hear these voices, visitors have to get close to the wall, making this an intimate experience.

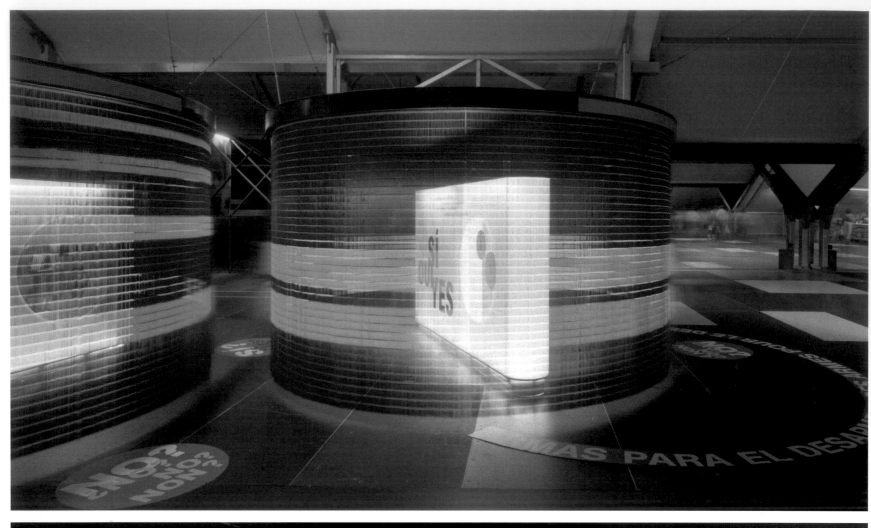

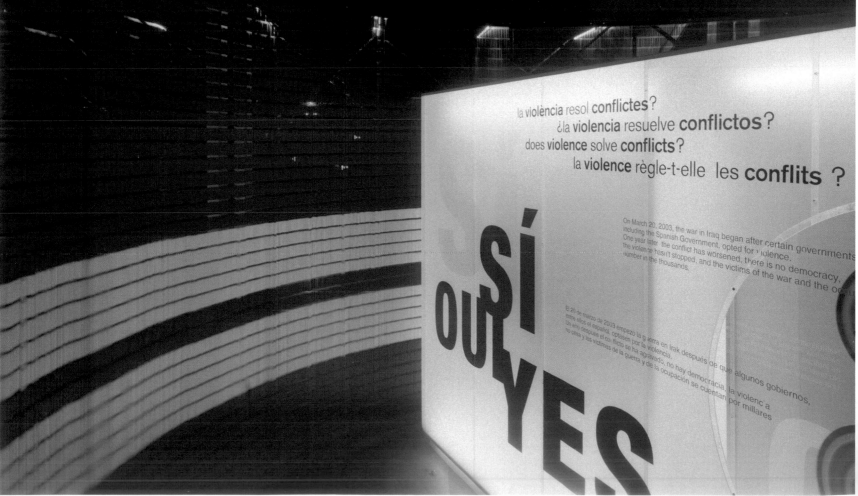

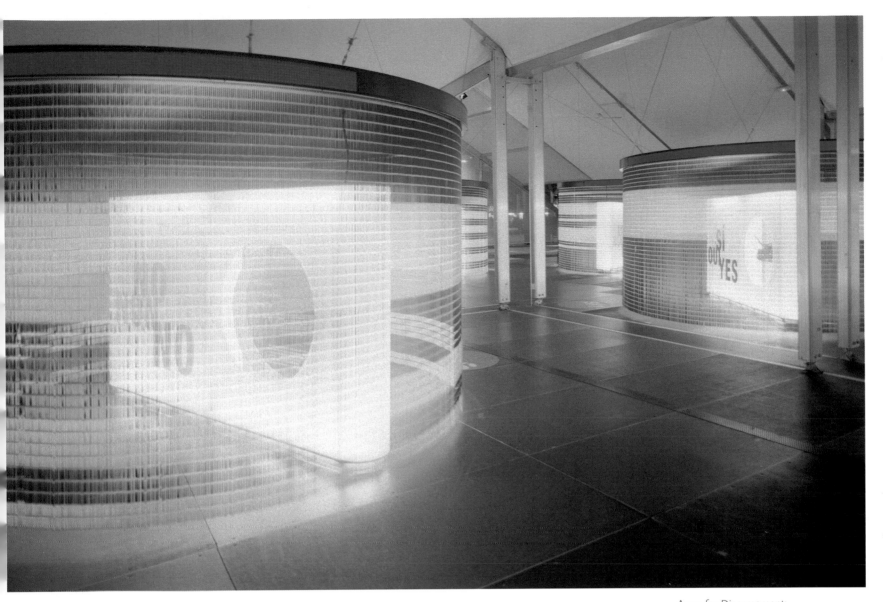

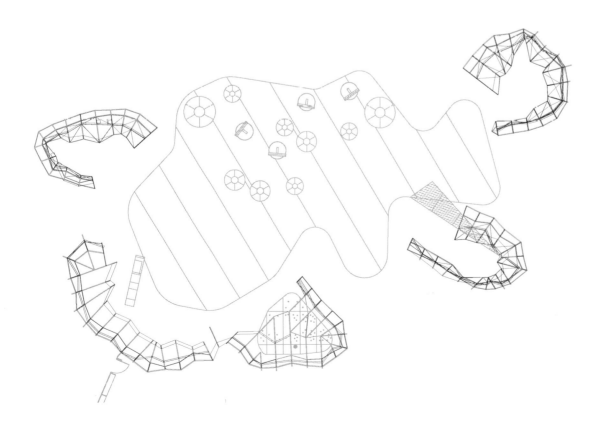

Arms for Disarmament:
With this installation, the International Peace Bureau sought to emphasize the importance of disarmament in the prevention of conflicts. Seven exhibition areas depict the serious consequences of the proliferation or use of certain weapons.

Double walls symbolize the two sides of the same reality. Presented in a question-option-answer form, the displays brighten and dim periodically thus arousing curiosity and attracting visitors.

The designers purposefully used bold familiar domestic materials. Red-and-White tubular curtains hang down to the ground. Dynamic lights located in the round curtain rods, illuminate the questions projected on the LED screens. Each booth is suspended by cables from the Haima structure, demonstrating to their lightness.

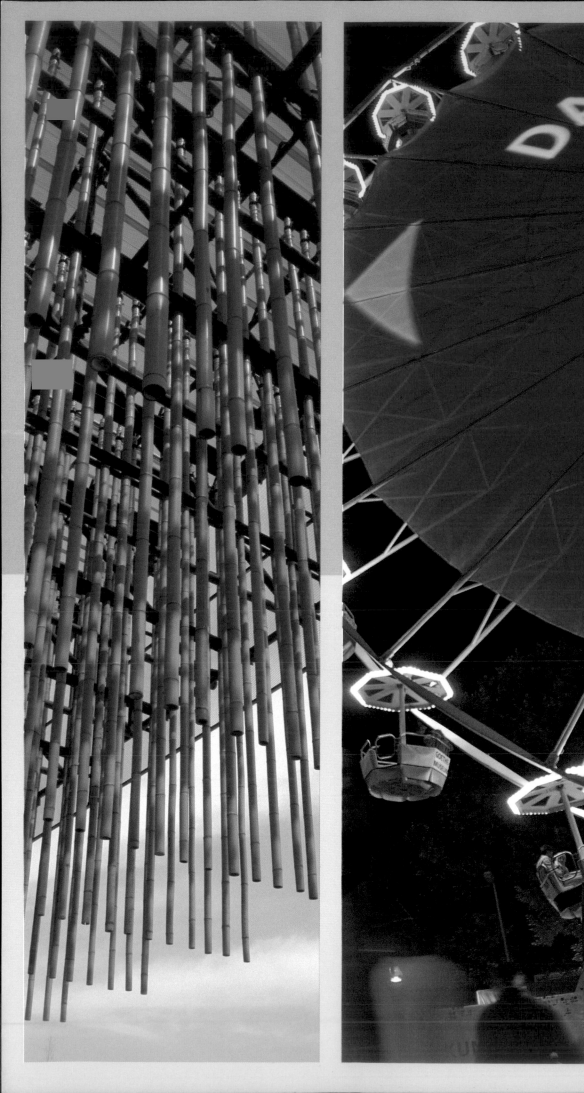

LEISURE

Outdoor and Other Innovative Exhibitions

A spectacular, three-day audiovisual overture celebrating one of the world's most beloved sporting events, an annual architectural competition organized by a private institution, a government-led local art project, and a two-day cultural event are some of the leisure events that encourage designers, architects and other communicators to experiment with new material and technologies.

Be they annual, biennial, quadrennial, organized by local governments or initiated by private institutions at a national or international level, these temporary large-scale events and projects are observed by many and remembered by most.

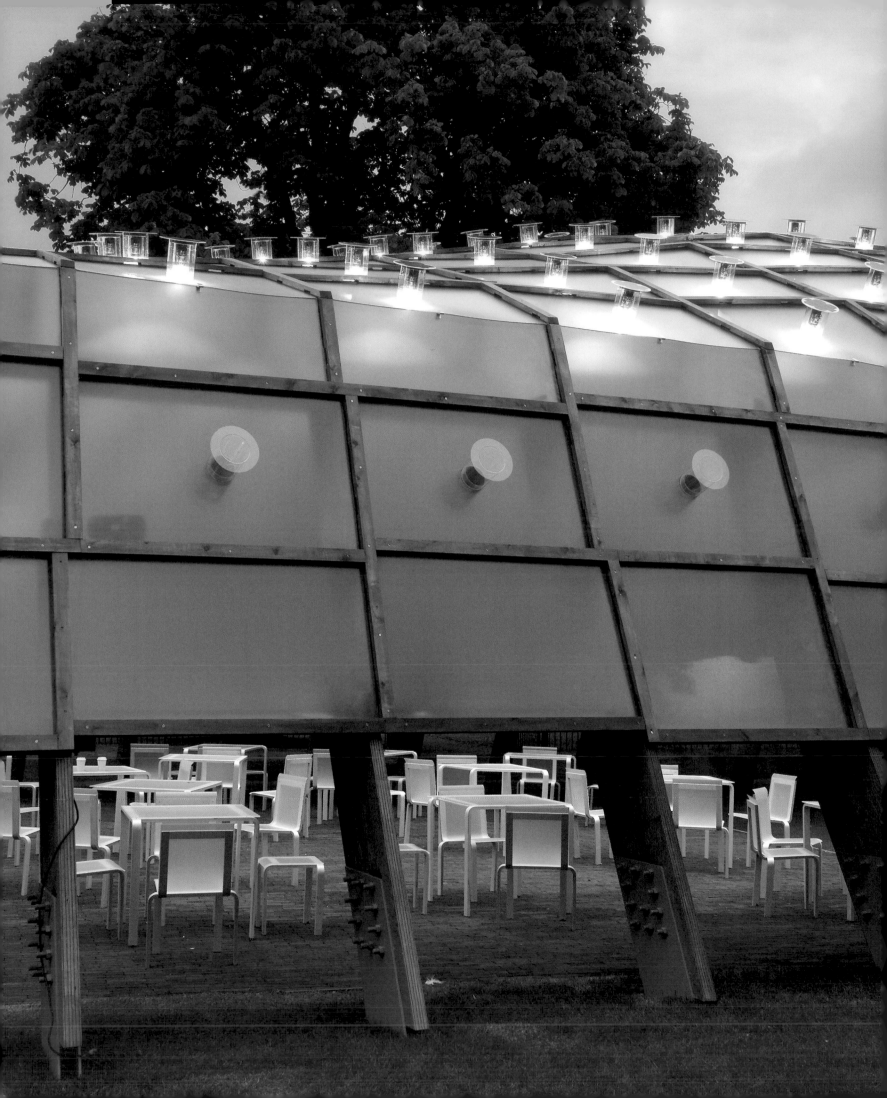

SERPENTINE PAVILION
Armadillo-like Structure

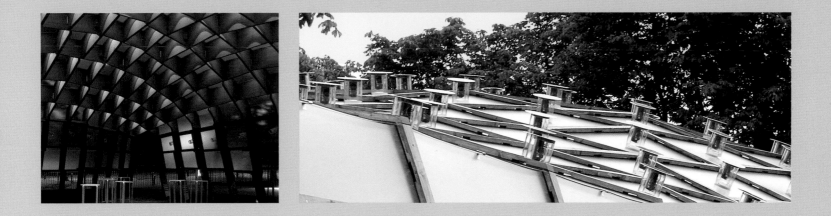

Souto Moura & Álvaro Siza

Address
Souto Moura Arquitectos Lda.
R. do Alcixo 53, 1°
4150-043 Porto
Portugal

Location
Serpentine Gallery, London, UK
July–August 2005

Other cities
None

Primary material
Laminated timber (Laminated Veneer
Lumber), translucent polycarbonate panels

Photography
© Duccio Malagamba

In 2000, the Serpentine Gallery in London, England, began to commission the annual building of a three-month temporary pavilion near the neoclassical building that houses the gallery of modern and contemporary art. In summer the pavilion is used as a café during the day and as a venue for parties, special programs and events in the evening. The ambitious aim is to create an instant work of architecture worthy of any show within the Serpentine Gallery.

Portuguese architects Eduardo Souto de Moura and Álvaro Siza were invited to design the 2005 pavilion. Architects of past pavilions include MVRDV, Oscar Niemeyer, Toyo Ito, Daniel Liebeskind and Zaha Hadid. Paramount to the Portuguese architects' pavilion design was the creation of an aesthetic dialogue between the temporary structure and the permanent gallery. Though Siza and Souto de Moura are known for their clean white lines, here they opted for a more vernacular design with their wooden-lattice structure, constructed out of an innovative strong laminated timber. The Laminated Veneer Lumber, made by Finnforest in Finland, allows light to pour in during the day. The sheets of timber are stained to resemble the nearby oak trees. The cladding consists of translucent polycarbonate panels, each of which is penetrated by a ventilation cowl; Battery-operated and solar-powered lights give the building a luminous aura at night. The pavilion, with its ethereal glow, is perfectly described by Álvaro Siza: "Lazy but restless, it scatters a golden light that puts its stamp on the London sky—peaceful in its corner of the world."

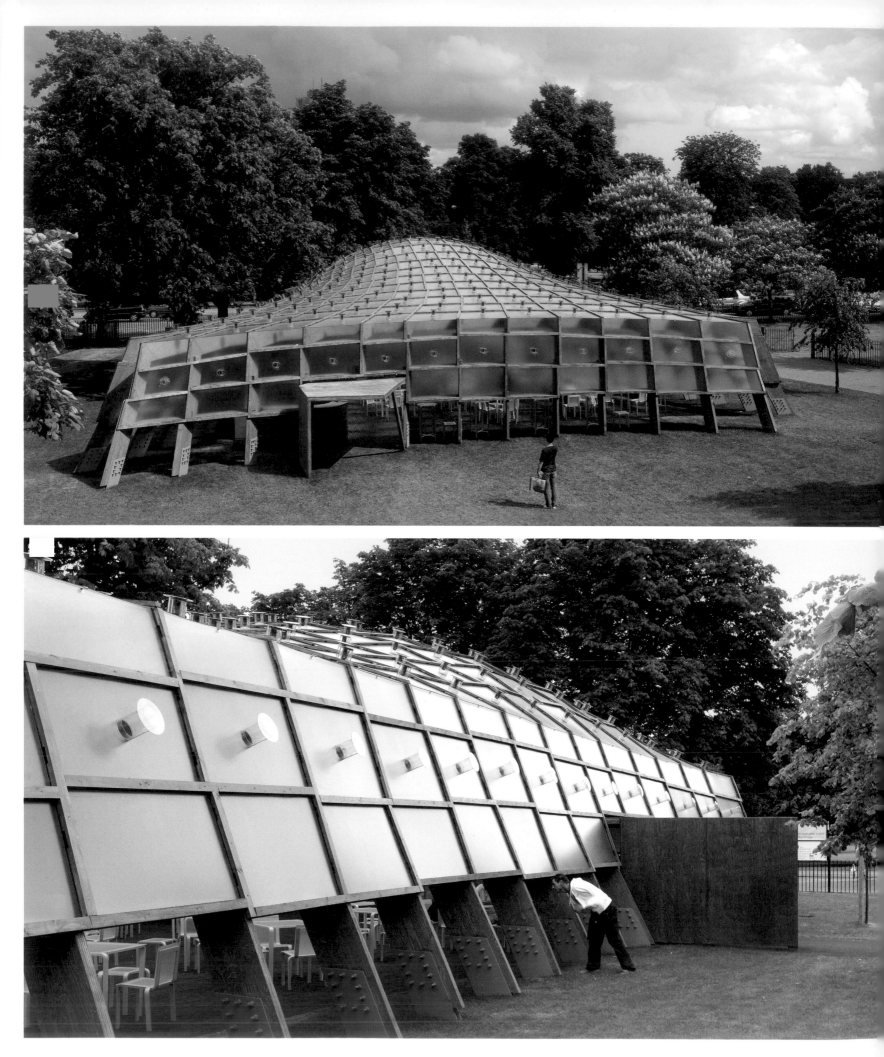

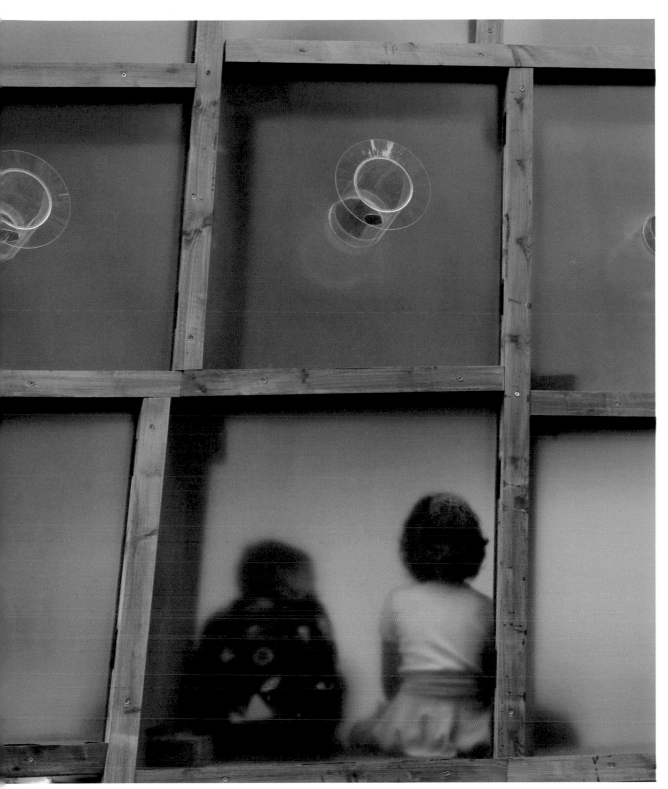

The pavilion is a wooden lattice structure open at the bottom to a height of 1.3 meters at the lower part and clad above that with polycarbonate panels. Light streams in through the grid during the day.

Each translucent polycarbonate panel is perforated by a ventilation cowl that holds a battery-operated, solar-powered light. This detail ensures there are no cables to hide or to spoil the effect of the pavilion.

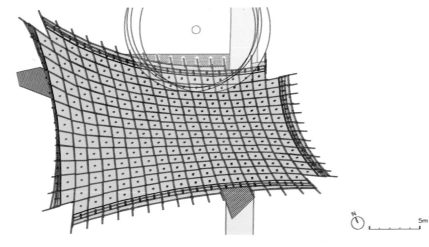

5m

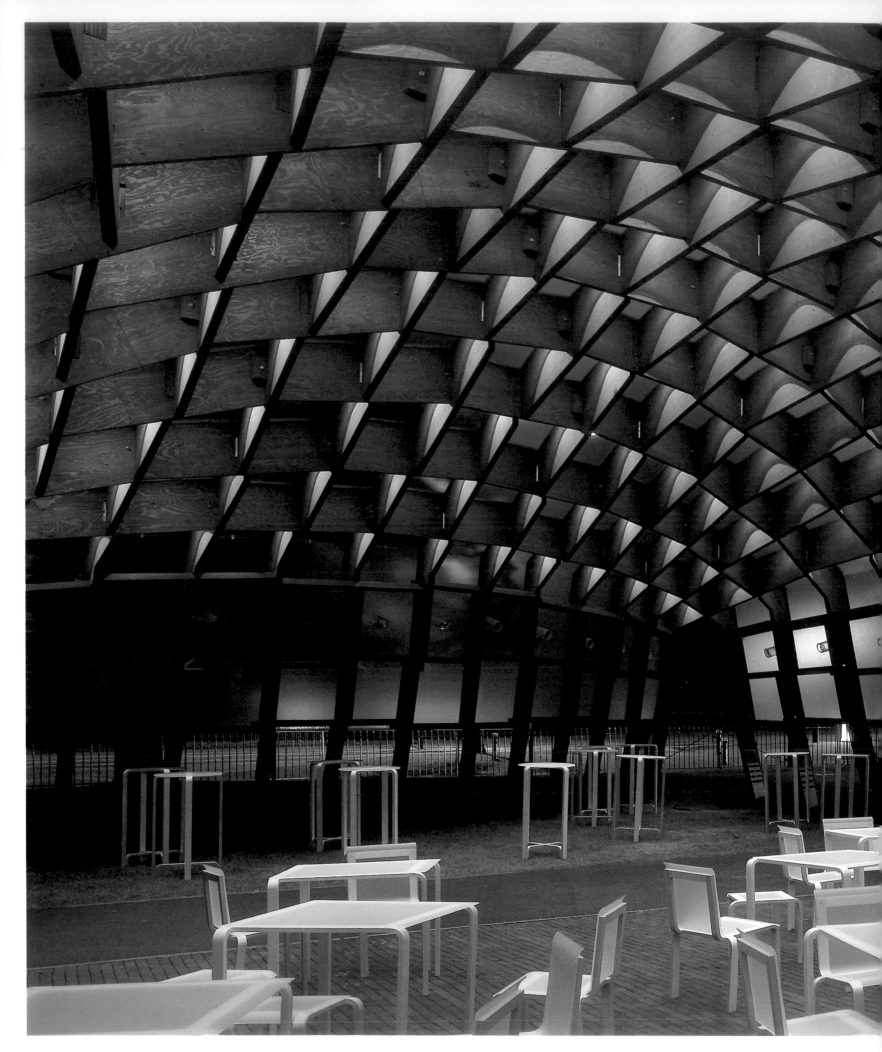

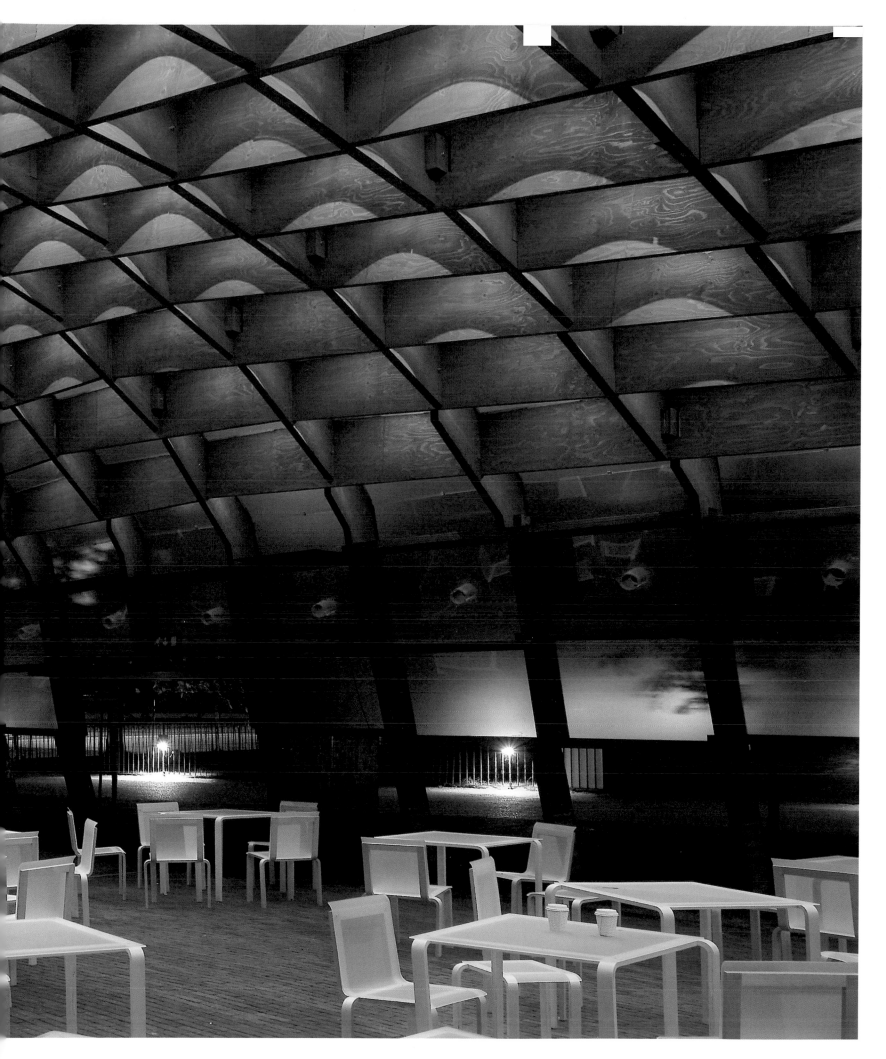

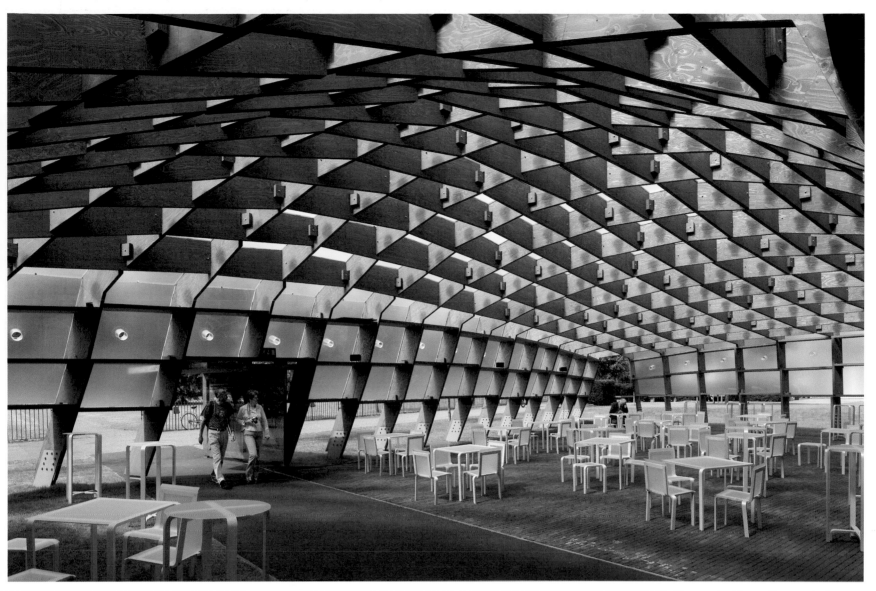

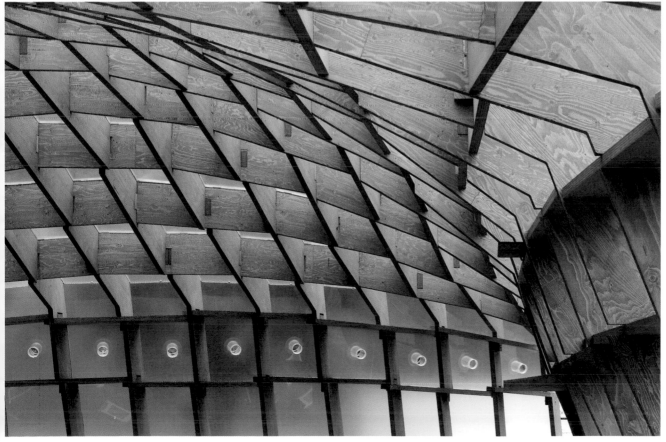

The tortoise-like pavilion was built using technologically innovative Finnish materials. It serves as a café during the day and as a venue for parties and activities at night.

The pavilion is located within the grounds of London's Serpentine Gallery. Álvaro Siza and Eduardo Souto de Moura's design is the fifth in the series of Serpentine Pavilions. Since 2000 the gallery has been commissioning different architects to design each summer's pavilion.

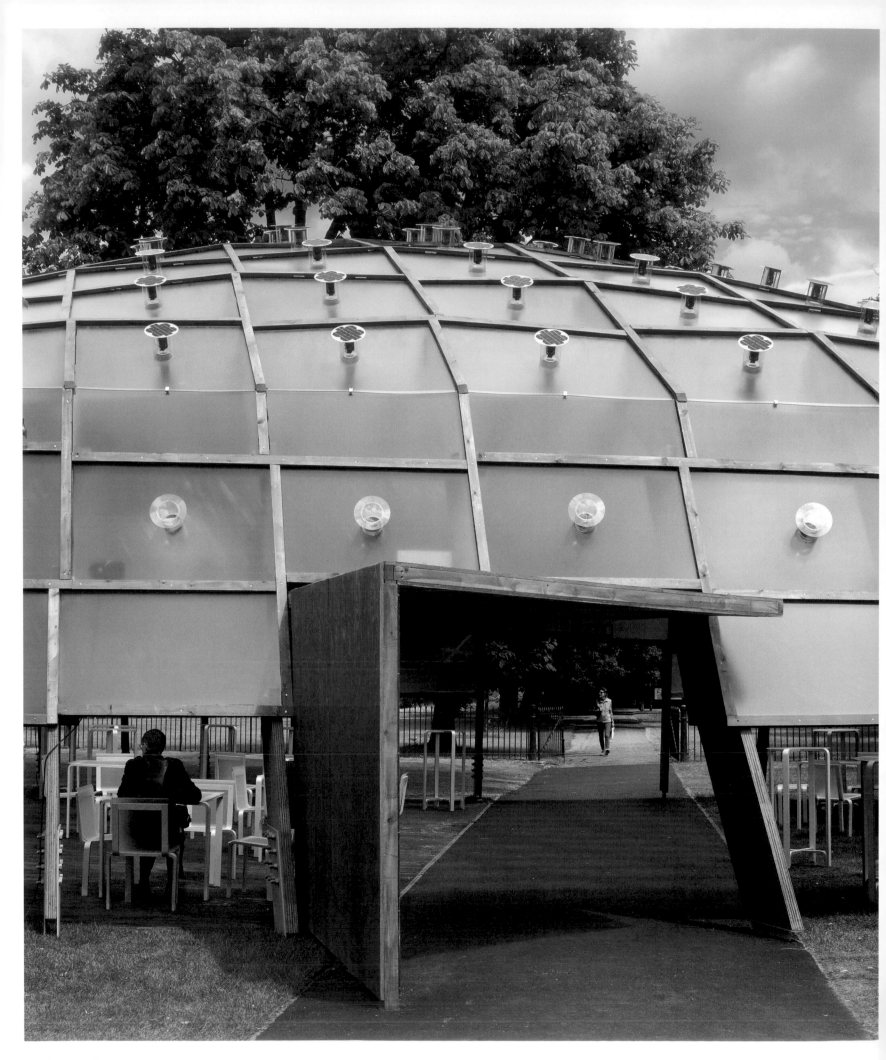

"The Pavilion leans towards the neoclassical building like an animal with its paws riveted to the ground, tense with the desire to approach but nevertheless restrained. Its back is distended, its hair standing on end. It glances sideways, with antennae twitching towards the building. It obliges it to define a space. It has to stop, lowering its head; it cannot go forward. But will it eat the building one day!" (Álvaro Siza)

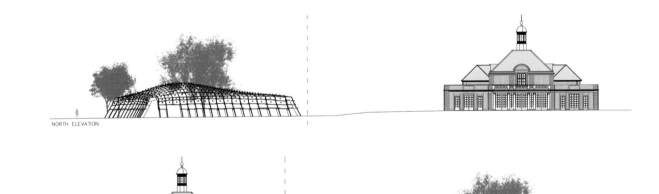

NORTH ELEVATION

SOUTH ELEVATION

TRANSVERSAL SECTION

ART/WHEEL

Artistic Amusement

Atelier Markgraph

Address
Atelier Markgraph GmbH
Hamburger Allee 45
60486 Frankfurt am Main
Germany

Location
Frankfurt's riverbank, Frankfurt, Germany
Inauguration August 26, 2005

Other cities
None

Primary materials
Ferris wheel, gauze, tarpaulin, Meso vvvv

Photography
© Amir Molana, Cem Yücetas

Once a year, the Museum Riverbank Festival turns Frankfurt's riverbank into a focal point for artistic diversity. In 2005, Art/Wheel brought the city's world-class museums out into the public eye, projecting images of hundreds of masterpieces onto a Ferris wheel. The Ferris wheel–cum–media expressed the installation expressed the festival's motto, "World Culture, Cultural World"; as a large, memorable central symbol, it heightened public awareness of the Rhine-Main region's cultural treasures.

Art/Wheel fused fairground romance with the German city's modern skyline and innovative technology. The result was a show of light, animations and media that could be seen from up to two hundred meters away. Images of one hundred masterpieces from sixteen different museums were projected onto 450 square meters of canvas suspended forty meters high. The surrounding high-rise buildings provided the perfect set while the neutral frame of the wheel acted as a stage and the gondolas as its characters. Each gondola represented a different museum. When the gondola was selected by the computer-controlled pointer, a corresponding animation ran on the wheel's hub, while the guests riding a gondola learnt more about "their" museum and its masterpieces. This mixture of grandeur, beauty and momentum fascinated thousands of visitors and turned the 2005 Riverbank Festival into a huge success.

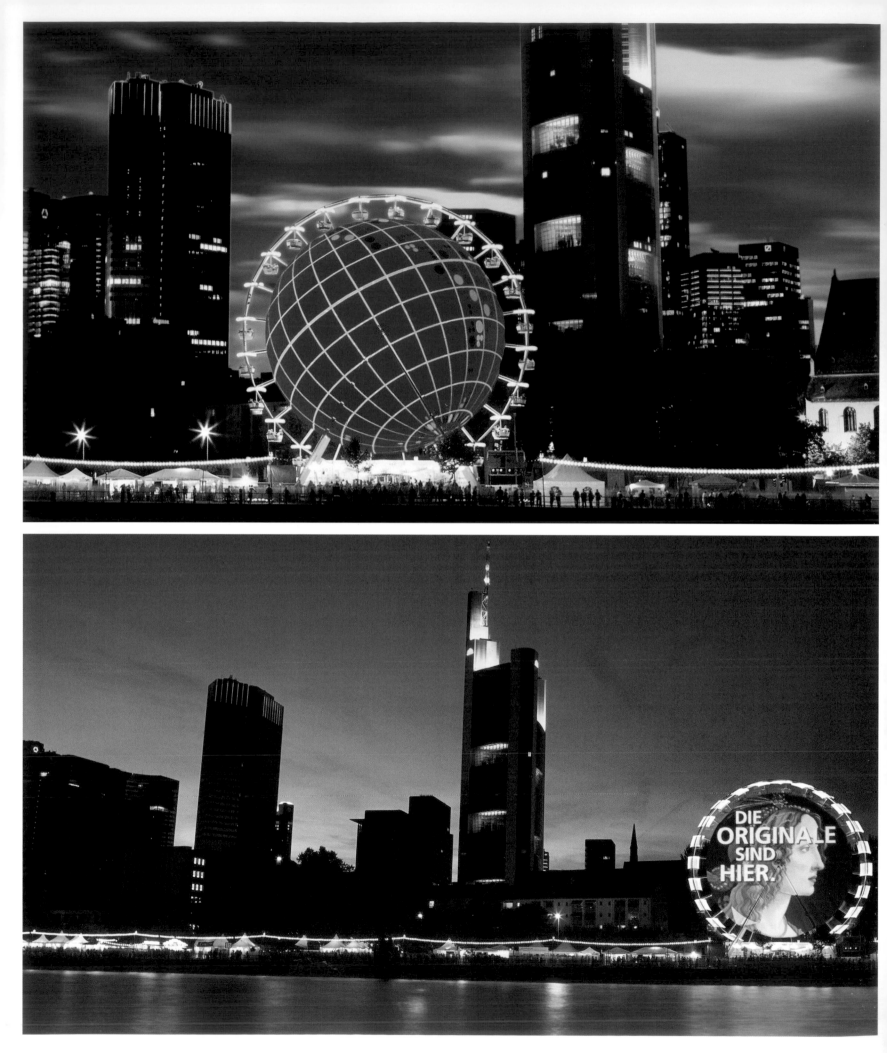

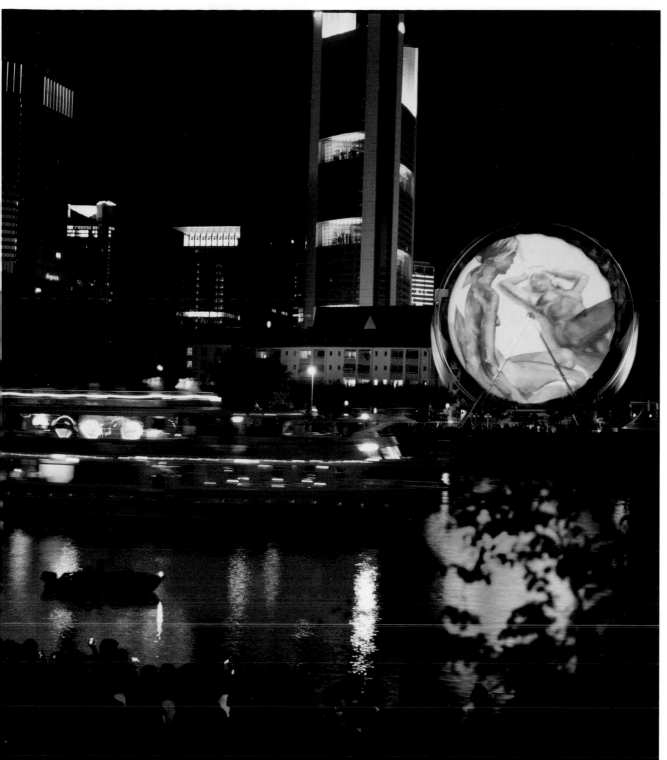

Frankfurt's riverbank turned into a unique spectacle in August 2005 as Art/Wheel lit up the city's skyline.

Impressive light, media and animation projections heighten the public's awareness of the city's diverse cultural treasures.

Images of one hundred masterpieces from sixteen different museums can be seen from up to two hundred meters away.

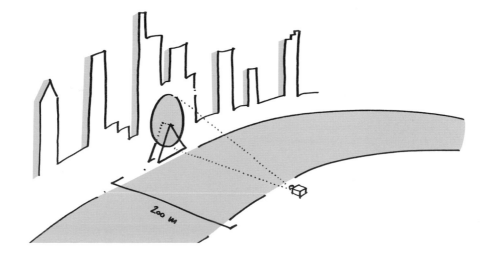

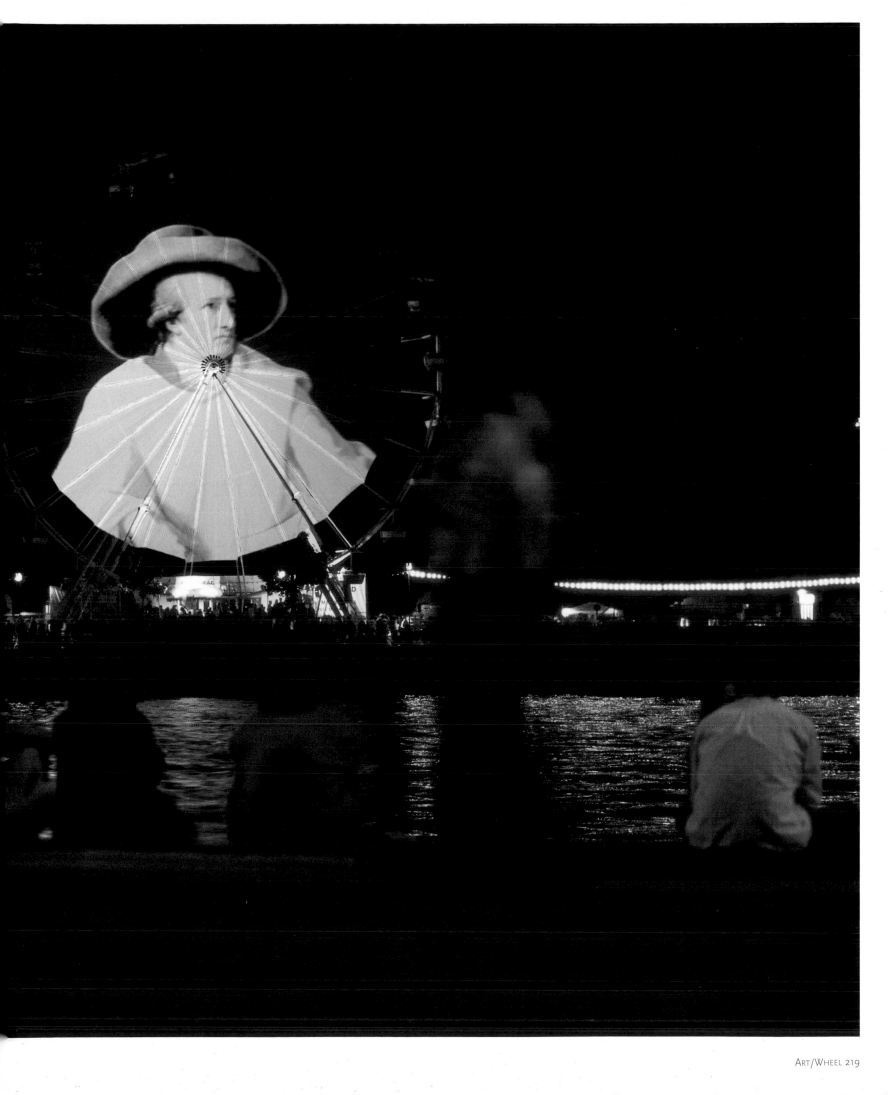

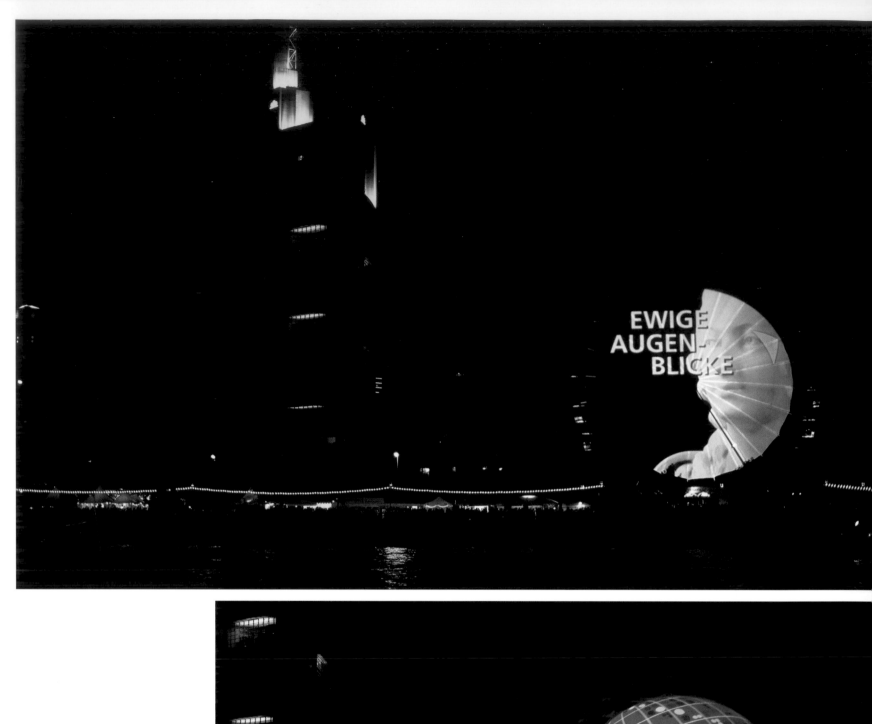

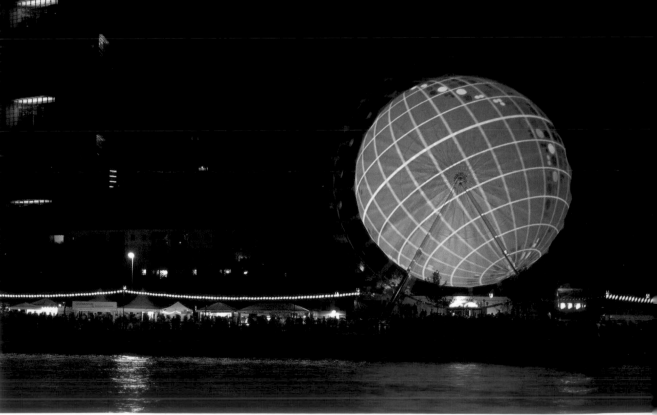

Sensors synch digital projections to the movement of the wheel. Each of the wheel's gondola represents a different museum. When a gondola is picked by the pointer, a corresponding video is projected on the wheel's hub. The guests inside the gondola learn more about "their" museum and its masterpieces.

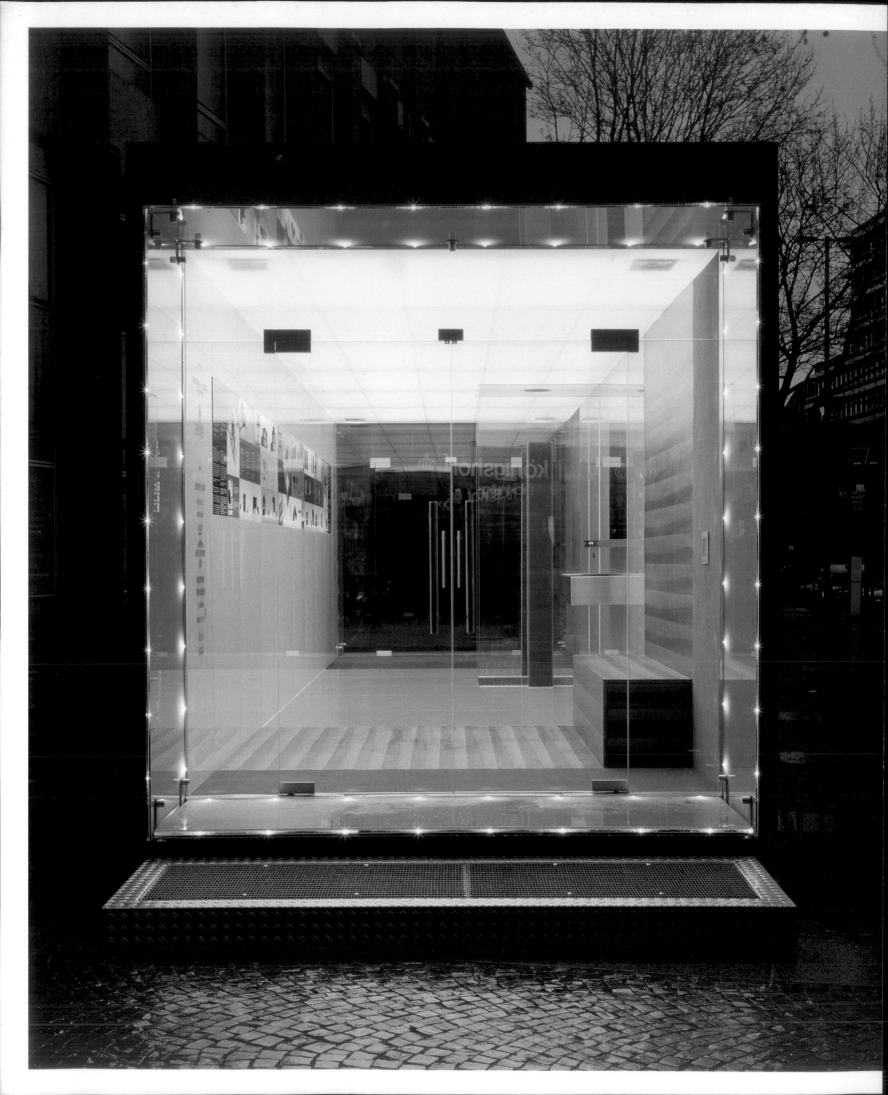

M.A.D.

Modular Architecture Design

Gatermann + Schossig

Address
Gatermann + Schossig
Richartzstrasse 10
50667 Köln
Germany

Location
Passagen, The Musuem of Applied Art,
Cologne, Germany
January 19–25, 2004

Other cities
None

Primary materials
Colored glass, LED technology, wood, Trespa,
Prodema, Betoglass

Photography
© Marcus Haefke

M.A.D. (Modular Architecture Design) was designed by Gatermann + Schossig for the German design event "Passagen 2004." This event coincides with the annual Cologne International Furniture Fair (IMM). IMM Cologne is one of the world's leading trade fairs for the furnishings sector. Traditionally held in January, IMM is the year's first event to present the latest home trends; it attracts more than 1,000 exhibitors and over 100,000 visitors from retailer's to specialist, interior designers, joiners, carpenters and interior decorators.

Every two years "Passagen" is staged; it's aimed at young designers and producers from the interior design field. Begun in 1990, the forum now includes more than 150 exhibitors. Gatermann + Schossig's M.A.D. is a presentation of some innovative concepts in interior and bath design. Responding to consumers call for customized and individualized living spaces, the German-based architects and their partners came up with an innovative glass design for bathrooms, including touch-controlled electronic panels and luminous entrance modules, their presented it at Passagen 2004.

Passagen is renowned for outstanding presentations of designs by Jasper Morrison, Ross Lovegrove, Philippe Starck and Ingo Maurer, among others.

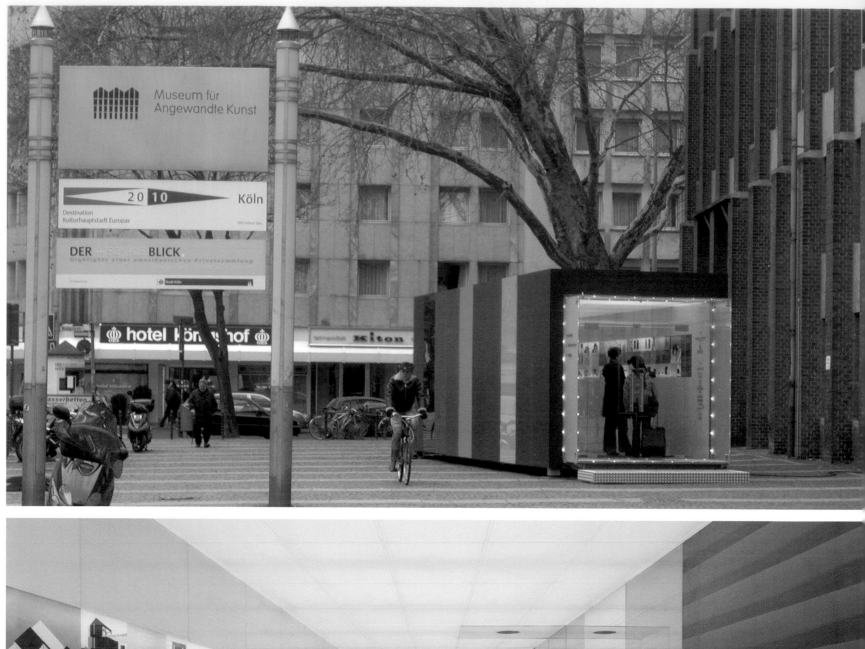

The modular structure presenting Gatermann + Schossig's innovative interior and bath designs is located in the center of Cologne. It formed part of Passagen 2004, a design exhibition that runs parallel to the Cologne International Furniture Fair and turns Cologne into a design metropolis for a few days.

Wooden accents and glass panels create a modern and attractive design which is also practical.

Electronic touch panels are used instead of traditional fittings. Other functions and accoutrements (water, light, lotion) are encased in stainless steel modules. Glass is the dominant material in the bathroom, shown in a number of different colors and surfaces.

The cube made of stainless steel an glass constitutes a charming modern bathroom.

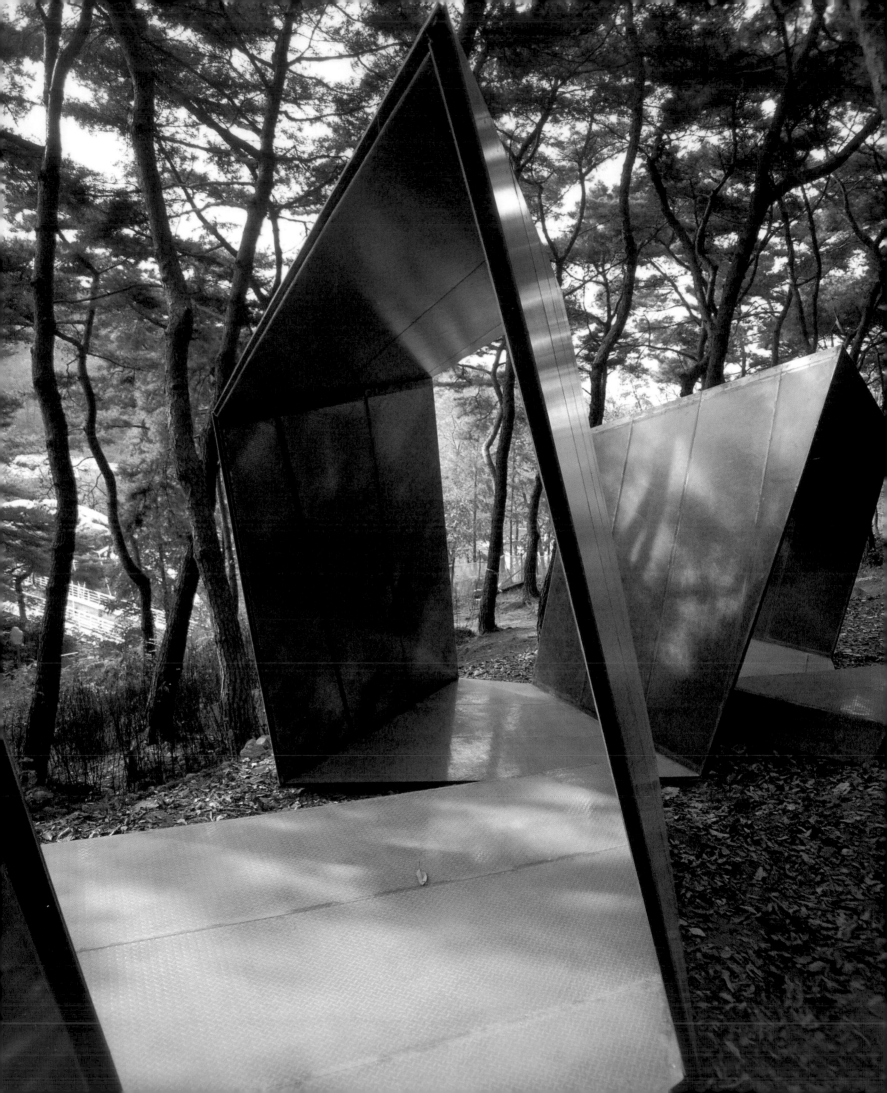

PAPER SNAKE PAVILION
Scaling Heights

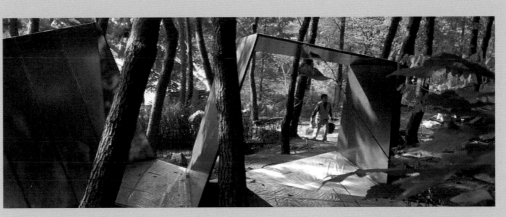

Kengo Kuma & Associates

Address
Kengo Kuma & Associates
2-24-8 BY-CUBE 2F
Minamiaoyama Minato-ku
107-0062 Tokyo
Japan

Location
Anyang Resort, Anyang,
Republic of South Korea
Anyang Public Art Project 2005 (APAP 2005)

Other cities
None

Primary materials
Semi-transparent paper honeycomb
panels, FRP sheets

Photography
© Javier Villar & Satoshi Erik Adachi

The Local Government Act took effect in Korea when civilian government came into power, allowing regions and communities greater autonomy in relation to the central government. Local governments understood the importance of cultural projects to promote their regions. The local government of Anyang invested US $20 million to turn the whole city into an art park. The Anyang Public Art Project (APAP) in November 2005 marked the first occurrence of this annual event.

Kengo Kuma & Associates was one of many firms invited to help transform the Anyang Resort into an "art valley" as part of APAP 2005. The architects designed a resting place in the forest where visitors could see works by various international artists and architects and also look down to the valley below. Kengo Kuma & Associates' idea was to create a pavilion that wound among the trees and followed the site's topography. They let nature guide them to the appropriate site for their Paper Snake Pavilion.

The structure is made of a 47-millimeter-thick "sandwich panel," a strong but light and semi-transparent material, so called because the paper honeycomb is sandwiched between two FRP sheets. The edges and joints are sealed to prevent rain from reaching the honeycomb. Fifteen panels of various sizes are each divided into two or three sub-panel, resulting in a very irregular and dynamic shape. The translucence of the material means that natural light can enter and shadows can be created. In this way, the pavilion becomes integrated into its natural surroundings and the weather conditions.

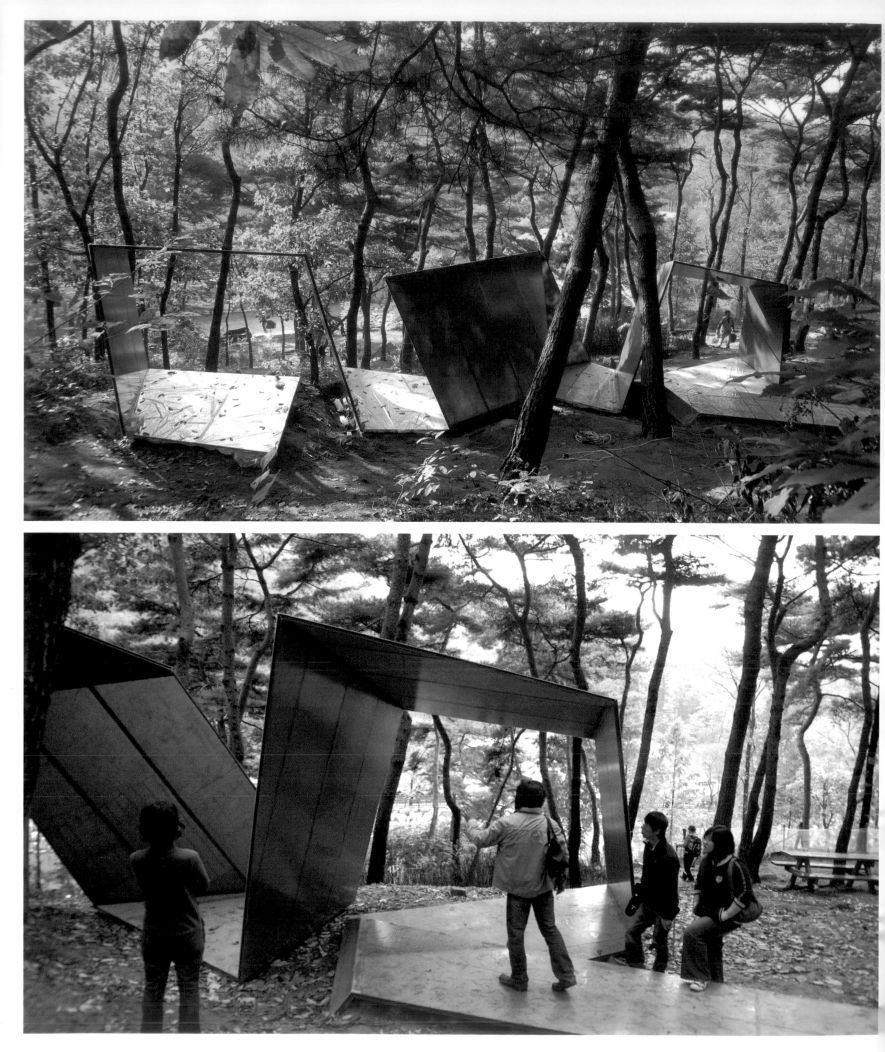

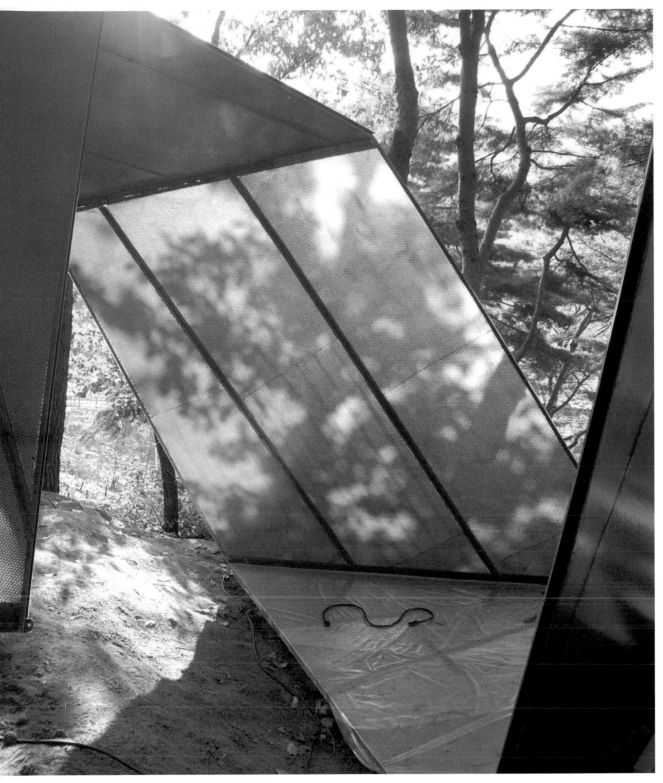

Kengo Kuma & Associates designed the Paper Snake Pavilion for Anyang Public Art Project 2005, the first annual art event in Anyang City, on the periphery of Seoul in South Korea.

The architects let nature guide them to the appropriate spot for Paper Snake Pavilion. The pavilion winds among the trees and follows the site's topography.

The building materials allow light to enter and create shadows on the pavilion, making the structure part of nature and reflecting the weather conditions.

SIDE ELEVATIONS _ E : 1 / 400

river river

FRONT ELEVATION _ E : 1 / 100

+64.0m
+63.0m
+62.0m
+61.0m
+60.0m

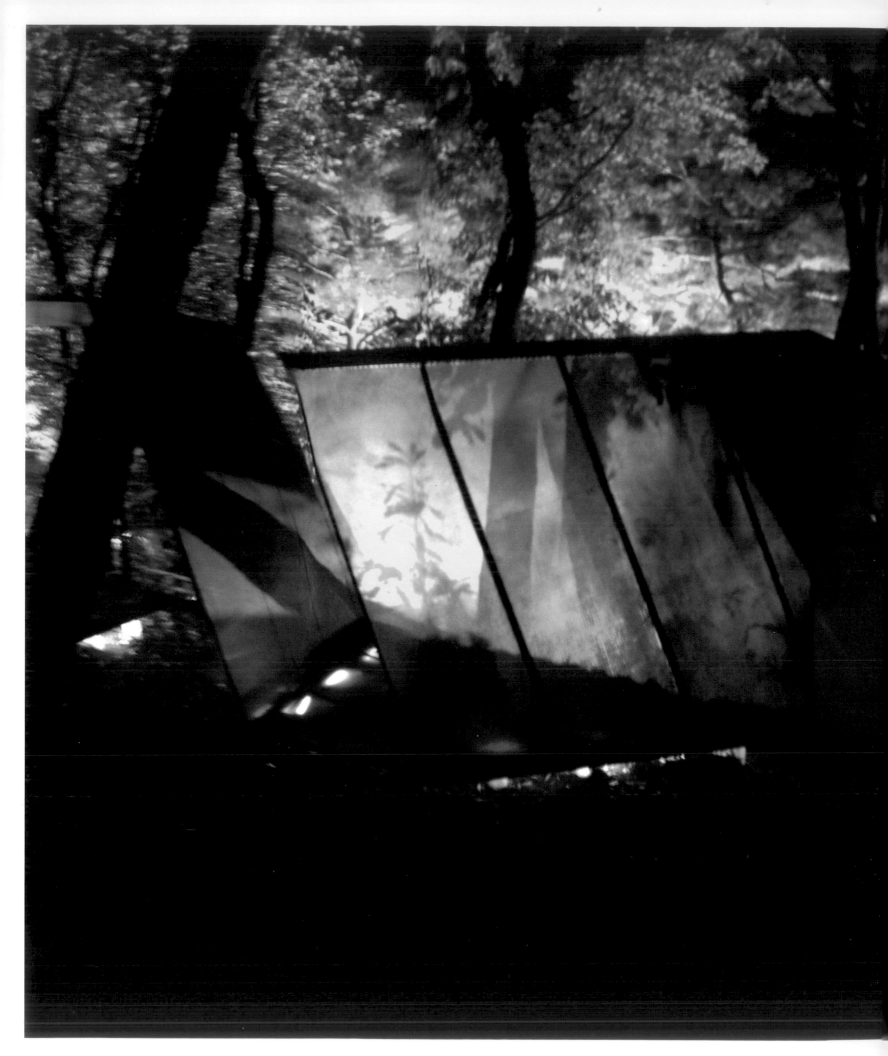

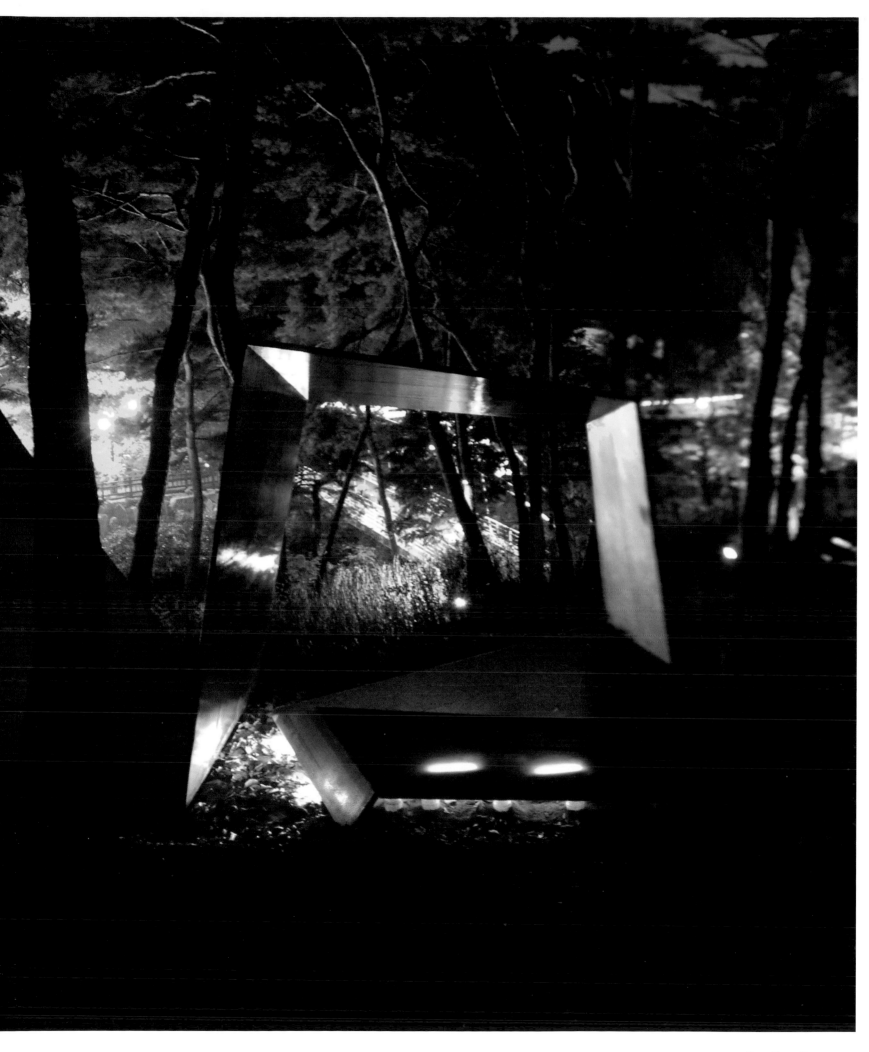

The light and semi-transparent yet strong structure is made of fifteen sandwich panels each a 47-millimeter-thick assemblage of paper honeycomb and FRP sheets.

The sandwich panel, traditionally used in airline aeronautics, is nowadays incorporated into many Japanese architectural designs.

The resting space is located in between trees, in a prime location from where visitors can look down to the valley and its river.

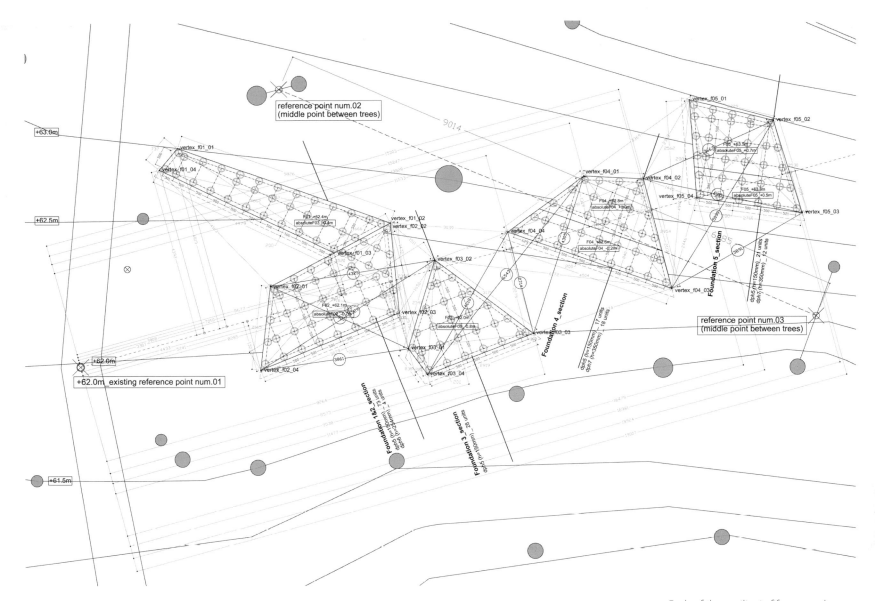

reference point num.02
(middle point between trees)

reference point num.03
(middle point between trees)

+62.0m_existing reference point num.01

Each of the pavilion's fifteen panels, measures approximately 10 square meters.

SITE PLAN s : 1 / 200

PROJECT BASIC DATA

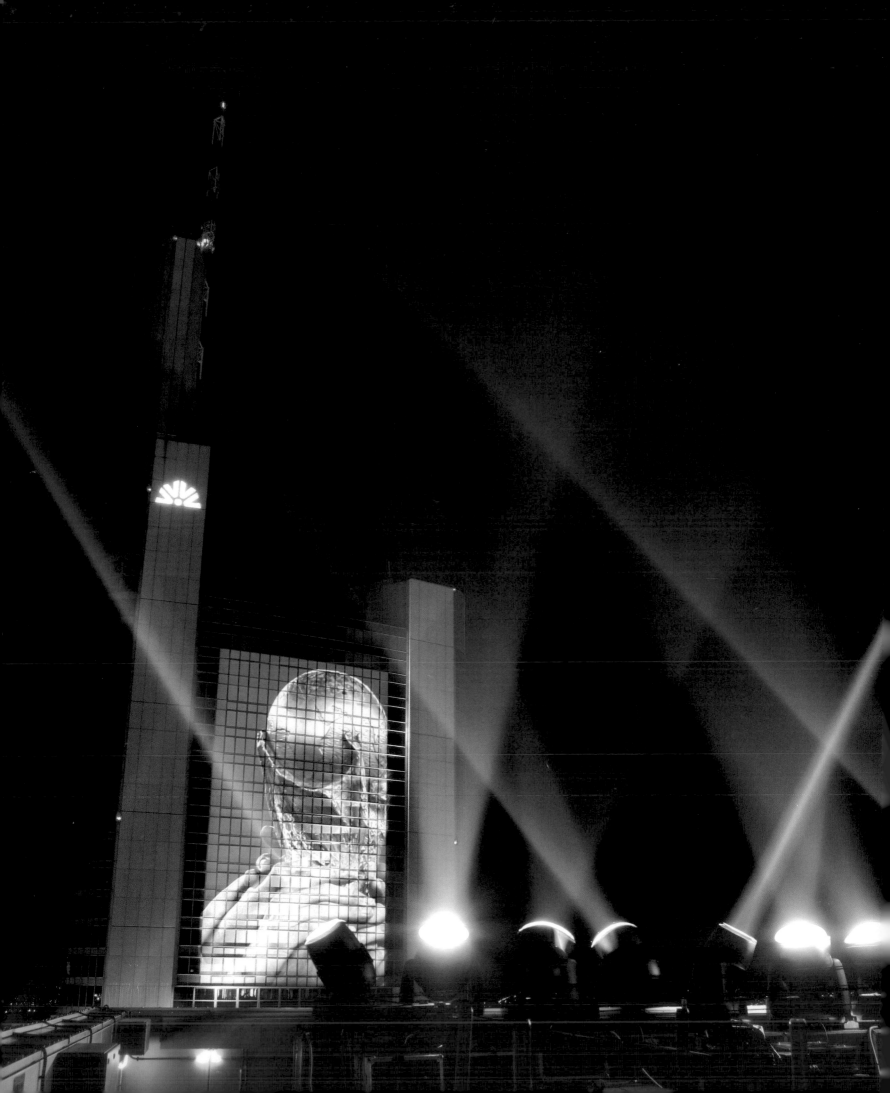

SKY ARENA
Public Entertainment

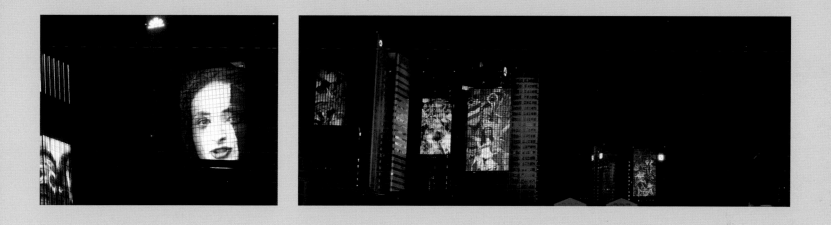

Atelier Markgraph

Address
Atelier Markgraph GmbH
Hamburger Allee 45
60486 Frankfurt am Main
Germany

Location
Frankfurt am Main, Germany

Other cities
None

Primary material
Projectors on celluloid strips

Photography
© Ralph Larmann

Although the 2006 World Cup officially kicked off in Munich, Frankfurt held a special three-day festival to celebrate the start of this international sporting event. Every night at 11:00 p.m., Atelier Markgraph, a Frankfurt-based agency that specializes in three-dimensional communication, illuminated the environment with Sky Arena, a show of light, pictures, graphics and music that turned the facades of the city's high-rise buildings into a giant album celebrating great football moments.

Frankfurt's skies perform this "nocturnal play" in eleven acts, representing eleven great football emotions: ambition, roughness, respect, mania, pride, hope, sorrow, and happiness. The images were selected from fifty years of football coverage and come to life as they are projected onto the buildings. The still photos appear animated via a simple technique involving slides and celluloid strips. The slides are projected onto celluloid strips, thereby taking on a lateral sense of movement similar to movies. Each slide appears on an average of four large-scale projectors.

The "play" lasted around half an hour and the projections were visible for miles around as Sky Arena covered a total area equivalent to two soccer fields (10,000 square meters). More than 60,000 square meters were available for spectators to watch the performance. More than 120 people were on site to make the show possible, while another forty industrial climbers attached sheets of special film to turn the buildings into giant projection screens. Around 20 kilometers of cable connected the projection areas, loudspeakers and sound systems.

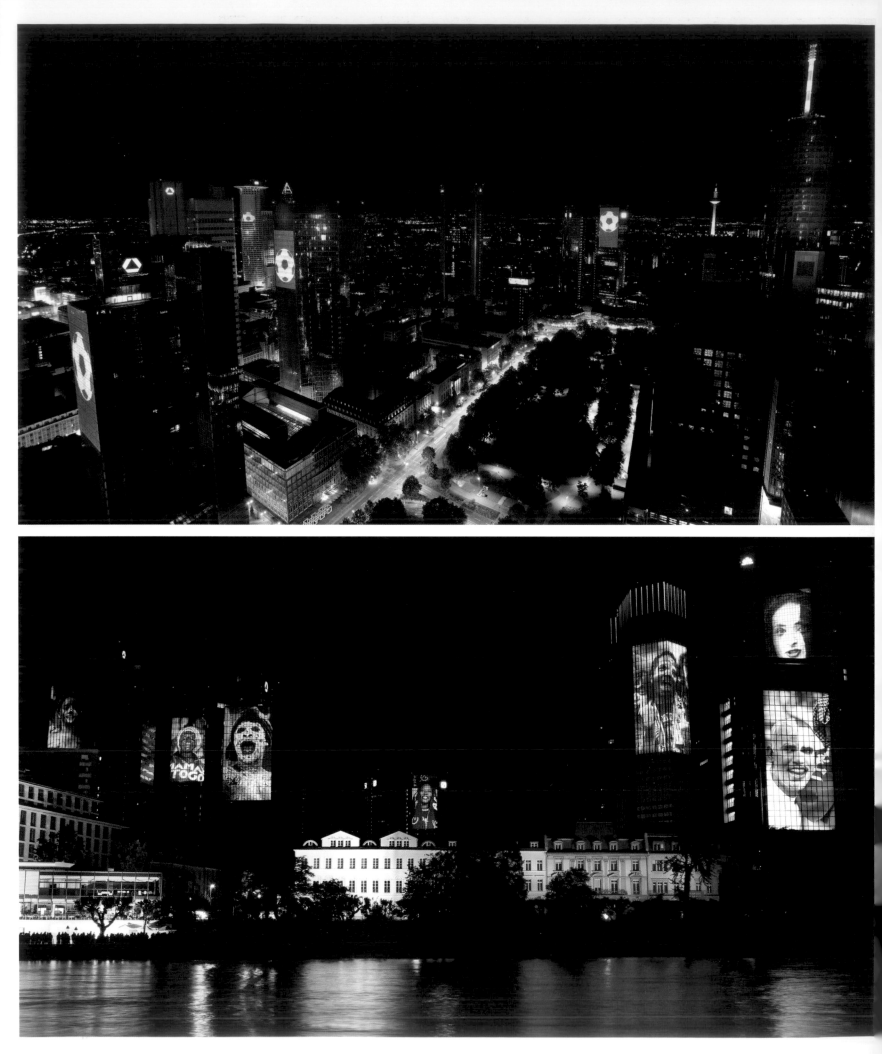

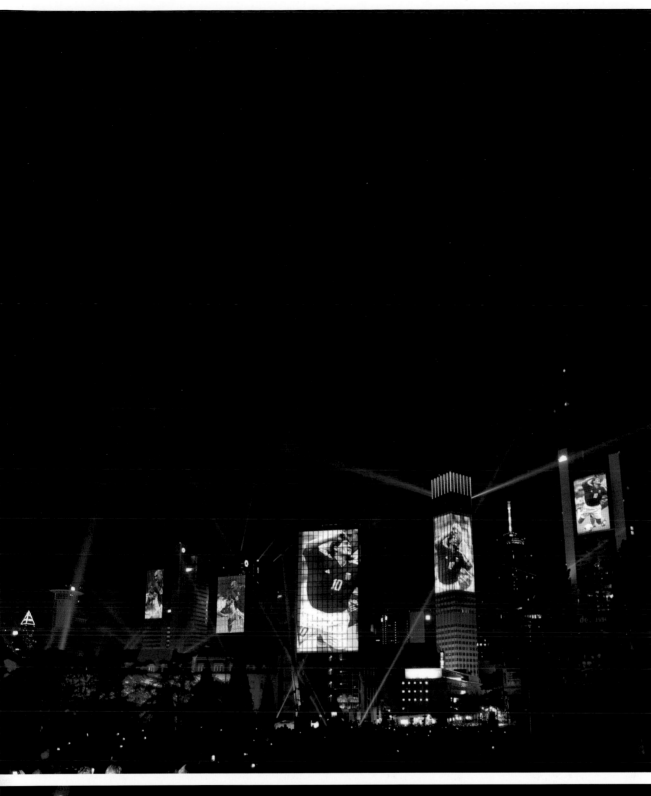

For three days Frankfurt's skyline became the setting for a nocturnal show of light, photographs, graphics and music to celebrate the start of the 2006 World Cup, hosted by Germany.

Still photos came to life as they were projected onto the city's high-rise buildings. Slides were used with celluloid strips, thereby creating a sense of movement similar to film.

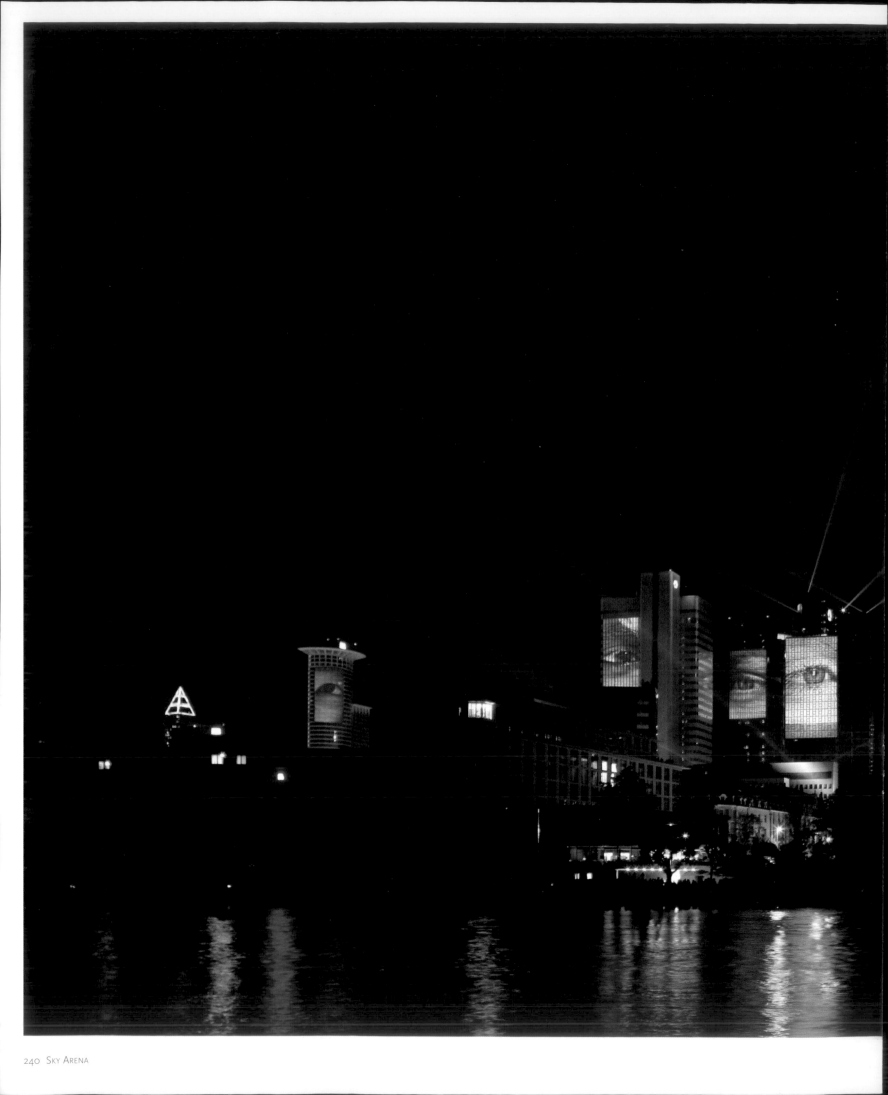

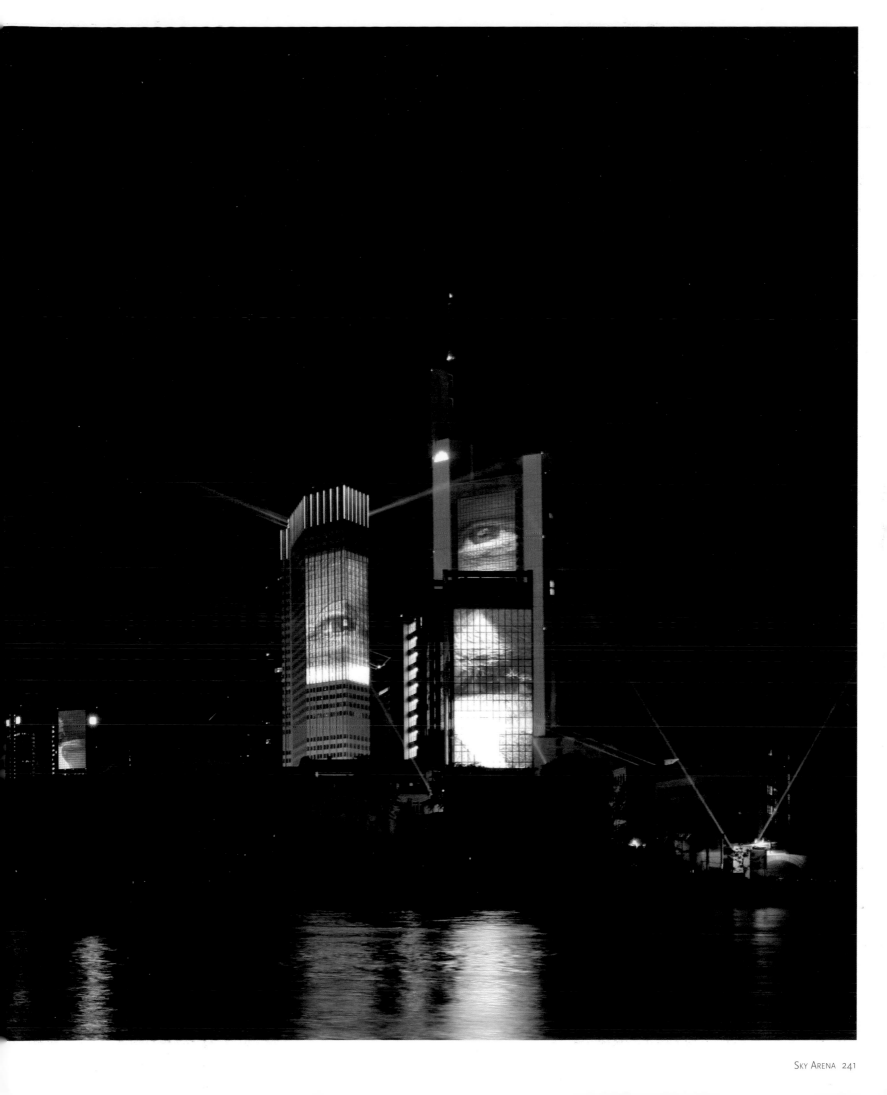

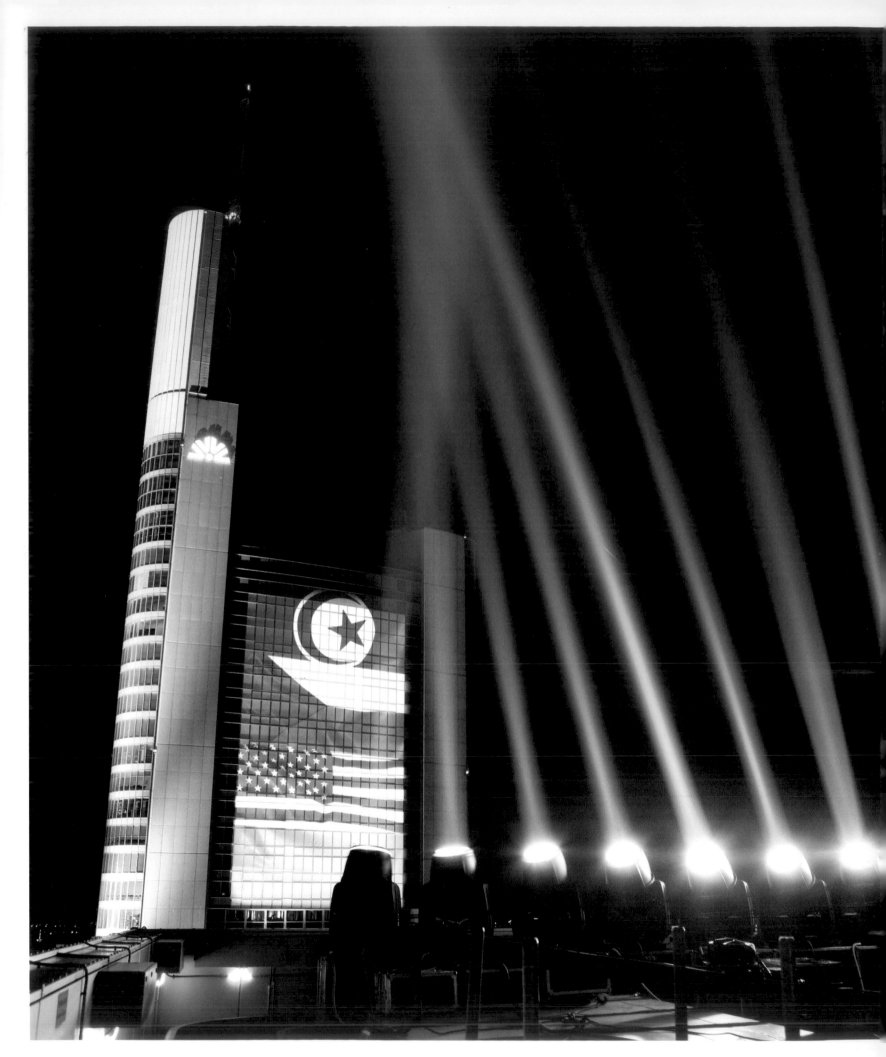

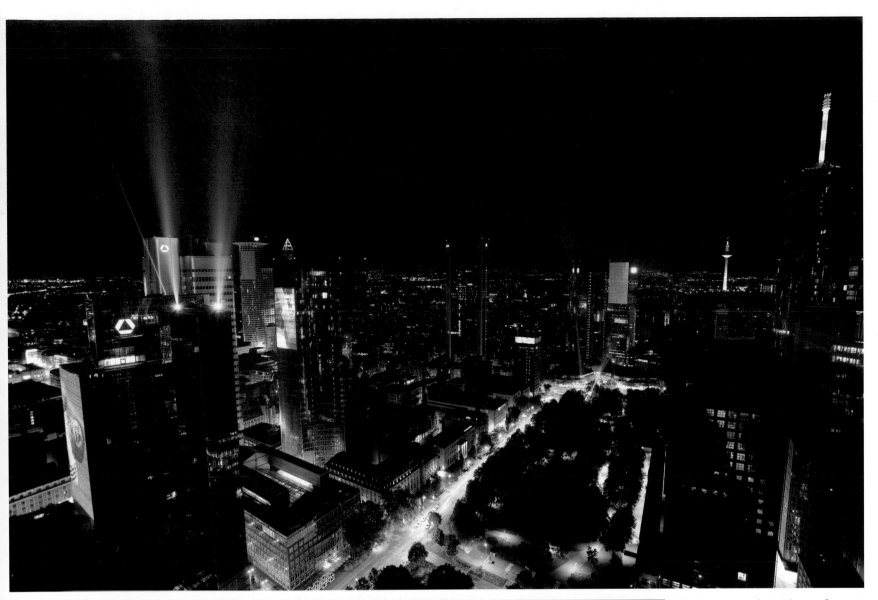

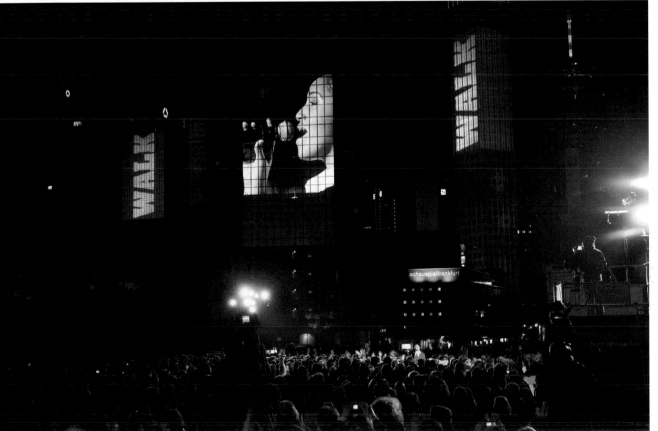

Sky Arena covered a total area of 10,000 square meters. The show was visible for miles around. Visitors could watch the show from the Sachsenhausen side of the river or on the Willy-Brandt-Platz.

A team of 120 workers, 40 industrial climbers and about 20 kilometers of cable made this huge three-day production possible.

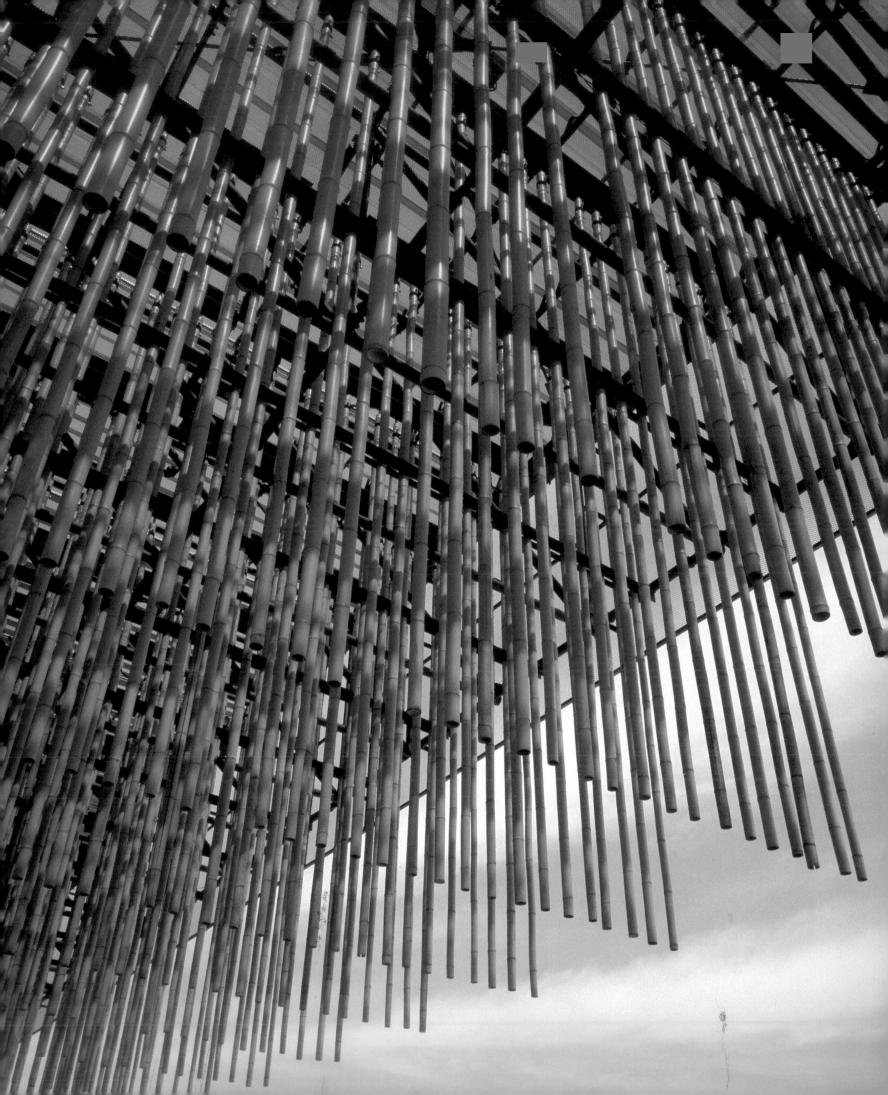

PACIFIC FLORA 2004 MAIN GATE

Bamboo Forest

Kengo Kuma & Associates

Address
Kengo Kuma & Associates
2-24-8 BY-CUBE 2F
Minamiaoyama Minato-ku
107-0062 Tokyo
Japan

Location
Shizuoka Expo Gate Building, Hamamatsu,
Shizuoka, Japan
April 8–October 11, 2004

Other cities
None

Primary material
Bamboo

Photography
© Daici Ano

Pacific Flora 2004, the International Garden and Horticulture Exhibition, opened its doors on April 8, 2004 beside Hamana Lake in Hamamatsu, a city in Japan's Shizuoka prefecture. This was the third time the International Organization of Horticultural Producers (AIPH) held its yearly international flower expo in Japan. Previous venues included Osaka in 1990 and Hyoko in 2000. In 2004 exhibitors from Japan and overseas displayed a variety of indoor and outdoor exhibits over 187 days.

Kengo Kuma & Associates wanted to create a unique exhibition gate, moving away from the traditional notion that the gates must clearly separate the interior exhibition space from the exterior. As this exposition encompassed outdoor and indoor exhibitions, the Japanese architects decided to create a gate that harmonized with the beautiful exterior, in particular nearby Hamana Lake. The firm designed a sequential gate with no walls to obstruct the interior-exterior flow. The gate is made of a grid measuring 200 meters by 1,500 meters; attached to the grid are pieces of bamboo measuring 60 millimeters in diameter and 6 meters tall. A translucent agricultural netting encloses the bamboo, subtly magnifying it. Kengo Kuma had often considered comparing architecture to a forest. With Pacific Flora Main Gate, a structure in the form of a bamboo forest, he has almost blended the two.

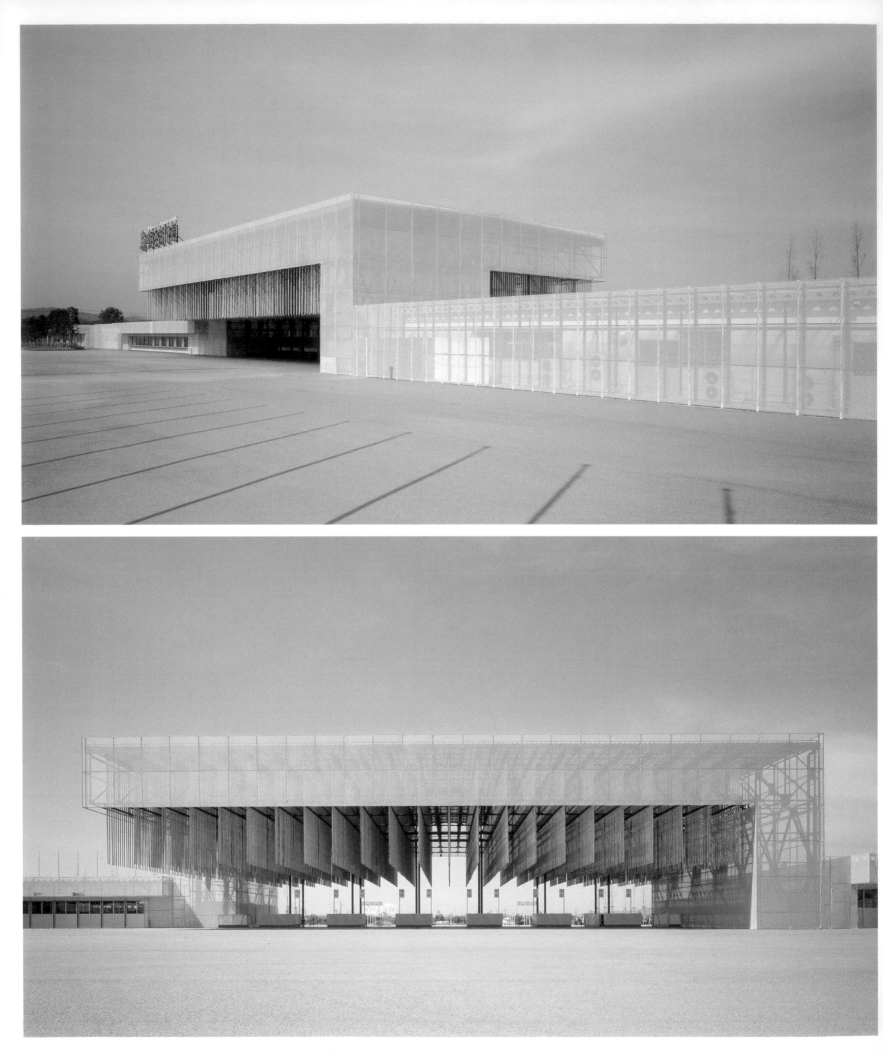

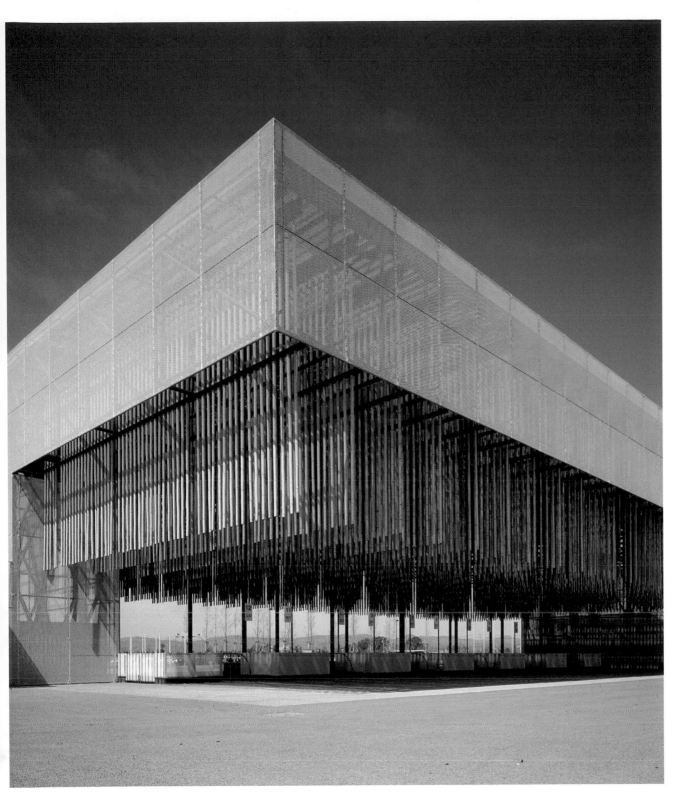

Pacific Flora 2004 Main Gate was constructed for that International Garden and Horticulture Exhibition; the event was held in Hamamatsu in Japan's Shizuoka prefecture from April 8 to October 11, 2004.

Inspired by the local flora, the open gate was intended to blend the outdoor and indoor exhibition areas.

A wall-free space based on grid measuring 200 meters by 1,500 meters became a sequential gate resembling a bamboo forest.

Pacific Flora 2004 occupied 56 hectares. Exhibitors presented both indoor and outdoor shows throughout the 187-day event.

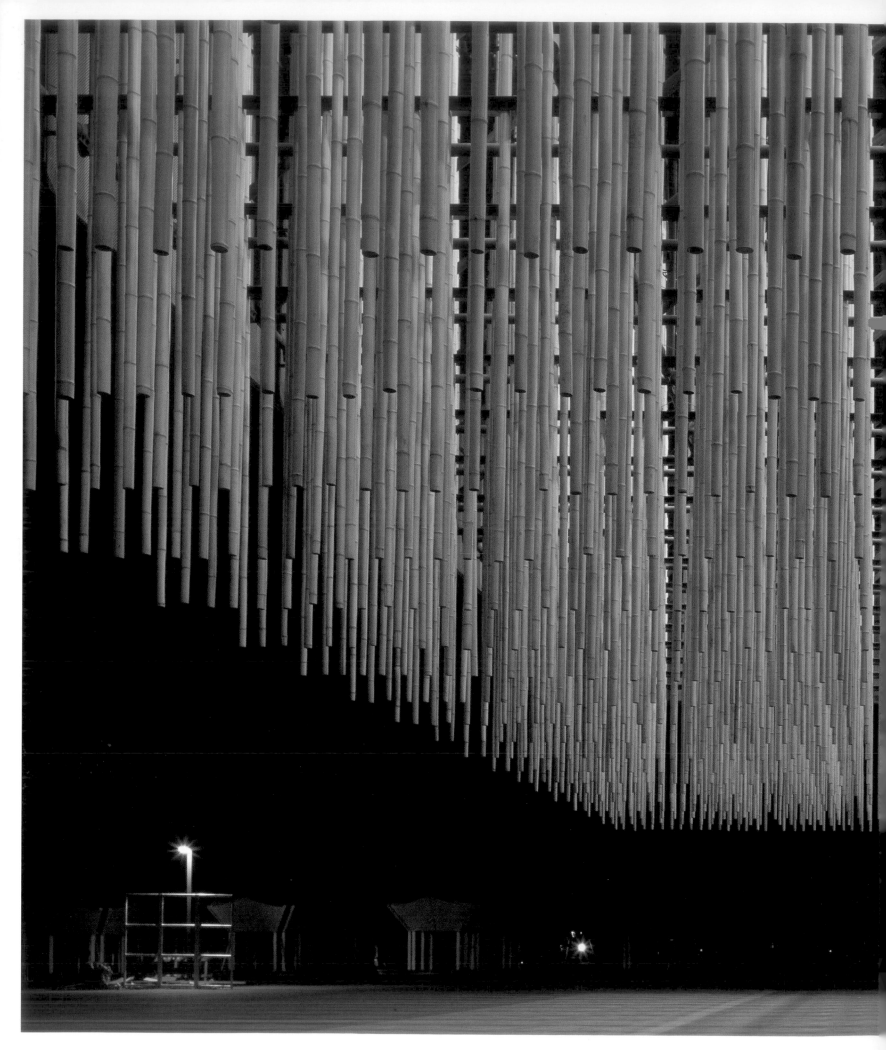

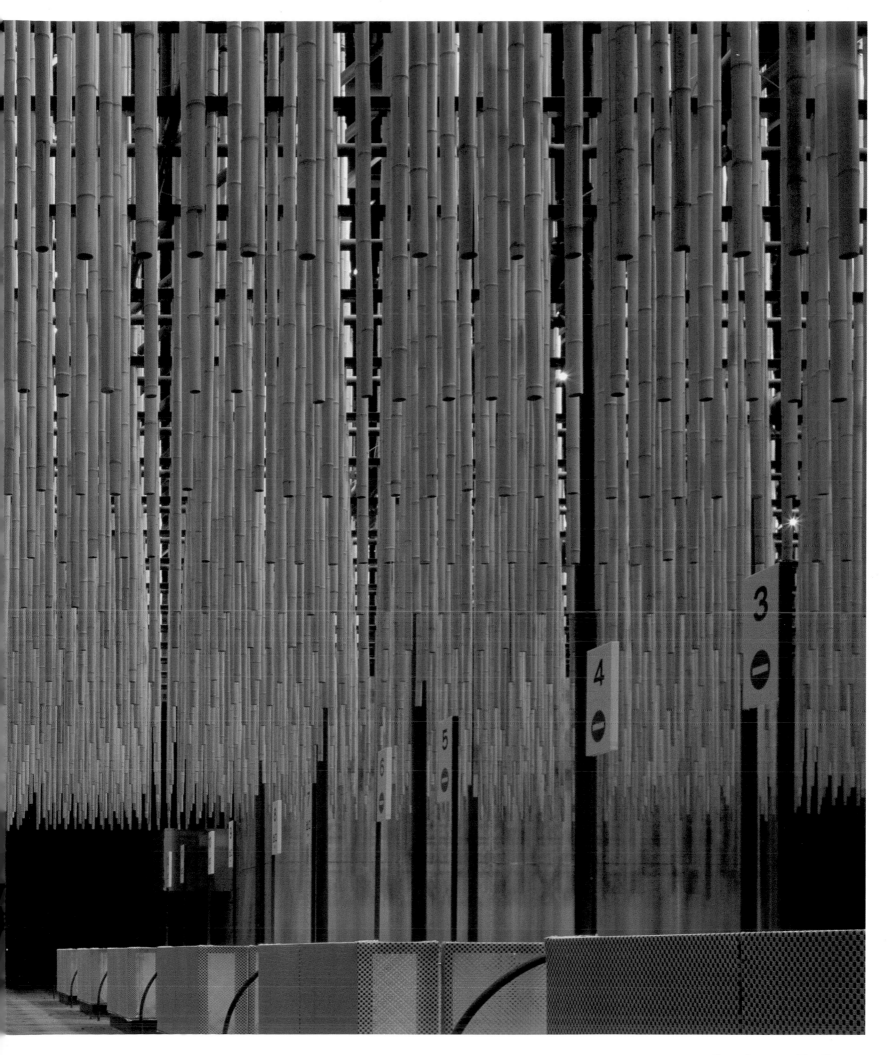

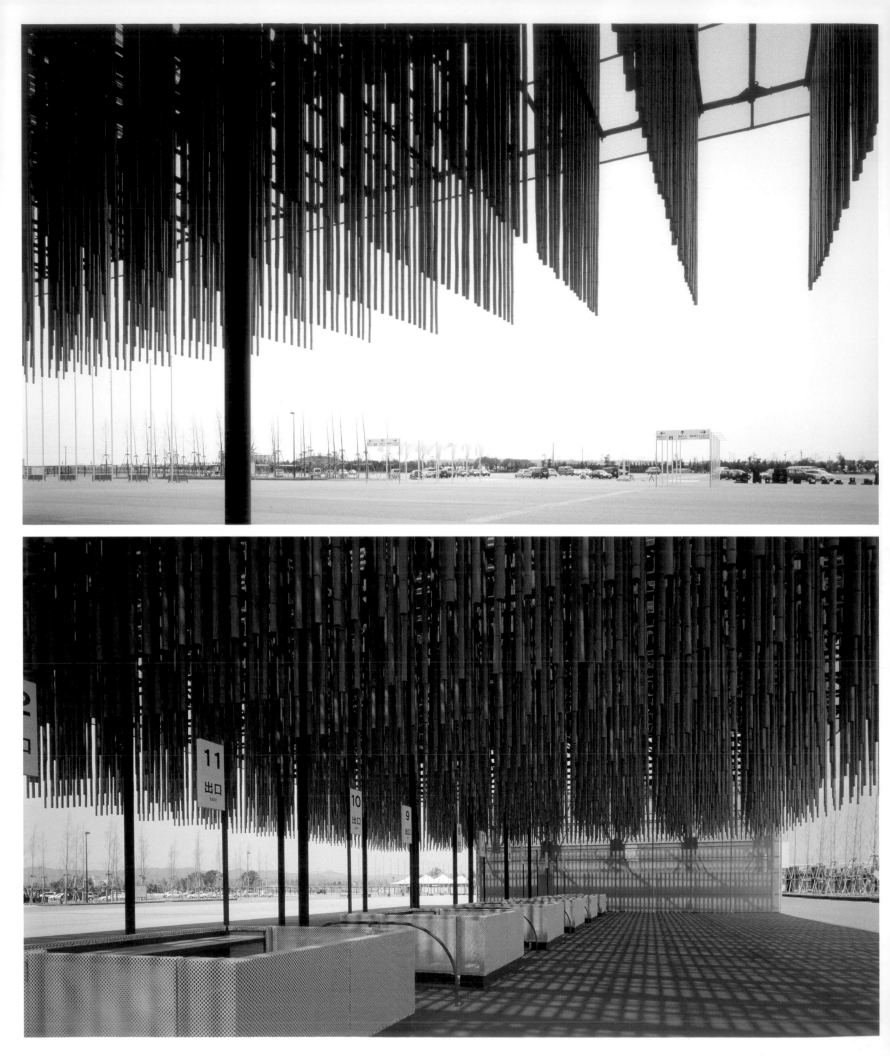

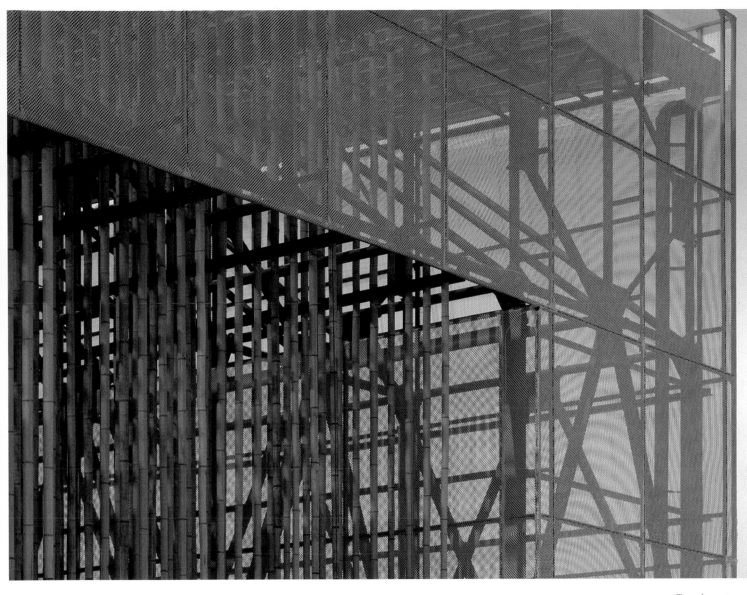

Translucent agricultural netting enclosed the rows of thin bamboo. The color and silhouette of the bamboo disappears through the netting while, at the same time, the bamboo seems subtly magnified.

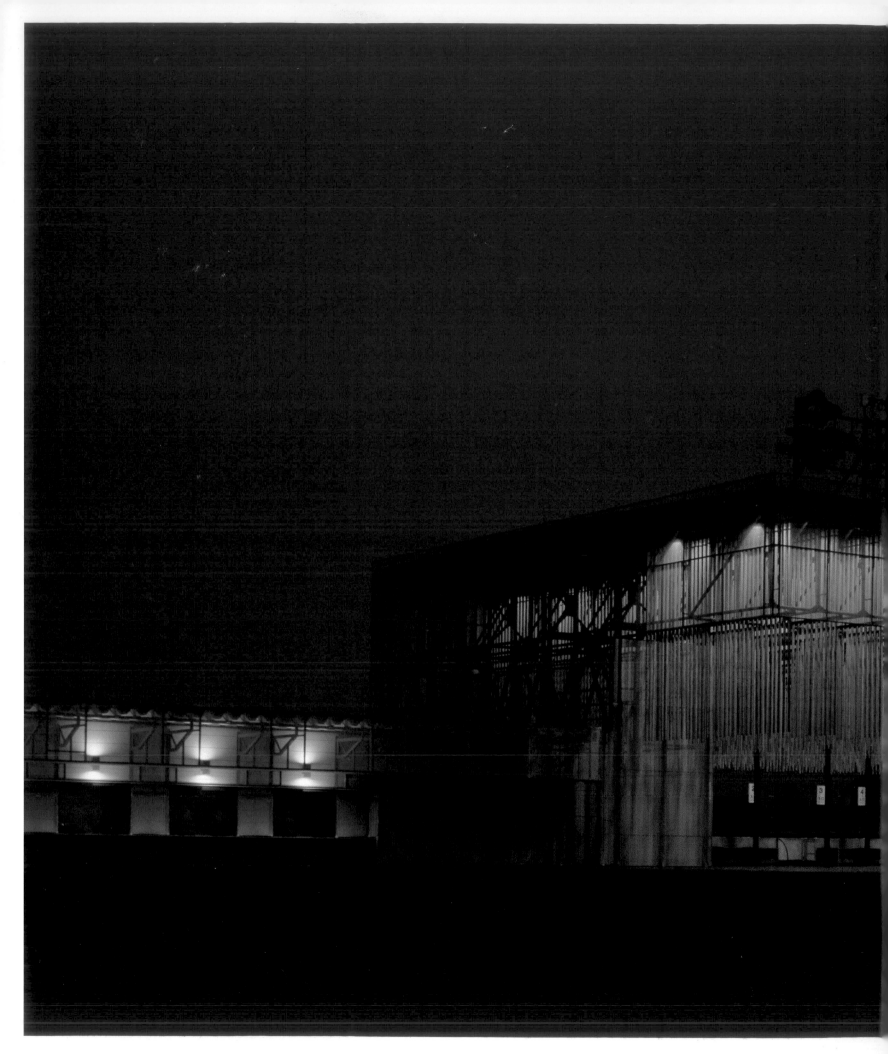

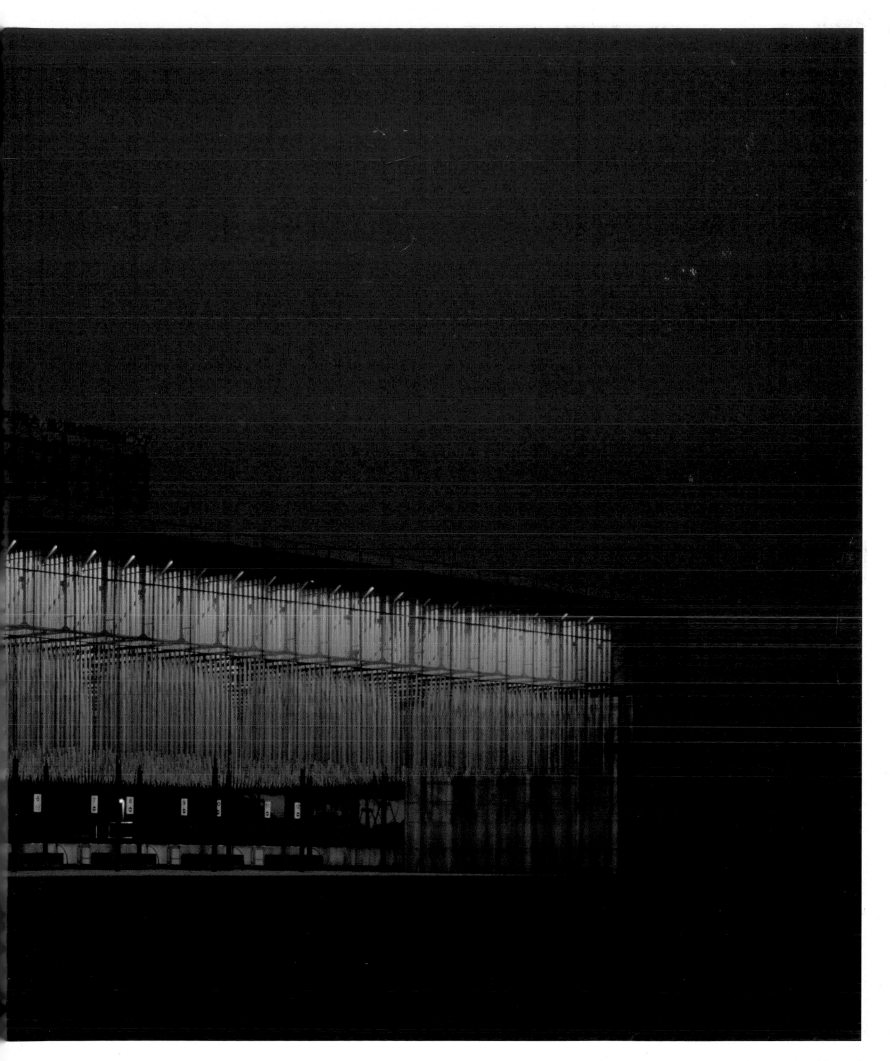

Directory

2b Architectes
20 Av. de Jurigoz, 1006 Lausanne, Switzerland
P: +41 21 617 5817
F: +41 21 617 5833
info@2barchitectes.ch
www.2barchitectes.ch

Arno Design GmbH
Friedrichstr. 9, 80801 Munich, Germany
P: +49 89 3801940
F: +49 89 337108
office@arno-design.de
www.arno-design.de

Asymptote Architecture
160 Varick Street, 10th Floor, New York, NY 10013, USA
P: +1 212 343 7333
F: +1 212 343 7099
info@asymptote.net
www.asymptote.net

Atelier Brückner GMBH
Quellenstrasse 7, 70376 Stuttgart, Germany
P: +49 711 5000770
F: +49 711 50007722
kontakt@atelier-brueckner.de
www.atelier-brueckner.de

Atelier Markgraph GmbH
Hamburger Allee 45, 60486 Frankfurt am Main, Germany
P: +49 69 97993 0
F: +49 69 97993 1181
akratz@markgraph.de
www.markgraph.de

Bonjoch Associats
Bonavista 6, int. pral. 4ª, 08012 Barcelona, Spain
P: +34 934 15 00 07
F: +34 932 37 26 52
ignasi@bonjoch.com
www.bonjoch.com

Concrete Architectural Associates
Rozengracht 133 III, 1016 LV Amsterdam, The Netherlands
P: +31 0 20 5200 200
F: +31 0 20 5200 201
info@concreteamsterdam.nl
www.concreteamsterdam.nl

Dagmar von Wilcken
Friedrichstrasse 217, 10969 Berlin, Germany
P: +30 850 78 210
F: +30 258 99 888
wilcken@f217.de
www.dagmarvonwilcken.com

Dean Maltz
330 W 38th St. Ste. 811, New York, NY 10018, USA
P: +1 212 925 2211
F: +1 212 925 2249
contact@dma-ny.com
www.dma-ny.com

Gatermann + Schossig
Richartzstrasse 10, 50667 Cologne, Germany
P: +49 221 925821 15
F: +49 221 925821 60
treitz@gatermann-schossig.de
www.gatermann-schossig.de

Indissoluble
Passatge de la Pau 11, 08002 Barcelona, Spain
P: +34 934 121 075
F: +34 934 120 675
roberto@indissoluble.com
www.indissoluble.com

Kengo Kuma & Associates
2-24-8 BY-CUBE 2F Minamiaoyama Minato-ku
Tokyo 107-0062, Japan
P: +81 334017721
F: +81 33401777
adachi@kkaa.co.jp
www.kkaa.co.jp

Kreon N.V.
112 Frankrijklei, 2000 Antwerp, Belgium
P: +32 3 231 24 22
F: +32 3 231 88 96
mailbox@kreon.be
www.kreon.com

Lynch/Eisinger/Design
224 Centre Street, 4th Floor, New York, NY 10013, USA
P: +1 212 219 6377
F: +1 212 219 6378
simon@LynchEisingerDesign.com
www.LynchEisingerDesign.com

Mamen Domingo + Ernest Ferré
Diputació, 239 1° 2ª B, 08006 Barcelona, Spain
P/F: +34 934 870 105
domingoferre@terra.es
www.domingoferre.com

Margarida Costa-Martins
Placeta Montcada 3, pral., 08003 Barcelona, Spain
P: +34 609 385 500
margaridamart@yahoo.es

Paolo Cesaretti
Corso Ventidue Marzo 42, 20135 Milan, Italy
P/F: +39 02 70121354
contact@paolocesaretti.it
www.paolocesaretti.it

Plajer & Franz Studio
Erkelenzdamm, 59-61, 10999 Berlin, Germany
P: +49 30 616 55 8 0
F: +49 30 616 55 819
studio@plajer-franz.de
www.plajer-franz.de

Ronan & Erwan Bouroullec
23 rue du Buisson Saint-Louis, 75010 Paris, France
P: +33 1 42 00 40 33
F: +33 1 42 00 52 11
info@bouroullec.com
www.bouroullec.com

Saeta Estudi + Margarida Costa-Martins
Passeig de Sant Joan 12, pral. 2ª, 08010 Barcelona, Spain
P/F: +34 932 476 562
saeta@coac.net
www.saetaestudi.com

Shigeru Ban Architects
5-2-4 Matsubara Setagaya Tokyo, 156-0043 Japan
P: +81 3 3324 6760
F: +81 3 3324 6789
eawata@shigerubanarchitects.com
www.shigerubanarchitects.com

Souto Moura Arquitectos Lda.
R. do Aleixo, 53 1ª, 4150-043 Porto, Portugal
P: +351 22 618 75 47
souto.moura@mail.telepac.pt

Studiomonti
Piazza S. Erasmo 1, 20121 Milan, Italy
P: +39 02 6599470
F: +39 02 29019795
info@studiomonti.com
www.studiomonti.com

Surface Architects
51 Scrutton Street, London EC2A 4PJ, UK
P: +44 20 7729 1030
F: +44 20 7729 8867
mail@surfacearchitects.com
www.surfacearchitects.com

Werner Sobek Ingenieure
Albstr. 14, 70597 Stuttgart, Germany
P: +49 711 76750 0
F: +49 711 76750 44
mail@wsi-stuttgart.com
www.wernersobek.com